# MEDIEVALIA ET HUMANISTICA

# MEDIEVALIA ET HUMANISTICA

New Series
Edited by Paul Maurice Clogan

# MEDIEVALIA ET HUMANISTICA

## STUDIES IN MEDIEVAL & RENAISSANCE CULTURE

NEW SERIES: NUMBER 7

*Medieval Poetics*

EDITED BY PAUL MAURICE CLOGAN

1976

CAMBRIDGE UNIVERSITY PRESS

CAMBRIDGE

LONDON · NEW YORK · MELBOURNE

Published by the Syndics of the Cambridge University Press
The Pitt Building, Trumpington Street, Cambridge CB2 1RP
Bentley House, 200 Euston Road, London NW1 2DB
32 East 57th Street, New York, NY 10022, USA
296 Beaconsfield Parade, Middle Park, Melbourne 3206, Australia

Library of Congress Catalogue Card Number: 75–32451

ISBN 0 521 21331 2
ISSN 0076 6127

First published in 1976

Printed in the United States of America
Typeset, printed, and bound by
Vail-Ballou Press, Inc., Binghamton, New York

## Contents

# *Editorial Note*

*Medievalia et Humanistica*, founded in 1943 by S. Harrison Thomson, achieved national and international recognition as the first American scholarly publication devoted solely to the study of the Middle Ages and Renaissance. The new interdisciplinary series, begun in 1970 and edited by an international board of distinguished scholars and critics, publishes in annual hardbound volumes significant scholarship, criticism, and reviews covering all areas of medieval and Renaissance culture: history, literature, philosophy, science, law, art, architecture, music, social and economic institutions. *Medievalia et Humanistica* encourages the individual scholar to examine the relationship of his discipline to other disciplines and to relate his study in a theoretical or practical way to its cultural and historical context. The new annual series seeks to integrate the study of medieval and Renaissance culture by considering important topics of common interest from different perspectives and by indicating current trends and new directions in humanistic scholarship. The series encourages cooperation between scholars in various disciplines and provides a forum for the exchange of ideas and information of general interest to medieval and Renaissance scholars and critics. Review articles examine significant recent publications and major areas of current concern within specific fields, and contributing editors report on the progress of medieval and Renaissance studies in North America and Europe.

*Medievalia et Humanistica* is sponsored by the Comparative Studies in Medieval Literature Section of the Modern Language Association of America, and publication in the series is open to contributions from all sources. The editorial board welcomes interdisciplinary critical and historical studies by young or established scholars and urges contributions to communicate in an attractive, clear, and concise style the larger implications in addition to the precise material of their research, with documentation held to a minimum. Texts, maps, illustrations, and diagrams will be published only when they are essential to the argument of the article. In the preparation and the submission of typescripts for consideration, potential contributors are advised to read and follow carefully the instructions given below on page xii.

Individuals, institutions, and libraries may enter standing orders for the new series. Future volumes will be sent to them automatically. Such

standing orders may, of course, be canceled at any time. Inquiries regarding single or standing orders for the new series and Numbers 1–3 and 6–7 should be addressed to the Publisher, Cambridge University Press, at 32 East 57th Street, New York, New York 10022, or at Bentley House, 200 Euston Road, London NW1 2DB. Books for review, original articles for future volumes, and inquiries regarding *Fasciculi* I–XVII in the original series and Numbers 4–5 in the new series should be addressed to the Editor, *Medievalia et Humanistica*, P. O. Box 13348, North Texas Station, Denton, Texas 76203.

# Preface

The first seven articles on medieval poetics are based upon papers that were presented at the Second Biennial Medieval Conference, held at Harvard University, November 10–12, 1974, under the direction of Professors Morton W. Bloomfield, John E. Murdoch, and Isadore Twersky. These articles are interdisciplinary (music, literature, history) and cross-cultural (Jewish, Arabic, Christian) in approach and were distributed to the participants in advance of the conference. In preparing the articles for publication, the authors have made some revisions in the light of their own second thoughts and of the discussion at the conference. Because there is no adequate history of literary criticism in the Middle Ages, O. B. Hardison surveys the entire field, analyzing the defects in such histories as we have, and sets standards for an adequate history of medieval criticism. Nino Pirrotta's essay is an outstanding piece of work because there is practically nothing written in English on the medieval theory of the music of the human voice. He contributes an interesting discussion of ninth- and eleventh-century theorists of music, and in particular the *Micrologus* of Guido of Arezzo, the most important and almost unique medieval statement on musical poetics. David Hughes deals with the relationship of musical development – particularly monophony and polyphony – to poetic (metrical) usage; his study is most useful in providing the non-musicologist with a basic vocabulary with which to discuss the subject of music and meter in his own work in an intelligent way. Winthrop Wetherbee selects and synthesizes twelfth- and thirteenth-century scientific and spiritual writings concerning a definition of "imagination." We think that his essay will become an essential item in any bibliography on the thought, literature, or culture of the period. Dante Della Terza provides that useful kind of article which summarizes succinctly and clearly a range of critical positions on a given topic and then makes an interesting contribution in its own right. The essay by S. A. Bonebakker is of great importance, providing a special insight into Arabic literary criticism. He analyzes the position of poetry and belles lettres in the world view of Islam and presents novel points of view which, we are sure, will be much discussed in the future. Finally, Raymond P. Scheindlin's article contributes to a greater understanding of the interaction between Hebrew and Christian literature in the Middle Ages. *Medievalia*

*et Humanistica* is pleased to publish these original and important articles.

Among the other articles in this volume, Peter F. Dembowski makes a trenchant analysis of the genre of hagiography and gives insight into its mode of existence and transmission during the Middle Ages. "Magic That Does Not Work" is an engaging article of an interdisciplinary nature and wide implications and should be of interest to many readers. The essay by Lee W. Patterson is an informative study of the use of intellectual or cultural history and of literary tradition and context in the illumination and interpretation of a work of literature. We think that this essay will become the standard one on the subject.

In addition, this volume also contains two review articles and six review notices of significant recent publications. The editor is indebted and most grateful to the members of the editorial board for their expert criticism and advice. Future volumes in the new series of *Medievalia et Humanistica* are open to contributions from all sources, and articles for future volumes are invited. The next volume will include essays on varied subjects. Review articles will evaluate significant recent publications and major areas of current concern within specific fields, and contributing editors will report on the progress of medieval and Renaissance studies in North America and Europe.

<div align="right">P.M.C.</div>

February 1976

# Articles for Future Volumes
## Are Invited

The original typescript should be presented on white medium weight (twenty-pound bond) paper 8½ x 11 inches in size with ample (1 to 1½ inch) margins. The article should be typed with DOUBLE SPACING throughout, including quotations. The length of the article depends upon the material. Brief endnotes should be prepared according to the twelfth edition of *A Manual of Style* (Chicago and London, 1969) or the second edition of the *MLA Style Sheet* (New York, 1970); and they should be typed with DOUBLE SPACING (triple spacing between notes), numbered consecutively, and placed at the end of the article. All quotations, citations, and references should be fully identified and carefully verified before submission. The completed article should be in finished form, appropriate for printing. Only the original typescript (not photocopy or carbon) should be submitted, accompanied by a stamped, self-addressed manuscript envelope, and should be addressed to the Editor, *Medievalia et Humanistica*, P. O. Box 13348, North Texas Station, Denton, Texas 76203.

Authors outside the United States and Canada may submit original typescripts in English to the nearest or most appropriate editor for consideration. A prospective author is encouraged to contact his editor at the earliest opportunity to obtain a copy of the style sheet and to receive any necessary advice. The addresses and fields of the editors outside the United States and Canada are:

Professor Giuseppe Billanovich, Foro Buonaparte 55, Milano 20121, Italia (Medieval and Humanistic Philology)

Dr. Derek Brewer, Emmanuel College, Cambridge CB2 3AP, England (Medieval Literature)

Mr. Peter Dronke, Clare Hall, Cambridge CB3 9DA, England (Medieval Latin Poetry and Thought)

Professor J. R. Hale, Department of Italian, University College London, Gower Street, London WC1 6BT, England (Renaissance History)

Professor Denys Hay, Department of History, University of Edinburgh, William Robertson Building, George Square, Edinburgh EH8 9JY, Scotland (Renaissance History)

Professor Ian D. McFarlane, Wadham College, Oxford OX1 3NA, England (Renaissance French and Neo-Latin Literature)

Professor Jean-Claude Margolin, 75 Bld Richard-Lenoir, 75011 Paris, France (Humanism, Renaissance Philosophy and Neo-Latin)

Professor Dr. Heiko Oberman, 7400 Tübingen, Hölderlinstr. 17, West Germany (Church History, Late Medieval Theology and Reformation)

Professor Dr. Paul G. Schmidt, Seminar für Klassische Philologie der Universität, 34 Göttingen, Nikolausberger Weg 9c, West Germany (Medieval Latin Philology)

# Toward a History of
# Medieval Literary Criticism

## O. B. HARDISON, Jr.

If you take one of the standard histories of literary criticism from the library shelf, your first reaction is likely to be one of satisfaction. Other areas of literary study fly off in all directions, raise unanswerable questions, and provide more material than the human mind – or even the mind of a computer, if computers have minds – can bring into focus. By comparison, literary criticism seems to be a four-lane highway leading from Plato to the moderns. As examples of criticism multiply, they can still be classified under labels such as affective, didactic, and descriptive, or as New Criticism phenomenology, structuralism, and the like. Of course, criticism is not really that simple, but at least it seems amenable to containment and definition. In 1957 Brooks and Wimsatt were able to package it in a one-volume "short history" which begins with Socrates and ends with "myth and archetype." Not too many years later, Murray Krieger suggested that criticism, rather than works of literature, should be the center of the graduate literary curriculum, since it would provide a core around which other studies could be organized.

I think there is a provisional truth in this point of view for all but one of the major periods of criticism. The exception is the Middle Ages. Today, in spite of many articles on specific authors and works, there is no book that could be called a standard history of medieval criticism.

The closest approach is the first volume ("Classical and Medieval") of George Saintsbury's *History of Criticism in Europe*, which was published around 1900. Yet, in spite of its learning and good sense, Saintsbury's *History* is both dated and, in places, erroneous. Edgar de Bruyne's three-volume *Etudes d'esthétique médiévale*, published in 1946, is a brilliant and, for the present, definitive survey of medieval aesthetics. It treats literary criticism, but only as criticism reflects concepts of beauty which de Bruyne finds more suggestively expressed in areas other than literary criticism – in theology, architecture, music, and visual art. Hans Glunz's *Literäresthetik des europäischen Mittelalters*, published in 1937, concentrates on literature, but Glunz is less interested in literary theory than in ideas which can be deduced empirically from various literary works. E. R. Curtius, of course, touches frequently on criticism, but again the emphasis is not on criticism per se.

I

After Saintsbury, I know of only two general works that deal with the history of medieval criticism. They are J. W. H. Atkins's *English Literary Criticism: the Medieval Phase* (1952) and Charles S. Baldwin's *Medieval Rhetoric and Poetic* (1924). Both of these works are useful, but, for reasons that I will discuss later, their value is limited.[1] W. K. Wimsatt and Cleanth Brooks summarize the prevailing attitude toward medieval criticism when they remark:

Let us say, in summation, that the Middle Ages. . . were not in fact ages of literary criticism. . . . It was an age of theological thinking in a theologically oriented and theocratic society. Such a society does not characteristically promote the essentially humanistic activity of literary criticism.[2]

After having been concerned with literary criticism for more than two decades, I have concluded that we are only beginning to gain control of medieval criticism. This is my major premise, and I will elaborate it under four heads: first, the incompatibility of the subject with standard modes of literary history; second, the difficulty of deciding what is and is not criticism in the Middle Ages; third, the problem of historical articulation; and fourth, the tendency of efforts to understand medieval criticism to force a rethinking of commonplace assumptions about ancient and Renaissance criticism.

To begin with literary history, it is a truism that medieval culture has a universal aspect which distinguishes it from both ancient and post-medieval culture. Since the Romantic period, however, literary studies have been organized linguistically, which is to say that they have been organized nationalistically. Many distinguished critics from Goethe to Irving Babbitt have protested this orientation, but their protests have had little effect. Comparative literature, it is true, began as an effort to enlarge on the parochialism of departments of English, French, German, and Italian, but comparatists tend to write about vernacular, rather than Latin literature. What Cleanth Brooks and Robert Penn Warren wrote in 1948 in their *Theory of Literature* holds true today:

It is clear that for many problems in the history of ideas, including critical ideas. . . artificial cross-sections are drawn through homogeneous materials. . . . The excessive attention to one vernacular is especially detrimental to the study of medieval literature, since in the Middle Ages Latin was the foremost literary language, and Europe formed a very close intellectual unity.[3]

The point made by Brooks and Warren cannot be stressed too heavily. Language is the most important symbolic form within which reality is created. For medieval Europe the dominant language was Latin. The Latin language created an international community, which Curtius has labeled Romania, that had a basic cultural unity. I suspect that, because of the Latin language, most intellectuals, from the fourth to the tenth century, felt a sense of kinship that we can hardly imagine today. It was a

kinship of purpose, primarily, reinforced by a common language and a common heritage that included the Bible and a group of literary, rhetorical, and grammatical works transmitted first- or secondhand from antiquity. After the tenth century there must have been an increasing awareness among intellectuals of the existence of two cultures, one Latin and universal, and the other vernacular and local; but it is worth remembering that, as late as the sixteenth century, Erasmus wrote, spoke, and probably thought entirely in Latin, although he was surnamed Rotterdamus.

Both Latin and the standard curriculum works associated with it were international. They were used by everyone, but they were no one's special possession. The Bible came from Palestine, and the works of Ovid, Vergil, Statius, Donatus, Priscian, and Cicero were produced by a Roman culture that ceased to exist after the fifth century, outside of the heated imagination of a few zealous Italians. In the eighth century, when Bede wrote in Latin, he ceased, in effect, to be a Saxon. For him the chief assets of the monasteries of Wearmouth and Jarrow were their libraries, which made the international culture of the Latin West available in farthest Britain. In *English Literary Criticism: The Medieval Phase*, J. W. H. Atkins summarizes this culture even as he lists the main works in these monastic libraries: "the Latin Vulgate, for instance, the works of the Latin Fathers, the treatises of fourth-century grammarians, the encyclopaedic writings of Cassiodorus and Isidore, the main body of Christian poetry, as well as works of Cicero, Vergil, Lucan, Statius, and other classical authors."[4]

This situation was not an accident, an anomaly, or a failure of creativity. It was the result of a deliberate choice, made in the West during the third and fourth centuries and reinforced by military power after the state allied itself with the aims of the church. The chief Latin apologists for a universal order, as against a parochial one, were Jerome and Augustine. Their program enlisted the support, in one way or another, of the most prominent Christian intellectuals who followed them.

The distortion which arises from attempting to apply nationalist literary history to an international culture is illustrated by Atkins's *English Literary Criticism: The Medieval Phase*.

In spite of his learning and his useful analysis of several authors, Atkins is forced by his approach to sin by omission and inclusion. Among the major Latin critics of the fourth to the eighth century were Servius, Macrobius, Donatus, Jerome, Augustine, Sidonius Cassiodorus, Bede, Fulgentius, and Isidore. Bede is important in the history of criticism, but less so, certainly – even in England – than Macrobius or Augustine. Yet, merely because of the accident of where Bede lived, Atkins is compelled to treat his criticism in detail, while omitting or considering only briefly most of the authors who were his mentors, sources, and successors. Con-

sequently, Bede's work is wrenched out of context. His two most important critical essays are the *De Arte Metrica* and the *De Schematibus et Trophis*. Each is part of a tradition that goes back to fourth-century redactions of classical works, and Bede's primary sources are all from the fourth century – Servius, Victorinus, Donatus, and Diomedes. The fact that Bede wrote in England, rather than Orleans or Rome, is a geographical accident.

If we turn to the content of Bede's essays, the significance of his work becomes clearer. The *De Arte Metrica* is a treatise on prosody illustrated by passages of Christian and pagan poetry. Its most interesting section is an analysis of rhythmic verse drawn from Victorinus but using Ambrosian hymns like the *Rex aeterne Domine rerum creator* to illustrate the form. Clearly, Bede is attempting to assert the continuity of pagan with Christian poetry and to include the most innovative type of Christian hymn in this tradition. The *De Schematibus* has the same general thrust. It lists the standard schemes and tropes of classical rhetoric but uses the Bible, rather than Vergil, to illustrate them. Both works, incidentally, are textbooks, and thus related to the educational aims which characterize humanism from the classical period to the Renaissance.

Evidently, Bede had enrolled himself enthusiastically in the program formulated by St. Augustine in the *De Doctrina Christiana*. Augustine advised his readers (Ch. XL) to use the knowledge of the ancients for Christian purposes in the same way the ancient Hebrews took the gold of the Egyptians with them on their flight from Egypt:

If those who are called philosophers, especially the Platonists, have said things which are true and well accommodated to our faith, they should not be feared; rather, what they have said should be taken from them as from unjust possessors and converted to our use. Just as the Egyptians had not only idols and grave burdens which the people of Israel detested and avoided, so also they had vases and ornaments of gold and silver and clothing which the Israelites took with them secretly when they fled, as if to put them to a better use.[5]

Far from being nationalistic, in his critical works Bede joined the effort to create a new and universal culture combining the ancient truths of reason with the higher revelations of Scripture. His goal here is not markedly different from his contributions to universal understanding of the Bible in his commentaries or his description of the triumph of the universal religion over Saxon paganism in his *Ecclesiastical History of England*.

I do not want to criticize Atkins unfairly, but I do want to make my point as emphatically as possible. The history of medieval criticism in the West must be a history of Latin criticism. It can be aware of geography, but it cannot follow the nationalistic path of modern literary studies without distorting its subject. The authors who created medieval criticism were part of an international cultural elite. Their ultimate

sources were Greek and Roman on the one hand, and Palestinian on the other, and their proximate sources were mostly fourth-century and Latin – the pagan redactors and commentators and the Church Fathers.

My second point has to do with establishing a definition of literary criticism that is workable for the Middle Ages. In general, literary criticism includes essays on the history and theory of literature and the nature of literary genres, discussions of style, biographies of authors, and readings of individual literary works. This definition intentionally avoids restricting criticism to a specific approach, and it accepts the inevitability of gray areas as criticism shades off into aesthetics, psychology, sociology, theology, and other disciplines. In spite of its inclusiveness, however, it creates problems for the would-be historian of medieval criticism. There are two minor but formidable reasons for this problem, and one major one.

First, many works which fall within the definition seem naive to the point of triviality when compared with the standard critical documents of other periods. Servius' *Commentary on the Aeneid*, for example, was a basic source throughout the Middle Ages. It is a vast collection of mostly trivial footnotes. If it is criticism, one's initial inclination is to dismiss it as abysmal criticism. A few scholars like Bolgar and Julian Ward Jones, who have studied Servius in detail, realize that this is not entirely fair, but unfortunately most historians of criticism have not been specialists. The *Commentary on the Aeneid* written in the sixth to seventh century by Fabias Planciades Fulgentius might seem, on first consideration, to be a little more promising. It is not a collection of footnotes but a sustained allegorical interpretation. However, the interpretation offered by Fulgentius is so distorted and is based on such lugubrious ignorance of elementary subjects like Greek and Latin etymology that it is usually dismissed as a prime example of medieval barbarism.

If some of the most familiar medieval critical texts are disappointing, another reason for the difficulty of arriving at an acceptable definition of medieval criticism is that many texts of potential interest to the historian of criticism are known only to medievalists. Professor Judson Allen has recently published an exemplary book on criticism in fourteenth-century England, *The Friar as Critic*. He remarks in the preface, "Not too many years ago, these friars were little more than names. The true character of their work was hardly suspected."[6] Except for John Ridewall, most of Professor Allen's friars are unpublished. Even published critics, however, are often unknown to historians of criticism. I include in this category the criticism of Proclus and Claudius Tiberius Donatus, the *Scholia Vindobonensia* (available only in Joseph Zechmeister's 1877 dissertation), the commentary on the first six books of the *Aeneid* by Bernard Silvestris, edited by Riedel (1924), Conrad of Hirsau, as edited by Huygens (1955), the edition of Gundissalinus by Ludwig Baur (1903), and the commen-

tary of Averroës on the *Poetics* of Aristotle, as translated into Latin by Hermannus Alemannus, which is available only in an unpublished dissertation by Professor William Boggess (University of North Carolina, 1965). Other works could easily be cited. The point is that most of these works are *terra incognita* to historians of criticism. This being the case, the historians tend to look to aesthetics, theology, and rhetoric, rather than criticism, for their material.

This leads me to the major reason for the problem of deciding what is and what is not criticism in the Middle Ages. Disappointed by the works which they know and unfamiliar with many others, historians of criticism have turned to authors whose contribution to criticism per se is negligible. Brooks and Wimsatt devote two chapters of their *Short History* – 42 out of 755 pages – to medieval criticism. Most of their first medieval chapter is a discussion of Plotinus, who had nothing to say about literature and whose influence on the Latin West was at best indirect. The remainder of this chapter deals with St. Thomas Aquinas (with a codicil on Joyce's Stephen Daedalus), in spite of the fact that, as Brooks and Wimsatt admit, "The student who inquires about poetry in the system of Aquinas himself will search the texts to find poetry treated only here and there, either as a problem in semantics . . . . or as an art of verbal reasoning lower even than sophistic or rhetoric (that is, at the bottom) in a scale which has Aristotelian metaphysical demonstration at the top."[7]

Plotinus and St. Thomas aside, there are two very large areas which any historian of medieval criticism has to confront head-on. These are rhetoric and biblical criticism.

Since Edmond Faral's edition of the *artes poeticae* of the twelfth and thirteenth centuries[8] and C. S. Baldwin's *Medieval Rhetoric and Poetic*,[9] historians of criticism have tended to assume that the history of medieval poetics is the same as the history of medieval rhetoric. This has led them to discuss works and traditions which are purely rhetorical – Alcuin's *Rhetoric*, for example, and the *artes praedicandi* – and to stress the rhetorical element in genuinely critical works like the *Poetria Nova* of Geoffrey of Vinsauf to the exclusion of other important features.

While this approach is understandable, evidence suggests that medieval authors may have been less confused about rhetoric and poetic than twentieth-century scholars. Medieval educational theory made emphatic distinctions among grammar, rhetoric, and logic. Until the thirteenth century, poetry was not assigned to rhetoric, but to grammar, while during the scholastic period it was often assigned to logic. Genuine rhetorical criticism can be found in the fourth century in the Vergil Commentary of Claudius Tiberius Donatus and the *Saturnalia* of Macrobius. Thereafter, until the thirteenth century, most critical treatises were clearly intended for, or related to, the grammar curriculum. As is well known, the *Poetria Nova* drew heavily on the lists of figures found in

the *Rhetorica ad Herennium* and the *De Inventione*. However, it is much more than an illustrated compendium of rhetorical figures, and to treat it exclusively in terms of its sources is to miss the point which Geoffrey of Vinsauf attempted to make in his title. *Poetria* was the common medieval term for the *Ars Poetica*. The *Poetria Nova* is a new *Ars Poetica*. Its originality is its most important feature, and the originality consists not in its list of figures, but in its theory of composition. For Geoffrey, poetic vision is the key to the creative process. His poet is an architect, not a clever manipulator of figures. As he writes at the beginning of the *Poetria:* "The mind's hand shapes the entire house before the body's hand builds it. Its mode of being is archetypal before it is actual. Poetic art may see in this analogy the law to be given to poets."[10] Without going into further detail, I would suggest that Geoffrey's use of rhetoric has to be seen in terms of his theory of composition, rather than in terms of the history of rhetorical figures. His theory of composition, in turn, was derived from Platonic theories of creativity which were developed quite independently of rhetorical theory, and it was to be applied in connection with exercises in literary imitation which were a regular part of the twelfth- and thirteenth-century grammar curriculum.

Biblical criticism poses an even more knotty problem than rhetoric. Among other things, the Bible is a literary work. Therefore, writings about the Bible are criticism just as surely as writings about Vergil. One important feature of biblical criticism is the broadening influence which it had on classical literary theory. As noted earlier, Bede used the Egyptian gold of classical prosody and Ciceronian rhetoric to interpret passages of the Old Testament. But when classical definitions were applied to the Old Testament, understanding of the definitions themselves changed. For example, if *The Song of Songs* is a drama, it follows that the dramatic genre is capable of effects undreamed of in the plays of Plautus and Seneca. And if David is, as Jerome believed, "our Simonides and our Pindar," the definition of lyric poetry has been enlarged far beyond the limits set by ancient theory and practice. To cite another example of the interrelation of biblical criticism and literary criticism, acceptance of the Old Testament as the central classic of medieval culture required an extensive rethinking of the history of literature. In the chronology of Eusebius, whose *Chronicles* were translated by Jerome, Homer is not an ur-author but a relative latecomer to a scene already crowded with Near Eastern and Egyptian authors. This led to speculation, which can be found in Jerome, Augustine, Bede, and elsewhere, that Hebrew literature is the source of Greek literature, that the poetic sections of the Bible are in Hebrew foreshadowings of classical meter, and that classical literature is not a unique, self-contained achievement, but dependent on, and perhaps even a falling-off from, Hebrew literature. Most important, Biblical exegesis means allegory. We know that allegory flourished in

classical times and that much medieval allegory was simply an extension of traditions that were familiar to Cicero. In the early Middle Ages the tradition that the Bible has four levels of meaning, three of which are allegorical, was one of several approaches to Scripture, but during the second half of the Middle Ages the four-level theory became dominant. As we know from Dante's *Epistle to Can Grande della Scala,* as well as from Judson Allen's English friars, it was applied to secular as well as sacred literature. Obviously, it deserves an important place in the history of medieval criticism.

The problem is to decide where biblical exegesis and medieval criticism part company. On the one hand, medieval criticism is larger than biblical exegesis. It includes secular criticism and classical theories and forms of allegory that held little interest for students of Scripture. On the other hand, biblical criticism is itself a subject of enormous dimensions, as witness the four volumes of Henri de Lubac's *Exégèse médiévale*[11] and Beryl Smalley's more compressed study of the subject.[12] Here, I think, definitions are useless. The historian of medieval criticism cannot exclude biblical exegesis, but he has to contain it, and this is a matter of selection and balance rather than arbitrary definitions.

Let me now turn to my third topic, which is the need for historical articulation. For criticism, the Middle Ages extends from the fourth to the fourteenth century. Specialists are well aware of the enormous changes which occurred during this thousand-year period, but historians of criticism still refer to "medieval theory" as though it were a complete and unchanging body of thought about literature which appeared mysteriously after the fall of Rome and was endorsed by every author between St. Jerome and Francis Petrarch. These historians know better, of course, but the habit persists and it encourages sloppy and often misleading thought about medieval critical texts.

In my own thinking about the subject, I have found it convenient to distinguish five major periods in medieval criticism. The first period was transitional. It began in the first century in Alexandria and extended in the Latin West through the fourth century. The literary critics of this period, Christian as well as pagan, were aware of the full scope of the classical tradition. In general, the pagan authors of the fourth century codified earlier tradition in commentaries and textbooks of the sort that fill the seven volumes of Heinrich Keil's *Grammatici Latini*[13] and Karl Halm's *Rhetores Latini Minores.*[14] The Christians, meanwhile, argued over whether the classical heritage should be rejected entirely (Tertullian) or incorporated into a new synthesis. The liberal party ultimately triumphed. It created the foundation on which medieval humanism rests.

The second period was the Carolingian period. In spite of the fact

that the *Monumenta Germaniae* includes four volumes of *poetae Latini aevi Carolini*, we know surprisingly little about Carolingian criticism. The small amount of criticism which does survive, coupled with works like Alcuin's *Rhetoric*, suggests that the dominant current of thought was analytic and didactic. Theodolphus of Orleans was familiar with allegorical readings of ancient myths on the pattern of the *Three Books of Mythology* of Fulgentius, an approach that derived from pagan tradition rather than biblical allegory. The *Scholia Vindobonensia* on Horace, which is the only extended critical essay of the period with which I am familiar, drew on several late classical writers – Porphyrius, Servius, Victorinus, and Hyginus among others. It is a sober and intelligent reading of the *Ars Poetica* which appears to share the suspicion of flamboyant style reflected in Alcuin's *Rhetoric*. To read a whole movement into the *Scholia* is risky, but the *Scholia* does carry forward tendencies in the thought of fourth-century "classicists" and opposes stylistic tendencies evident in Sidonius, Martianus Capella, and Fulgentius. In short, the *Scholia* appears to be a contribution to a sustained campaign against Asiatic extravagances, and this is in accord with the "classicizing" style of much Carolingian poetry. De Bruyne discusses the anti-Asiatic campaign in detail. It was, in general, an effort to revive Roman traditions in the face of new literary fashions encouraged by the extravagance of the style of the Bible and by secular authors like Martianus.

The sub-dominant current in Carolingian criticism is Neoplatonism. As far as I know there was no clearly neoplatonic criticism between the fifth and twelfth centuries, but encouragement was given to a revival of Neoplatonism by the translation of the works of Dionysius the Areopagite by Scotus Erigena in the tenth century. Neoplatonism was widespread in late classical criticism. It is evident in the critical theory of Proclus and in Porphyry's analysis of the "Cave of Nymphs" episode in Homer, and it is endemic in Alexandrian biblical criticism from Philo Judaeus to Origen. In the West, it was reflected in Macrobius' *Somnium Scipionis* and in Augustine's analysis of Genesis.

One assumes that Neoplatonism survived during the Carolingian period, but unless we go rather far afield from criticism, there are no documents to illustrate it. The flowering of medieval Platonism occurred in the twelfth century, and the important documents are well known. They include: (1) several exemplars of the critical form known as the *accessus ad auctores*; (2) the *artes poeticae* first edited by Edmond Faral, with several more recent editions of individual works; (3) the commentary on the first six books of the *Aeneid* by Bernard Silvestris and the Ovid commentary of Arnulf of Orleans; and (4) comments on literary and critical topics in encyclopedic works like the *Policraticus* and *Metalogicon* of John of Salisbury and the *Philobiblon* of Richard of Bury. Each of these

groups of works has its own tradition. E. A. Quain, for example, traces the *accessus* to Greek dialectic,[15] while Bruno Sandkühler shows its pervasive influence on Dante's *Epistle to Can Grande della Scala.*[16]

Note that almost all of the works included in these categories were intended for the grammar curriculum or were arguments that reading the poets should be a part of grammar, rather than logic. Moreover, their Platonism tends to be humanistic rather than mystical. That is, reading the poets is encouraged, but the emphasis is on moral improvement and preparation for biblical studies, rather than for mystical revelation. The exceptions, and they are only qualified exceptions, are the commentaries on Vergil of Bernard Silvestris and the Ovid commentary of Arnulf of Orleans. Bernard drew on Fulgentius, Macrobius, and Calcidius' translation of the *Timaeus*, as well as on Servius and late classical rhetoric. His basic thesis is that the *Aeneid* is a moral allegory of the life of Man. However, in the commentary on Book VI, which is his most elaborate section, Bernard does touch on the "hidden mysteries" and "inspired poetic visions" so attractive to late classical and early Renaissance Platonists.

The fourth major period of medieval criticism is the scholastic period. Scholasticism is often equated with the Middle Ages as a whole in the popular mind. For the history of criticism, however, it was a reaction *against* twelfth-century humanism. John of Salisbury, Roger Bacon, and Henri d'Andeli all agreed that scholasticism represented an abrupt and, to them, mistaken departure from earlier tradition. If its ultimate source was Aristotle, its proximate sources were the Latin translations of Arabic commentaries on Aristotle which began to be circulated in the West in the late twelfth century. For criticism, the characteristic feature of scholasticism was its subordination of poetic to logic. This approach may seem harmless enough in the abstract, but in practice it was anti-literary. It was a device for moving literary studies from the center of the curriculum to the periphery. When included in logic, poetry was defined as the art of manipulating images, or a technique for telling convincing lies, or, at best, a trivial amusement which is sometimes useful for moral instruction. This is the view of literature found in the later sections of Gundissalinus' *On the Division of Philosophy*, a work derived from al-Farabi, and, with important qualifications, in Averroës *Commentary on the Poetics of Aristotle*, translated into Latin in 1256. It is a view which influenced Aquinas and was reiterated as late as the end of the fifteenth century by Savonarola in his battle with the Florentine humanists. It denies inspiration, diminishes allegory to a literary game, and undermines medieval humanism by denying that reading the poets is an especially useful occupation.

The fifth period of medieval criticism is early humanism, by which I mean the period from Dante to Boccaccio. Dante's *De Vulgari Eloquentia* is a remarkable variation of the venerable tradition of the *ars metrica.*

His *Convivio* is an allegorical reading of three of his *canzoni*. It is restrained in comparison to Books XIV and XV of Boccaccio's *Genealogy of the Gods*, which form an impassioned defense of inspiration and allegory against a group of "cavillers." Evidently, these were Dominican monks committed to the scholastic view of poetry.

Here, however, the picture becomes extremely mixed, and this leads to my final point. The study of medieval criticism raises questions about some time-honored assumptions. There is a breadth of learning and focus in Boccaccio which was new in critical history, but Boccaccio's sources were as frequently medieval as classical, and most of his thought could have been understood by Bernard Silvestris and Petrus Bercorius. Was the early Italian Renaissance a new departure or was it in some sense a reworking of attitudes and theories already evident in the twelfth century? This question, of course, was asked by Charles Homer Haskins many years ago. As far as criticism is concerned, there was, in fact, considerable continuity between twelfth-century France and fourteenth- and fifteenth-century Italy. If so, scholastic literary theory might be considered a temporary *aberration* from the medieval norm, not an example of that norm.

The same problem arises if we turn our attention from the Renaissance to the classical period. Allegory is usually considered a medieval invention par excellence, as witness C. S. Lewis' *Allegory of Love*. However, allegorical criticism flourished in antiquity. As J. Tate demonstrated in several articles published in the *Classical Quarterly* between 1929 and 1934, allegorical criticism began in Greece in the sixth century B.C. and was continuous thereafter.[17] In the first century B.C., Heraclitus wrote an allegorical interpretation of Homer which is more extensive and considerably more persuasive than Fulgentius. There is little difference between Heraclitus's Homer and much that is considered typically medieval. Should Heraclitus be considered "premedieval"? The question is ridiculous. It is possible only because many of the commonplaces of the history of classical criticism are based on a very limited selection of available materials. The truth is that much that we consider typically medieval pervades ancient criticism. Consideration of medieval criticism thus forces us to reconsider what we mean by the classical tradition. A classical tradition that includes Heraclitus, Maximus, Tyrius, Proclus, Porphyry, Philo Judeaus, and Origen, as well as Aristolte, Horace, and Cicero, is more complex, but also considerably richer, than the sanitized classicism offered in most histories of ancient criticism.

I recognize that I have touched on no more than a few high points of my topic; that many questions have not been asked at all; that others have been only partially answered; and that many authors and works, not to

mention whole traditions, have been omitted. In spite of these limitations, I hope that my major point has been made convincingly. We do not have an adequate history of medieval literary criticism. Such a history is possible and highly desirable. If it were written, it would have to be a history of Latin criticism and would need to define criticism more narrowly than has been the case in previous treatments of the subject. It would have to incorporate a meaningful division of medieval criticism into major periods and accept the burden of calling into question some widely-held opinions about criticism in the periods that precede and follow the Middle Ages. If these are difficult requirements, they also promise fresh insights into a neglected but important area of literary history.

## NOTES

1. For a selective bibliography of general studies and monographs, see Alex Preminger, O. B. Hardison, and Kevin Kerrane, eds., *Classical and Medieval Criticism* (New York, 1974), pp. 479–90.
2. Wimsatt and Brooks, *Literary Criticism, A Short History* (New York, 1957), p. 154.
3. Brooks and Warren, *Theory of Literature* (New York, 1948), p. 40.
4. J. W. H. Atkins, *English Literary Criticism: The Medieval Phase* (London, 1952), p. 40.
5. D. W. Robertson, Jr., tr., *St. Augustine On Christian Doctrine* (New York, 1958), p. 75.
6. Judson Allen, *The Friar as Critic* (Nashville, Tenn., 1971), p. vii.
7. Wimsatt and Brooks, p. 131.
8. Edmond Faral, *Les Arts poétiques du XII^e et du XIII^e siècle* (Paris, 1924).
9. C. S. Baldwin, *Medieval Rhetoric and Poetic* (New York, 1928).
10. Geoffrey of Vinsauf, *Poetria Nova*, Margaret F. Nims, tr. (Toronto, 1967), p. 17.
11. Henri de Lubac, *Exégèse médiévale* (Paris, 1959–64).
12. Beryl Smalley, *The Study of the Bible in the Middle Ages* (2nd ed., Oxford, 1962).
13. Heinrich Keil, *Grammatici Latini* (Leipzig, 1857–80).
14. Karl Halm, *Rhetores Latini Minores* (Leipzig, 1863).
15. E. A. Quain, "The Medieval *Accessus ad Auctores*," *Traditio*, III (1945), 215–264.
16. Bruno Sandkühler, *Die frühen Dantekommentäre* (Munich, 1967).
17. J. Tate, "Plato and Allegorical Interpretation," *CQ*, XXIII (1929), 142–54, and XXIV (1930), 1–10; "On the History of Allegorism," *CQ*, XXVIII (1934), 105–14.

# *"Musica de sono humano" and the Musical Poetics of Guido of Arezzo*

## NINO PIRROTTA

Not much love was lost during the Middle Ages between music theorists and performers. The theorists arrogated to themselves the name of *musici*, while stressing that instrumentalists took their names from their instruments, the *citharoedus* from the *cithara*, the *lyricen* from the *lyra*, the *tibicen* from the *tibia*, and so on. They stated that "in every art or discipline reasoning is naturally honored above the *artificium* that is practised by hand and toil," or even that "what takes place in instruments has nothing to do with the science and understanding of music."[1]

It seems natural that they should have had a low opinion of the instrumentalists, who as jugglers or minstrels were often assimilated into the scum of society. Anyway, the classical bias was applied to them, by which the *artista*, who possessed the knowledge of one or more of the liberal arts, took preeminence over the *artifex*, who exercised his manual skill and industry in a mechanical art. Less natural is the extension of the same bias to the singers; for, although Boethius considered the human voice to be an instrument, like a pipe or a bell, and included singing in the class of *musica instrumentalis*, it seems farfetched to see a singer as a mechanical worker. Yet music theorists, whose judgement of the instrumentalists was expressed in dispassionate terms, became harsher, even emotional, when they spoke of singers.

We must realize that the men we list as music theorists were usually scholars with broader interests as well. They were often abbots or bishops, or at least the scholastici or praecentores in a monastery or episcopal church, responsible in every case to some degree for the singing and teaching of music in their own institutions.[2] They had in mind their own singers, part and parcel of their daily life, and were aware that, even in the ecclesiastical world, the gift of a good voice usually magnifies the ego of the owner more or less in the measure to which it dulls, if not his head, his willingness to take advice. Just as St. Jerome and St. Ambrose had once complained of singers who were in the habit of dyeing and curling their hair, Guido of Arezzo several centuries later opened his *Regulae musicae de ignoto cantu* with the passionate outburst: "In our times singers are foolish above all other men."[3]

Granted that the theorists' concern was real, the reasons they gave for complaint were mostly intellectual snobbery. Singers were blamed because "they think they can sing well just by practice, with no knowledge of the *ars;* but they do not know how to answer when asked the numerical ratio of an interval."[4] It did not matter that they could sing without mistakes and come to the proper end of a melody; despite this, their performance was compared to the "coming home of a drunkard" or to the attempts made by a blind man to hit a running dog.[5] Sternest of all was another pronouncement by Guido of Arezzo, a poetic one, which was quoted again and again by generations of theorists:

> Musicorum et cantorum magna est distantia;
> Isti dicunt, illi sciunt, quas componit Musica.
> Nam qui facit quod non sapit diffinitur bestia.[6]

But snobbery defeats itself when a theorist compares a singer to a nightingale yet refuses to recognize him as a *peritus cantor,*[7] or when another writer states that "whoever is utterly ignorant of the power and rationale of musical science boasts the name of singer in vain even though he is able to sing very well."[8]

The truth is, that singers were good or bad without much help from theory. In fact, for many centuries theory had little to offer that applied to practice. Even when it went beyond its metaphysical statements about *musica mundana* and *humana* – the music of the spheres and the accord of man's soul and body – it dealt with problems either removed from actual music making or handled in an abstract way, in the apparent belief that every problem was solved for which one could give rational explanations, most often in the form of numerical ratios. More specifically, references to numerical ratios had little to do with the new problem which writers from the eighth to the eleventh century were most involved with, the definition of modal patterns and the classification of liturgical melodies according to them.

Nor were all melodic deviations from such patterns actually to be blamed on singers' faulty or arbitrary interpretations. This was the very time when the modal system, whether derived from the classical *harmoniae,* from the Byzantine *echoi,* or from both, was being used to channel toward uniformity a variegated repertory of melodies (or, should we say, melodic habits) which had been evolving during many centuries through the procedures, and in the fluid conditions, of an oral tradition. To be sure, classification and codification of the melodies was the most effective way to achieve a unified musical liturgy, short of a precise notation of pitch, which was still in the process of being perfected. Nevertheless, it must be admitted that the whole operation, a turning point in the history of Western music, was an intrusion of the theorists (representatives, we might say, of "the system") in a field which had been for

centuries the exclusive domain of singers. However, numerical ratios were of no help when a decision had to be made, concerning any given melody, whether the most orderly succession of pitches and intervals according to the modal theory, or the most effective according to the singers' experience and taste, should be preferred. It is most likely that the big display theorists made of them was merely intended to impress the *cantor artis expers*.[9]

Once in a while, the stiff intellectualistic approach was softened by a more sympathetic view of the facts of musical life. The example I have in mind is that of Regino, abbot of Prüm, the author of an *Epistola de harmonica institutione*, of a *Chronicon* covering events from Christ's birth to the year 906, and of a work *De synodalibus causis et disciplinis ecclesiasticis*.[10] To me, Regino is a good representative of a ninth-century Renaissance, if there was one. Many other theorists were polymaths and polygraphs, but few let the variety of their interests and readings show in a single work as those of Regino transpired in his *Epistola*, with the added bonus of a certain humanistic fervor and flavor.[11] This does not help the Epistola to be a model of organization, nor is it entirely free of the usual statements asserting the superiority of the *musicus*.[12]

It is refreshing, however, that this particular *musicus* did not pretend to have all the answers. Much as he was conversant with all the works produced up to date by medieval theorists (of which there were not too many) and with the available classical literature, Regino believed that, "as Music keeps most of itself concealed from both those who know and the ignorant, it is as if it was lying in a depth dense with fog."[13] A little earlier he compared the *musica institutio* to a forest, "immense and very thick, obscured by so much fog that it seems to withdraw from human recognition,"[14] an almost Dantesque *topos*.

What gives Regino's work such feeling? It has all the current intellectualistic equipment, mostly gathered from Boethius;[15] however, he was selective in its use. It does not repeat, for instance, the usual tripartition of music into *mundana, humana* and *instrumentalis*. It does not reject it, either, but cuts across it, dividing music into *naturalis* and *artificialis*.[16] The latter is the equivalent of Boethius' *musica instrumentalis*, minus the vocal music, of instrumental music, then, in a modern sense. But Regino's *musica naturalis* comprises Boethius' *musica mundana*, plus a modified view of *musica humana*, basically coinciding with what we call vocal music – the *musica de sono humano* of my title.[17]

As a matter of fact, Regino first uses the expression *naturalis musica* in referring to the "cantilena, quae in divinis laudibus modulatur," that is, to plainsong.[18] Only after a description of the ecclesiastical modes does he come back to it with a more comprehensive definition: "Natural music does not sound because of any instrument made by man, or because of any action of fingers, or because of any human touch or percussion,

but shapes sweet melodies by divine inspiration, with the sole guidance of nature; such music exists in the motion of the sky and in the human voice."[19] We have long since untuned the sky and no longer care for the cosmic aspect of natural music. As for plainsong, if it is "Gregorian" chant, it fits the definition, for it was thought to have been created by St. Gregory, with the assistance of the Holy Ghost.[20] But in our progress through Regino's text we are brought to realize that the human side of *musica naturalis* is by no means restricted to plainsong. "No one who is aware of himself," he wrote, "can question that music naturally exists in conjunction with all men, all ages and all sexes. Which age or sex does not enjoy musical songs? . . . Children and youths, as well as old people are taken by musical modulations with such a spontaneous feeling that no age exists that has not enjoyed sweet songs." He even goes on to quote the case of people who can not sing, yet "sing disagreeably something agreeable to them."[21]

How such a propensity is built into human nature, and how it works, is what, I think, Regino regarded as an enigma, and a mystical one, for his work seems to imply that a divine inspiration is inherent in the act by which the soul is created. It never mentions the Boethian rational explanation that a numerical ratio links or attunes soul and body in a consonant relationship, "quaedam coaptatio et veluti gravium leviumque vocum quasi unam consonantiam efficiens temperatio."[22] I shall not investigate which theological reasons are behind Regino's rejection, but rather will content myself with stressing that trends of musical theory existed in which musical practice was seen not only as a question of rules and skills, but also as something related to an innate ingenuity of the human spirit.

A Christian refusal of the rationalizing interpretation of man's musical nature (now referred to Plato) was stated by Aribo, a German *scholasticus* about two centuries younger than Regino: ". . . quamvis non vere, verisimiliter tamen tractat Plato de animae genitura. Cum enim dupla proportio, sesquitercia, sesquialtera, sesquioctava, incunditatem mentibus intonat, potest a gentilibus credi non incongrue animas ex eisdem proportionibus consistere."[23] Aribo was still convinced of the superiority of the *musicus*, for, as he stated, "By means of *ars*, what Mother Nature has born rough and unpolished is made more refined."[24] But his recognition of a natural, spontaneous creativity, here merely implied, is more clearly asserted in such paragraphs as the following: "We can best appreciate how very much music is part of our blood and nature from the fact that even the jugglers, totally unaware of the *ars musica*, can warble any secular song without fault, offending no rule whatsoever in the varied disposition of tones and semitones, and reaching correctly the final note."[25] Nor was he the only writer to express such an ambivalent attitude, a mixture of admiration and disapproval, in regard to popular, instinctive ways of music making.[26]

I have used Regino's and Aribo's reluctant recognition of musical spontaneity to set the stage for the most important, indeed almost unique, musical poetics I know from the Middle Ages. Chapter 15 of the *Micrologus de disciplina artis musicae* by Guido of Arezzo[27] is a chapter most widely discussed (for reasons, however, entirely different from mine) both by medieval theorists, including Aribo, and by modern scholars. Old writers thought that a few passages needed clarification;[28] more or less the same passages have been used by modern scholars to support, in turn, each one of the various theories about the rhythm of plainsong: mensuralism, proportionalism, and free rhythm.[29] The only argument I need to worry about concerns the title of the chapter. The old edition by Gerbert gives it as follows: "De commoda componenda modulatione";[30] but the latest editor, Josef Smits van Waesberghe, has found that the majority of the sources add a small word, making it: "De commoda vel componenda modulatione."[31] Smits van Waesberghe also maintains that the word "componenda" must not be taken in a modern sense and interprets it as "coniunctim ponenda."[32] His interpretation might very well fit such precepts that were addressed by Guido to performers, were they not already covered by the adjective "commoda." I do not see that anything short of the modern sense of composing may apply to other aspects, and I hope my reader will agree when we come to read the text of the chapter.

The added word to the title makes the translation slightly more difficult; the best I can think of is, with some freedom: "Of a good melody or how to make one." As I read it, the title already gives the gist of Guido's poetics: a new *modulatio* must be made in imitation of the best available models. Needless to say, Guido's taste was conditioned by his lifelong concern with plainsong; his idea of what makes a melody *commoda* – that is, *cum modo*, or, in good taste – was too obviously dependent on what he most admired in the liturgical repertory. This was so much so that his chapter was the main source for the most essential part of a fundamental work on the aesthetics of plainsong.[33] It is pertinent to my purpose, however, to observe how he endeavoured to explain in the rational terms of a medieval *ars* what he admired because of an inner feeling of beauty, as art, then, in the modern sense of the word. This I propose to do by reading through the prose of Guido's chapter, of which I have tried to render the clarity and precision in an English translation. I might have referred to the text established by Smits van Waesberghe in his critical edition, but I believe in the interpretive (and provocative) value of a translation.[34]

Just as in metrical poetry there are letters and syllables, feet and *partes* and lines, similarly also in vocal music[35] there are *phthongi*, that is, sounds, one, two, or three of which are combined to make syllables; and these [syllables], singly or in pairs, form a *neuma*, that is, one *pars* of the *cantilena*; and one

*pars,* or more, make a *distinctio,* that is, a suitable place for breathing. Concerning which things, the following needs to be observed, that the whole *pars* must be written and uttered all together (*compresse*), the syllable even more so (*compressius*). But the *tenor,* that is the sustaining (*mora*) of the last note (which is short in the syllable, longer in the *pars,* and very long in the *distinctio*), is the mark in them of their division.

This is a preamble, in which a description is given first of the components of a melody, and then of the longer and shorter stops marking their articulation.[36] For the former, an analogy which had already been hinted at by other theorists is not only enlarged but specifically referred to metrical poetry, whereas it had been previously referred to language in general.[37] The purpose of this shift will become apparent when the analogy is resumed in the next section, which is, I must warn, the most controversial in the whole chapter.

And thus, the *cantilena* ought to be scanned as if it were in metrical feet, and certain sounds ought to have a lengthening (*morula*) twice as long or twice as short as others, or else a *tremula,* that is a *varius* [vibrato?] *tenor,* which sometimes is shown to be long by a horizontal line placed above the letter.[38] And by all means such a distribution of the *neumae* ought to be observed (the *neumae* being formed either by the repetition of the same sound or by the connection of two or more) as to let them always be related to each other, either in the number of sounds or in the proportion of the *tenores,* and respond [to each other] now like equal to equal, now like double, or triple, to simple, and others in a *sesquialtera* or a *sesquitertia* proportion.

With all respect to eminent scholars who have given this matter much more thought than I have, it is my impression that controversy has unnecessarily arisen around this passage out of a comprehensible eagerness to take advantage of every available bit of information to foster the solution of a very important musicological problem. But can precise conclusions be inferred from an analogical description? The parallel with metrical poetry is repeatedly stressed by Guido to be an analogy, evidently intended to justify his rationalization of the kind of balanced proportion he would have liked to find in a good melody. The suggestion made in the paragraphs I have just quoted is that a balance or proportion should already be present in the number of sounds forming each *neuma;* if not – and this might be a suggestion addressed to performers – it should be forced on the *neumae, partes,* and *distinctiones* by means of different lengths given to their *tenores.*

What is most important for our purpose (and further clarifies the motive dictating the analogy) is once more that an ingrained habit of the medieval mind translates the artistic need for balance into precise numerical ratios. Not surprisingly those mentioned by Guido are the very ones by which perfect consonances are produced between two pitches: *porportio dupla,* producing the octave; *tripla,* producing the fifth above the octave, that is, the twelfth; *sesquialtera,* producing the fifth; and *sesquiter-*

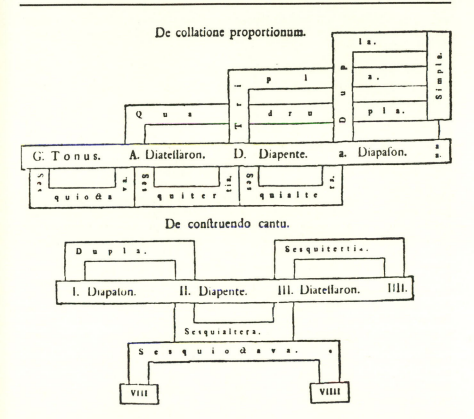

Figure 1. "De costruendo cantu" according to Gerbert, *Scriptores ecclesisatici de musica,* Vol. II, p. 15.

*tia,* producing the fourth. The connection is made even more evident by Figure 1.[39] Thus, the same principle by which the harmony of the cosmos, the orderly succession of the seasons, and the *coaptatio* of soul and body are ruled must be also applied by the *melopoieta* to the temporal ordering of his melody.

The sentences I am going to quote next give evidence, if any is needed, that composing in the modern sense was very much in Guido's mind. Then comes a rare moment of truth, in which he seems about to admit that not everything is crystal-clear in the would-be all-rational world of his *ars.* The disturbing thought, however, is immediately supplanted by a brilliant sophism, adroitly reconciling reason and aesthetic pleasure.

Let the *musicus* propose to himself in which ones of these divisions he will make his *cantus* to proceed, just as the *metricus* [proposes to himself] in which feet he will cast his verse; except that the *musicus* will not bind himself to an equally stringent law, for his *ars* diversifies itself in everything with a rational variety in the disposition of sounds. We may often not understand such ration-

ality, *yet that is thought to be rational in which the mind, the seat of reason, takes pleasure*. But such things and similar ones are better shown in spoken words than in writing.

It is a narrow escape, after which Guido, having settled the point of what we can describe as a quantitative balancing and proportioning of melodic parts, has much easier going in prescribing procedures by which a qualitative balance, that is, a unified melodic style, can be achieved:

Therefore, it is convenient that the *distinctiones* be comparable among them like *versus*, and sometimes repeated just the same, or else modified by some small variation; and then[40] they would be very beautiful if they were repeated having *partes* not too different, and if similar ones were changed in regard to their modes, or were made (*inveniantur*) similar but higher or lower. Also [it is convenient] that a *neuma reciprocata* should go back the same way it came and by the same steps; and also that, whatever turn or line one [*neuma*] makes in leaping from the high range, the second should repeat just the same, but from an inverted direction, answering from the low range, as happens when we watch our image reflected in a well. Also [it is convenient] that one syllable should have at times one or more *neumae*, and that one *neuma* should be split at times into many syllables. These and indeed all *neumae* shall be diversified, some being made to begin from the same note, others from one that is different according to different qualities of gravity and acuity. Also [it is convenient] that almost all *distinctiones* should move toward the principal note, that is, the *finalis* [of the mode], or toward any note related to it which they may have chosen in its stead; and that the same note [the *finalis* or its substitute], as it ends [all] the *neumae* [i.e., ends the melody] and many *distinctiones*, similarly should sometimes also begin them;[41] which things, if you are curious, you may find in Ambrose.

I shall not embark on a detailed comment of the techniques by which, according to Guido's sharply worded advice, variety should be afforded and integrity of melodic style still preserved. All but two of the devices he prescribes can be easily verified in the liturgical repertory,[42] the two exceptions being, as far as I know, those that came later to be known as, respectively, crab canon (Guido's *neuma reciprocata*) and mirror canon (Guido did not have a name for it, but the later term is clearly fore-shadowed by his reference to the image reflected in a well). Even these are so vividly described that I surmise there should be models for them somewhere, even though they have not been recognized.

In the following sentences the parallel with metrical poetry is insisted upon – actually even buttressed by a second one with prose – and yet confirmed to be an analogy, not an identification. And thus, we come to the passage in which Guido, having previously defined his ideal of harmonious quantitative balance, adds to it the requirement of qualitative consonance, unifying the melodic style of the new composition:

To be sure, there are *cantus* resembling prose which pay less attention to such things and in which it does not matter whether larger and smaller *partes* and *distinctiones* are found everywhere without a rule, in the manner of proses.

On the contrary, I speak of metrical *cantus* because we often sing in such way as to seem to be scanning *versus* into feet as when we sing real *metra*. In which [*cantus*] we must avoid causing too many two-syllable *neumae* follow each other without a mingling of three- or four-syllable ones. For, just as the lyrical poets combine sometimes certain feet, sometimes others, similarly those who make a *cantus* combine *neumae* rationally selected and diversified. In fact, there is a rational criterion when a moderate variety of *neumae* and *distinctiones* is so arranged that *neumae* respond to *neumae* and *distinctiones* to *distinctiones*, always in consonance because of some resemblance, that is, in such way as to create a *similitudo dissimilis*, in the manner of sweetest Ambrose.[43] In fact, there is no little resemblance between *metra* and *cantus* – if the *neumae* stand in place of feet, and the *distinctiones* of lines – inasmuch as the *neuma* flows in a dactylic, that one in a spondaic, the other in an iambic meter, and you can see that the *distinctiones* are now tetrametrical, now pentametrical, and at another place, as it were, hexametrical, and many other things likewise.

One last point I wish to bring to the reader's attention is what Guido has to say about the relationship between words and music:

Also [it is convenient] that the *partes* and *distinctiones* of [both] *neumae* and words should end at the same time. Nor should a long *tenor* on some short syllables, or a short one on some long [syllables], give offense, which fact, although unusual, shall be taken care of. Also [it is convenient] that the effect of the *cantio* [on the audience] be in imitation of the topic (*rerum eventus*), so that the *neumae* shall be grievous in sad matters, pleasant in quiet things, joyous in happy ones, and so on.

It would have been difficult to explain rationally what makes the *neumae* grievous, pleasant, or joyous; but Guido goes on to the next topic, without even attempting to settle this one, with another of his masterly sophisms. Previously, it seems to me, he gave vent to the concern for prosodic observance of the classically-oriented grammarian in support of his own aesthetic need for harmonious proportions; here, he just pays lip service to some faint, though persistent, reminiscence of the classical *ethos*.[44] As I have already pointed out, Guido's poetics, like his aesthetics, were those of plainsong; the melodies he spoke about, whether models or newly-composed imitations, were meant for liturgical use. Now, I am aware I am about to make a generalization, bound, like all generalizations, to have exceptions; yet it seems to me that liturgical music was not so much intended to express the contrition of the sinner or the suffering of the martyr as to exalt the power bestowed on the Church to bring salvation to the former and celestial glory to the latter. Liturgical music essentially celebrates the celebration and seldom has any need for the kind of emotionalism which became the artistic concern of later times. Accordingly, Guido's prescriptions, fashioned on his models, need to be taken with a grain of salt; the equivocal assimilation of *effectus* and *affectus* is still far off in the future.

More tangible than a concern for emotional intensity is Guido's deep feeling for the effectiveness of the performance. His advice is now mainly

addressed to the singers, in whose behalf such time-honored musical devices as *crescendo, diminuendo,* and *rallentando* are described with clarity and no attempt at a rationalization.[45] Less familiar to us, the singing of liquescent sounds on liquescent syllables is brought nearer to our experience as a kind of *portamento,* which also makes Guido's wary attitude toward such graces easier to understand. The final sentence of the chapter is one last appeal to the intuitive *discretio* of good taste.

Also, we often superimpose an accent, grave and [or?] acute, on the sounds, for we often utter them with greater or lesser force, to such extent that the repetition of the same sound often seems to be a raise or a descent.[46] Also [it is convenient] that the sounds come near to the place of breathing, at the end of the *distinctiones,* in the manner of a running horse, as if they were dragging tiredly to get a rest. Of which dragging the arrangement of the written notes (*notae compositae*) might often give a hint, if they are set thickly or sparsely as needed.[47] Finally, sounds, like letters, become often liquescent, so that the initial pitch of one, trespassing smoothly into the other, does not even seem to be ending. Hence, we place a dot like a spot on the liquescent note.[48] But if you want to pronounce it more fully, and not liquescent, it does no harm, for this is often liked better. And do all that we have said neither too seldom nor too often, but with good judgement.

Even though Guido's writings enjoyed wide diffusion, his poetics remained to a great extent isolated. Among the theorists who followed him, Aribo included extensive quotations from, and commentaries on, Chapter 15 of the *Micrologus* in a chapter entitled "De oportunitate modulandi" of his own *De musica;* but he was mainly concerned with prescriptions made by Guido in order to introduce, or improve, quantitative proportions in a melody, that is, with the performance aspect. In this regard Aribo's first sentence sounds like one of approval: "The beauty of singing is doubled if the *neumae* and the *distinctiones* are proportionally related in the way in which the sounds of the monochord are arranged, as taught by dom Guido . . ."[49] Yet only a little later, he comes to the conclusion that such practices, beautiful as they may be, are a thing of the past: "In former times, great attention was paid, not only by the composers of *cantus,* but also by the singers themselves, that they should invent and sing everything applying proportions. Such consideration died long ago, [and] indeed is buried."[50] In a later addition to his treatise, also dealing with Guido's chapter, Aribo trifles "super obscuras Guidonis sententias," argues about them with an earlier commentator, but never comes to terms with the real substance of Guido's poetics.[51]

After Aribo, or about the same time, Johannes Affligemensis comes nearer to Guido's intentions in two chapters (XVIII and XIX) of his *De musica,* entitled, respectively, "Praecepta de cantu componendo" and "Quae sit optima modulandi forma."[52] His skepticism in regard to Guido's passionate striving for artistic poise and balance (or at least in regard to the ways how to achieve them) can be gathered *ex argumento silentii.* In

Johannes's chapter XVIII, the basic prescription comes first that the *cantus* should be varied "secundum sensum verborum," but also according to which audience they are meant to please (gone is Guido's dedication to an ideal of liturgical beauty).[53] Then the "laudis cupidus modulator" is warned against monotony, or, in Johannes's words, against the "vitium similium tonorum," parallel to the "vitium similium casuum" avoided by the poets.[54] Chapter XIX touches lightly upon the need that the melody pause "ubi sensus verborum distinctionem facit," then plunges into a lengthy discussion of which sounds and intervals ought to be preferred in each mode, partially a duplication of previous chapters.[55] Nothing is left of the poetic *afflatus* sweeping through Guido's prose and its rationalizations. Even much later, Machaut's *Remède de Fortune* or the *Règles de seconde rhétorique* dealt with matching musical and poetic forms, but had little to say about music itself.

Guido's isolation is partly to be explained by the changing times and musical taste. The creation of new liturgical offices was a rare event, while new forms of ecclesiastical music, such as the sequence and the monophonic *conductus,* were becoming fashionable, and were ruled by different poetics – not to speak of polyphony, which was soon to capture the main interest of music theorists. New tastes may have brought about new confrontations between the humanistic principle of *dulcedo,* and *subtilitas* or the sophistication of music through symbolic or rationalizing devices; but few theorists were as pragmatically motivated as Guido to come out of their ivory towers and let their feelings for beauty transpire through the intellectualizing equipment of music theory.[56] Guido not only did it, but he came near to adding a new expression, *irrationalis ratio,* to such favorite medieval oxymora as *concordia discors* or his own *similitudo dissimilis.*

# NOTES

1. See, for instance, Aurelianus Reomensis in Martin Gerbert, *Scriptores ecclesiastici de musica* (St. Blaise, 1784), I, p. 39a, and Regino Prumiensis, in *ibid.,* p. 246b. The third statement, which I translate from Aurelianus, *ibid.,* p. 33a, was still reflected by Adam de Fulda in the late fifteenth century; see also Gerbert, in *ibid.,* III, p. 347b.

2. Some who were abbots, or became such in the course of their ecclesiastical careers: Regino (d. 915) at Prüm, Odo (d. *ca.* 1030) at St. Maur-des-Fossés, Berno (d. 1048) at Reichenau, Wilhelm (*ca.* 1030–1091) at Hirsau, his pupil Theogerus (1117, bishop-elect of Metz) at St. George in the Black Forest, and Engelbert (*ca.* 1250–1331) at Admont. Aurelian of Réomé dedicated his tract to the *archicantor* and bishop-elect Bernardus, Regino of Prüm to the archbishop of Trier, Guido of Arezzo to his bishop Theodaldus, the *scholastici* Adebold (later bishop of Utrecht) and Aribo to, respectively, Pope Sylvester II (999–1003) and Ellenhard, bishop of Freising. Hucbald of St. Amand (*ca.* 840–*ca.* 940) was a teacher there, as well as at St. Bertin

and Reims. Many of these writers, and such others as Notker Balbulus, Notker Labeo, and Hermannus Contractus (not to speak of Bernard de Clairvaux) were also theologians, chroniclers, mathematicians, or astronomers.

3. In Gerbert, *op. cit.*, II, p. 34a.

4. Adam de Fulda, in *ibid.*, III, p. 347a. An older statement is that of Berno of Reichenau, in *ibid.*, II, p. 78a.

5. Johannes Affligemensis, *De musica cum tonario*, J. Smits van Waesberghe, ed. (Rome, 1950), p. 52. (I am not fully convinced by the editor's attribution to Johannes Affligemensis, nor by various attempts, more recent, such as those of E. F. Flindell in *Musica disciplina* XX and XXIII [1966 and 1969], to give the work back to Johannes Cotton). See also the "Summa musicae," no longer thought to be by Johannes de Muris, in Gerbert, *op. cit.*, III, p. 195a: "Cui ergo cantorem artis expertem comparare possumus, nisi ebrio versum locum propositum currenti, vel caeco alicui canem verberare volentem?"

6. "Musicae Guidonis regulae rhythmicae," in Gerbert, *op. cit.*, II, p. 25.

7. See Berno of Reichenau, quoted above, note 4.

8. Regino of Prüm, in Gerbert, *op. cit.*, I, p. 240a. Similarly, Aurelianus, in *ibid.*, p. 39b.

9. It is worth noticing that several works I have quoted, including Regino's *Epistola* (which I shall presently discuss in more detail), are preambles to *tonaria*. For a perceptive presentation of the problems connected with the transition from oral to written tradition see Leo Treitler, "The Transmission of Epic Poetry and Plainchant," in *The Musical Quarterly*, LX (1974), 333ff.

10. See H. Hüschen, "Regino von Prüm, Historiker, Kirchenrechtler und Musiktheoretiker," in *Festschrift für K. G. Fellerer* (Regensburg, 1962), p. 205ff. O. N. Dorman, "A Study of Latinity in the Chronicon of Regino of Prüm" in *Archivum latinitatis medii aevi*, 8 (1933), 173ff., finds the vocabulary rather limited in that work; yet I agree with one bibliophile's report, quoted by Gerbert, *op. cit.*, c. d 3v, stating that from Regino's *Epistola* "eximia eius doctrina in variis disciplinis longe plenius et uberius, quam ex eiusdem chronico & libris de disciplina ecclesiastica publice extantibus, cognosci potest." Very little I found useful to my purpose in E. Oberti, 'L'estetica musicale di Reginone di Prüm" in *Rivista di filosofia neoscolastica*, 52 (1960), 336ff.

11. A number of passages I have already quoted are derived from Boethius (see also note 15 below). In addition, Regino repeatedly quotes Virgil, Cicero, Macrobius, Martianus Capella, occasionally Plato, Philolaus, Cassiodorus, Isidorus, and Aurelius Reomensis. At least once he expresses the typical humanistic longing for the classical past, in comparison with "nostris . . . longe inferioribus temporibus." *Chronicon*, Fr. Kurze, ed. (Hannover, 1890), p. 1.

12. His invective can be quite colorful: "Nequaquam autem haec legenda Walcaudo proponimus, aut ad talia discenda eius animum provocamus; frustra enim lyra asino canitur." In Gerbert, *op. cit.*, I, p. 247a.

13. *Ibid.*, p. 246a. Thereupon, Regino embarks on an allegory identifying music with Eurydice, whose name, he says, means "profunda diiudicatio": "Orpheus . . . vult revocare de inferno Eurydicem sono citharae, sed non praevalet, quia humanum ingenium conatur profunditatem harmonicae subtilitatis penetrare & discernere, & ad lucem, id est, ad scientiam revocare;

sed illa humanam cognitionem refugiens in tenebris ignorantiae latet."
14. *Ibid.*, p. 245b.
15. I have quoted some Boethian reminiscences which Regino shares with Aurelianus; however, his direct quotations from Boethius' *De institutione musica* (including his own title) are more numerous than Aurelianus's and often independent from them. See G. Pietzsch, *Die Klassification der Musik von Boethius bis Ugolino von Orvieto* (Halle, 1929), pp. 24–25. Regino also knew Boethius's *Arithmetica*.
16. Gerbert, *op. cit.*, I. p. 233. The description of artificial music in *ibid.*, p. 236b, includes intriguing ideas: "Artificialis musica dicitur, quae arte & ingenio humano excogitata est, & inventa, quae in quibusdam consistit instrumentis. . . . Omni autem notitiam huius artis habere cupienti sciendum est, quod, quamquam naturalis musica longe praecedat artificialis, nullum tamen vim naturalis musicae recognoscere potest, nisi per artificialem. Igitur quaevis a naturali nostrae disputationis sermo processerit, necesse est, ut in artificiali finiatur, ut per rem visibilem invisibilem demonstrare valeamus." I wonder whether Regino had in mind general procedures of scientific thought or was hinting at the demonstration of pitches through an artificial instrument, the monochord. The latter would be corroborated by a passage by Guido of Arezzo: "Voces, quae huius artis prima sunt fundamenta in monochordo melius intuemur, quomodo eas ibidem ars natura imitata discrevit, primus videmus." *Micrologus*, J. Smits van Waesberghe, ed. (American Inst. of Musicology, 1955), p. 92.
17. My title quotes a later writer, Roger Bacon, whose partition of music, "de sono humano" ("in cantu" and "in sermone") and "instrumentalis," has many points in common with Regino's; see Pietzsch, *op. cit.*, p. 89.
18. Gerbert, *op. cit.*, I, p. 232a. It is worth noticing that Regino relates the modal system only to church music; *musica instrumentalis* does not seem to depend on it.
19. *Ibid.*, p. 23b.
20. Regino, unlike Aurelianus, never mentions Gregory; yet the *introitus* crediting the latter with having composed "huic libellum musicae artis" is already present in antiphonaries of the late eighth century, and the expression "Gregorianum carmen" had already been used by Pope Leo IV (847–55). For the legend of the Holy Ghost presiding at the creation of the Antiphonary and the evidence in pictorial sources, see Treitler, *op. cit.*, pp. 337–42 and pl. I–IV.
21. Gerbert, *op. cit.*, I, p. 235a.
22. Boethius, *De institutione musica*, G. Friedlein, ed. (Leipzig, 1887), pp. 188–89.
23. Aribo, *De musica*, J. Smits van Waesberghe, ed. (Rome, 1951), p. 46. According to the editor, Aribo was active in Bavaria and Liège. His treatise may be dated *ca.* 1070 (*ibid.*, pp. XXV–XXVI).
24. *Ibid.*, p. 46.
25. *Ibid.*, and then again, p. 58.
26. See, among others, Johannes Affligemensis, *op. cit.*, p. 51, and Jacobus of Liège, "Speculum musicae," in E. de Coussemaker, *Scriptorum de musica . . . nova series*, II (Paris, 1867), p. 312. Most colorful is the language in Arnulphus de Sancto Gilleno, "De differentia et generibus cantoribus" in Gerbert, *op. cit.*, III. A small sample concerning instrumentalists (p. 316b) may suffice: "Ex istis nonnullos videmus clericos, qui in organicis instrumentis difficillimos musicales modulos, quos exprimere vix praesumeret vox

humana, adinveniunt atque tradunt per miraculosum quoddam innatae in eis inventivae musicae prodigium." How different from the invectives against singers!

27. For Guido's life and works, see J. Smits van Waesberghe, *De musico-paedagogico et theoretico Guidone Aretino* (Florence, 1953). The *Micrologus* was written by Guido *ca.* 1026, on the request of Theodaldus, bishop of Arezzo.

28. They were mainly concerned with the meaning of individual words or scribal errors; see Smits van Waesberghe, *op. cit.*, pp. 189–93, and his introduction to Aribo, *De musica*, pp. XVI–XXIV.

29. The question is summarized by Smits van Waesberghe, *op. cit.*, pp. 188–89, G. Reese, *Music in the Middle Ages* (New York, 1940), pp. 140–48, and W. Apel, *Gregorian Chant* (Bloomington, Ind., 1958), pp. 126–32.

30. *Op. cit.*, II, p. 14b.

31. *Micrologus* (quoted above, note 16), p. 162; Smits van Waesberghe, *op. cit.*, p. 187.

32. Smits van Waesberghe, *ibid.*, p. 187, note 2: "Agitur enim de *commoda* i.e. recta et probata modulatione et exponitur quomodo recta vel commoda modulatio *componenda* i.e. coniunctim ponenda (igitur non in sensu posterioris aetatis nempe *modos conficiendi*) sit ita, ut legibus modulationis satisfiat" (italics replace quotation marks of the original). In the next paragraph I shall give a slightly different interpretation of the word *commoda*.

33. P. Ferretti, *Estetica gregoriana* (Rome, 1934), pp. 106–10.

34. The text in *Micrologus*, pp. 162–77. I have taken into account J. Smits van Waesberghe, "Wie Wortwahl und Terminologie bei Guido con Arezzo entstanden und überliefert wurden" in *Archiv für Musikwissenschaft* 31 (1974), 73ff., an analysis of Guido's literary style based precisely on this chapter of the *Micrologus*. I have felt it to be advisable, however, to leave a number of technical terms untranslated.

35. The adjective *harmonica* is applied by Aurelianus first to that part of *musica humana* which "discernit in sonis acutum & gravem accentum" (a meaning inherited from classical theory) and then to the "nature" of a sound which "ex vocum cantibus constat." After him a number of theorists meant vocal music when they spoke of *musica harmonica*. This, I think, is also the meaning of Guido's *harmonia* in this passage.

36. *Tenor* for *mora vocis* is uncommon, but there are other instances of its meaning the holding or sustaining of a note. Here, as elsewhere in the chapter, the idea is expressed of a *neuma* formed by a number of syllables; we are accustomed by our more restrictive use of this term to think that many *neumae* can be set to a syllable, not the opposite.

37. See, for instance, the beginning of "Musica enchiriadis" by the pseudo-Hucbald in Gerbert, *op. cit.*, I, p. 152a.

38. This, too, has an antecedent in "Musica enchiriadis," *ibid.*, p. 182a. Smits van Waesberghe, *De musico-pedagogico*, pp. 185–96, gives the *tremula* an intermediate length between long and short notes; he also distinguishes longer *tremulae* from shorter ones with no mark. I think all *tremulae* ought to be long to develop their special effect. Guido's alternative term, *varius tenor*, combining the ideas of length and *varietas*, is better explained by an anonymous commentator quoted by Smits van Waesberghe, *ibid.*, p. 196, note.

39. Only the lower part of the figure in Gerbert, *op. cit.*, II, p. 15, resembles the one reproduced in Waesberghe's edition, p. 166 and pl. 10.

40. The text established by Smits van Waesberghe p. 168 reads: ". . . et cum perpulchrae fuerint duplicatae." I read "tum" instead of "cum."
41. Something in the last clause – either terseness or redundance – caused a number of interpretive interpolations or marginal glosses to be added to the text in many sources.
42. The remarkable consistence of the so-called Gregorian tradition having been constantly stressed in about one century of scholarly research, we need now to be reminded that it did not mean deadly uniformity. It would seem, for instance, that repetition and symmetry were sought and emphasized at certain times and places, obliterated at others, as shown by T. F. Kelly, "Melodic Elaboration in Responsory Melismas" in *Journal of the American Musicological Society* XXVII (1974), 461ff.
43. Guido's repeated reference to St. Ambrose seems to indicate that he saw many of his requirements embodied in the Ambrosian chant. See the chapter on "Ambrosian Chant" by R. Jesson in W. Apel, *Gregorian Chant*, most particularly pp. 481–83.
44. It must be said, however, that a particular *ethos* (the term itself is never used) was often attributed to each mode.
45. Strangely enough, the suggestion is omitted that different melodies be given different tempi, although such a possibility had already been mentioned by the pseudo-Hucbald; see Gerbert, *op. cit.*, II, p. 183 (this section, answering the question "Quid est numerose canere?" probably was the starting point of many of Guido's thoughts).
46. Guido evidently refers to the so-called *distropha* and *tristropha*. Although he clearly asks for *crescendo* or *diminuendo*, his words still reflect the ingrained habit of seeing *accentus* in terms of raise or descent of pitch.
47. Here neumatic notation is clearly referred to, as it had been previously in the requirement that certain *partes* be notated *compresse* or *compressius*.
48. Guido gives as an example the beginning of the introit *Ad te levavi*, whose first syllable has a liquescent neum also in modern editions.
49. Aribo, *De musica*, p. 48. Guido's chapter does not mention the monochord; yet see above, note 16.
50. *Ibid.*, p. 50. The whole chapter is spent in finding examples in the liturgical repertory for other, less binding prescriptions.
51. See the section of the editor's introduction mentioned above, note 28.
52. Johannes Affligemensis, *De musica cum tonario*, pp. 117–26.
53. *Ibid.*, p. 117. Compliance with the listeners' taste had already been suggested in chapter XVI, where the "cautus musicus" is warned to use such mode "quo eos maxime delectari videt quibus cantum suum placere desiderat." The "qualitas" of each mode is described in such terms as "curialis vagatio," "modesta petulantia," "mimicos saltus," "matronalis canor," etc. The need is stressed for the socializing *musicus* to be able to grasp quickly the mode of each song.
54. *Ibid.*, pp. 118–19.
55. *Ibid.*, pp. 120–26. Knowledge of the modes seems to have been Johannes's favorite topic.
56. Smits van Waesberghe's analysis of Guido's literary style, quoted in note 34, shows its observance of the rules of rhythmic prose. Of course, this is not enough to make Guido's style effective, were it not implemented by an unerring feeling for the sound and rhythmic weight of words, cognate to Guido's striving for quantitative and qualitative balance in the *modulatio*.

# Music and Meter in Liturgical Poetry

## DAVID G. HUGHES

Beginning in the ninth century, and continuing into the thirteenth, a vast repertoire of liturgical poetry[1] came into being. All of it was intended to be sung – if only because the liturgy itself was sung – and in most cases the original music survives, in more or less decipherable form. With the passage of time, two general tendencies made their appearance: (1) in the poetry, an increasing interest in regular (rhythmic) meter and in rhyme; and (2) in the music, an increasing interest in the deployment of complex musical means (there are of course exceptions, with those in the musical far outnumbering those in the poetic area). These two tendencies are fundamentally contradictory: complex musical techniques will, in most cases, obscure rather than enhance perception of poetic regularity. Who, other than the specialist, is conscious of the verbal prosody of *Le nozze di Figaro?*

In later periods, this conflict became the subject of much debate; but in the Middle Ages, as far as I know, even the existence of a problem was not acknowledged. The treatises on poetry do not generally mention music (although some cite poems that exhibit the problem in critical form). The musical theorists speak only rarely of poetry, and then only by way of analogy. And, more generally, medieval writers give no sign that there is a conflict between the two arts.

The practical sources merely confirm this impression. In manuscripts containing both music and words, it was the regular custom for the text scribe to enter his material first, leaving appropriate space above for the music to be entered later. It sometimes happens that a poem appears without music, but this is the result of oversight or the temporary un-availability of the correct tune; the space (usually quite accurately measured) is left available. Notated melodies lacking their text are hardly known – as indeed is natural, given the method of manuscript production. There are, to be sure, some manuscripts that preserve only texts, with no space for music, but these give no sign of being the result of literary protest. They are, rather, analogues of the non-notated missals and breviaries that served as incomplete but useful substitutes for the notated service books.

It would seem, therefore, that there existed what we in our wisdom would call a problem, but one that passed largely or wholly unrecognized by musicians and poets of the time. Music was the invariable companion of liturgical poetry, but was she (to adopt the celebrated seventeenth-century formulation) the servant or the mistress of the words? Did the poet foresee either confirmation or distortion of his elegantly-wrought rhythms by the music to which they were to be sung? Was the musician aware of his role in the composite art work he helped to produce?

It is unlikely that there can ever be full answers to questions such as these, but an examination of some of the types of poetry and of music may help at least to define the problem (*our* problem, it will be remembered).

What may have been the earliest type of liturgical embellishment – the addition of elaborate melismas to official chants of the liturgy – may at first appear to be irrelevant to this inquiry, but, in fact, melismas, whether added to or already present in a chant, provided the musical substance for one of the fundamental species of liturgical poetry, the prosula and its relatives. The basic technique of the prosula was simple: for the chosen melisma, the "prosulator" devised a series of words, appropriate in content to the chant in which the melisma occurred, in such a way that each note of the melisma was supplied with one syllable of text. Since the music was, of course, pre-existent, with its own internal grouping of notes into phrases (groupings generally respected by the prosulator), the result could hardly be poetry in the traditional sense. At best, the prosulator could see to it that his text phrases ended with the vowel sound to which the unadorned melisma would have been sung – producing assonance and occasionally rhyme. But the lengths and, largely, the rhythms of the lines were beyond his control. The music was clearly mistress, the poetry servant. Nevertheless, what may be called the syllabic principle – the one-to-one correspondence between notes and syllables – results in a clear and unimpeded perception of the added text. Indeed, in the end it is the music – mistress though she may be – that suffers most. Its original free and smooth arches are fragmented by the incessant articulation of consonants and weighted down by the slower tempo required to utter the separate syllables. Poetry is here the real winner, and it needs only the (admittedly momentous) step of adapting or inventing, rather than merely borrowing, the melismas to produce a musical means ideally suited to the projection of poetic values.

In fact, something of this sort probably occurred by the ninth century in the early "sequences" or (to use a more exact term) prosae. It appears that pre-existent melismas were altered so as to receive a specific kind of text – the paired-line, arhythmic (but usually assonating) verse of the Notkerian or early Aquitanian prosa. The later development of the prosa

was in the direction of increased regularity of textual rhythm and more frequent use of rhyme, culminating in the fully-rhymed and rhythmic prosae of Adam of St. Victor (twelfth century). Paradoxically, however, this development was accompanied by the frequent use of more complex music: later prosae often have some or even many two- and three-note groups over single syllables. Thus, the gain in metrical clarity is partially offset by an increase in musical complexity.

Fundamentally different from the prosa and prosula is the trope,[2] best represented for the present purposes by the trope to the introit. In this, new music as well as new text is added to the liturgical chant. All introit tropes have a prefatory sentence, sung before the introit itself was begun, and most have interpolative phrases as well, intercalated between the phrases of the chant.

Some tropes appear even less "poetic" than the prosulae. Others are in rhythmic verse (these are for the most part found only in German sources). Many more, however, are in quantitative dactyllic hexameters (not always faultless by classical standards). Whatever the literary type, the musical style remains fairly constant. Probably, in order to make the tropes approximately similar in musical style to the introits that they embellished, composers supplied them with rather elaborate music, averaging three or four notes per syllable, but often including brief syllabic patches and occasional melismas. In no case does the meter of the text appear to have acted as a determinant in the shaping of the music. Long syllables may have single notes, short syllables ornamental note groups, or the reverse. In the following, reasonably typical hexameter, the numerals indicate the number of notes each syllable carries:

$$5 \quad 4 \quad 35 \quad 5 \quad \quad 1 \quad 11 \quad 74 \quad 83 \quad 21 \quad 1$$
Ecce pater cunctis ut iusserat ordo peractis

There is no evidence that this sort of music was somehow rhythmicized so as to permit apprehension of the poetic meter; and there is plenty of internal evidence to suggest that such a procedure would have been virtually impossible. In performance, the meter must inevitably have been drowned by the music.

Thus, before the eleventh century we have on the one hand a method of syllabic musical setting ideally suited to the projection of metrical values but almost invariably used for wholly or nearly non-metrical texts; and, on the other, a considerable body of metrical poetry, set so as to obscure its metrical properties. It would, however, be risky to infer too much from the evidence so far presented. Medieval musicians may have had no interest in bringing quantitative meters to rhythmic life – indeed, considering the lack of stylistic differentiation between settings of metrical and non-metrical tropes, the composers may not even have recognized the hexameters as verse. The earlier writers of prosae were not yet

interested in rhythmic verse, and the syllabic settings were as much the result of tradition as anything else. By the twelfth century, moreover, both genres were in their old age (the proper tropes were beginning to disappear), and it is precisely in the twelfth century that the most critical confrontation of musical and poetic innovations took place.

One outward sign of a new orientation is evident from the nature of the sources. Liturgical poetry of the ninth through the early twelfth century is preserved in collections closely related to the traditional liturgical books: the tropers and prosers are liturgically ordered with the same care one finds in graduals. When the collections are relatively small, they are, in fact, merely entered at the end of the gradual and bound with it. Larger collections are often written and bound separately, but, while such manuscripts are regularly known as "prosers," "tropers-prosers," and so on, almost all of them contain strictly liturgical items – offertory or alleluia verses, for example – as well. The supremacy of the liturgy, at least, remains unchallenged.

While books of this sort continue to be made throughout the Middle Ages, the twelfth century saw the appearance of a new type of manuscript – one organized either wholly or partly on *musical* principles, with little or no regard for the liturgy, even though some or all of the content may have been intended for liturgical use. Manuscripts of this sort coincide with – and almost certainly result from – the increased cultivation of notated (as opposed to improvised) polyphony. Such music was apparently beyond the abilities of the ordinary singer – even the ordinary soloist – and was entrusted to specialists. It was therefore natural to separate polyphony from the rest of the repertoire, and to gather it into books directly intended for such specialists whenever the polyphonic corpus in use was large enough to justify a separate volume. Since the raison d'être of such books was musical, not liturgical, their internal ordering might also be non-liturgical.

These polyphonic collections, while few in number, have been extensively studied by historians of music, because the twelfth century was the beginning of that development that made polyphony synonymous with art-music in Western culture. For the present purpose, however, their primary importance lies in their elevation of musical values to a position superior to that of liturgical ones.

Also during the twelfth century, another type of musico-poetic composition began to appear with some frequency – the independent or near-independent Latin lyric poem with only tenuous connection to the liturgy. Two subtypes may be distinguished. The first (and probably earlier) is a free poetic expansion of the verse and response "Benedicamus Domino – Deo gratias" that serves as termination for the services of the Office (not the Mass, which sometimes uses this formula, but always in penitential seasons, during which poetic additions were not used). Some

of these Benedicamus poems (a term preferable, I think, to the more common "Benedicamus trope"), recognizable as such by the quotation or paraphrase of the liturgical words at the ends of the first and second stanzas or stanza groups, are of the prosula type, texting melismas borrowed from diverse sources. Others, however, are set to newly-composed music and are hence free to respond to current poetic tendencies. Only these latter will be considered here.

The second subtype consists of wholly free poems set to new music. Some of these were intended to precede lections. Others may have been used in processions. Still others appear to have had no specific liturgical function, but may still have been inserted into the liturgy at some point where further embellishment was desired.

Pieces of this latter subtype are termed *versus* in Aquitanian sources, but *conductus* in northern French manuscripts. The terminology necessitates a brief excursus. The *versus* of the type under consideration appear to be unrelated to the ninth-century repertoire of poems having the same title (Paris, Bib. nat. lat. 1154): only the idea of recurrent rhythms (versus as opposed to prosa) connects the two groups. The word *conductus* also poses a problem, for it suggests, at least to the musicologist, a specific type of polyphonic composition uniquely defined by characteristics primarily of a musical nature. While there is some medieval theoretical support for such a view, there is ample evidence that the word *conductus* was (also) simply a term for a Latin lyrical poem without a clearly defined liturgical function. At no time does the word necessarily imply polyphonic setting. The term will be used here in its more general meaning, and, to avoid prolixity, will even be extended to include the Benedicamus poems also, since the latter, apart from their terminal "clue words," are similar in many respects.

This repertoire never enjoyed the wide distribution of the tropes and prosae. While some prosae, especially, may be found in dozens of sources spanning four or five centuries and covering almost all of Europe, it is rare for a conductus to appear in more than three or four manuscripts, and many pieces are unica. The importance of the repertoire lies elsewhere. It is the first corpus of "modern" Latin sacred poetry to achieve at least a kind of functional autonomy with respect to the liturgy. And, while the repertoire as a whole was never widely circulated, individual pieces do turn up in numerous manuscripts of diverse provenance and date: evidently the *idea* of such poetry was an attractive one. For example, in one manuscript, a conductus is rubrically promoted to the rank of prosa – and for one of the Christmas Masses. In another, the compiler, one Johannes Decanus, claims – or admits – to having composed new conductus to add to the repertoire available to him, in order to have available plenty of edifying songs for festival seasons.

Novelty and relative independence were, then, the chief characteristics

of the conductus. How did musicians react to this novelty? As might be expected, there is no simple answer to the question. There survive musical settings corresponding to all of the combinations of the technical pairings syllabic/non-syllabic and monophonic/polyphonic. To a limited extent, musical and poetic style are related to provenance. Apart from isolated poems from various places, there are three major "schools" of conductus-production: (1) the Norman-Sicilian (Madrid, Bib. nac. MSS 288, 289, and 19421); (2) the Aquitanian (Paris, Bib. nat. lat. 1139, 3549, 3719, London, Br. Mus. add. 36881, and perhaps the "Codex Calixtinus"); and (3) the Parisian or Notre-Dame school (Florence, Bib. Med. Laur. Pl. 29.1, Wolfenbüttel, Herzog-August-Bibliothek, 628, 1099; these latter universally known by the abbreviations F, $W_1$, and $W_2$). The repertoire of the Norman-Sicilian school is contained in manuscripts of the traditional type – tropers to which miscellaneous collections of various sorts have been added. Somewhat the same can be said of the earliest of the Aquitanian sources, B. n. lat. 1139: while somewhat disorderly, it is still clearly a book intended as an adjunct to the liturgical books. Predictably, these sources contain little or no polyphony. The remaining manuscripts are, however, primarily polyphonic, and thus no longer liturgical books (although lat. 3549, a confused potpourri of many hands, still contains a few traditional tropes). The (later) Notre-Dame manuscripts, especially, are elegantly executed and carefully organized on the basis of musical typology; liturgical influence is present only in the arrangement of polyphonic settings of true liturgical chants.

Obviously, one very coarse line may be drawn through this repertoire: almost all of the Norman-Sicilian repertoire is monophonic, but about half of the Aquitanian and nearly all of the Parisian (with the exception of a corpus to be mentioned below) is polyphonic. Is the distinction important for this subject (quite apart from its importance in the general history of music)? Less so, perhaps, than one might first assume. In those cases (and only those) where the polyphony consisted merely in the addition of another voice (or even two other voices) differing in pitch but not substantially in rhythm ("homophonic" polyphony) from the basic tune, the hearer's perception of the verse is not much altered. Moreover, some conductus appear monophonically in one manuscript and with an added voice elsewhere, surely implying that the polyphony is incidental to the "real piece." Finally, thirteenth-century theoretical descriptions of (polyphonic) conductus composition make it plain that the melody (the *tenor*) comes first, both temporally and conceptually: any further voices are added as enrichment or elaboration. Nevertheless, when a second voice causes rhythmic distortion of the tune (e.g. by having many more notes than the tenor, irregularly distributed), perception of the text is, in fact, altered. In such cases (not infrequent in Aquitanian polyphony), the added voice assumes an important role.

But this new role simply transfers to another part of the musical fabric the essential distinction between syllabic and non-syllabic settings – a distinction already observed above. The fourfold catalogue of setting types mentioned earlier must merely be amended to read:

1. Syllabic
   a. monophonic
   b. polyphonic, but homophonically set
2. Non-syllabic
   a. inherently, in the tenor
   b. as a result of non-syllabic behavior in the added voice(s).

Instead of the coarse line dividing polyphony from monophony, a much finer one, infinitely more difficult to draw, must attempt to separate syllabic from non-syllabic settings. In what follows, a fairly considerable middle ground must necessarily be ignored, for there are many pieces that appear to stand between the two basic categories, without, however, forming a clearly definable category of their own. The extremes, however, and a good deal of ground bordering upon them, are clearly recognizable – and, curiously, in some cases actually appear to join hands. In a number of Aquitanian and Notre-Dame conductus, a basically syllabic setting is found to be interrupted by structurally significant melismatic sections (most often terminal, but sometimes initial and medial as well). In the terminology of the thirteenth-century theorists, these are called *caudae*, presumably because of their frequently terminal function. That they "interrupt" the conductus in which they occur is not only evident to the ear, but also demonstrable by somewhat more objective evidence. In almost all cases, the conductus melody makes perfectly good musical sense, even if the caudae are admitted – the end of one syllabic phrase ties in neatly with the beginning of the next, despite the intervening melisma. Moreover, the manuscript transmission of the melismas is generally less consistent than that of the syllabic sections. It would appear that the caudae are extended ornaments – carefully fitted to but not necessarily of the essence of the conductus in which they appear. They are, however, structurally functional in that they serve to demarcate large segments of the overall form. One might regard them as roughly analogous to the instrumental ritornellos of traditional opera arias. In both cases, such sections are tangential to the poetry itself, serving rather as musical frames in which the poetry may be viewed.

It is known that the caudae of Notre-Dame conductus were metrically performed and that the syllabic sections were also (the caudae are written in explicitly rhythmic notation; the rhythm of the syllabic sections must be inferred from various considerations, and there is still disagreement about details). The rhythmic patterns, or *modi*, that governed such performance were apparently a specifically Parisian invention of the late twelfth century; hence their applicability to the Aquitanian or Norman-Sicilian repertoire is questionable at best. Indeed, the modi, which were

specifically devised for polyphonic music, may never have been intended for monophonic song. How, then, were the Aquitanian and Norman-Sicilian conductus performed? While details of performance practice are beyond the scope of this article, general considerations in that area are decidedly relevant, since the manner of performance may directly affect perception of the nature of the verse.

That musical rhythm was not notated in the Norman-Sicilian sources (and only imperfectly in those of Paris) has been explained as the result of notational inadequacy: no system for such notation had as yet been invented. But it is surprising how quickly notational means were found when they were really required. The Notre-Dame conductus did not need symbols for single long and short notes – the singer could read rhythmic values directly out of the poetry. In the slightly later motet, such symbols became necessary, owing to increased musical complexity – and, seemingly at once, they were found. (The counter-argument that the invention of the symbols permitted advances in rhythmical style seems not to hold here: who, in music, mathematics, or whatever, invents a symbol for which there is no use?) The lack of rhythmic notation is better ascribed to: (1) the existence of a strong local singing tradition that prescribed one or several ways of performing a notated series of pitches associated with a particular kind of text; and (2) a tolerance for

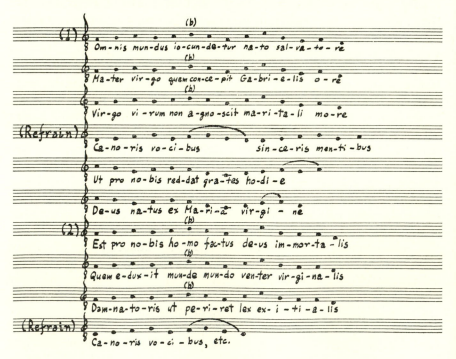

Figure 1.

Figure 2.

some (perhaps considerable) latitude in rhythmic performance. Given the first, notation of rhythm is superfluous; given the second, it may even become a positive hindrance.

But the tradition is lost, and the latitude with it. Can it be reconstructed? In part, perhaps. Figure 1 is an apparently simple example from the Norman-Sicilian repertoire, *Omnis mundus iocundetur* (Madrid, Bib. nac. MS 289, fol. 144). It is virtually impossible to sing the first lines, with their powerful trochaic meter and wholly syllabic music, in anything but a metrical fashion. Exactly how one does so is less important: one might consider the accented syllables long and the unaccented ones short, or one might make all syllables equal. In either case, the text determines the musical rhythm. In practice, this will result in either 4/4 or 6/8 meter, as shown in Figure 2 (the second versions provide for lengthening of the penultimate to compensate for the contraction at the end of the line).

The example is, however, only apparently simple. In the almost primitive structure – aBaB, where B is the refrain – the refrain fails to continue the strong trochaic rhythms of the "a" sections (as it happens, refrains often display irregularities). In point of fact, the rhythms are still there, but the anacrusis of the beginning of the refrain, and, later, the repeated 4 plus 4 plus 3, combine to produce a less obvious metrical effect (indeed, on reading the poem only, one might be tempted to connect the words "hodie deus natus . . . " into a single phrase: the musical repetition, however, shows that "hodie" is the end of a line). The singer might have to hesitate momentarily in beginning the refrain. If, however, he had already lengthened the penultimate of the preceding line (and many poems suggest that this was a fairly common procedure), he could then begin the refrain on the upbeat, and continue without difficulty, as shown in Figure 3 – or of course the analogue in 6/8. This would hardly be beyond the capacity of a twelfth-century singer. He would surely not be sight-reading an unknown song publicly in church – there would have been some prior time for thought; and he would have the benefit of the tradition, including perhaps an actual hearing of the song at some earlier time.

This supposes, of course, that the setting was wholly syllabic, which, as is very often the case, it was not. So long as the setting is completely

Figure 3.

syllabic, then one syllable equals one note in length. So far, I have postulated the syllable as the basic determinant. What if the single note, rather, were the unit of measure, as it apparently was at this time in the performance of liturgical chant?

The improbability – perhaps even impossibility – of this may be demonstrated for the musical reader by an attempt to sing poems of this type with all notes equal in length. The result is disastrous. Wherever a group of notes appears over a syllable, that syllable is doubled, tripled, or quadrupled in length, and these lengthenings are wholly unrelated to any structural points of the meter. Patches in syllabic style make possible the brief emergence of metrical regularity, but this is then irritatingly destroyed at once by another note-group. In the end the stanza becomes wholly shapeless – chaotically irregular, with strong agogic accents strewn about at random.

There is also some evidence of a less subjective kind. In many strophic poems, a given syllable may have a single note in one strophe, while the syllable occupying exactly the same place in another strophe has two or even three notes (invariably of a sort suggesting a little ornamental figure). More generally, single notes and small note-groups are freely interchangeable in identical metrical contexts. Are we seriously to believe that successive strophes of the same poem were performed with what would in performance amount to serious differences in musical meter because of these casual melodic variations? I, for one, cannot believe it: the rhythmic shape of the stanza or of the line, once revealed,

cannot be so lightly altered. There is also evidence that twelfth- and thirteenth-century musicians did not readily tolerate changes of stress in repeated pitch series.[3] Admittedly, even this is not proof, but the weight of probability is overwhelming.

If, then, the single note is not the unit of value, the syllable must be: there are no other choices available. In that case, small note-groups must be rendered as subdivisions of the basic value. In Figure 1, there are three such groups, all in the refrain. The first occurs on the last syllable of a metrical sub-unit – a point of least metric momentum. It could therefore be regarded as a terminal melisma on a microscopic scale, deliberately intended by the composer to call attention to the new line-shape and perhaps to prevent reading "vocibus" as a dactyl. It is, however, still performable in strict meter: the first syllable of "canoris vocibus" is taken as an upbeat, the next four syllables fill the following measure, and the last ("-bus") occupies the first three beats of the next. (The details of the metrical subdivision necessary in the case of the last syllable may have been part of the tradition, or may have been left largely to the singer. In any event, they are doubtless lost beyond recovery.)

Much the same may be said of the second ornamental group. Here, as noted before, there is a natural tendency to attach "hodie" – which in fact is the last word of a line – to the following "Deus natus." The ornament tends to impede this – to impose a musical caesura suggesting the correct line-division. Here, too, there is no difficulty in finding a metrical reading: the first two syllables of "hodie" have normal length, and the third occupies two beats (again the details of subdivision must be regarded as irrecoverable). The third group is less clearly functional. It might, to be sure, be a kind of cadential ritardando. This is one case where an equal-note rendering is not objectionable. My own experience with these poems inclines me to the opinion that it is a non-functional ornament, the two notes having each the duration of half the normal syllable value.

Many more examples might be cited, both to refine the proposals already made, and to suggest further details of interpretation (particularly of songs with more numerous and more complex ornaments). But for our purposes it would seem sufficient to propose that there is a strong case for a metrical performance of conductus having either entirely or mostly syllabic melodies. As noted earlier, the presence of one or two homophonic added voices would not involve any fundamental difference in interpretation.

There is thus some hope of reconstructing, at least in part, the performance tradition of the syllabic or near-syllabic conductus, and at least in the method proposed above, it would appear that poetic values served as a primary determinant of musical rhythm. With the melismatic pieces (whether inherently melismatic in their tenors, or made so by a melismatic added part), the case is quite different. Despite valiant and ingenious

attempts, no method of metrical interpretation has yet achieved general acceptance. This is understandable. Quite apart from matters of detail, the imposition of musical meter on melodies of this type would demand of the singer an almost incredible ingenuity in manipulating complicated numerical groupings (assuming a robust faith that the groupings were meaningful) or an almost equally incredible memory of previous performances of the song. Especially perturbing are the fairly numerous Aquitanian conductus that begin syllabically, only to become more and more ornate as they go on. How would a singer react to such contradictory signals?

While perhaps some day a convincing metrical solution may be found, for the present it would seem preferable to assume that melismatic songs were non-metrically rendered. In practice, the most reasonable assumption is that the single note here takes on the role of basic rhythmic value, rather than the syllable. The resultant ambiguity of notational symbols would not have bothered the singer: the melismas, very evident to the eye, would have served as a more than adequate clue to the change in meaning. The chief practical problem occurs in some Aquitanian polyphony in which simultaneous performance of different-sized groups is required – e.g., five against seven.) Needless to say, this and, indeed, any plausible interpretation of the melismatic conductus prohibits clear perception of the poetic meters. It does not produce the intolerable irregularity that the same method yields in the near-syllabic poems, because in the latter the verse rhythms are only partly concealed, and it is precisely the semi-concealment that produces irritation. In the melismatic songs the meter is, for the most part, wholly drowned. The text is again the obedient daughter of the music – in Mozart's sense. The effect is similar to that produced by the richly melismatic graduals and alleluias of the Mass (except that these, of course, are prose).

This, in turn, suggests a final paradox. Merely mentioning the gradual and alleluia calls to mind the musical splendor and opulence associated with these and similar chants. During their performance at Mass, even the Pope, if present, was merely to sit and listen: music was indeed the mistress. For, while we have been treating melisma as, in a sense, "the enemy" – the musical style that conflicts with or hinders perception of poetic values – the Middle Ages saw it as the apex of musical solemnity, the jeweled musical garment with which to clothe the highest and most precious utterances.

A study of the verbal content of the conductus repertoire suggests that in part, at least, the same attitude prevails there as well. The syllabically-set poems – most of the Benedicamus poems and many of the conductus – are mostly simple in all respects: stanza form, thought, and diction and choice of images. The same metaphors, often identically expressed, recur

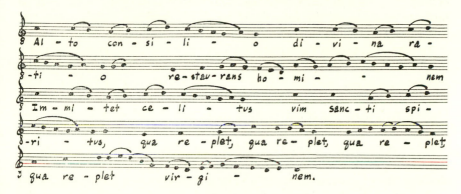

Figure 4.

in dozens of poems (there is hardly a Christmas poem of this type that does not contain some form of the phrase "virga Iesse floruit," and this is only the first example to come to mind). To be sure, in some cases the Aquitanian polyphonists applied elaborate added voices even to verse of this sort, but perhaps this was no more than an excess of musical exuberance. More often, melismatic treatment is reserved for poems of a more serious, complex sort (Figure 4, *Alto consilio*, from the version in Br. Mus. Eg. 2615, fol. 67; only the first few lines are given[4]).

The monophonic conductus repertoire of "F" (see above), which is problematic in many respects, demonstrates this point quite clearly. There are two basic groups of poems. The first group consists mostly of serious works (including a number of poems by Philip the Chancellor). Almost without exception, the musical settings are complex and melismatic. The second, and smaller, group is a collection of refrain songs similar to the secular rondeau. The scribe notes the change (as he notes all changes of style in the manuscript) by beginning the new group with an elaborate initial. The music in this section is simple and syllabic. Instead of the long, through-composed settings of the previous group, the refrain songs are set strophically, with the music entered only for the first strophe.

One may therefore establish a tentative and exception-riddled equation: serious and often complex poetry calls forth complex musical settings. And we are bothered by this, for to us it appears that the poet's best effort has been partly or wholly frustrated by the "appropriate" style of the music. Perhaps, however, there is a more general equation at work: complexity at one level invites complexity on all levels. While the analogy is far from exact, it is worth considering the case of the thirteenth-century motet. Here, the poetry, while often not serious, is certainly not simple, in its quotation of refrains from other poems – it is challenging, rather than complex. And the musical setting – usually two such poems,

declaimed simultaneously over an also-quoted liturgical melody – is as intricate as music of the time could be (more intricate, surely, than our ears can easily follow).

At best, however, this is mere analogy. For the conductus repertoire, we must merely note that the poet's high intent called forth what the medieval musician regarded as the most appropriate response. It may well be that the thirteenth century saw the end of this close relationship. Dante's lyrical poems could well be sung, and doubtless were: no music survives. The *Commedia* may have been sung – in part and from time to time[5] – but no music is known to have been composed for it, and indeed the mere idea of a composed setting of so much as a canto provokes a shudder.[6] For later music was to go her own way, often intimately bound with, but generally mistress of, the words she clothed. In a way, the composer of the melismatic conductus had begun to walk in this path, but he did so within a venerable tradition – one embedded in the liturgical chant itself, and thus, indirectly, authorized by the Holy Spirit. Later musicians neither had nor appeared to have needed such exalted authorization, but the paradoxical pairings of the twelfth century – simple, text-dominated settings of lighter verse, as against complex music often obstructing perception of the text for serious poetry – recur in later periods. One need think only of the chordal villanella in contrast to the strongly contrapuntal madrigal or of the simple strophic lieder that Goethe liked, compared to the complex songs of Schubert and later composers. As observed earlier, the problem with which we began is not a peculiarly medieval one; but perhaps not since the Middle Ages has it been possible for two high arts to achieve union so effortlessly.

## NOTES

1. The rather loose term "liturgical poetry" will here be taken to mean Latin verse that either was used or could have been used as a supplement to or embellishment of the liturgy. This article is an attempt to convey to the non-musician some of the musical aspects of certain types of medieval verse. I offer apologies to the musicologist if I have (intentionally) evaded some of the more challenging problems and to the layman if I have (of necessity) made free use of technical terms.
2. "Tropus" is used in both medieval and modern sources to refer to several different types of elaborative pieces. For clarity, the term will be here restricted to the type described in the text.
3. See Heinrich Husmann, "Das Prinzip der Silbenzählung im Lied des zentralen Mittelalters," *Die Musikforschung* VI (1953), p. 21.
4. The whole piece may be found in Wulf Arlt, *Ein Festoffizium des Mittelalters aus Beauvais* (Cologne, 1970), *Editionsband*, pp. 157–159. This valuable publication also contains modern editions of numerous conductus of various styles.
5. John Larner, *Culture and Society in Italy, 1290–1420* (New York, 1961), pp. 162–164. The references here are to accounts of lower-class people

singing Dante (as if his work was not high literature). The practice is deplored by men of letters, but it is not clear whether they objected to singing Dante, or merely to the class and the manner of those who sang. I owe this reference to Mr. Paul Clogan.

6. Sixteenth-century composers occasionally set excerpts from the *Inferno* as madrigals, but the excerpts are invariably quite short. In effect, they convert a brief descriptive passage into an independent lyric poem that differs only in quality from the bulk of madrigal poetry.

# The Theme of Imagination in Medieval Poetry and the Allegorical Figure "Genius"

## WINTHROP WETHERBEE

Before Dante, it is difficult to talk about medieval attitudes toward poetry. There is little discussion of its function as anything but a pedagogical device. Grammarians seek to deal in an orderly way with poetic technique and, occasionally, to define the relation of poetry to the liberal arts, but its status remains uncertain, and it is never quite conceded an official role in the pursuit of *scientia* except insofar as a given poem is seen to contain knowledge which a commentator may reduce to non-metaphorical terms.

And yet, this is a time when, as Richard McKeon has noted,[1] "the poets and the philosophers were engaged on a single set of problems," and when poetry, whatever its relation to the formal *cohaerentia artium*, came into its own as an art. We can hardly doubt that the implications of poetry as a special mode of perception and expression were appreciated; and, though the tendency of formal statements about its intention and import is to reduce it to precise and manageable ethical terms, we can hardly doubt when we read good medieval poetry that it was valued largely for its capacity to communicate complex and ambiguous experience.

In this essay I will attempt to explain one aspect of the special position of poetry in the twelfth and thirteenth centuries by reconstructing the view of imagination which seems to me to be implicit in this poetry; by suggesting how spiritual and scientific writings of the period provide a context for this view; and, finally, by showing how this view is synthesized and made explicit in the allegorical figure Genius, as employed by Alain de Lille.

The imaginative faculty in question includes, largely undifferentiated, the aesthetic sense and may be broadly defined, first as the faculty or power *cito percipiendi aliquid*, which responds to and synthesizes sense perception in a form accessible to reason and memory, and secondarily as the "internal sense" which draws on memory to form an image of the objects of thought and desire.[2] At its lowest level it serves our animal nature, disrupting rational activity and distorting consciousness by its responsive to physical desire and sensory stimuli or exploiting mem-

45

ory to conjure up *terrenas phantasias,* imaginary objects of sensual desire, often embellishing or idealizing them in the process. At its highest it is in the service of memory in a Platonic-Augustinian sense – not just a thesaurus of desirable images, but a repository of authentic wisdom through which the mind may make imaginative contact with its divine and primordial origins. On this level it aids in the largely intuitive process of reorientation by which human understanding seeks to recover its primal dignity.

Twelfth-century thought on imagination tends to fall into two main categories. One, represented largely by the pioneers of the new science and their followers in the cathedral schools, tends to consider imagination as intimately bound up with the influence of the natural *motus* which activate cosmic and human nature. Imagination expresses our impulse to realize, to possess, or to participate in what we naturally desire and thereby to give expression to the *ingenium,* or natural bent, of our nature, which is ultimately oriented toward harmonious participation in the natural order. Twelfth-century spirituality, on the other hand, tends to emphasize the psychological process of imagining and its role in our intuitions of spiritual reality, its power to abstract from the external world images which, by their beauty, intricacy, or variety, enable us to form a notion of the richness of the divine.

These two views of imagination are closely related. Twelfth-century theology tended to conceive of redemption, not as the divine bestowal upon Man of a new and uniquely exalted status, but as restoring Man to his prelapsarian condition; thus it accepted, in M.-D. Chenu's phrase, an "ontological continuity" between the orders of nature and grace.[3] The highest attainment of imagination in the spiritual view is also the final result of that impulse to a full participation in nature which the scientists saw as implicit in imaginative activity. The two views are based on a common body of psychological knowledge and overlap in many respects. Both reflect the influence of the new science and address the question of the nature and value of imaginative perception in terms conditioned by Stoic, Hermetic and neo-Platonic conceptions of its sources.

An index to the potential scope of imagination as the twelfth century conceived it is the treatment of the faculty called *ingenium,* a term which in its broadest application refers to the natural tendency or aptitude of any nature, but which in psychological contexts is often effectively synonymous with imagination. It is used interchangeably with *vis imaginativa* or *phantasia* in the tri-partite scheme of post-sensory faculties or "internal senses," imagination, reason, and memory, common in twelfth-century writings[4] and is defined, at length, professedly on the authority of Bernard of Chartres, by John of Salisbury.[5] John describes three types of *ingenium:* the first, *ingenium aduolans,* consists in sheer perceptivity and flits restlessly from one object to another; the second,

*ingenium infimum,* is wholly sensual; the third, *ingenium mediocre,* is the aspect of *ingenium* which lends itself to philosophy, and, if carefully nurtured, is capable "not only of comprehending the Arts, but of discovering a straight and unhindered path to things which are, as it were, naturally inaccessible."[6]

Another influential characterization of the faculty occurs in the glosses on Martianus Capella of Johannes Scotus Erigena. In glossing Vulcan's gift to Psyche, the human soul, of "unquenchably enduring fires," which represent the effects of *ignis terrenus* in human nature, Johannes explains that Vulcan's *igniculi* are at once the *calor voluptatis* and a *figura generalis ingenii,*[7]

ex quo veluti quidam igniculi ad expellendas ignorantie nebulas rationabili incenduntur naturae. Ut enim ignis invisibiliter omnem corpoream penetrat creaturam, ita naturale ingenium quod universitati rationabilis nature commune est omnibus veritim in hoc mundo nascentibus distribuitur mortalibus, ne et conditoris sui et naturalis dignitatis cognitione omnino priventur, sed semper interiore lumine illustrati et se ipsos et deum suum assidua veritatis indagine inquirunt.

The same range of activity, with a greater emphasis on the sensual aspect, is attributed to Vulcan as *ingenium* in the commentary on Martianus attributed to Bernardus Silvestris. Glossing Vulcan's gift to Psyche, Bernardus presents him first as a type of *animus,* the rational aspect of the soul, "lame" in his view of eternal things but capable, through his possession of *ingenium, ratio,* and *memoria,* of pursuing wisdom: "for if by these means he does not pursue perfect understanding he is yet capable of doing so; . . . though he see nothing, he does not lack the power of vision."[8] Hence, he was permitted by Jove to woo Pallas. But in pursuit of her he becomes a type of intellectual presumption: the goddess eludes him, and he spends his seed upon the ground to produce the mandragon Erichthonius.[9]

Turning to the specific function of *ingenium,* Bernardus compares it to Vulcan as artisan, ceaselessly engaged in the *conceptus rerum.* Its activity is random and perverse: able to discover things of value, it often rejects them to root in the dung-hill. In the midst of prayer it will rise to the divine, only to descend suddenly and "seize upon some uncleanness."[10]

These views of *ingenium* are important for our purposes, largely as they suggest a context for viewing the activity of imagination itself. The significance of *ingenium* as a perceptive faculty lies in its responsiveness to natural desire in all its aspects, and the cosmic "spark" which quickens desire can be the *calor voluptatis* or the *igniculus* of higher understanding, a hindrance to full awareness or a source of orientation. Thus, the imagination implied by *ingenium* will be capable of expressing our impulse to participation in the natural order but at the same time of confounding reason with carnal fantasy through its involvement with the senses. Thus,

it illustrates, like Vulcan's abortive pursuit of Pallas, the plight of fallen human nature. It is important as a precedent for later poetic uses of imagination insofar as it enables us to see in desires and actions which are corrupt or ineffectual the underlying presence of a power which is intrinsically orientative.

Essentially the same psycho-physiology is applied more precisely in the brief but influential *De unione corporis et spiritus* of Hugh of St. Victor. Hugh describes the work in human nature of a *vis ignea* whose effects ascend from the simple sustaining of vegetable existence to the work of sense and imagination.[11] In motivating the senses to pursue the good and shun the bad, this power imitates the control exercised on a higher level by reason: as imagination, transmitting sense perception to the brain, it becomes something quasi-spiritual which Hugh calls *vitalis sapientia*.[12] Hugh describes the transformation: the form of a thing is adapted to vision and enters the eye, undergoing a refinement in the process; then,

novissime purificata et collata introrsum ad cerebrum usque traducitur, et imaginatio efficitur. Postea eadem imaginatio ab anteriore parte capitis ad mediam transiens, ipsam animae rationalis substantiam contingit, et excitat discretionem, in tantum jam purificata et subtilis effecta, ut ipsi spiritui immediate conjungatur. . . .

This heightened perception of *sensibilia*, the purified form in which they "excite" reason, is what Hugh means by *vitalis sapientia:* the point at which we see things most nearly as they are by nature, a "pure" perception which brings us to the threshold of illumination. Hugh goes on to suggest an analogy between the knowledge derived from the informing of reason by imagination and the *sapientia* gained when reason is informed by the divine.[13]

But the potential value of imagination is also a potential danger. The barrier between purified *imaginatio* and spiritual vision, however imperceptible, is absolute. Reason is light, but imagination, which can never transcend its material ties as *similitudo corporis*, is shadow.[14] The two are joined by the soul's *affectio imaginaria*, and when this functions *secundum solam naturam*, reason is dominant, "circumscribing" by perfect understanding the nature whose image it perceives.[15] But the bodily appeal of the image may subvert reason's power, and then, says Hugh in a brilliant image, imagination adheres to reason like a fleshly body,[16] contaminating perception with desire and debasing their natural *coaptatio*.

Imagination serves reason and the soul only when it offers them the *propria natura* of its object by purging its own apprehension of all contamination. When it attains this purity it may by extension be seen to approach the archetypal vision of primal man, which responded directly to the natures of all things and so enabled man to attain that full realization of his relation to nature which it is the object of *vitalis sapientia* and

all knowledge to recover.[17] Hugh does not develop this aspect of his conception, but he says enough to point the way toward a state of psychological integration in which the powers of the purified imagination as he describes them and the fundamental impulse of *ingenium* as conceived by the "scientists" would be directed toward a single goal.

A balance of appreciation and mistrust appears in the view of imagination of William of St. Thierry. Like many Cistercians, he was well versed in medicine,[18] and his *De natura corporis et animae* reviews the hierarchy of vivifying forces which sustain human life to show how their action at each level may be seen to resemble and emulate a higher level.[19] In his *Expositio altera* on the Song of Songs, he uses this hierarchical conception to define three psychological attitudes toward prayer, the animal, the rational, and the spiritual. The prayer of "animal" man fails to realize God, for if he does not simply conceive God as a power capable of granting his desires, he conceives Him in human form and so reduces prayer to the terms of human affection.[20] And yet, when the affection thus shown is real and expressed in simplicity of heart, though it may simply forestall spiritual communion, it may also come to pass that this "animal" feeling is illumined "ex dulcedine ipsius animalis imaginationis" and quickens into spiritual life.[21]

William's language recalls Hugh's figure of imagination as the fleshly covering of reason when he describes how such prayer "quasi corpoream induit orationis affectionem,"[22] and though his language is difficult at crucial points, he seems to suggest that prayer of this sort, insofar as it realizes the full capacity of strictly human affection and knows nothing beyond, attains the threshold of spirituality, like Hugh's purified imagination.[23] I think it is possible to see in William's notion the apotheosis of an imagining which has attained the status of *vitalis sapientia*. And as Hugh's concept of purified imagination evokes the vision of primal man, so William's seems to concede a certain intrinsic value to human love. He himself considers this love only as addressed, like the Magdalene's, to Christ; but viewed more broadly his conception of "animal imagination" might serve as the formulation of an idea implicit in many love-lyrics: that at its heart the natural bent of our emotion, though aroused by carnal and subjective motives, reveals the traces of a primordial state of psychological integrity in which human and spiritual feeling were one.

For these twelfth-century thinkers, then, imagination provides a means for the expression of intuitions inaccessible to reason in its fallen state, and the two aspects in which its response to these is interpreted, as urging a fuller participation in the natural order or as encouraging an incipient appreciation of spiritual things, are really complementary. The *ingenium* of the scientists is closely involved with those vital forces, Hugh's *vis ignea*, which coordinate the impulses of human nature as the *ignis artifex* sustains and refines the life of the universe; to the extent that it articulates

and guides their work, *ingenium* brings our debilitated consciousness to a tentative recognition of the full extent to which the human mind mirrors the scope and complexity of the divine plan.[24] Imaginative intuition becomes *vitalis sapientia* and prepares the mind to respond to that grace which is present, in Chenu's phrase, "comme une nature" beneath the surface of man's restricted consciousness.

To the vast potential for self-deception illustrated in William of St. Thierry's analysis of the prayer of animal man corresponds the scientist's awareness of the inseparability of the imaginative aspect of *ingenium* from the influence of man's physical nature. Imaginative desire, while capable of sublimating and refining physical appetite, is always in danger of being reduced to the physical level or of disguising merely sensual impulses in a seemingly nobler form. The difficulty of distinguishing between the positive and negative tendencies to which imaginative desire is liable is the source of a fundamental irony in poetry on this theme.

The poetry of the later twelfth century is both freer and in certain ways more complex than the texts considered above, in its treatment of the intrinsic value of psychological experience and the role of imagination as a means of access to the archetypal memory. As poetic themes these are closely related to a central concern with the imaginative experience of love – "love" being understood to encompass affinities so diverse as the cosmic *amor* which holds the elements in harmony, the impulse of man toward a fuller participation in the natural order and the reciprocal "appeal" of nature to his will and instincts, and the variously passionate and idealizing manifestations of human sexual love. The sophisticated love-poetry of the period reflects the contemporary philosophical and spiritual view of imaginative perception as capable of participation in the larger order of things; and at the heart of the experience of love as these poets conceive it is the intuition of an essential coherence, an integrity and harmony which are represented as potentially accessible through the fulfillment of human love, or as symbolized by it.

In some poems this fulfillment on a higher plane is affirmed as an essential ingredient in human love, while in others it is presented as unattainable, as a paradise lost through the disorientation of man's will or, more ironically, as a pathetic fallacy created by the self-deceiving will to justify its carnal desires. The continuity and discipline of poetic form itself become a model of the coherence which the experience of love in a given poem invokes, affirms, or ironically denies; and the concern to locate an intrinsic value in human emotion – a concern strongly implied even in those poems which are most skeptical about the possibility of attaining this and – appears as a nostalgia for lost or impossible unity, an impulse toward recovery or reform, or simple protest against the constraints imposed upon human nature by its chronic instability.

It is important to recognize that these poets address such themes only

as part of an experiment, a new departure which amounts to virtually a reinvention of their own art. In bringing poetic form and imaginative intuition to bear on fundamental human needs and problems they are assimilating them to a *poetic* context which, however charged with allusions to the concerns of contemporary psychological thought, nonetheless exists in an essentially oblique relation to such concerns. Insofar as they affirm the dignity and integrity of human nature, they do so in a wholly aesthetic way by articulating its aspirations in poetic form.[25] Their affirmation or equivocation about the capacities of existential man is simultaneously a statement about the capacities of poetry, independent of the sanctioning authority of science or theology.

In the following pages I will attempt to illustrate how this new love-poetry adapted to its own purposes the conception of imaginative activity outlined above and to sketch, even more briefly, the later history of the poetic tradition thus inaugurated. Once established as poetic themes, the problems of the imaginative experience of love become part of a tradition distinct and often radically divergent from the mainstream of medieval psychological thought[26] and serve to define the central preoccupations of later medieval poetry. Jean de Meun and Chaucer are still concerned (though from largely opposed points of view) with the same problems of imaginative experience that engaged the twelfth century, and Dante himself must deal with them on the path to his uniquely transcendent vision.

A scene which centers on the complexity of imaginative desire occurs in the *Tristan* of Thomas after King Mark, unable either to live with Ysolt's infidelity or to take stronger measures, has banished the lovers to the forest. One day while hunting, Mark is accidentally led to their bower and sees them asleep with a naked sword between them. After a moment of confusion in which he feels awe, attraction, jealousy, and wrath, he performs an act which both constitutes a participation in the scene and defines his exclusion from the "mystery" at its center. Seeing that a ray of sunlight threatens to mar Ysolt's cheek as she sleeps, he lays his glove against her face and then, invoking God's blessing on the lovers, departs in deep sorrow.[27]

There is nobility in Mark's act: he asserts no claim, exercises mercy instead of justice, and we may see in his gesture toward Ysolt a selflessness which approaches real charity. But his mercy is self-deceiving: the willed belief in the lovers' innocence on which it depends coexists with sure knowledge of their guilt and a deep desire to know the bliss he imagines them to share. Even in its delicacy his intrusion on them as they sleep is a covert act of possession.

We can reconcile the diverse implications of Mark's role by seeing him as the artist of the scene he beholds, focusing in his own attitude a number of possible responses. He is placed, in fact, in essentially the role of the

poet of *fin amor*, suspended between desire and reverence. His interception of the sunbeam may be seen as an attempt to prolong this moment of suspension and render perfect the image of bliss which he contemplates. All of his emotions are subsumed by the imaginative experience of the state of loving; he is at once the victim and the author of the scene. The more we respond to the noble side of Mark's role, and the more it seems to adumbrate a full renunciation, a complete transcendence of a scene in which he already seems a larger figure than the lovers, the more striking is the power of the scene to draw him back and suspend him in its circle. The irony is reinforced by the lovers' response when they wake to find that Mark has discovered them and feel only relief that he has found them in an uncompromising situation. Mark has defined their "true" role as a kind of ikon, an image of the imaginative desire of others, and their restoration to real life is inevitably a reduction.

Like the experience of the lovers themselves, Mark's experience is finally, to a great extent, the creation of his own imagination, and I think we may see in its effect on him the operation of essentially those deceptive workings of imagination discussed by Hugh and William. Implicit in their assertion of the power of imagination to elevate our minds by proferring an intuition of the beauty of spiritual things is the negative implication of the imagination's ability to contain desire wholly within its own sphere, and this seems to me to be the situation of Mark. Though his vision of the lovers is purified to the point at which the aggressive and covetous aspects of desire are suspended, the beauty he sees in them is still a reflection, however sublimated, of his own desire, and so the spiritual potential of his emotion is suspended as well. In his willed acceptance of the lovers' innocence and the impulse which leads him to bless them, we may see a version of that wholly human "animal" devotion which, in William's conception, is capable of transformation into true piety; but we can also see the distortion of perspective which makes this devotion inevitably abortive and reduces it to mere idolatry. "Fine" as Mark's love becomes, it remains impure: his perception is obscured by the fleshly veil of his idealized imagining of the lovers' bliss, and his charity remains an imaginative emulation, a "shadow" of its spiritual counterpart.

A group of complex lyrics found together in the manuscript of the *Carmina Burana* approach the theme of imagination by way of the "pathetic fallacy" of a rapport between erotic love and the larger *motus* of external nature. The theme is stated plainly in a lyric in which love is the agent of a *vitalis calor* which preserves life from extinction at the hands of winter:[28]

> Estas in exilium
> iam peregrinatur,
> leto nemus avium

cantu viduatur,
pallet viror frondium,
campus defloratur,
exaruit
quod floruit
qui felicem statum nemoris
vis frigoris
sinistra denudavit,
et ethera silentio
turbavit
exilio
dum aves relegavit.

Sed amorem
qui calorem
nutrit, nulla vis frigoris
  valet attenuare,
sed ea reformare
studet, que corruperat
  brume torpor. . . .

The poem's development of this theme is tentative, offering only the suggestion that beneficent nature should serve as a pattern for similar kindness from the lady, but in other lyrics the treatment of love and nature is more complex. The strange "Saturni sidus lividum" devotes four of six stanzas to creating its natural setting, culminating in an elaborate analogy:[29]

Dulcis aura Zephyri
  spirans ab occidente
Iovis favet sideri
  alacriori mente,
Aquilonem carceri,
  Eolo nolente,
deputans; sic ceteri
glaciales spiritus diffugiunt repente.
  redit calor etheri
dum caligo nubium rarescit, Sole Taurum tenente.
Sic beati spes, halitus flagrans oris tenelli
  dum acclinat basium
  scindit nubem omnium
  curarum; sed avelli
nescit, ni congressio sit arcani medica duelli.

The *avelli/nescit* of the second of these stanzas can be understood in at least two ways, but plainly it suggests tension and ambiguity in the moment depicted, the impossibility of a direct communion with the *beati spes* manifested in the beloved, the inseparability of such love from anxiety and uncertainty. The analogy with the advent of fair weather can be carried no further; it is suspended and then broken as the natural process implicit on the human level goes forward. The presumably orgas-

mic conclusion shows the dissipation of vision in a moment which is perhaps *felix* precisely insofar as the attempt to maintain an articulating tension and clarity of focus has been abandoned:

> Felix hora huius duelli
> cui contingit nectar adunare melli!
> quam felix unio
> cuius suavitatis poculo
> sopiuntur sensus et ocelli!

To the analogy between the movement toward sexual fulfillment and the processes of nature in the "Saturni sidus lividum," the finest of the *Carmina Burana*, "Dum Diane vitrea," adds an even closer association between the imagination itself and the operation of sexual desire. The post-coital languor in which the former poem ends provides the setting of the latter. In a sensuous opening movement the tranquil associations of nightfall are interwoven with reflections on the soothing effect of music:[30]

> Dum Diane vitrea
> sero lampas oritur
> et a fratris rosea
> luce dum succenditur,
> dulcis aura zephyri
> spirans omnes aetheri
> nubes tollit;
> sic emollit
> vis chordarum pectora
> et immutat
> cor, quod nutat
> ad amoris pondera.

As the influence of music counters the *pondera amoris*, the several levels of reference come together; the larger setting is recreated within the lover's mind and introduces a further comparison, this one to the state of drowsy reverie after love-making:

> Orpheus in mentem
> trahit impellentem
> ventum lenem,
> segetes maturas,
> murmura rivorum
> per harenas puras,
> circulares ambitus
> molendinorum
> qui furantur somno
> lumen oculorum.
>
> Post blanda Veneris commercia
> lassatur cerebri substantia;
> hinc caligant
> mira novitate
> oculi nantes

in palpebrarum rate.
heu quam felix transitus
amoris ad soporem –
sed suavior
    regressus ad amorem!

This state, in which love is simultaneously recalled and anticipated and
the poet's imagination is lulled as if by the motion of a boat at rest, is
the still center of the poem. It is followed by a stanza in which the imag-
inative process of tranquillization described earlier is glossed in terms
of contemporary physiology, expressing in concrete terms the correla-
tion of imagination and sexuality which underlies the poem's movement.
Then two final stanzas balance an idyllic vision of love and spring against
a reflection on the chronic instability of lovers:

Fronde sub arboris amena,
dum querens canit Philomena,
suave est quiescere,
suavius ludere
in gramine
cum virgine
speciosa.
Si variarum
odor herbarum
spiraverit,
si dederit
thorum rosa,
dulciter soporis alimonia
post Veneris defessa conmercia
captatur,
dum lassis instillatur.

O in quantis
animus amantis
variatur
vacillantis!
Ut vaga
ratis per aequora
dum caret anchora,
fluctuat inter spem
metuque dubia
sic Veneris milicia.

These lines dramatize the reawakening of desire, carefully suppressed in
the preceding stanzas, and set the poem's moment of suspension in the
context of an opposition between ideal yearning and frustrating actuality.
As the vacillation of the *vaga ratis*, the anchorless vessel of the final lines,
displaces the *palpebrarum ratis* in which the poet's vision has been lulled,
the contingent status of the lyric synthesis is revealed.

In these lyrics the reduction of the moment of articulate response, the
*balansa* which in the lyric of a vernacular troubadour might occupy the

entire poem, to a phase within the larger movement of the poem is in itself a comment on the attempt to integrate imaginative experience with the natural order. Sexual desire is a metaphor for this impulse to participation, and the synthesis it suggests, the rich harmony of cosmic and emotional movement on which the poems are based, stands for the intuition of deeper harmonies in which both sexual and imaginative desire have their source. But the intuition of this source is momentary, and the imaginative synthesis is disrupted by the same forces which had inspired it. Orgasm and the ebb and flow of awareness which attend it seem to define a cycle within which, as for the "narcissistic" lover of *fin amor*, desire is perpetually contained by its own subjectivity.

But the dramatization of the frustrated impulse toward the fulfillment of imaginative desire in these lyrics may provoke us toward a fuller appreciation of the impulse itself. Though we see irony in the quasi-charity of Mark in the *Tristan* and question the authenticity of the *beati spes* reflected in the lady of the anonymous Latin lyrist, it may not be going too far to see in the imaginative orientation of these lovers and their capacity to intuit a state of emotional integration which they cannot attain a synthesis which is at once a delusion and, like William's "animal" devotion, an adumbration of something beyond itself.

I would like, however, to offer no more than this tentative reading of the imaginative movement of these lyrics before turning to consider the *De planctu naturae* of Alain de Lille and his use of the allegorical figure Genius. I think it is possible to see in this figure a synthesis of the *ingenium* of the scientists, the "animal" imagination of the devotional writers, and the quasi-paradisal yearning of the lyric, here presented in their full implications.

The *De planctu naturae* deals with the effects of original sin, characterizes the "divorce" of man from the natural order as an abandonment of normal procreative sexuality, and uses a host of linguistic metaphors to define this repudiation of nature. The laws of grammar, the *copulae* of subject and predicate, the functions of gender have been forsaken. Language no longer conveys ideas; its denotative and tropological powers of reference have been distorted, and it is at the mercy of a bizarre and an almost inarticulable rhetoric.

The bulk of the poem consists of a dialogue between the poet and the goddess *Natura*, who reviews the history of human sexuality and tries to account for inconsistencies in the behavior of Venus and Cupid. But nothing is resolved, for Nature, while aware of the effect of Man's fall, can offer no remedy but the example of that order in which she herself perpetually abides, a standard to which human behavior cannot adequately respond. She sees the necessity of a new dispensation, but in attempting to grasp its nature, she says, "Meae rationis confunditur lumen."

Though the stress on perversion obviously strikes a harsher note than

the irony with which sexual desire is treated in the lyric, it is possible to see the *De planctu* as providing a moral setting in which to view essentially the same flawed aspirations to which lyrics allude. The failure in both cases is a failure of consciousness, a psychological inadequacy to the demands of fulfilling participation in the natural order. The inadequacy is dramatized in the poet's initial encounter with Nature herself, before whose powerful feminine presence he faints away, and the contrast between the vision of potential fulfillment and the actual failure amount to a stronger version of the implication in the "Dum Diane vitrea" that poetic vision is finally at the mercy of the weaknesses of human nature.

A more striking correspondence between the *De planctu* and the lyrics occurs with the entry of Genius, the "priest" of Nature, whom she summons after her own attempts to deal with the problem of human sin have failed, to excommunicate Man from her "church." He supplies what is needed to complete Alain's picture of the psychology of fallen human nature and adds a new dimension of more positive meaning to the allegory as a whole.

The associations of Genius are complex. His character owes a good deal to the classical concept of a tutelary spirit born with each soul and responsible for instilling an instinct toward the good. He is also a creative principle, responsible for uniting matter to form and ensuring that the resulting creature expresses its proper nature, pursues its *ingenium*. As Alain explains elsewhere, the "genius" of a creature is its "substantific" principle, that which defines and preserves the integrity of its nature.[31]

The Genuis of the *De Planctu* combines all of these attributes. As "priest" of Nature he administers all natural creation and oversees the fulfillment by creatures of their natural obligations. Alain alludes to him as the "interpretative ikon," harbinger of the incarnation of form in matter as Gabriel was herald of the conception of the Word in Mary.[32] But Genius's ability to realize this role in man's psychological and sexual life has been thwarted by sin. His communion with *Natura* takes place across an impassable barrier and expresses both his yearning for the goddess and the failure in man which makes their union impossible. The terms of his address are significant; of their encounter he says:[33]

quamvis enim mens mea hominum vitiis angustiata deformibus, in infernum tristitiae peregrinans, laetitiae nesciat paradisum, in hoc tamen amoenantis gaudii odorat primordia, quod te mecum video ad debitae vindictae suspirare suspiria. Nec mirum, si in nostrarum voluntatum unione conformi concordiae reperio melodiam, cum unius ideae exemplaris notio nos conformet. . . .

That reunion with Nature revives Genuis's memory of Paradise is significant, for it is just this memory which it is his office to keep subliminally alive in the human psyche. This tentative link with man's primordial state of psychological integrity accounts for Genius's orientative function, here expressed in a sort of *fin amor* directed toward Nature. Genius's

posture is that of a lyric poet, his yearning constrained by sin but capable of lyric expression, and here, on the visionary plane of allegory, becoming fully articulate. Nature's response, primarily one of gratitude, also suggests the bestowal of the "grace" of a courtly *Domna*:[34] "suae exclamationis quasi aurora nascente, tristitiae tenebras paulisper abstractans, salvo suae dignitatis honore, Natura Genio gratiarum iura persolvit."

In this encounter and in the formative impulse with which Genius responds to the summons of Nature by evoking the primal harmony between them, we may see a new vindication of the yearning of the love-lyric and of the imaginative impulse which inspires it. It is sheer *ingenium* that is vindicated in Genius, an impulse toward the natural, uncomplicated by any associations except an awareness of loss and a yearning for recovery. Genius exercises a constant pressure on human nature, endowing it in spite of itself with the instincts of self-preservation and procreation and, on the level of consciousness, preserving at least a dim intuitive sense of orientation toward Nature, and so toward that larger regeneration which reunion with Nature implies.

Genius's "innocence" is, of course, a source of danger: ignorant, like Nature, of the theological implications of the Fall and unable to prevent the abuse and corruption of his influence at the hands of Man's debased will, he is liable to all the dangers we have seen associated with the volatility of *ingenium* and the self-deceptions of *animalis imaginatio*. But this very innocence is the source of his deepest meaning: Alain compares him, in his "substantific" role as quasi-angelic intermediary in the union of form and matter, to the mystical integrity which all created natures reveal through "theophany," or as illuminated by the divine.[35] These are the terms on which Hugh of St. Victor had compared the informing of the mind by pure imagination with its illumination by God,[36] and it is just this informing influence that Genius, with his uncorrupted vision of *Natura*, seeks to exert in human consciousness. He is preeminently the agent of *vitalis sapientia*, and thus the reconstitution of the human psyche to which he points the way in an important step in the process of redemption.

The *De planctu* sets the themes and resources of love-poetry in a new perspective. Alain's appropriation of the conventions of the lyric, together with his use of the failure of sexuality and the failure of language as interchangeable metaphors for the effect of sin, brings the tradition of *fin amor* and the "learned" tradition of clerical Latin poetry into significant confrontation, defining in absolute terms the conflict between idealizing imagination and the realities of the human condition. He both underlines the critique of *fin amor* implicit in the Latin lyrics and effects a compromise between the two traditions, preserving the formal integrity of the lyric of *fin amor* while integrating it with the natural order and opening to its conventional themes the new dimension of allegory.

We can see the implications of this in Guillaume de Lorris's portion of the *Roman de la Rose*. His allegorical garden of *Deduit* preserves the decorum of vernacular lyric while locating it in more concrete psychological and moral terms. Of his allegory Guillaume asserts

> Ce est li *Romanz de la Rose*,
> ou l'art d'Amors est tote enclose.

There is a significant play on the idea of containment in the final phrase, for the Garden exactly defines the perimeter of the Lover's consciousness, the psychological barrier which separates his conscious submission to Amors from the deeper influence of more fundamentally natural forces. Highly artificial in its professed purpose and values, the Garden is at the same time rich in natural beauty, warmed by the sun, and capable of harboring not only the ritual life of the followers of Amors but the wholly unreflecting behavior of innocent *Jonece*, Youth, and her lover:[37]

> car qui tenist d'aus .ii. parole,
> il n'en fussent ja vergondeus:
> ainz les veissiez entr'aus deus
> baisier come deus colombiaus.

The garden is both a natural and an artificial paradise, and the same dual associations adhere to the fountain at its center. This is identified as the fountain where Narcissus died, but when the Lover overcomes his fear of its fatal associations and looks into it, he undergoes an experience which, while its immediate effect is to draw him into continuum of *fin amor*, with all its narcissistic associations, brings him at the same time into contact with a larger order of experience. Within the fountain lie two crystals, and in these he sees reflected the whole of the garden, "mil choses," and finally the rose-garden which harbors his love. His conscious reflections on the experience of falling in love are tainted by self-reproach and anxiety, but at a deeper level he has made contact with the sources of that combination of imaginative idealism and sexuality which commits him to the quest of the Rose, a quest which, even as treated with Guillaume's delicate equivocation, is clearly adumbrative of participation in a more profound experience.[38]

Without violating the essential lyric coherence of the experience he describes, and without defining systematically the relation of his allegory to the spiritual dimension allusively suggested by its imagery, Guillaume manages to neutralize the exclusive, hermetic tendency of *fin amor* and establish a new paradigm for the work of later poets. Extending the work of transformation and adaptation begun by Alain, the *Roman* marks a major stage in the process by which the highly developed formal and linguistic decorum of the Romance vernaculars was adapted to the lofty program defined but imperfectly realized in the Latin poetry of the twelfth century. It exhibits an allegorical structure and an incipient sym-

bolism but preserves the fundamental obliquity of the "grand chant courtois" in an allegorical mode which is essentially poetic, defying categorization as mere courtly metaphor and at the same time refusing to yield to a purely symbolic, mystical reading. Guillaume's achievement confirms the achievement of the "grand chant courtois" itself, the decisive assertion of the autonomous status of poetic expression, "ou l'art d'Amors est tote enclose."

The full implications of Guillaume's allegory of the experience of love become clear only as it is adapted and elaborated by a long line of later poets, and lends itself to the transforming vision of Dante. Certain dangers inherent in the conception of imaginative experience which it dramatizes are, however, made crystal clear by the poem's continuator Jean de Meun, whose powerful reductive effort exploits not only the calculated ambiguity of Guillaume's garden but also the precarious status of Alain's Genius as at once the guardian and the victim of fallen human nature. I have attempted elsewhere to interpret Jean's continuation as a whole in the light of his use of the *De planctu naturae*[39] and will here only note briefly the major features of the treatment of Genius, whose intervention in the quest of the Rose at the instigation of Nature arouses the Lover to his final decisive effort. Jean's Genius, like Alain's, possesses a unique visionary capacity, the sign of the survival in him of the vision of primal Man. He is able to see sexual love and the world of *Deduit* in the light of the paradisal realities of fulfilled love and natural harmony of which they are imperfect reflections, and his exhortation to the Lover to fulfill his mission and perpetuate the human race through union with his Rose is an appeal for the reassertion of Man's original dignity.

The problem is that Genius can see the garden and its sexual purpose *only* in the light of their paradisal originals and is sublimely unaware that the reattainment of Paradise involves more than a realignment of human activity with that *ingenium* and those sure intuitions of which he is the spokesman. Like Alain's Genius, he can only appeal to man on behalf of these, and in making him urge the conquest of the Rose as a means of access to the *Beau Parc* which he (rightly enough) sees symbolized in the garden of *Deduit*, Jean is only following out, albeit rather unfairly, the implications of Alain's conception. In an elaborate parody of the excommunication scent in the *De planctu*, Jean shows how Genius plays innocently into the bawdy hands of Venus and Amors; and when the Lover, having explicitly repudiated Raison, nonetheless manages wholly accidentally both to fulfill the commandment of Genius and to express the *ratio* of his primal nature by impregnating the Rose, the irony is complete.

The world of the Roman is a world without morality and almost without love. Love and moral responsibility are central to the theory of lyric poetry and its inspiration present by Dante in the *De vulgari eloquentia*,

a theory which implies the full scope and implication of imaginative activity as the twelfth- and thirteenth-century poets had conceived it. The *Natura* of the *De planctu* had entered into dialogue with the poet "quasi cum familiari et secretario meo"; for Dante the poet is *domesticus* and *familiaris* of his native vernacular,[40] a language which is itself a "nature,"[41] aspiring to realization through the ordering power of *grammatica*. The affinity, or *convenientia*, among its different branches reflects its impulse toward recovery of the universality of the speech of primal Man, that archetypal speech in which Adam, "mox postquam afflatus est ab Animante Virtute,"[42] responded to God. Poetry expresses the potential integration of our nature by harmonizing the different forces which animate it,[43] and thus poetry, in proportion as the poet's appreciation of his art and its objects, *salus, venus, virtus*, matures, is a means to the recovery of self-awareness and the recognition of God as the source of inspiration.

Personal and profoundly symbolic as this conception of the implications of poetry is,[44] and though Dante's special concern is to clarify the responsibility of poetry to language in a new and rigorous way, his largely mythic account of the nature and history of language may be seen to bring together virtually all the philosophical and psychological concerns of the poetry we have considered. If we substitute *materna locutio* for *Natura* in her relations with human *ingenium*, *grammatica* for the model of harmony and justice provided by the natural order, and an Aristotelian for a Platonist conception of natural fulfillment, we may see the *De vulgari eloquentia* as a new version of Alain's mythic treatment of the implications of poetry in the *De planctu naturae*. Dante, like Alain, is concerned to vindicate the intrinsic impulse which urges the inchoate *materna locutio* toward poetic form, and he does so in a way which seems to illuminate retrospectively the whole history of medieval love-lyric and of the conception of the imagination which this poetry embodies.

## NOTES

1. "Poetry and Philosophy in the Twelfth Century: The Renaissance of Rhetoric," *Modern Philology* 43 (1945–46), 234. Preparation of my article has been aided by a fellowship awarded by the John Simon Guggenheim Memorial Foundation. I would also like to acknowledge the help of my friends Dennis O'Connor and Allen Shoaf.

2. On imagination in ancient and medieval psychology, see Murray Wright Bundy, *The Theory of Imagination in Classical and Medieval Thought* (*University of Illinois Studies in Language and Literature* 12.2–3, Urbana, 1927) and the useful brief account of Morton W. Bloomfield, *Piers Plowman as a Fourteenth-Century Apocalypse* (New Brunswick, N.J., 1961), pp. 170–74, who stresses the extreme confusion of the terminology used to denote the different "internal senses," among which imagination is com-

monly classified. On these, see Harry Austryn Wolfson, "The Internal Senses in Latin, Arabic and Hebrew Philosophical Texts," *Harvard Theological Review* 28 (1935), 69–133; and below, note 4.

3. M.-D. Chenu, *La théologie au douzième siècle* (Paris, 1957), p. 294.

4. On the puzzling early history of this scheme and its diffusion in the twelfth century, see Theodore Silverstein, "The Fabulous Cosmogony of Bernardus Silvestris," *Modern Philology* 46 (1948–49), 97–98.

5. *Metalogicon* 1.11, ed. C. C. J. Webb (Oxford, 1929), pp. 28–30. It is tempting to speculate on the role these notions might have played in Bernard's celebrated Platonism, but in the *Metalogicon* the *senex Carnotensis* often seems less a source than a symbol of authority.

6. Cf. Apuleius, *De Platone et eius dogmate* 2.3; *De Philosophia libri,* ed. Paul Thomas (Leipzig, 1908), p. 105.

7. *Annotationes in Marcianum,* ed. Cora E. Lutz (Cambridge, Mass., 1939), pp. 10–11. Cf. Firmicus Maternus's account of how astrology quickens the spark of *caelestis ignis* in the human mind, *Mathesis* 1.4.1–4; 3 *Proem.* 2–4; 8.1.1–9, eds. W. Kroll and F. Skutsch (2 vols., Leipzig, 1897), Vol. I, pp. 11–12, 90–91, Vol. II, pp. 281–83. A similarly orientative function is assigned to *ingenium* in Fulgentius's *Virgiliana continentia; Opera,* ed. Rudolph Helm (Leipzig, 1898), p. 94, where its influence recalls that of the classical "genius" and anticipates the role of this figure in twelfth-century allegory.

8. Cambridge, University Library Mm.1.18, f. 15rb. Printed with other passages cited from the commentary in my *Platonism and Poetry in the Twelfth Century* (Princeton, 1972), pp. 267–72. Cf. Augustine, *De civitate Dei* 22.24 (*PL* 41.789CD): ". . . qua capacitate hauriat [mens humana] sapientiam virtutibusque sit praedita, quibus . . . adversus errores et cetera ingenerata vitia dimicet eaque nullius rei desiderio nisi boni illius summi atque immutabilis vincat. Quod etsi non faciat, ipsa tallium bonorum caparitas in natura rationabili divinitus instituta quantum sit boni, quam mirabile." This is part of Augustine's famous "eulogy of fallen Man," which may also have influenced the passage just quoted from Erigena.

9. C.U.L. Mm 1.18, f. 15rb. Guillaume de Conches, source of many of Bernardus's glosses, uses this myth to illustrate the inevitably imperfect wisdom attained through *fervor ingenii* in his *Glosae super Platonem,* ed. Jeauneau (Paris, 1965), p. 93.

10. Ibid., f. 15va: "Dum enim uerbi gratia in ecclesia orando mediationem mean celestibus affigere studeo, illam statim elapsam repente alicui immundicie inherentem inuenio." Cf. Richard of St. Victor on the intrusion of *phantasia* on prayer, *Benjamin minor* 6 (*PL* 196.5D).

11. Hugh of St. Victor *De unione corporis et spiritus PL* 286–87B. Cf. the brilliant account of the evolution of knowledge in the *Epistola de anima* of Isaac of Stella, *PL* 194.1884D–1885A.

12. Ibid., *PL* 177.287A: "Summum est corpus et spirituali naturae proximum, quod per se semper moveri habet, extra nunquam cohiberi habet; quod quidem, in quantum sensum praestat, imitatur rationalem vitam, in quantum imaginationem, format vitalem sapientiam. Nihil autem in corpore altius, vel spirituali naturae vicinius esse potest quam id ubi post sensum et supra sensum vis imaginandi concipitur." Cf. Isaac, *Epistola, PL* 194.1878BC.

13. Ibid., *PL* 177,289A: ". . . rationi concurrens conjungitur praesentia divina, quae sursum informans rationem facit sapientiam, sive intelligentiam, sicut imaginatio deorsum informans rationem, scientiam facit." On the passage see Chenu, "*Imaginatio:* note de lexicographie philosophique médiévale," in

*Miscellanea Giovanni Mercati*, Vol. II (*Studi e testi* 122, Rome, 1946), p. 596.

14. Ibid., *PL* 177.288A: "Rationalis autem substantia [in]corporea lux est; imaginatio vero, inquantum corporis imago est, umbra est."

15. Ibid., 288B: "Habet namque et ipse spiritus quamdam in sua natura mutabilitatem, secundum quam corpori vivificando appropinquat, in qua illa spiritualis et incorporea substantia nonnihil suae puritatis deponit, et quasi quandam grossiori proprietate corpori assumendo occurit. Quae quidem coaptatio, si secundum solam naturam fit, mutationem habet, corruptionem non habet."

16. Ibid., 288C.

17. On this theme, see Hugh, *Didascalicon* 1.2, 2.1, ed. Charles Buttimer (Washington, 1939), pp. 6–7, 23; *Epitome Dindimi in philosophiam* 2.14–15, ed. Roger Baron, *Hugonis de Sancto Victore Opera propaedeutica* (Notre Dame, 1966), pp. 193–94.

18. On this subject, see Bernard McGinn, *The Golden Chain: A Study of the Anthropology of Isaac of Stella* (Washington, 1972), pp. 163–64; Robert Javelet, "Image de Dieu et nature au xiie siècle," in *La filosofia della natura nel Medioevo: Atti del Terzo Congresso Internazionale di Filosofia Medievale, 1964* (Milan, 1966), pp. 286–296.

19. William of St. Thierry, *De natura corporis et animae* (PL 180.700BC, 710D–711B).

20. Ibid., *Exposito altera super cantica canticorum* (PL 180–477C–478B; read with French translation and useful notes by P. Robert Thomas, *Pain de Citeaux* 9–12, [Chambarand, 1959], pp. 40–48). On William and the "animal imagination," see Javelet, "Psychologie des auteurs spirituels du xiie siècle," *Revue des sciences religieuses* 33 (1959), 30–33.

21. Ibid., *PL* 180–478B, ed. Thomas, p. 50.

22. *Expositio altera, PL* 180.478B, ed. Thomas, p. 48.

23. William describes *Homo animalis* as "constituens sibi eum quem orat seipsum qui orat," so that "secundum formam constitutionis suae format etiam modum orationis suae" (*PL* 180.478B, ed. Thomas, p. 48). To the extent that his imagining is pure, he will realize the *idea* of man in the power he addresses, Christ in his human aspect.

24. On this theme, see Richard of St. Victor, *Benjamin major* 2.4–5 (*PL* 196.82C–83D). The Fall so clouded human understanding that our *acumen ingenii* no longer sees clearly that innermost *vis naturae* which "rebus medullitus impressa profundius introrsum latet," and we can only "feel our way" to an awareness of it – "palpamus potius quam videmus" (82CD). But the analogy and complementarity of the *operationes* of nature and those of the human mind offer a valuable source of guidance; in studying nature we discover ourselves, and we advance in contemplation when "ingenii nostri acumen in hac gemina naturalis et artificialis consideratione circumquaque se diffundit, et mira intelligentiae vivacitate multipliciter huc illucque discurrit" (83D).

25. The remarks of Peter Dronke, *Poetic Individuality in the Middle Ages* (Oxford, 1970), p. 116, on Abelard's *Planctus* apply to fictional versions of subjective experience as well as semi-autobiographical ones.

26. Post-twelfth-century philosophy tends to deny a value to imagination beyond its role as a link between senses and intellect, though as Bloomfield points out (*Piers Plowman*, pp. 172–74), it had an important role in Jewish and Arab theories of prophecy and is clearly important to Dante's sense of vocation as a prophetic poet. In the late twelfth century, however, it

is worth noting the support which the conceptions discussed above might have received from such newly available authorities as Avicenna and Algazel. With the texts cited above on *ingenium*, for example, cf. Avicenna's account of the relation of desire and imagination, *Metaphysics* 9.2 (ed. Venice, 1508, f. 103rb); with the "pure" imaginings described by Hugh and William, and the dangers to which these are subject, the view of an imagination which is pure but devoid of higher knowledge given in Algazel, *Metaphysica* 2.5.3, ed. J. T. Muckle (Toronto, 1933), p. 186.

27. In Gottfried's version, which transforms the bower into the elaborate allegory of the *Minnegrotte*, Mark can only view the lovers through a window, which he covers over with leaves, grass, and flowers before going away.

28. *Carmina Burana* 69, stanza 1 and 2, ed. Hilka-Schumann, pp. 34–35.

29. *Carmina Burana* 68, st. 4 and 5, ed. Hilka-Schumann, pp. 33–34.

30. *Carmina Burana* 62, st. 1, ed. Hilka-Schumann, p. 19; Peter Dronke, *Medieval Latin and the Rise of European Love-Lyric* (2 vols., Oxford, 1965), Vol. I, pp. 307–308. I have followed Dronke's text throughout.

31. *Hierarchia Alani*, ed. M.-T. d'Alverny, *Alain de Lille: textes inédits* (Paris, 1965), p. 228.

32. *De planctu naturae*, ed. Thomas Wright, *Anglo-Latin Satirical Poets* of the *Twelfth Century* (2 vols., London, 1872), Vol. II, p. 518; *PL* 210.480B, in an account of the birth of *Veritas*, "cum Ylem formarum speculum meditantem aeternalis salutavit idea, eandem iconiae interpretis interventu vicario osculata."

33. Wright, p. 520; *PL* 210.481AB.

34. Wright, p. 520; *PL* 210.481AB.

35. See the *Hierarchia Alani*, ed. d'Alverny, *Textes inédits*, p. 228, and the *Expositio prosae de angelis*, ibid., pp. 203–06.

36. See above, note 13.

37. *Roman de la Rose*, 1270–1273, ed. Felix Lecoy (Paris, 1965–70), Vol. I, p. 40.

38. See Jean Frappier, "Variations sur le thème du miroir, de Bernard de Ventadour à Maurice Scève," *Cahiers de l'Association International des Etudes Françaises* II (1959), p. 151; Daniel Poirion, *Le Roman de la Rose* (Paris 1973), pp. 69–72, 83–84.

39. "The Literal and the Allegorical: Jean de Meun and the *De planctu naturae*," *Medieval Studies* 33 (1971), 264–91.

40. Dante Aleghieri, *De vulgari eloquentia* 1.16.5–6.

41. See ibid., 1.1.4 and the commentary of Roger Dragonetti, *Aux frontières du langage poétique* (Ghent, 1961), pp. 29–33.

42. See ibid., 1.5.1.

43. See ibid., 2.2.6–8: Man is animated on the vegetable, animal, and rational levels of his nature, and on these three levels desires what is *utile, delectabile,* and *honestum;* the three levels converge in realizing the three noblest themes of poetry: *salus, venus, virtus.*

44. As Dragonetti notes, *Aux frontières du langage poétique*, p. 14, Dante "dit *je* quand les sources se taisent"; his theory of the origin of language is based on intuition, as when he says at *D.v.e.* 1.4.4, "Quid autem prius vox primi loquentis sonaverit, vero sane mentis in promptu esse *non titubo* ipsum fuisse quod Deus est, scilicet *El.*"

# An Unbridgeable Gap?

## Medieval Poetics and the Contemporary Dante Reader

### DANTE DELLA TERZA

The recent project by a task force of Italian scholars to sponsor an encyclopedic initiative around a subject of major concern in the field of learning – Dante, his poetry, and his culture, has led me to analyze, in obedience to a friendly request, the contributions to scholarship of a number of Dante critics belonging to various countries and to two generations. The remarks that follow are inspired by the desire, not unprecedented I hope, to fill the gap between names imposed by the alphabetical order of the encyclopedia with a discourse that aims at defining and relating to each other the different approaches used by the critics to understand the complexity of Dante's mind.[1]

With all due respect to the scholarly achievements of the followers of the historical method, one can not ignore the obstacles they created for themselves in their quest for a "total" order to be achieved beyond the schemes of Dante's own imagination. Using as a guiding principle the endless faith in the power of human reason to dissipate the clouds separating the present from a past whose secrets they felt called upon to disclose, they ended by occasionally imposing working hypotheses as full-fledged philological certitudes. Obviously, the greater the authority of the scholar in forcefully defending a daring hypothesis, the easier and more tempting it has been to the reader to cross with him the borderline between probable and possible results, between the realm of philology and that of guesswork. As far as I can see, no reader has been able to avoid being influenced by the powerful suggestions of a systematic approach of one sort or another in the diachronic reconstruction of Dante's intellectual career. It is indeed quite possible that such an avoidance is a dream that could scarcely be fulfilled. But even a dream can be helpful if it is conducive to a sound methodological doubt and a "reductive" philology. In other words, if the reader feels compelled to accept the global theory which appears to him more plausible, it may be useful to give it a cautious assent rather than an unrepentant belief.

If it holds true that contradictory theories should be considered expendable until one of them or a combination of them are proven to be closer to the noumenal truth which is one of the basic aspirations of the human

mind, it becomes relevant to our purpose to be first of all acquainted with a list of paralogisms inherited by the reader as controversial guidelines for his journey through Dante's work. I shall indicate the terms of the debate with an alphabetical letter, and I shall try to relate as impartially as possible, the different positions at stake.

A. Dante wrote the concluding paragraphs of his *Vita Nuova* only when he came to realize that the *Commedia* would replace the *Convivio* and felt the urge to establish a link between the youthful experience of his "libello" and his major poem. The mentioning of Dante's spiritual return to Beatrice must therefore be considered as a later addition to the text. *Convivio* II, 2, truthfully relates the impact on Dante's life at the end of the *Vita Nuova* only of a "donna gentile," Beatrice's influence being confined to the realm of the angels. (L. Pietrobono).[2]

B. There is no need to believe that a later amplification was necessary to bring the vision of the *Vita Nuova* closer to that of the *Commedia*. The *Vita Nuova*'s last paragraphs contain important options for Dante's future poetry; they are indeed a bridge thrown toward the future. Dante had no intention of belatedly constructing a trilogy with a middle term, the *Convivio*, denying the first and being corrected in its rationalizing pretentions by the third term, the *Commedia*. (M. Barbi).[3]

C. Dante's *Vita Nuova* has mystic overtones, since Guinizzelli's and Dante's poetic inspiration was entrusted to the charismatic and mystic function of the blessed lady. Such a function, however, is under the spell of an initial theoretical misunderstanding. The mystical impact of Dante's *Vita Nuova* certainly appears to be the end result of an heterodox approach to the truth. According to St. Thomas Aquinas, in fact, (S. Thomas, I–II,9.26,a.4.) in addressing our love to an individual, we love our own good more than the good of the being we love (*Amor concupiscentiae*) and we have no other choice. (K. Vossler).[4]

D. If in the abstract the rational appetence of the universal St. Thomas calls *Amor amicitiae* can in no way pertain to even a highly priviledged individual, it may very well be that Dante, in writing his *Vita Nuova*, consciously adapts the Thomistic doctrine of *Amor amicitiae* to the special circumstances of his poetry. He is in fact able to transfer the operation of an exceptional being – the blessed lady – within the same frame of absolute morality valid in the case of the universal object. By operating in the realm of ethics, rather than in that of metaphysics, Dante excludes from his poetic aim any mystical aspiration. Lady Beatrice, however noble and blessed, can not go beyond the limit of her human possibilities. In his *Vita Nuova* Dante never truly detaches speculation and contemplation from the world and the active life. (E. G. Parodi).[5]

E. Dante put a hasty end to his *De Vulgari Eloquentia* when he realized that he had unwittingly accumulated so many obstacles in the path of the poet writing in vernacular as to make his task practically impossible. The

excellence of Latin poetry stood before Dante as an unbearable challenge. He was unable to resolve theoretically the conflict between Romania and Rome. (E. R. Curtius).[6]

F. Dante interrupted both the *Convivio* and the *De Vulgari Eloquentia* because he became involved in a more urgent task.

1. He had in mind the composition of the *Commedia* (this is the opinion of the majority).
2. He was involved in the composition of the *Monarchia*. While writing the fourth treatise of the *Convivio* he came to see the light of truth as far as the function of the emperor was concerned. He felt the urge to say more about the value of the *philosophica documenta* upon which the independence of the Emperor from the Pope was to be based. (B. Nardi).[7]
3. The *Inferno* and the *Convivio* are contemporary. Dante started writing the *Inferno* in the early period of his exile but finished it later. In *Inferno* II, 22–24 and in *Convivio* IV, 5,34, Dante is still under the spell of the theory of Papal supremacy over the Emperor. Such a theory, staunchly defended by Egidio Colonna in his *De Ecclesiastica potestate* and accepted by Dante in his early period, is refuted by *Monarchia* III,12,3, where the sacredness of the Emperor is given as anterior to the existence of the church. *Monarchia*, *Epistole*, and *Purgatorio* are related to the descent into Italy of Henry VII and to the related high hopes for a *restauratio magna* of the power of the Empire. (E. G. Parodi).[8]
4. There is no conflict between *Inferno*, *Convivio*, and *Monarchia*. Around 1306 Dante interrupts his *Convivio* in order to write *Monarchia*. While writing this treatise, he feels an urge to fortify his knowledge of theology in order to comprehend better the patristic precedents of the debate between the secular power and the church. Along this path, he ends by assuming the gesture and the language of the prophets. The *Commedia*, which he began to write soon after the *Monarchia*, is a prophetic journey to the other world. The doctrine of the Empire in the *Commedia*, however, represents a step backward as far as the secularization of Dante's thought is concerned. It is quite possible that the last paragraph of *Monarchia*, recognizing the Pope's spiritual supremacy over the Emperor is a later addition by a Dante already involved in writing the *Commedia*. (B. Nardi).
5. Dante started writing the *Inferno* in the early stages of his exile. (Parodi).
6. Dante had already written the first seven cantos of the *Inferno* while in Florence, as is evident from the beginning lines of Canto VIII, which correct an erroneous statement made by the pilgrim at the end of Canto VII (G. Ferretti).[9]
7. Dante started writing his poem around 1314, (after the death of Henry VII in Italy. (K. Vossler).[10]

It would, of course, be grossly unfair to the great scholars who were involved in presenting a case in favor of a complete and irreversible picture of Dante's thought not to acknowledge the fact that they were well aware of the risks involved in their operation and often tried to free themselves from the prejudices implicit in the rigid system they were sponsoring. Bruno Nardi, for one, used to put the reader on his guard, as if he had reason to believe that he had unknowingly led him toward a well-constructed building where the doors and windows appeared to be shut

forever. E. G. Parodi, while identifying with daring intuition the people who are as remote from God's will as the earth is from heaven "which highest hastens" (*Purgatorio* XXXIII,90) with the advocates of Papal supremacy, backs away from the rigid implications of his theory, explaining that *Purgatorio*, although contemporary with Henry's descent into Italy, is not the Cantica of the Empire: it is rather the celebration of terrestrial paradise, as well as of the happiness of human nature in the state of innocence. However, in spite of the skill, the moderation and the sophistication with which so many problems are handled, it remains true that the wealth of theories, irreconcilable among themselves, are so overwhelming that the reader should not fail to respond to any suggestion to suspend cautiously his belief.

Of course, the factor which might be decisive in determining the prudent approach of the reader to any "total" interpretation of Dante's work must ultimately come from an evaluation of the connecting links between the factual assumptions upon which the diachronic reconstruction of events related to Dante's life appear to be founded and the textual exegesis which should be the ultimate aim of any form of critical approach to Dante. The people Parodi discusses a propos of *Purgatorio* XXXIII,90, may or may not be the treatise writers favoring the Papacy over the Empire (and there is a chance that they are not), but certainly we are compelled to accept Parodi's suggestion without choice, if we believe his designation of the years and cirmumstances in which *Purgatorio* was written. If an assent to Parodi's theory associating *Purgatorio*, *Epistole*, and *Monarchia* to the Emperor's Italian adventure in 1313 may mean for the Dante reader the sharing of the many advantages of a well-guided exploration of *Purgatorio* and the overcoming of textual difficulties under the critic's skilled direction, it also implies that the reader will not hesitate to accept the responsibility for such a theory and the co-sponsorship of a series of interpretations connected with it.

It is indeed in the difficult field of accepting or repudiating the rigid, though authoritative schemes handed to us by a prestigious scholarly tradition that the reader's discriminating love for Dante is the more often called to task. The example of a well-known Dantesque fallacy: the dating of *Monarchia*, placed by Parodi in 1313, by Nardi in 1306, will appear very relevant to the matter under discussion. Among the critics I was asked to discuss for the *Encyclopedia dantesca*, there is a classical scholar, E. K. Rand, still remembered by some of our less youthful colleagues at Harvard, since he taught Latin until 1942. Rand, trained as a classicist at Harvard and Chicago, had in Germany been the disciple of a great medievalist, Ludwig Traube, who gave him solid notions of paleography, medieval Latin and textual criticism. On the strength of this acquired skill, he accepted to be involved, between 1910–12 in a team operation sponsored by the Dante Society of America: the *Dantis Aldigherii*

*Operum Latinorum Concordantiae.* As a consequence of such an involvement, which had opened up for him the broad, unknown horizons of Dante's mind, he wrote an invaluable essay. "The Latin concordance of Dante and the genuineness of certain of his Latin works" (in *Annual Report of the Dante Society*, XXIV [1912] 7–38), which was wrongly overlooked by E. Rostagno, who edited *Monarchia* for the *Societa dantesca* in 1921.

A painstaking study of Dante's technical phraseology, a survey of phrasal recurrences and of these syntactical connections that give the true dimensions of the logical organization of Dante's thought brought him to demonstrate as more than plausible the attribution to Dante of the Latin works denied to him around 1910: the *Letter to Cangrande* and the *Quaestio de aqua et terra*. As for *Monarchia*, an enlightened exploration of the similar stylistic tools used in the treatise and in *Quaestio de aqua et terra* suggested to Rand the hypothesis of a very late date, the very last years of Dante's life. Such an hypothesis, of course, would not outweigh, per se, the articulated constructions of either Parodi or Nardi, were it not particularly appealing to the reader alerted by the incidental sentence of *Monarchia* I,XII, "sicut in Paradiso Comedie iam dixi" (as I have already said in *Paradise* of my *Commedia*) – a sentence Rand submitted to careful analysis and trusted to be Dantesque. If the sentence is not a later addition by Dante or a spurious interpolation by a glossator, *Monarchia* must have been written at least after the poet had conceived the fifth canto of *Paradiso*, that is, late in his life. A recent study of the manuscript tradition by P. G. Ricci convincingly shows that the previous editors of *Monarchia*, K. Witte and, later, E. Rostagno, in discarding the incidental sentence were under the influence of the idea that *Monarchia* could have in no way been written in Dante's late years.[11] Confronted with a case where the textual structure has been predetermined, with doubtful philological reasons, by a preconceived, though well-thought-out plan, the reader feels compelled to ask himself whether any significant critical solution should not be inspired by textual indications, as disturbing as they may appear to a general theory of knowledge, rather than the other way around.

Since the events of Dante's life are so uncertain and acceptance of any of the chronological schemes we have discussed is so risky, we would be far better off if we relied more upon a method I would call that of synchronic criticism. In this case, the cleavage between what is plausible and what is not can only come from an interior measure of persuasion, the critic's diagrams being the vehicle that bridges the distance between the text and the reader, nothing more. Leo Spitzer, who used to consider the narrowest operative space of persuasion as a condition of privilege for the critic, would insist on the splendid isolation surrounding him when he was in Turkey conducting a seminar on Dante's *Vita Nuova:* no

libraries, a few studious friends, and Dante's book. His *Bemerkungen zu Dantes "Vita Nuova,"*[12] which were the result of such a seminar, is a work conceived in a kind of aseptic laboratory, unspoiled by the grievances of the usual partners, the Dante specialists, excluded for once from a Dante *ergasterium*. The daring intuition on which his essay is built could be defined as the synchronic presence of Dante in Dante, of *Vita Nuova* in *Paradiso*, and *Paradiso* in *Vita Nuova*, of the medieval tradition in Dante, and Dante in the medieval tradition. There is, so to speak, a sort of gravitation of the poet's youthful experience toward the definitive shores of Paradise, and a mystical reverberation of the attained maturity toward the remote origins of his poetry. Thus, when Dante explains in *Vita Nuova* XI that *Amore*, overwhelmed by the power of Beatrice's greetings, is unable to be a veil and a shield (*obumbrare*) between Dante's soul and the divine light coming from her, according to the critic, coherent in his synchronic premises, the verb *obumbrare* has the same conceptual meaning as Dionigi l'Aeropagita's "divine darkness" and describes the same situation as *Paradiso* XXX, where Dante speaks of the radiation of light on the shade of God. Spitzer, of course, makes in this case the most radical use of synchronic criticism based on a series of intuitions that are brilliant, although they do not disdain to appear paradoxical. Spitzer's remarks should be taken for what they are meant to be: intuitions in view of a syntonic evaluation of Dante's poetry. They could never be brought to interfere with diachronic hypotheses concerning the conditions under which *Vita Nuova* was written or with the true or supposed addition of some paragraphs to the original texture of Dante's youthful book. In a sense, the way of reading Dante suggested by the scholar shuns even the possibility of a diachronic debate that, in fact, Spitzer felt to be obsolete. But, whatever may be the limit of Spitzer's seminal essay, the twofold problem advanced by it of a synchronic reading of Dante to explain Dante and of the medieval tradition in Dante to explain the presence in Dante's imagery of a medieval heritage, stands on firm ground and has become so central to Dante criticism that no reader can ignore it. We have on the one hand Dante's memory working within the framework of the poem as a never elusive self-consciousness, a powerful instrument for the narrator, who must deny himself any distraction in order to create a character – the pilgrim – who can really be what he has become, the entelechy of his past; on the other hand, the endless heritage of absorbed thoughts and intellectual experiences, all urging to become one and the same with the rhythm of Dante's poetry. E. G. Parodi in his unchallenged essay of 1896,[13] had talked of rhyme in the *Divine Comedy* as the zone of containment and resistence against the endless pressures from the outside world of linguistic peculiarities and idiosyncratic thoughts, but also as a filter allowing the exceptional entry into the *Commedia* of selected forms belonging to the discarded areas. Gianfranco

Contini has authoritatively spoken of the subliminal characteristics of Dante's memory, of its power of association, dissociation, and dissimilation, as quick and subconsciously instinctive as the driver's reflexes.[14] A younger Dante scholar, laboriously involved in detecting the consonance of Dante's poetic harmonies with the numerological theories of Isidore, Rabanus Maurus, and Hugh of St. Victor, has, somewhat sternly, proposed an exploration of medieval patterns of thought to be relentlessly pursued, were the ratio allowing the identification of them with Dante's poetic thoughts – the *reductio ad unum* – one thousand to one.[15] Be it as it may, it is a fact that there is a common ground of interest present in a broad range of critics using diversified methodological approaches for Dante's intellectual heritage to be studied not in its remote origins and sources but in the very moment of combustion with Dante's thought, in the act of assimilation in his poetry. Again, the word synchrony comes to the fore, if for synchronic approach the reader understands an absolute priority given to the text and to the textual values of Dante's world.

A sense of the textual priorities is undoubtedly present in C. S. Singleton's approach to Dante.[16] In his first exegetical book, *An Essay on the Vita Nuova*, capillary attention is payed to the narrative techniques adopted by Dante: to the role of the *scriba* in selecting notions from the book of memory and transcribing them, to his interference with the framework of events through reflection upon them, to the faith the *scriba* shares with Dante that every event opens up toward a transcending meaning. The linear authorial approach toward the events is accompanied by the critic's deep movement of discovery of medieval patterns of thought which are analyzed "in re" as they appear in the articulated texture of the story, in the iconic *épaisseur* of the Dantesque imagery. The medieval relationship between systems of ideas and systems of images that Singleton was to develop in later years in his brilliant theory of "semantic fields," is tested in Singleton's close reading of the numerologic symbolism inlaid in the very core of the action: a reading which helps him to the discovery of a Christocentric pattern of thought, the analogy of action between Beatrice and Christ. There is respected in Beatrice both the charisma coming from her blessedness and her human destiny, since she lives and dies like any human creature but allows Dante's loving sigh, through her blessed intervention, to reach her in her place among the saints where she belongs.

Equally imbued with a dramatic sense of the priority to be given to narrative values is Singleton's second book, *Commedia: Elements of Structure (Dante Studies, I)*. In this case, the discussion concerns the imitation in the *Commedia* of a book far different from the book of memory – the Bible – and stresses the certitude that Dante's poem mirrors and reproduces the allegory of the theologians according to which the letter and what the letter implies are both historically true. This is the most per-

sonal and the most delicate aspect of Singleton's criticism, the crucial point of his exegesis that has required his greatest effort of persuasion. One should add that this is the only moment, in a criticism so exemplarily textual, in which there is indulgence for a form of diachronic ecdosis, since a deterministic explanation of some sort is given on the reason why and the time when the *Convivio* was interrupted. When the allegory of the poet that considers the letter a beautiful lie, and only what the letter means as valid, gives way to the biblical allegory, the *Convivio* could not be continued any further. It is no use to return to St. Thomas's opposition to the extension of the biblical allegory to non-biblical texts and to Singleton's brilliant discussions about the statement on allegory by Dante in the *Convivio* and in the *Letter to Cangrande*. What really counts here is an appraisal of the positive consequences Singleton's way of reading Dante has had for the evaluation of Dante's poetic practice. Nobody would, of course, be so naive as to believe that Singleton's is a purely subjective vision of the Dantesque world and unrelated to what Dante really thought. His is an interpretation of Dante's structure of thought which wants to be objective, far removed from the purely aesthetic concerns dominating Croce's essay on Dante in 1921. However, it is safe to say that, even if the assent to his theory of the allegory in the *Commedia* ought to be submitted to the usual discriminating evaluation to which any human intuition is bound to be submitted, his interpretation of the poem stands on firm ground. First of all, for the emphasis given to the letter of the journey. The great critic of the figural interpretation, Erich Auerbach, faithful to the Hegelian view that Dante transfers the living and suffering world of actions and individual destinies into a changeless existence, sees in the creatures represented by Dante the quintessence, the figural fulfillment of what they had been in life, and therefore trusts their worldliness as being the crucial point of departure of Dante's poetic attention. Singleton starts from the *hic et nunc*, from the souls' condition, symbolically gravitating toward their destiny of glory or eternally trapped into remembering the great event of their afterlife – the meeting with the pilgrim journeying toward his salvation, and then goes on to explore the allegorical meaning of the journey, its relationship to the reader, who is also involved in a journey, since he is a viator in this life, as Dante is a pilgrim in search of truth in the other-world. Singleton's relevance is, secondly, in his discovery of the common poetic ground where Dante, speaking of the pilgrim, directly involves the reader, of these "pivotal" points in the journey where the awareness of the pilgrim becomes greater and his power of persuasion over the reader increasingly significant. In the description of the parenetic moments of Dante's poetry, when the poet, in telling a story, like Cavalcante's story of a journey that failed, patently addresses the reader, Singleton has found the convincing tone of

a very great scholar and has written pages which have opened new perspectives for Dante criticism.

At this point a question will unavoidably arise concerning my own position as a reader of the *Divine Comedy*. Am I not giving a simultaneous assent to different forms of syncretic criticism and contenting myself with it? I must say that the self-obliteration implied by the understatement of a "personal" position can be justified, in my mind, only if accompanied by a highly discriminating understanding of the plausibility of other critics' vision of Dante's text. There is, for instance, a limit to my assent to Spitzer's position. When in the fourth paragraph of his *Bermerkungen* he reads the lines of the *planh* "Morte villana" (*Vita Nuova*, VIII), "Più non voi discovrir qual donna sia / che per le propietà sue canosciute," according to the thomistic concept that every imperfect form is absorbed in a more perfect one which adds to its own the qualities of the previous form, he fails to convince me. The barriers separating the *Commedia* from the *Vita Nuova* are here certainly cancelled, but the figural principle of construction reverberating backward from the poem to the youthful "libello" appears to me misused and out of place, leading toward unacceptable interpretations.

I am ready to accept the authenticity of Dante's letter to Cangrande della Scala, but I am also aware that an overextended simultaneous plurisemantic reading of the *Commedia* leads to an exegetical paralysis and/or to a farfetched, though ingenious, evaluation of the text. The text only is a totality: figural interpretations, allegorical exegesis confided to the enlightening of pivotal points of Dante's journey are nothing but dramatic moments of focal reverberation of such a totality. Their action need not be extended beyond the meaning of their strategic function.

On the other hand, one must acknowledge the fact that the newness and the seminal value of a critical interpretation of Dante such as Singleton's is, in fact, linked to its underlying effort to attain totality, to see reflected in the microcosmos of the exegetical approach the macrocosmos of the poem. What we learn to avoid by a careful and pragmatic reading of the most convincing examples of syncretic criticism is the rigid and abstract coherence of the overall picture which sacrifices focal accomplishments of Dante's episodic poetry on the one hand, and on the other, an aesthetic reading which ignores the interrelation existing between the episodes and the totality of the journey. If we avoid the risks of these polarities, we are entitled to theorize the possibility of manifold readings of the *Commedia* and even to give privilege and priority to the reading with which we are most at ease: pro captu lectoris habent sua fata libelli.

As far as I am concerned, I have been brought by my intellectual education to believe that the reader will be enhanced in his understanding of Dante especially by considering the dynamic texture of the poem's

imagery as an operative ground for the discovery of significant patterns of thought selected by Dante's memory. The image is the focus of repose for an idea born and elaborated within an intellectual surrounding close to Dante; the idea, absorbed within the framework of the poem, received from it a new light and a far different propulsion. One of the most profitable fields for the application of a synchronic approach to Dante's poetry can be found in those not uncommon moments in which the pilgrim entertains himself with a personality, especially a poet, who deserves more than a passing allusion, a full-fledged portrait. The poetic portrait brings into focus Dante's intellectual passion: words are the point of revelation of the character's personality, but also an ambiguous palimpest hiding and revealing at once his idiosyncrasies. A beautiful example of the existence of well-hidden structures and pluridimensional directions in Dante's poetic emotions is offered by the episode of Brunetto Latini in *Inferno* XV.

The old teacher who appears at the beginning of the canto as an unknown dweller of the realm of the burning sand and rain of fire (fui conosciuto da un che mi prese/ per lo lembo . . .) takes leave of Dante with a statement of authorial pride: "sieti raccomandato il mio Tesoro/ mel quale io vivo ancora." Is this final statement not a sign that Dante, in order to reconstruct his teacher's portrait, mobilizes with a precise function his direct memory of Brunetto's *Trésor?* Interestingly enough, while Dante the pilgrim is supposed to ignore the identity of this "uno" who attracts his attention by taking him by the hem, Dante the poet is well aware of who the unknown sinner might be. Take, for instance, the following initial lines of the canto (XV,4–6):

> Quale i Fiamminghi tra Guizzante e Bruggia
> temendo il fiotto che 'nver lor s'avventa
> fanno lo schermo. . . .
>
> (As the Flemings, between Wissant and
> Bruges, fearing the flood that rushes toward
> them, make the bulwark. . .).

The word *fiotto*, an apex in Dante, stems directly from Brunetto's *Trésor*[17] and *Tesoretto*. Speaking of the effect of the moon on the sea tides Brunetto says: "la mers croist et *boute* lors grandisme flos,"[18] where *boute* is splendidly translated by Dante with *s'avventa* and *flos* is kept intact, while Bono Giamboni, who translated the French text into vernacular, used the term *maroso*. And equally expressive is Brunetto's *Tesoretto:*

> E ha una natura
> ch'e a veder ben dura
> ch'un'ora cresce molto
> e fa grande timolto

> poi torna in dibassanza
> cosi fa per usanza
> or prende terra or lassa
> or monta ora dibassa
> e la gente per motto
> dicon ch'a nome *fiotto*

The tide, the sea, the moon, all of the ingredients of the encyclopedic knowledge dear to Brunetto reappear with a far greater dynamism and poignancy in Dante's landscape. Here is Brunetto's new moon: "Et quant ele vient en i signal tout le soleil est, ele est alumee de la partie deseure dont li solaus l'esgarde, a ce k'el cort dessous lui, et *por ce n'en poons nos point voir*."[19] Dante's selective memory captures the flavor of Brunetto's description in the rapid sway of the comparison:

> e ciascuna
> ci riguardava come suol da sera
> guardare uno altro sotto nuova luna (XV, 17–19)

In a sense, Dante mobilizes Brunetto's encyclopedic notions and learned tools to use them against him. Words handed by the teacher to the younger poet assume the objective rhythm of an ineluctable destiny: they become themselves objects, elements of composition of a landscape which exists there independently, as it were, from the pilgrim's intention. The rest of the canto is filled with precise allusions to the *Trésor* which contribute to the verbal construction of Brunetto's portrait – at once ambiguous and poignant. Thus, the reader of Dante will identify Brunetto's definition of the blindness of fortune (fortune est aveugle et tournoie sa roe a non veant) in a sentence which will become a paradigm of Dante's poetic imagination, even if in a perspective of unabashed resistance ("pero giri Fortuna la sua rota/ come le piace, e 'l villan la sua marra," XV,94). The reader will also recognize the powerful impact on Dante's inspiration of Brunetto's greatest page concerning exile: "Paours dit tu seras chasie en essil, seurte respond li pais ne m'est contredit mais li lieus, car tout çou ki est dessous le ciel est mon pays,"[20] a page that should help us to understand the complexity of the canto and detect the different stratifications of Dante's technique. But this is not the place to do so.

It will suffice for the moment to advise the young Dante reader of the endless possibilities offered by Dante's poetry and to encourage him on the road of sound discoveries, a road which is still wide open in spite of centuries of exegesis and ever-renewed efforts to close it forever.

## NOTES

1. I give here the list of Dante critics I have discussed for the *Enciclopedia dantesca:* Contini, Parodi, Pernicone, Rand, Schiaffini, Singleton, Spitzer,

Vossler and Wilkins. The last published volume includes the letter R.
2. L. Pietrobono, *Il poema sacro: Saggio di una dimostrazione generale della Divina Commedia*, 2 vols. (Bologna, 1925), Vol. 1, pp. 101–02. Of the same opinion is B. Nardi, in his "Le Rime Filosofiche e il Convivio", in *Dal "Convivio" alla "Commedia" (Sei saggi danteschi)* (Roma, 1960), p. 7. A. Pézard seems to share Nardi's view (though with some perplexity), as in the introduction to his French translation of the *Vita Nuova* (Paris, 1953), p. 68.
3. M. Barbi, "La Questione di Beatrice," in *Problemi di critica dantesca* (Firenze, 1934); also, "Razionalismo e misticismo in Dante," *Studi danteschi*, Vol.XVII.
4. K. Vossler, *Die philosophischen Grundlagen zum "Süssen neuen Stil"* (Halle, 1904).
5. For references, see my article, "E.G. Parodi," *Enciclopedia dantesca*, pp. 315–18.
6. E. R. Curtius, "Dante and Latinity," in *European Literature and the Latin Middle Ages* trans. W. R. Trask (New York, 1953), p. 355.
7. B. Nardi, "Il concetto dell'Impero nello svolgimento del pensiero dantesco" in *Saggi di filosofia dantesca* (Firenze, 1967), especially 256ff.
8. E. G. Parodi, "Del concetto dell'Impero in Dante e del suo averroismo" in *Bullettino della Società dantesca italiana*, XXVI (1919), 105–48. Also, "La data della composizione e le teorie politiche dell'Inferno e del Purgatorio" in *Studi romanzi*, III (1905), 15–22.
9. G. Ferretti, *I due tempi della composizione della "Divina Commedia"* (Bari, 1935).
10. K. Vossler, *La "Divina Commedia" studiata nella genesi delle sue fonti e interpretata*, trans. 2nd ed., (Bari, 1927).
11. Dante Alighieri, *Monarchia*, a cura di P.G. Ricci, Società dantesca italiana (Edizione Nazionale, 1965), p. 158.
12. L. Spitzer, *Bermerkungen zu Dantes "Vita Nuova,"* Publications de la Faculté des Lettres de l'Université d'Istanbul, II (1937), 162–208.
13. E. G. Parodi, *Poesia e storia nella Divina Commedia: Studi critici* (Napoli, 1920).
14. G. Contini, "Filologia ed esegesi dantesca," in *Varianti ed Altra Linguistica* (Torino, 1970), 407–32.
15. G. R. Sarolli, *Analitica della "Divina Commedia,"* I: *Struttura numerologica e poesia* (Bari, 1974), p. 10.
16. C. S. Singleton, *An essay on the Vita Nuova* (Cambridge, Mass., 1949); *Commedia: Elements of structure, Dante Studies, 1* (Cambridge, Mass., 1954); "The vistas in retrospect," *Atti del Congresso internazionale di studi danteschi* (Florence, 1965), pp. 279–304; "The Irriducible Vision," *Illuminated Manuscripts of the Divine Comedy*, by Peter Brieger, Millard Meiss, and Charles Singleton (New York), pp. 1–29.
17. Brunetto Latini, *Li Livres dou Trésor*, ed. F. Carmody (Berkeley, 1948).
18. *Ibid.*, I, 117, p. 103.
19. *Ibid.*, I, 115, p. 101.
20. *Ibid.*, II, 84, p. 265.

# Religious Prejudice against Poetry in Early Islam

## S. A. BONEBAKKER

The oldest forms of poetry that we know of in Arabic are rhymed prose known as *saj'*, *rajaz* poetry, and *qaṣīd* poetry. *Saj'* in its most common form consists of short sentences with rhymes that change quite frequently. There is reason to believe that the second medium, the *rajaz* poem, was directly derived from *saj'*. *Rajaz* consists of short rhyming lines with an equal number of feet, though considerable variation is allowed in the pattern of long and short syllables which make up these feet. Unless, therefore, one makes the *rajaz* poem a long one – and this does not seem to have been an early practice – *rajaz* is an easy meter.[1] It could be described as metrically-arranged *saj'*. The third medium known to us from pre-Islamic times is the poetry collectively called *qaṣīd*, or *qarīḍ*, which may use any of fifteen different meters. Every line of a *qaṣīd* poem consists of two hemistichs. The rhyme appears only in the second hemistich and occasionally in the first. In the classical period, no variations in rhyme or meter are allowed in any one poem. Variations in the pattern of long and short syllables within the feet are less frequent than in the *rajaz* poem. It has been suggested that there was an evolution from *rajaz* to *qaṣīd* in the same way as there was an evolution from *saj'* to *rajaz*. This question will probably never be solved and does not interest us here. It should be noted, however, that a distinction was always felt to exist between *rajaz* and poetry composed in the *qaṣīd* meters.[2] In spite of short-lived attempts to raise *rajaz* to the level of *qaṣīd* poetry, the former has always been considered an inferior medium.

Whatever differences may have been believed to exist between *saj'*, *rajaz*, and *qaṣīd*, the source of the artist's inspiration was believed to be the same in these three media, at least in the early days of Islam. This is nowhere clearer than in the Koran and in some of the discussions on the interpretation of the Koran and the personality of the Prophet Muhammad to whom it was revealed. The Koran generally uses *saj'*, though there is a marked difference between the *saj'* used by Muhammad in the earliest period of his mission around 612 and that of the later revelations ending with his death in 632. Identical rhythmical patterns are sometimes substituted for rhymes in the strict sense in the later period, and

77

sentences tend to reach a length where the appearance of rhyme at the end of a long clause no longer has the slightest stylistic effect. Whatever rhythmical similarity one may be able to discern between one sentence and the next in revelations of the early period, of course also disappears with the lengthening of the clauses.[3] The question of why Muhammad chose the medium of *saj'* for his revelation and continued to use it after it must have lost all its attraction for him and his audience is one which I do not feel competent to answer. The question of whether or not he had a model to imitate is more pertinent and can, I think, be answered with reasonable safety. *Saj'* was the medium of solemn incantations in pre-Islamic times and some examples have been preserved in anthologies. It is easy to present arguments for considering these examples as adulterations or forgeries. Even if to some degree authentic, they may not have been committed to writing before the second century of Islam (the eighth century of our era); but what we know of the practices of some early Islamic philologists with regard to pre-Islamic literature and literary history is not reassuring. Still, the fact remains that the use of incantations on solemn occasions existed in Islamic times and probably continued a pre-Islamic tradition. Rebels like Mukhtār (d. 67/686), who claimed to possess supernatural faculties, used the medium.[4] Even in modern times the use of *saj'* in incantations has been noted.[5] Moreover, one has to assume that in the case of forgeries, the forger followed his model very closely, though he may of course have tried to improve upon its traditional style by bringing in some refinements in imagery and vocabulary. It seems reasonable to conclude that *saj'* was widely used before Islam, and it is understandable that the superficial similarity between these *saj'* incantations and the style of Muhammad's early revelations should not have passed unnoticed.

According to R. Blachère,[6] the Koran itself alludes twelve times to the fact that the charge of sorcery was levelled against Muhammad. Let me quote only some of the most significant passages:

Sūra 46: 6–7:
And when Our signs are recited to them, clear signs, the unbelievers say to the truth when it has come to them, 'This is manifest sorcery.'

Sūra 52: 29–30:
Therefore remind! by thy Lord's blessing thou art not a soothsayer, neither possessed. Or do they say, 'He is a poet for whom we await fate's uncertainty'?

Sūra 69: 40–43:
. . . it is the speech of a noble Messenger. It is not the speech of a poet (little do you believe) nor the speech of a soothsayer (little do you remember). A sending down from the Lord of all Being.

In the two last passages there is question of Muhammad being accused of being a mere soothsayer and a poet. In the two following passages he is only qualified as a poet:

Sūra 36: 69:
We have not taught him poetry; it is not seemly for him. It is only a Remembrance and a Clear Koran.

Sūra 37: 34–35:
. . . for when it was said to them, 'There is no god but God,' they were waxing proud, saying, 'What, shall we forsake our gods for a poet possessed?'

In 52: 29–30 and 37: 34–35, Muhammad, moreover, is described as being "possessed." The term in Arabic, *majnūn*, indicates possession by *jinn* (genii, demons). As we will see next, this accusation was serious, because it put the source of the Prophet's inspiration on the same level as that of the common poet.

We come now to the Koran's most important passage on the poets, one which I hope to show became a subject of serious discussion among philologists and theologians alike, though most often it had no profound effect on the practices of the representatives of either of these disciplines, much less on the poets themselves. It appears in a chapter appropriately called "The Poets", and runs as follows:

Sūra 26: 224–228:
And the poets – the perverse (lit.: those who go astray) follow them; (225) hast thou not seen how they wander in every valley (226) and how they say that which they do not? (227) Save those that believe, and do righteous deeds, and remember God oft, (228) and help themselves after being wronged; and those who do wrong shall surely know by what overturning they will be overturned.[7]

It is difficult enough to establish the correct interpretation of this passage, let alone to determine what conclusions a pious Muslim should draw from it. Who are "those who go astray"? Are they the "satans" mentioned in the preceding verses?[8] Is it possible, as has recently been suggested, to translate: "The poets are inspired ('followed' in the active sense) by those (the *jinn*) who lead them astray"?[9] Or should we adopt the traditional interpretation presented in the above translation? In the first case the passage could be taken as a repetition (and implicit refutation) of previous statements which mention how Muhammad is accused of being a possessed poet, though a clear connection is being made this time between being a poet and being possessed by *jinn*. In the second case the reference is most likely to a group from among Muhammad's contemporaries, probably his opponents. But in either case there is an important difference between this passage and the passages quoted earlier: the reference to the Prophet is omitted, but the poets are put in the category of God's enemies. This is clear from the exception which has followed, which is meant to confirm the general rule set forth in the first three verses. What is meant by "wander in every valley"? Could it refer to the theme of the love-stricken poet who seeks consolation in the silence of the desert? Or are we to think of professional panegyrists who

wander from tribe to tribe to earn a living? Blachère, who suggests these last two interpretations,[10] also points out that verses 227–228 cannot date from the same period as 224–226. In 224–226 the rhyme *ūn* appears four times. Verses 227–228, which are also sometimes counted as one verse, consist of two long sentences, only the second of which shows the rhyme *ūn*. The beginning of the passage, therefore, shows all the characteristics of the early revelations, whereas the second half is typical of late revelations.[11] Blachère suggests that, after a number of poets had joined the Muslim community, verses 224–226 had become a source of embarrassment and verses 227–228 had to be added to accommodate these new converts. He also draws attention[12] to the existence of numerous reports in the biography of Muhammad of poetic insults directed against the Prophet and his followers in Medina by poets and poetesses from among his opponents and of elegies composed on pagan warriors who lost their lives in battles against Muhammad. Blachère suggests that these attacks, as well as the need to charge the poets among his followers to reply to them, could have inspired verses 227–228, but apparently he does not feel justified to explain the earlier verses on the same basis.

The rest of Blachère's article deals with the problem of how the passage was interpreted by later generations. The first question that comes to mind is why the Muslim community found it necessary to make an issue out of the permissibility of poetry, since the exception made in the second half of the passage clearly excludes the believers from the general condemnation. I believe the answer is that one could very well ask: Who qualifies as a believing poet? The burden of proof would then be on the poets. For not every poet could claim to "do righteous deeds, remember God oft", etc. Moreover there were other passages in the Koran that could be interpreted as a disapproval of the poet and his trade. Tradition has it that Muhammad, after having received the first revelation, thought that he had become "a poet or a man possessed", probably because he realized that he had been speaking in *saj'* (though this is not explicitly mentioned). He hated this thought so much that he would have committed suicide had not the archangel Gabriel intervened.[13] Whatever the reason is, there is a large body of traditions about the Prophet Muhammad, his companions, and his immediate successors to prove that the condemnation of poetry had made a considerable impact. That most, perhaps all, of these traditions must be considered forgeries does not alter the fact that they reflect certain tendencies. Unfortunately, these forgeries do not date further back than the end of the first century of the Muslim era (around 700), and many may have come into being only in the second century.[14] To what extent the positions taken in the second century reflect those current in the first is therefore largely a matter of speculation, since few reliable historical data exist. The same is true of the traditions that are more directly concerned

with the exegesis of the "Chapter of the Poets." Let me begin by quoting the main points of this exegesis. I follow the summary presented by Blachère in the article to which I have already referred.[15] Blachère bases himself on the Koran commentary of Ṭabarī (d. 311/923)[16] who quotes the earliest authorities in extenso.

a. Al-ghāwūn, "the perverse," or "those who go astray," are the "demons" (shayāṭīn),[17] "the foolish," "those who go astray from among mankind or from among the jinn and mankind," "the polytheists."[18] In explaining what is meant by "the foolish" (as-sufahā'), Blachère (p. 99) identifies this group as "ceux que la réflexion n'a pas tirés du polythéisme et de l'aveuglement." Ṭabarī, quoting Ibn 'Abbās and Ḍaḥḥāk [b. Muzāḥim] (d. 102/720 or 105/723), states, however, that two poets, one from among Muhammad's followers in Medina (Anṣār), the other from another tribe, had engaged in an exchange of invective. Both were accompanied by ghuwāt (syn. of ghāwūn) from their own tribe, and this leads to the conclusion that ghāwūn has to be taken as meaning "foolish." This inter-pretation by Ibn 'Abbās and Ḍaḥḥāk (not Ḍaḥḥāk quoting Ibn 'Abbās as Blachère states) is remarkable because it places the passage in the Medinan period of Muhammad's mission (traditional exegesis attributes the chapter to the Meccan period)[19] and mentions explicitly that the occasion was an exchange of lampoons between two poets.

b. Verses 225 and 226 refer to the poets mentioned in verse 224, not to the poets in general.

c. On the basis of (a) and (b), the exegesis discovers in "Save those that believe," etc., the poets who joined Muhammad and are therefore to be distinguished from their rivals who did not accept Muhammad's message. There is even an attempt to explain verses 227 and 228 as an "abrogating revelation," that is, a revelation that reverses an injunction set forth in an earlier revelation, in this case the condemnation contained in 224–226.[20]

Let us now examine some of the traditions which condemn poetry or make its acceptance subject to certain conditions, as well as those tradi-tions intended to defend the poet and his art. I have noted already that most of these traditions are probably forgeries. An exception must be made for some traditions describing the measures taken by the caliph 'Umar (13–23/634–644) against poets who were guilty of composing lampoons against individuals or groups. The reason I consider these tra-ditions as fundamentally accurate is that they consistently attribute such measures to 'Umar (occasionally to 'Uthmān and to some Umayyad rulers or dignitaries) and that the authority of the Koran is not invoked.[21] Rather suspect, on the other hand, are those traditions which depict 'Umar as a connoisseur of poetry. This second body of traditions no doubt serves to counterbalance the reports of 'Umar's severity.

Most famous is the story of 'Umar's imprisonment of the poet Ḥuṭay'a, who was guilty of attacking the governor of Medina. Perhaps this story is less convincing than some of the other reports. There were also other reasons for putting Ḥuṭay'a in jail. He had committed apostasy after the death of Muhammad, and his reconversion does not seem to have been

sincere. Moreover he had attacked the caliph himself.[22] Perhaps a better illustration of 'Umar's attitude is the story of two poets from Mecca, Ḍirār b. al-Khaṭṭāb and 'Abdallāh b. az-Zibaʿrā, who pay a visit to Medina, the residence of 'Umar and the poet Ḥassān. Ḥassān has become famous for his assistance to the Prophet Muhammad. The two are dissatisfied because their work, directed against Ḥassān, is no longer heard, while Ḥassān's work is allowed to survive. They persuade their host at Medina to invite Ḥassān and then let Ḥassān hear all the lampoons they ever directed against him, till "he boiled with rage and in his anger became like a cooking vessel." As soon as they finish, they jump on their riding animals and flee. 'Umar hears of the incident, brings the two poets back to Medina, and gives Ḥassān his chance to rebut, this time in public. At the same time, he makes clear that the recitation of such poetry only revives old feuds between Muhammad's supporters and opponents which were better forgotten. But if people refuse to follow his advice, they should rather write down this poetry to save it from oblivion (without reciting it in public).[23] In a similar story in the *Kitāb al-Aghānī* (XIV, 318), there is an altercation (partly in *sajʿ*) between two poets in the presence of 'Umar, one accusing the other of having composed elegies on Jews. 'Umar threatens both with flogging if they are not willing to end their quarrel.

It is possible to take these stories at their face value and to assume that 'Umar only feared the revival of fierce rivalries which had existed during Muhammad's lifetime. He may also have felt that the foundations of the Islamic state were not strong enough to survive the outbreak of new tribal conflicts and tried to nip such conflicts in the bud. He may not have had the Koranic prohibition in mind, though there is one set of traditions which suggest that he was aware of it ('Umar trying to keep Ḥassān from reciting poetry in the mosque).[24] There is, however, still another explanation for 'Umar's attitude which I shall suggest later.

Characteristic of literature of this kind is the fact that numerous traditions were brought into circulation which were apparently aimed at limiting the effect of 'Umar's negative attitude. He is quoted as an accomplished critic of poetry, defends poetry as a gift with which the Arabs have been particularly endowed and of which they make good use. 'Umar interprets an insulting poem in such a way that the offended party cannot maintain its claim. 'Umar himself becomes a poet. 'Umar recommends the study of poetry to help people understand the Koran, to help them improve their moral and intellectual level and understand their rights and obligations in a society based on tribal affiliation. He calls it the science (*'ilm*) most worthy of the name among the Arabs and never settles a matter without quoting a line of poetry that has become a current proverb. He insists that a father teach his son poetry. 'Umar also recom-

mends the study of grammar (which, of course, involves the use of poetry as *locus probans*).

Far more enigmatic and at the same time crucial for the understanding of the attitude of early Islamic scholarship towards poetry is the case of 'Abdallāh b. al-'Abbās (commonly known as Ibn 'Abbās), cousin of the Prophet and ancestor of the Abbasid dynasty which came to power in 132/750. L. Veccia Vaglieri, in her article on Ibn 'Abbās in the *Encyclopoedia of Islam*,[25] describes him as "one of the greatest scholars, if not the greatest, of the first generation of Muslims." If the reports are true, he lectured from memory and from written notes on different questions ranging from Koran interpretation to ancient poetry. If it is also true that he referred to ancient poetry while explaining difficult passages in the Koran, there is obviously good reason to believe that there existed no controversy over the legality of the poetic art in those early days (Ibn 'Abbās died around 68/687). Fragments of such interpretations are quoted in later works on literature and philology and even complete commentaries are attributed to him. The truth about Ibn 'Abbās will probably never be known. I. Goldziher, speaking of Ibn 'Abbās's principle of interpretation, observes that there is no internal evidence that would contradict the reports that he used this method.[26] Educational methods and some forms of intellectual life prevalent in the conquered countries could not have failed to make their influence felt almost immediately after the Muslim conquests.[27] Assuming that Abbasid historians, eager to extoll the scholarly qualities of the ancestor of the ruling dynasty, would have been inclined to credit Ibn 'Abbās with more scholarly acumen than he actually possessed, there is little reason to believe that they would have chosen to associate him with a practice that was frowned upon by some scholars of the period.[28] If a tradition was needed to give official sanction to what had become an established practice, they would have preferred to attribute it to the Prophet himself. This does not mean that there are many traditions about Ibn 'Abbās that should not a priori be regarded with suspicion. His famous pupil, the fanatical Nāfi' b. al-Azraq, one day bored him so much with questions on difficult Koranic passages that Ibn 'Abbās welcomed the visit of 'Umar b. Abī Rabī'a, a famous libertine poet, and even invited this poet to recite some of his poetry, to the astonishment and dismay of his pupil.[29] Equally suspect is a tradition in which he describes a chaste line by a pre-Islamic poet as the word of a prophet (*kalimat nabiyy*).[30] These traditions may very well be attempts to sanction the transmission and study of poetry in the face of objections by strict Muslims.

The traditions about the Prophet Muhammad's attitude towards poets and poetry, as far as they are known to me, tell us very little that is of real interest.[31] Since the majority of them are favorable to poetry, while

few condemn it, there must have been a strong need to put an end to the objections which some pious people had raised against poetry: the prophet gives every encouragement to his "court poet" (if we may use this term), promises him Paradise, lets him recite his poetry from a pulpit which he has built for him in the mosque at Medina, laughs when he chances upon a party where one of Ḥassān's singers is reciting erotic poetry. He even urges him to direct invective against his enemies, promising that the *rūḥ al-qudus* (the holy spirit that assists Jesus, God's assistance) will be with him. The fact that Muhammad associated himself with a poet, which is historically indisputable, was clearly exploited to full advantage by those who thought it necessary to defend the poets.[32] However, there are also traditions unfavorable to poetry. Among the best known is one where the Prophet states that it is better for a man that his belly be full of pus, so that it affects his lungs, than that it be full of poetry,[33] and another where the famous, though legendary, pre-Islamic poet Imru'ul-Qays is described as the standard bearer of poets in Hell. Also of some interest is a saying attributed to Muhammad which condemns, as signs of lukewarm adherence to religion (*nifāq*), "foul speech and eloquence," and praises as signs of true belief "bashfulness and inability to express oneself properly."[34] Since the tradition is not specifically directed against poetry, but against eloquence in general, it should perhaps be interpreted as an attempt to condemn grammatical studies. Finally, there is a small body of traditions condemning panegyric.[35]

Among the sayings attributed to Muhammad's contemporaries or the Muslims who lived in the first century of Islam, there is one more group which deserves special notice: those which condemn both lampoons and erotic poetry. 'Uthmān, 'Umar's successor, is offered a slave for sale. To make the bargain more attractive, it is pointed out to him that the slave is a poet. 'Uthmān refuses: nothing is sacred to a poet. "If well fed, he will address amorous poems to the wives of [the members of] his tribe, and, if hungry, he composes lampoons on his companions."[36] According to another report, 'Umar himself actually threatened to flog poets composing erotic poetry.[37] Mu'āwiya, the first of the Umayyad caliphs (41–60/661–680), warns the poet 'Abdarraḥmān b. al-Ḥakam not to compose amorous poems by which he could beguile noble and chaste women, nor lampoons by which he could make himself the enemy of noble people or incite those of vile disposition. At the same time, the caliph urges 'Abdarraḥmān to boast of the virtues of his tribe and to engage in gnomic poetry by which he would give dignity to himself and edify (*yu'addib*) others.[38] The motives behind these traditions can be easily explained if one keeps in mind that attacking the honor of chaste people of either sex was considered a punishable offence[39] and that the famous passage in the "Chapter of the Poets" could, as we have seen, be explained as a reaction

to the poetic insults to which Muhammad was subjected by his enemies.[40] It should also be remembered that lampoons often contained attacks on the honor of the victim's mother or sister.

Perhaps there were also other motives behind the tendency to single out lampoons as particularly objectionable. The idea I mentioned earlier, of poetry being connected with magical practices, is reflected often in stories connected with the composition of *hijā'* poems. This question was first studied in an article in Goldziher's *Abhandlungen zur arabischen Philologie,* to which I have referred before.[41] The term *hijā',* which I have so far translated as "lampoon," "invective," and "abuse," is often, I feel wrongly, translated as "satire." The etymology of the term is uncertain, but Goldziher[42] has connected it with the Hebrew *hăgā,* "to utter a sound in a low voice," "to murmur," leading to the meaning "to pronounce incantations in a low voice." He points out that *hăgā* is used when speaking of the cooing of doves and that the Arabic verb *saja'a,* of which *saj'* is the verbal noun, is used in the same sense. Since, as we have seen, *saj'* is the medium of incantations, he cautiously suggests that *saj'* and *hijā'* may originally have been synonyms. Elsewhere, he draws attention to the fact that "waging war in poetry is considered as the serious start of hostilities between two tribes, just as the cessation of fighting coincides with putting an end to the satires" (he means *hijā'*).[43] The objection has been raised against Goldziher's views on the *hijā'* poetry that he does not distinguish between magical spells directed against the enemy and the later *hijā'* which consists of a personal invective or abuse directed against an enemy. This objection may be a valid one,[44] but one can at least maintain that the use of the term in this context, and possibly also the term's etymology, point to the continuation of an ancient tradition whose content and form underwent considerable change. Goldziher supports his theory with some further arguments: the terms *shā'ir,* "poet," and *shi'r,* "poetry," evolve from *sha'ara,* "to know," in the sense of possessing knowledge of the supernatural or the practice of magic. This puts the poet in the same category as the *kāhin*[45] or the *'arrāf,*[46] who are endowed with similar faculties. Goldziher also demonstrates convincingly the original meaning of the word *qāfiya,* "a curse that had the effect of wounding a victim in the neck."[47] This word was used as a technical term for "rhyme," but it was also widely used (even in the late Middle Ages) for "line of poetry." These arguments, of course, do not justify the conclusion that the ancient poet had no other function than to cast spells. In fact, Goldziher believes that this function could very well have been combined with that of the tribal poet as we know it from later times.[48] But there are other indications that primitive *hijā'* was, sometimes at least, connected with magical practices. People who were afraid of becoming the victims of a curse used to lie down and turn

over on their sides.[49] When, therefore, the Prophet Muhammad observes that Ḥassān's [*hijāʾ*] poems have a more devastating effect than arrows flying in the darkness of night, it becomes clear that these people were trying to avoid becoming targets of such arrows.[50] Goldziher lists a whole series of examples of curses being compared to dangerous missiles. It is important to keep in mind that these examples often take us into the early Islamic period or even later. Aṣmaʿī (d. 213/828), who belonged to the second generation of Abbasid philologists, still mentions the existence of the old notion when he quotes a Bedouin as saying in reference to another tribe: "These are people whose necks have been grazed by *hijāʾ*."[51]

*Sajʿ* is, as we have seen, the medium of incantations, and *rajaz* is most likely simply a metrically more strictly organized *sajʿ*. Goldziher presents the story of two poets who begin with *sajʿ* and then continue their invective in *rajaz*,[52] and he quotes numerous examples from the Umayyad period of the verbs *rajaza* and *irtajaza* being used in the sense of "scoffing" and "villifying." The Umayyad *rajaz* poet Abu 'n-Najm (d. after 105/ 724) is a typical example of the survival of practices that may or may not reflect actual beliefs: He used to foam at the mouth and throw off his clothes when he recited.[53] Moreover, Abu 'n-Najm once observed a curious ceremony, whose meaning is not clear, when he was answering a *hijāʾ* by another poet. He asked for a camel which normally drove a mill and had been smeared with tar. He then took a pair of trousers and put one of his legs in one of the trouser's legs, wrapping his waist with the rest of the garment. The scene, which ended with the flight of his opponent, may have been intended as burlesque. The camel may have been smeared with tar in order that Abu 'n-Najm might succeed in soiling the precious garments of his opponent. But it must have been, at least in part, an imitation of magical practices.[54]

It now becomes possible, perhaps, to add another dimension to the objections against *hijāʾ* poetry. These objections could be the result of the general condemnation of the poets in the Koran. This condemnation could very well have been interpreted as an attempt to ban invective directed against the Prophet by his enemies; and in later years this could have led to a reluctance to accept any poem belonging to the same genre. The objections against *hijāʾ* might also have been the result of the measures taken by ʿUmar, for the opinions held by the companions and younger contemporaries of the Prophet often carried as much weight as those of the Prophet himself. One could also suggest that some pious people, including ʿUmar himself, were still aware of the magical, and therefore un-Islamic, background of the *hijāʾ*[55] but before one can consider this suggestion, it must first be proven that the examples quoted earlier were based on actual beliefs or that they were at least considered as such by the early Abbasid scholars who preserved them. So far, I have

found no clear evidence to support either of these two assumptions.[56]

We have seen that it is almost impossible to reach any firm conclusions with regard to moral reservations about poetry in the first or even the second half of the first century. Blachère[57] believes that in the holy cities of Mecca and Medina there were occasional outbursts against the poets and that a hostile attitude also existed in the newly-founded cities of Baṣra and Kūfa in Iraq. But Blachère also believes that there is no question of systematic opposition. He considers these outbursts as no more than "sursauts d'humeur." The Tradition scholar 'Ubaydallāh al-Makhzūmī who lives in Medina and dies there in 98/717[58] keeps company with poets and composes poetry himself. Asked how he can allow himself to do this, "in spite of his piety, his distinguished rank, and his knowledge of Islamic law," he replied that "One suffering from a disease in the chest cannot avoid expectorating."[59] Another Medinese poet, Nuṣayb (d. around 111/729 or 113/731), refuses to answer a *hijā'* poem: God has not endowed him with the gift of poetry to use it in an evil manner.[60] Somebody asks him if it is true that he cannot compose *hijā'*. He answers by asking if it is possible to imagine that somebody saying, "God preserve you" would not also be capable of saying, "God disgrace you." He then argues that there are two possible situations: One does not ask a man (i.e. a prospective patron) anything, and then one does not have the right to make him the victim of *hijā'* if he does not fulfil the poet's expectations; or one asks somebody for something, but the request is turned down. In that case it is more appropriate that the poet direct *hijā'* against himself, because he has been foolish enough to entertain false hopes.[61] In the presence of one of the Umayyad caliphs (the Umayyads resided in Syria), the poet Farazdaq (d. betw. 110/728 and 114/732) recites poetry from which it can be inferred that he has committed adultery. He staves off the prescribed punishment by observing that, "What the poets say they do not do."[62] A similar story appears in a Christian setting: Farazdaq's contemporary, Akhṭal (d. around 91/709), gets into trouble with the ecclesiastical authorities. He is imprisoned in "the church of Damascus," where he is being held captive by a priest. He is released only after a member of the Prophet's family has interceded on his behalf and after he has promised that he will not again "revile and insult people and attack the reputation of virtuous women." Asked why he has to humble himself in this way, he answers, "That is religion, that is religion."[63]

Among the scholars of Tradition [Abū 'Amr 'Āmir b. Sharāḥīl] ash-Sha'bī (d. between 103/701 and 110/728),[64] who was also famous for his extensive knowledge of poetry, is reported to have said that [in his days scholars] were reluctant to use the customary introductory formula, "In the Name of God, the Merciful, the Compassionate," when noting down poetry. This report, if correct, would indicate that philological

studies existed at a much earlier date than is commonly assumed. [Abū ʻĀʼisha] Masrūq [b. Ajdaʻ al-Hamdānī] (d. 62/681 or 63/682),[65] teacher of Shaʻbī and, like his pupil, a resident of Kūfa, once caught himself quoting a familiar line of poetry and stopped in mid-sentence. Asked why he did not finish the line, he explained that he would not like to find a line of poetry in his "writ" (the account of his deeds presented to him on the Day of Judgment).[66]

Most stories from this period have the character of fictitious anecdotes. In the Abbasid period, though we still find stories of a legendary nature, there are also reports that cannot be easily dismissed as fantasies. They date mostly from the second generation of Muslim philologists, which was active around the end of the second and the beginning of the third century. Among modern scholars this generation has earned itself a reputation for accuracy.[67] There is reason to believe that the reports they handed down about each other are, on the whole, reliable. Moreover, since they were not considered authorities in religious matters,[68] it becomes more difficult to explain stories about their attitudes towards poetry and literature in general as fabrications. If there is any truth in Blachère's claim that there was no systematic opposition to poetry in early Islam, one cannot escape the conclusion that scholars living at the end of the Umayyad period and during the first century of the Abbasids (from 132/750 onwards) were much more deeply concerned with the problems raised by the Koranic condemnation of poetry than were the first three generations of Muslims. This would coincide with the trend towards speculation and rationalization in legal as well as in theological matters which characterized the period. Aṣmaʻī (d. 213/828) observes, speaking of a line by the pre-Islamic Christian poet ʻAdī b. Zayd, that he never heard a line that was "more in agreement with the *sunna* (the Prophet's normative conduct of life)."[69] Jumaḥī (d. 231/845 or 232/846) finds that some pre-Islamic poets were pious and chaste in their poetry, did not make up stories of love affairs with which they would compromise chaste women (*yastabhiru bi-ʼl-fawāḥish*), nor scoffed (at others) in *hijāʼ*.[70] Abū ʻAmr ash-Shaybānī (d. 205, 206, or 213/820, 821, or 828) would draw *loci probantes* from the work of Abū Nuwās if it were not for the latter's obscenities (*rafath*).[71] He collected ancient Arabic poetry by arranging poets belonging to the same tribe in separate volumes. The total amounted to over eighty volumes. Before going to the next volume, he would never fail to make a copy of the Koran which he would deposit in the mosque of Kūfa.[72] During his stay in Mecca, the poet and philologist Abū Muḥammad al-Yazīdī (d. 202/817–8) wished to meet his circle of literati only so long as no obscene poetry or *hijāʼ* was quoted, implying that under normal circumstances there was no restriction on the discussion of such poetry. He himself composed in this period only poetry with *mawʻiẓa* (pious admonitions) and *ḥikma* (wisdom) themes.[73]

A similar, probably apocryphal, report on Nuṣayb tells how this Umay-yad poet, during a stay at Kūfa, was invited by a visitor to recite some of his own poetry, but refused to do so on a Friday. Strangely enough, Nuṣayb invited the same visitor on that occasion to entertain him with some Ḥijāzī love poetry.[74] The report of the meeting ends with a comparison between various poets of the school, such as are often attributed to early poets and philologists and which give the story a fictitious character. Abū ʿAmr b. al-ʿAlāʾ, one of the earliest representatives of the second generation of Abbasid philologists (d. around 154/770), once excused himself from listening to a would-be poet who wished to hear Abū ʿAmr's opinion of his work by saying: "We are on our way home from the pilgrimage and too much occupied [by pious meditations] to listen to poetry."[75] Abū ʿUbayda (d. 209/824–5) uses a similar excuse for not listening to the poet Ibn Munādhir. Memorizing the Koran, he says, occupies all his time, and he cannot give attention to the poetry of Ibn Munādhir or similar literary productions. The authority who reports this story adds that Ibn Munādhir had once addressed a satire to Abū ʿUbayda and that this was the reason for the latter's reluctance to listen.[76] Yet the dissolute life and reported heresy of Ibn Munādhir may very well have played an important part in Abū ʿUbayda's refusal. Another early philologist, Khalaf al-Aḥmar (d. 180/796), also known as a poet (and a notorious forger), refrained from composing poetry for a while, though, according to others, he later engaged again in the art of versification.[77] The poet Buḥturī (d. 284/897) is said to have ordered on his deathbed that all *hijāʾ* he had composed during his lifetime be destroyed.[78] Earlier, the poet Muslim b. al-Walīd (d. 208/823) is reported to have thrown into the river a notebook in which his "transmitter" (*rāwiya*) had noted down his verses. This happened after a "conversion," the circumstances of which are not specified. It is said that as a result of this, only part of his poetry survives.[79]

Of particular interest are those traditions according to which scholars expressed doubts as to whether or not it was quite proper for a Muslim to engage in philological, or even grammatical, studies. Abū ʿAmr b. al-ʿAlāʾ is said to have burnt all his notes when he turned to the study of the Koran (*taqarraʾa*). According to Abū ʿUbayda, "Abū ʿAmr was the greatest authority on [problems of] lexicography (*gharīb*, var. ʿ*Arab*, "the Arabs"), the Arabic language (ʿ*arabiyya*), Koran and poetry, and important events in the history of the [ancient] Arabs and contemporary history (?) (*ayyām an-nās*). His house was situated behind that of Jaʿfar b. Sulaymān (a cousin of the first two Abbasid caliphs). The books in which he had noted down [the information he had gathered] from Arabs of pure speech (*al-ʿArab al-fuṣaḥāʾ*, i.e. reliable informants) filled a whole room in his house almost to the ceiling." When, later, he turned again to his old discipline (*ilā ʿilmihī al-awwal*) he had to rely on his memory.[80]

Tha'lab (d. 291/904) once complained to the Koran scholar Abū Bakr b. Mujāhid that, whereas scholars of the Koran, Islamic law, and prophetic tradition were all certain to earn Paradise, he who was "occupying himself with Zayd and 'Amr" (i.e. with grammar, Zayd and 'Amr being two names customarily used in grammatical examples) was left wondering what would become of him. Fortunately, Ibn Mujāhid saw the Prophet the same night in a dream (the appearance of the Prophet in a dream always means that the prediction in this dream will come true), bidding him to assure Tha'lab that his was a "far reaching science" ('ilm *mustaṭīl*), explained by a later authority as meaning that inasmuch as no argument (*kalām*) or spoken word (*khiṭāb*) could do without it, all sciences depended on the discipline in which Tha'lab was engaged.[81] Traditions claiming that pious people among the first Muslims encouraged the study of grammar may, of course, be forgeries intended to remove lingering doubts. According to one such tradition 'Umar writes a letter to Azerbaijan (one of the early provinces to be conquered) to encourage people to learn [proper] Arabic.[82] In another tradition, which may well be in the same category, Abū 'Amr b. al-'Alā' describes the study of Arabic as the very essence of religion and Ibn al-Mubārak (d. 181/797) expresses his approval by pointing out that Christians only worship their Messiahs because of a grammatical error.[83]

From the above, it will be clear that the view often found in Western handbooks that Arabic philology (including, of course, the study of poetry) owes its existence to the need to find the correct interpretation and reading of the Koran is wrong, or at least one-sided.[84] This view may have been inspired by uncritical acceptance of the traditions on Ibn 'Abbās who, as we saw earlier, was believed to have encouraged the study of poetry for this purpose. Also prompting this view could be the fact that in later years the study of poetry was not only legal, but actually obligatory, in the sense that it was the responsibility of part of the Muslim community.[85]

Another common belief which is no longer held acceptable is that the study of history was, in its early stages, closely related, if not actually dependent upon, the Science of Tradition (*ḥadīth*). This refers to the traditions I have already mentioned which deal with the life of the Prophet Muhammad. We have seen that these traditions are mostly normative in character or offer interpretations of difficult passages in the Koran. The more accurate view seems to be that "the beginnings of historical studies followed broadly two lines which were distinct from each other – that of *ḥadīth* and that of the tribes, which is in a sense a continuation of pre-Islamic activities. These two lines reflect the two major currents in Islamic society – the Islamic and the tribal, which influenced all aspects of life".[86] A. A. Duri, whom I quote here, also observes that "Arab cul-

ture was basically oral, and poetry was its documentary evidence and the best means of preserving traditions." Early in the second century we find tribal monographs and later we hear of "genealogists and philologists, who left historical works or a wealth of historical narratives."[87]

That a strong tendency towards specialization existed already in the first half century of Abbasid rule is evident also from the existence of Sībawayh's (d. around 177/793) fundamental work on grammar and the dictionary (and presumably also the treatise on prosody) of Khalīl b. Aḥmad (d. 160/776, 170/786, or 175/791). Both drew their material from poetry, and this alone is enough to prove that the study of poetry had found a place of its own among the Muslim sciences. A fact that has passed almost unnoticed even among medieval Muslim scholars is that the terminology for the figures of speech in Arabic literature may have existed as early as the second century of Islam. The term *isti'āra* (metaphor) is said to have been used by Abū 'Amr b. al-'Alā', Aṣma'ī, Abū 'Ubayda, and Ḥammād (d. 155/772 or 156/773).[88] The term *iltifāt* (apostrophe) appears in a tradition on Aṣma'ī.[89] Critics reporting such traditions may have unintentionally been guilty of anachronistic thought: they may well have substituted, for instance, the term *isti'āra* in such traditions for a description of the image used by the poet in the line of poetry under discussion, and similar changes in the wording of traditions could have occurred elsewhere. However, the authenticity of the traditions on rhetorical terminology finds some measure of support in other traditions which quote examples of detailed and sometimes quite sophisticated literary criticism from the same early authorities. I have argued elsewhere[90] that there are as yet no good reasons to question the authenticity of all but a few of these traditions. Some of the discussions center around the relative merits of "new poetry," that is, poetry dating from the early Abbasid period and old or pre-Islamic poetry (but also, sometimes, the poetry of early Islamic and even Umayyad times). Goldziher was the first to draw attention to these discussions.[91] He found that the early Abbasid philologists were almost all hostile to the "new poetry." Though his conclusions, in my opinion, need some revision, there can be no doubt that a controversy existed.[92]

I feel that the material on the views of the first two generations of Abbasid philologists has not been sufficiently explored. This is particularly true of their views with regard to the position of poetry in Islamic scholarship. The material is indeed extensive enough, so that it might eventually be possible to reach some firm conclusions. The problem should be approached from different angles. I hesitate therefore, to come to any conclusion as to whether the traditions quoted earlier represent an attempt by these scholars to justify public interest in an art that had never ceased to draw admirers (fragments of literary criticism were not only attributed to 'Umar, but also to some Umayyad caliphs and digni-

taries) or reflect the scholars' own scruples or scruples voiced by theologians. In either case, pious objections, whether of recent date or carried over from the Umayyad period, must have played an important role, but there is as yet no way of telling if these objections were widespread or limited to a small body of zealots.

Any discussion of the views on poetry in this period should also take into account the impact of the Shuʻūbiyya movement. This movement asserts the superiority of non-Arab, mainly Iranian, civilization over the Arabs' civilization, which was, according to the Shuʻūbiyya view, limited to the primitive customs of the desert and did not show the refinement of manners and ethical conduct which the Persians had achieved before the Islamic conquests. If the scanty reports on the movement are accurate, the Shuʻūbiyya drew their arguments from ancient Arabic poetry. It is certain, however, that the counterarguments by their opponents were drawn from the same source.

I also believe that the study of the history of the term *adab* may throw interesting sidelights on some of the problems I have raised so far, including perhaps that of the influence of the Shuʻūbiyya. I would venture to suggest that the adoption of this term for "literature," particularly poetry, was somehow connected with the need to justify the study of poetry as a discipline that deserved its place among the Muslim sciences. Pietistic tendencies may have prompted scholars to use this term, or it may have been a reaction against the attacks of the Shuʻūbiyya. In either case, it would have been attractive to adopt for the knowledge or study of the ancient Arab literary heritage a term that had an educational, as well as a social and ethical, connotation.[93] Speaking of poetry as *adab* qualified poetry as part of "education," rather than an idle pastime. If one prefers to explain the adoption of the term as a reaction against the Shuʻūbiyya alone, one has only to keep in mind that *adab* stood also for those ancient Arab virtues which gave the Arabs their title to glory.

When Saʻīd b. al-Musayyib (d. 93/711), who is not only characterized as one of the best authorities on Islamic law, but is also identified as a pupil of the caliph ʻUmar(!) is told that some people condemn the recitation of poetry, he answers, "They practice a non-Arab piety"[94] (the word *aʻjamī*, which I have rendered "non-Arab," generally means "Persian"). The characterization of Saʻīd as such an early authority on Islamic law, as well as the tradition itself, are probably the product of imagination.[95] But the story may well reflect a tendency to promote Arabic poetry against the opposition of non-Arab scholars who were looking for a pious excuse to discredit the study of pre-Islamic literature.

I am not suggesting that the more or less explicit attempts to play down or explain away the Koranic condemnation ended all objections of conscience. Time and again, we find examples of abstention from poetry, as well as extremely sophisticated attempts to explain away unfavorable

traditions. But from the third century onwards, and perhaps even earlier, few scholars appear to have had serious doubts that what they were doing was good Muslim practice. The positions of Jāḥiẓ (d. 255/868–9) and Ibn Qutayba (d. 276/889) have been defined by Pellat and Lecomte.[96] Jāḥiẓ made eloquence (*balāgha*), and therewith the study of poetry, part of his educational program. His acceptance of the Arab humanities was restricted only by his rationalistic outlook. Ibn Qutayba went further in the sense that he integrated the pre-Islamic virtues into his ideal of the standard of conduct of a true Muslim and believed the study of the humanities to be an essential element of an organized society. For him, therefore, there could not be a conflict between his activities as a philologist and as a theologian. Let me end by quoting a few examples to show that the acceptance, if not the integration, of philological studies can be traced back to the generation that preceded Jāḥiẓ and Ibn Qutayba:

Aṣmaʿī (d. 213/828) held the curious view that the ethical standards of Islam had had an unfavorable effect on poetry. "Poetry is harsh," he said, "it only succeeds when motivated by evil. As soon as it engages in what is good, it becomes weak"[97] (or, according to another version, "The style of poetry when used in the description of good, loses force").[98] As an example, he quotes Ḥassān, whose poetry was excellent before his conversion but declined after Ḥassān had accepted Islam. True poetry, Aṣmaʿī believes, deals with a number of typical pre-Islamic subjects which he enumerates in detail. One is surprised to find that they even include *hijāʾ*, amorous poetry, and descriptions of war. The same Aṣmaʿī compares the poetry of Labīd (which, though dating mostly from the pre-Islamic period, is nevertheless accepted and even praised because of some pietistic themes) to a well-made cloak that has no elegance[99] and speaks of him on another occasion as "a decent man."[100] Abū ʿAmr b. al-ʿAlāʾ (d. about 154/770) calls the same Labīd a "[rattling] seed mill".[101] Aṣmaʿī also does not hesitate to compare the merits of obscene poems by Abu ʾn-Najm and Bashshār.[102] According to another report, however, he refuses to recite and interpret *hijāʾ*.[103] This attitude on the part of a man who was reputed for his piety becomes understandable if one keeps in mind that he kept secular philological studies and Koranic exegesis strictly apart. He refused to interpret poetry whose interpretation would involve some Koranic saying. He feared that, by doing so, he might imply non-traditional and perhaps unorthodox interpretations of certain passages in the Koran and Tradition.[104] With knowledge of other similar traditions, one could draw a more detailed picture of Aṣmaʿī's views on theology and literature. Those I have presented here only justify the tentative conclusion that he saw no basic conflict between the two disciplines and felt that there was no reason for a good Muslim to abstain from the study of poetry. His numerous commentaries on pre-Islamic poets are

there to prove it. An almost identical case is that of Aṣmaʿī's contemporary, Yaḥyā b. Muʿīn (d. 233/847–8)[105] who is asked to give an opinion on Ibn Munādhir. He describes him as a man of evil leading a dissolute life whose testimony consequently cannot be trusted. Yaḥyā's interrogator then confesses that he writes down Ibn Munādhir's poetry and some "stories" which Ibn Munādhir relates on the authority of the grammarian Khalīl b. Aḥmad. Yaḥyā's answer is: "That of course! But as far as Tradition [on the Prophet Muhammad] is concerned, he cannot be trusted".[106]

The observations which I have presented in this paper deal with only a few aspects of a problem that can and should be examined from different angles. It deals with a period on which a rich and varied, though usually fragmented, documentation has been preserved. This brings with it the danger that one is tempted to draw premature conclusions from a superficial affinity of statements presented in traditions that are essentially unrelated. In Islam, perhaps more than in other civilizations, the first three centuries determine what is still to come. For this reason I chose to give attention to early Islam, rather than to later periods on which systematically arranged and often more interesting material is available. In the context of this paper it is not possible to offer even a summary account of this material. Nor can I give attention to some other questions that eventually will have to be considered, such as the social function of poetry in the two centuries with which we have been dealing. We cannot yet assess the depth and the sincerity of the religious scruples which motivated these scholars to formulate their apologies of the poetic art or their qualified acceptance of this art. The essence of what they have to say can best be summed up in the famous tradition, "Some eloquence is indeed magic, and some poetry is indeed wisdom,"[107] and in the equally famous saying, "Poetry is the true record of the Arabs".

## NOTES

1. *Abh.*, I, 79; M. Ullmann, *Untersuchungen zur Raǧazpoesie* (Wiesbaden, 1966), p. 26ff. Abbreviations used in the course of this article are: *Abh* = I. Goldziher, *Abhandlungen zur arabischen Philologie* (Leiden, 1896–9), 2 vols; *Agh* = Abu ʾl-Faraj al-Iṣfahānī, *Kitāb al-Aghānī* (Cairo, 1345/1927–1381/1961). This is the edition in 16 vols. published by the *Dār al-Kutub al Miṣriyya;* the publication of this edition was resumed in 1389/1970 by *al-Hayʾa al-Miṣriyya al-ʿĀmma li-ʾt-Taʾlīf wa-ʾn-Nashr.* Wherever Western studies refer to the old Būlāq ed. of 1285 of the *Aghānī,* I have changed the reference to the above editions; *EI = Encyclopaedia of Islam* (Leiden, 1913–36) and 2nd ed. (Leiden – London, 1960–); *HLA =* R. Blachère, *Histoire de la littérature arabe* (Paris, 1952–66), 3 vols; *Muslim Studies =* I. Goldziher, *Muslim Studies,* trans. C. R. Barber and S. M. Stern (London, 1967–71), 2 vols; *Religious Influences =* L. Kopf, "Religious Influences on Medieval Arabic Philology," in *Studia Islamica,* V (1956), 33–59.

2. Ullmann, *Untersuchungen*, p. 1ff.

3. R. Blachère, *Introduction au Coran* (Paris, 1959), p. 173ff.

4. *Abh.*, I, 72ff.

5. A. Musil, *The Manners and Customs of the Rwala Bedouins* (New York, 1928), pp. 403–404.

6. Blachère, 'La poésie dans la conscience de la première génération musulmane,' in *Annales Islamologiques* (Publications de l'institut français d'archéologie orientale du Caire), IV (1963), 93–103.

7. The above translations were taken from A. J. Arberry, *The Koran Interpreted* (New York, n.d.).

8. Verse 221: "Shall I tell you on whom the satans come down? (222) They come down on every guilty impostor. (223) They give ear (or: are given ear), but most of them are liars." The parentheses in the translations of Sūra 26 are mine. In Sūra 69: 40–43 they are part of the Arabic text.

9. I. Shahid, "A Contribution to Koranic Exegesis," in *Arabic and Islamic Studies in Honor of H. A. R. Gibb* (Leiden, 1965), pp. 563–580, especially 565–572.

10. Blachère, *La poésie*, p. 94, note 2.

11. *Idem.*, pp. 95–96.

12. *Idem.*, p. 97.

13. A. Guillaume, *The Life of Muhammad* (London, 1955), p. 106 (quoting Ṭabarī).

14. Blachère, *La poésie*, p. 98. See also J. Schacht, *An Introduction to Islamic Law* (Oxford, 1964), p. 34ff.

15. See note 6.

16. *Jāmiʿ al-Bayān fī Tafsīr al-Qurʾān* (Cairo, 1323/1905–1330/1912), XIX, 77–80.

17. Frequently considered to be identical with the *jinn*, see *Abh.*, I, pp. 7 and 106–107. Both the *jinn* and the *shayāṭin* are mentioned in the Koran and therefore accepted as a reality by most Muslim theologians.

18. The interpretation *ghāwūn* = "transmitters of poetry" is cited by Blachère (*La poésie*, p. 99) as an unacceptable, but interesting, attempt to explain the passage in a positive sense, i.e., offer an explanation favorable to the poets (?). I wonder if this interpretation could perhaps be taken as an attempt to make philological studies an object of suspicion.

19. Blachère, *La poésie*, p. 96, note 1.

20. For this method of exegesis, see *El*, s.v. KORAN, 3. Ṭabarī also mentions an isolated instance of an authority who maintains that "and remember God oft" has to be taken in the sense that they mention God in their poetry.

21. I. Goldziher, "Der Dîwân des Garwal b. Aus. Al-Ḥuṭejʾa" in *Zeitschr. der Deutschen Morgenl. Gesellschaft*, XLVI, 17–21.

22. *El*, 2nd ed., s.v. ḤUṬAYʾA.

23. *Agh.*, IV, 140–141. Blachère, *HLA*, p. 354, note 6, refers to this story, but on p. 309 he expresses doubts that Ḍirār was still alive when ʿUmar came to power.

24. *Agh.*, IV, 143–144.

25. 2nd ed., s.v. ʿABDALLĀH B. AL-ABBĀS.

26. I. Goldziher, *Die Richtungen der Islamischen Koranauslegung* (Leiden, 1920), p. 70, note 3.

27. F. Rosenthal, *Knowledge Triumphant, The Concept of Knowledge in Medieval Islam* (Leiden, 1970), p. 43.

28. *Religious Influences*, p. 37. Goldziher, *Richtungen*, p. 71, draws attention

to passages where Ibn 'Abbās appears as an authority on philological matters that have no relation to Koranic studies.

29. Mubarrad, *Kāmil*, ed. Z. Mubārak and A. M. Shākir (Cairo, 1355/1936–1356/1937), pp. 964–966; *Agh.*, I, 71–73.

30. Hātimī, *Hilyat al-Muhādara* (MS Fez, Qarawiyyīn 2934), fol, 30b.

31. Several collections of traditions offer chapters on the Prophet's attitude towards poets and poetry, as well as the attitude of his companions, his immediate successors, and other Muslims living in the first century. See, for instance, Muttaqī al-Hindī, *Kanz al-'Ummāl* (Hyderabad, 1364/1944), III, 325–327, 482–500. On the following pages I offer no more than a small sampling of such traditions. In addition, one often finds these traditions quoted in works on literary theory and "*adab* works," such as Mubarrad, *Fādil*, ed. 'Abdal'azīz al-Maymanī (Cairo, 1375/1956), pp. 9–14; Abū Zayd al-Qurashī, *Jamharat Ash'ār al-'Arab*, ed. 'A. M. al-Bajāwī (Cairo 1387/1967), I, 29–39; Ibn Rashīq, *'Umda* (Cairo, 1325/1907), I, 9–12; 'Abdalqāhir al-Jurjānī, *Dalā'il al-I'jāz*, ed. M. R. Ridā (Cairo, 1367/1947), pp. 9–34.

32. Abu 'l-Layth as Samarqandī (d. between 373/983–4 and 393/1002–3) in his *Bustān al-'Ārifīn* (Cairo 1319/1901 on the margin of the *Tanbīh al-Ghāfilīn* by the same author), pp. 32–33, argues that there is reason to give credit to traditions which attribute some verses in *rajaz* to the Prophet. He admits that this would contradict Koran Sūra 36: 69: "We have not taught him poetry. It is not seemly to him." On the other hand, these poetic utterances may have been a coincidence, "since *rajaz* is not poetry, but rather a form of *saj'*." Cf. Jāhiz, *K. al-Bayān wa-'t-Tabyīn*, ed. 'A. M. Hārūn (Cairo, 1367/1948–1369/1950), I, 288–289.

33. According to a tradition quoted in Abu 'l-Layth, *Bustān*, p. 32, 'Ā'isha, one of the Prophet's wives, observed that in making this statement Muhammad was only referring to the lampoons directed against him by his opponents.

34. Jāhiz, *Bayān*, I, 202.

35. Al-Muttaqī, *Kanz*, III, 326–327, 491–492. See III, 492–493 and 496–497 for two curious traditions relating how the Prophet, on two occasions, had to keep a poet reciting the Koran from adding some rhyming phrases of his own making. In both cases the Prophet does not fail to praise the poet's compositions in the traditional *qasīd* meters. The moral of the two stories is obviously that the close affinity between the medium of the Koran and that of poetry does not justify hasty conclusions, but I do not feel competent to suggest a precise identification of the tendencies they reflect.

36. *Agh.*, XXII, 306 (a different version of the same tradition on p. 305).

37. *Agh.*, IV, 356.

38. Ibn 'Abd Rabbih, *al-'Iqd al-Farīd*, ed. A. Amīn et al. (Cairo, 1367/1948–1372/1953), V, 281. Tabarī, *Annales*, ed. M. J. de Goeje et al. (Leyden 1897–1901), II, 213–214, offers a different version which reads *fa-ta'urra 'sh-sharīfata*, "bring shame upon women of standing," as well as some further variants.

39. See *EI*, 2nd ed., s.v. KADHF.

40. Further examples of the views on poetry attributed to Muhammad's companions and other members of the early Muslim community in al-Muttaqī, *Kanz*, III, 482–485, 487–491, 495–496, 498–499.

41. "Ueber die Vorgeschichte der Higā'-Poesie" in *Abh.*, I, 1–105.

42. *Abh.*, I, 69, note 4.

43. *Muslim Studies*, I, 48 (quoting the *Sīra* of Ibn Hishām and *Agh.*, XVIII, 79).

44. However, cf. *Abh.*, I, 75, where Goldziher makes a distinction between this ancient *hijā'* and the personal taunts and invective of later times.
45. *Abh.*, I, 17–18; *HLA*, pp. 190ff. and 332ff., and the references quoted there.
46. *Abh.*, I, 17, 22, and the notes on pp. 21–22 and 25; *EI*, 2nd ed., s.v.
47. *Abh.*, I 83–105, especially p. 104.
48. *Abh.*, I, 18–19, and note. Cf. also p. 23 and Rosenthal, *Knowledge Triumphant*, pp. 12–13.
49. *Abh.*, I, 29.
50. *Abh.*, I, 31, note.
51. *Abh.*, I, p. 104.
52. *Abh.*, I, p. 80 (quoting *Agh.*, II, 291–292).
53. *Abh.*, I, 74 (quoting *Agh.*, X, 151).
54. *Abh.*, I, 54 (quoting *Agh.*, X, 153).
55. Goldziher (*Muslim Studies*, I, 40–41) draws attention to the survival of pagan customs among the Bedouins in the Middle Ages and even today.
56. Equally difficult to assess is the position of early Islam with regard to *saj'*. H. A. R. Gibb (*Arabic Literature*, Oxford, 1963, p. 89) suggests that, "in early times a certain veneration had attached to rhymed prose, as the medium employed in the Koran, which militated against its general adoption for profane purposes." An interesting, but unfortunately anonymous, quotation in Jāḥiẓ's *Bayān*, I, pp. 287–288, suggests that the objections against *saj'* may not have had anything to do with its being the medium of the Koran; and in that case, one could argue that these objections resulted from the character of *saj'* as a medium of pre-Islamic incantations. The passage says that the Prophet encouraged in every possible way not only those listened to, but also those who composed, *qaṣīd* and *rajaz*. The passage goes on to say that since *saj'* and *muzdawij* (couplets of *rajaz*) are inferior to *qaṣīd* and [long] *rajaz* [poems], and *qaṣīd* and *rajaz* are legal, there is no reason to consider *saj'* illegal. See also *HLA*, p. 194.
57. Blachère, *HLA*, pp. 665–667, and *La poésie* pp. 101–102.
58. *HLA*, pp. 622 and 667.
59. Jāḥiẓ, *Bayān*, I, 357 and II, 97; *Agh.*, IV, 146.
60. *Agh.*, I, 352.
61. *Agh.*, I, 355–356.
62. *Agh.*, XVI, 167–168.
63. Agh., VIII, 309–310, paraphrased in R. A. Nicholson, *A Literary History of the Arabs* (Cambridge, 1956), pp. 240–241.
64. *EI*, s.v.
65. Al-Khaṭīb al-Baghdādī, *Ta'rīkh Baghdād* (Cairo, 1349/1931), XIII, 232–235.
66. Both reports are in the *Bustān* of Samarqandī, p. 31.
67. R. Blachère, "Les savants iraqiens . . . aux IIe–IVe siècles" in *Mélanges W. Marçais* (Paris, 1950), p. 47.
68. The fact that Abū 'Amr b. al-'Alā' as well as some others were known as "readers" of the Koran, i.e. engaged in the grammatical and lexicographical interpretation of the Koran, does not necessarily qualify these scholars as theologians.
69. Ḥātimī, *Ḥilyat al-Muḥāḍara* (MS Fez, Qarawiyyīn 2934), fol. 30b.
70. Jumaḥī, *Ṭabaqāt Fuḥūl ash-Shu'arā*, ed. M. M. Shākir (Cairo, 1952), p. 34; Marzubānī, *Muwashshaḥ*, ed. 'A. M. Bajāwī (Cairo, 1965), p. 179.
71. Ibn al-Mu'tazz, *Ṭabaqāt ash-Shu'arā*, ed. 'A. A. Farrāj (Cairo, 1375/1956), p. 202.
72. Ibn an-Nadīm, *Fihrist*, ed. G. Flügel (Leipzig, 1871–2), p. 68; Ibn al-Qifṭī,

*Inbāh ar-Ruwāt*, ed. M. A. Ibrāhīm (Cairo, 1369/1950), I, 221. Cf. *Religious Influences*, p. 34.

73. Ibn al-Mu'tazz, *Ṭabaqāt*, p. 275.
74. *Agh.*, II, 397. Goldziher (*Muslim Studies*, I, 56), who quotes this anecdote, gives the date 108 for Nuṣayb's death and mentions that Nuṣayb was asked to recite poems by others, not his own.
75. *Muwashshaḥ*, p. 559.
76. *Agh.*, XVIII, 180.
77. Ibn al-Mu'tazz, *Ṭabaqāt*, p. 147.
78. *EI*, 2nd ed., s.v. BUḤTURĪ.
79. *Agh.*, XIX, 45.
80. *Bayān*, I, 321, cf. *Abh.*, I, 139 and Blachère in *EI*, 2nd ed., s.v. ABŪ 'AMR B. AL-'ALĀ', Blachère quotes three references for somewhat different versions of the same story.
81. Ibn al-Qifṭī, *Inbāh*, I, 143–144.
82. Zubaydī, *Ṭabaqāt an-Naḥwiyyīn*, ed. M. A. Ibrāhīm (Cairo, 1373/1954), p. 3, and similar traditions on p. 4. The tradition may, of course, also have been invented to counteract the Shu'ūbiyya.
83. Yāqūt, *Irshād*, ed. D. S. Margoliouth (London, 1923), I, 8; cf. Muḥ. b. Ḥibbān al-Bustī, *Rawḍat al-'Uqalā'* (Cairo, 1374/1955), p. 197.
84. *Religious Influences*, p. 34.
85. Suyūṭī, *Sharḥ 'Uqūd al-Jumān* (Cairo, 1358/1939), p. 3. Cf. also, C. A. Nallino. *La letteratura araba dagli inizi all'epoca della dinastia umayyade*, Italian translation by M. Nallino (Rome, 1948), p. 13.
86. A. A. Duri, "The Iraq School of History to the Ninth Century – A Sketch," in B. Lewis and P. M. Holt, *Historians of the Middle East* (London, 1964), p. 46. See also the article by W. Montgomery Watt in the same volume, p. 23ff, and *Muslim Studies*, I, 168ff.
87. Duri, p. 47.
88. Bāqillānī, *I'jāz al-Qur'ān*, ed. A. Ṣaqr (Cairo, 1374/1954), p. 108.
89. Hātimī, *Ḥilyat al-Muḥāḍara* (MS Fez, Qarawiyyīn 2934), fol. 9a; Abū Hilāl al-'Askarī, *K. aṣ-Ṣinā'atayn*, ed. 'A. M. Bajāwī (Cairo, 1371/1952), p. 392; Ibn Rashīq, *K. al-'Umda* (Cairo, 1325/1907), II, 37–38. See also my article "Reflections on the *Kitāb al-Badī'* of Ibn al-Mu'tazz" in *Atti del III Congresso di Studi Arabi e Islamici* (Naples, 1967), pp. 194–195.
90. S. A. Bonebakker, "Poets and Critics in the Third Century," in *Logic in Classical Islamic Culture*, ed. G. E. von Grunebaum (Wiesbaden, 1970), p. 91.
91. "Alte und Neue Poesie im Urtheile der Arabischen Kritiker," in *Abh.*, I, pp. 122–174.
92. Bonebakker, pp. 86–96.
93. See Ch. Pellat, "Variations sur le thème de l'*adab*," in *Correspondance d'Orient*, Études 5–6 (Brussels, 1964), pp. 21–22. I cannot agree with Pellat when he claims that in the Middle Ages *adab* was not used for poetry as such. I hope to discuss this and other questions in the context of a chapter on *adab* which is scheduled to appear in the second volume of the *Cambridge History of Arabic Literature*.
94. Zubaydī, *Ṭabaqāt* (Cairo, 1373/1954), p. 8; Jāḥiz, *Bayān*, I, 202. The same Sa'īd, according to a tradition reported by Qālī, *Amālī* (Cairo, 1373/1953–4), III, 113, asked God's forgiveness a hundred times after he had listened to a poem. See Goldziher in *Zeitschr. der Deutschen Morgenl. Gesellsch.*, LXIX (1915), 202. One could suggest that Sa'īd had no objections against poetry as such, but against the poem or its author, 'Umar b. Abī Rabī'a. A

different version of the same story in the *Agh.*, I, 113–114, V, 92–93, to which Goldziher makes no reference, states explicitly that Saʿīd used to recite poetry in the Mosque of the Prophet in Medina and was only asking God to pardon him for "boasting of the merits of a compatriot" (*li-'l-fakhri bi-ṣāḥibih*). The edition of the *dīwān* of ʿUmar by P. Schwarz (Leipzig, 1901–1909), p. 237 (no. 394) quotes the poem, but makes no mention of the tradition in the *Amālī*.

95. See J. Schacht, *An Introduction to Islamic Law* (Oxford, 1964), p. 31. On the attribution of teaching of the Medinese school, of which Saʿīd was considered a member, to the caliph ʿUmar, see p. 32.

96. For Ibn Qutayba, see G. Lecomte, *Ibn Qutayba* (Paris, 1965), pp. 143–144, and Ch. IX, especially pp. 421ff. and 449ff; and Rosenthal, *Knowledge Triumphant*, pp. 254–265, especially p. 264. For Jāḥiẓ and Ibn Qutayba, see Pellat, *Variations*, pp. 31ff. and 36–37.

97. Ibn Qutayba, *Liber Poesis et Poetarum* (*Kitāb ash-Shiʿr wa-'sh-Shuʿarāʾ*), ed. M. J. de Goeje (Leiden, 1904), p. 170.

98. Marzubānī, *Muwashshaḥ*, ed. A. M. Bajāwī (Cairo, 1965), pp. 85 and 90. See also *Abh.*, I, 136.

99. *Muwashshaḥ*, p. 100; *Abh.*, I, 130.

100. *Muwashshaḥ*, p. 100; *Abh.*, I, 130 (Aṣmaʿī's pupil who reports this saying adds: "as though he denied that Labīd could compose good poetry').

101. *Muwashshaḥ*, p. 100.

102. Ṣūlī, *Akhbār Abī Tammām*, ed. Kh. M. ʿAsākir et al. (Cairo, 1356/1937), pp. 25–27.

103. Mubarrad, *Kāmil*, ed. Z. Mubārak and A. M. Shākir (Cairo, 1355-6/1936-7), p. 745.

104. See *Religious Influences*, p. 36. The passage quoted by Kopf appears on pp. 744–746 of Mubarrad's *Kāmil*, where it is given on the authority of (Abū Isḥāq Ibrāhīm b. Sufyān) az-Ziyādī, a pupil of Aṣmaʿī (See Ibn an-Nadīm, *Fihrist*, ed. G. Flügel [Leipzig 1871–2], p. 58). Kopf's explanation of Aṣmaʿī's motive is supported by an amusing anecdote in the *Taʾrīkh Baghdād* of al-Khaṭīb al-Baghdādī (Cario, 1349/1931), XIII, 255, describing a discussion between Abū ʿUbayda and Aṣmaʿī. See also Abū Ḥātim Aḥmad ar-Rāzī, *K. az-Zīna*, ed. H. F. Hamdānī (Cairo, 1957), I, 127. In the *K. az-Zīna*, Abū ʿUbayda is quoted as saying that one can draw supporting evidence from poetry in interpreting the Koran as long as only questions of lexicography and syntax are involved. But as soon as the interpretation touches upon legal matters, this practice is no longer permissible, and only the *sunna* (normative conduct) of the Prophet and his immediate followers can be admitted as evidence.

105. Ibn an-Nadīm, *Fihrist*, p. 231.

106. *Agh.*, XVIII, 208–209 (I prefer the reading *naktubu* of the apparatus).

107. See E. W. Lane, *An Arabic-English Lexicon* (London/Edinburgh, 1863), s.v. *ḥukm* for a variant to this tradition and J. Fück, *ʿArabiyya* in the French translation by C. Denizeau (Paris, 1955), p. 177 for references.

# Rabbi Moshe Ibn Ezra on the Legitimacy of Poetry

## RAYMOND P. SCHEINDLIN

Alongside the large quantity of Hebrew poetry that has come down to us from the Golden Age of Hebrew literature in Muslim Spain there has survived only one complete and extensive book of poetry theory, the *Book of Discussion and Conversation,* by Rabbi Moshe Ibn Ezra (c. 1055–c. 1140.)[1] Long recognized as the most important source of information on Golden Age poetry, this work has claimed attention primarily because of its historical survey of Hebrew poets and its list of twenty rhetorical devices. But no attempt has yet been made to learn from the book what were the views of the author, himself a prolific and admired poet, regarding the nature of poetry and its place among the activities of the intellect. Although Ibn Ezra does not discuss these problems systematically, his views may be disclosed by a careful reading of the work and analysis of its structure. The book emerges from this study as a defense of poetry based on a complex combination of Arabic and Jewish ideals characteristic of Ibn Ezra's class and providing insight into the ambiguous position of Hebrew poetry within the intellectual life of its practitioners.

The book is introduced as a series of replies to eight questions about poetry asked by a friend, to whom the introduction is addressed. The enumeration of the questions is prefaced by somewhat tautological definitions of the terms *question* and *answer,* emphasizing the need for exact correspondence between the two. Ibn Ezra's purpose in beginning with these definitions seems to be to fix in the reader's mind the notion that the questions are the framework of the book, and that the book's apparent digressions are to be viewed as being integral to its main theme. Indeed, Ibn Ezra frequently terminates or avoids a digression by remarking that his only purpose is to answer the eight questions. They are:

1. A request for an explanation of "the matter of rhetoric and rhetoricians."
2. A request for an explanation of "the matter of poetry and poets."
3. How is it that poetry is a natural aptitude of the Arabs but an affectation among the other nations?
4. Did the Israelite people have rhymed, metrical poetry during their monarchic period, and when did they begin to compose poetry?
5. Why are the Andalusian Jews more diligent and successful at composing poetry than any other Jewish community?

6. A request for a selection of opinions on this subject.
7. Is there any truth to the claim of some people that poetry can be composed in a dream?
8. A request for practical advice for one who wishes to compose Hebrew poetry in accordance with Arabic taste.

The eight chapters devoted to answering these "questions" vary greatly in length, the first two filling only a few pages, while the last constitutes about half the book. But the last chapter differs from the first seven not only in length, but also in form and content. While Chapters 1–7 never (except for the introduction and occasional formulas such as *i'lam* [= know that. . . ]) directly address the inquiring friend, and are entirely theoretical and historical in content, Chapter 8 frequently employs the second person and is devoted largely to practical advice. As if to call attention to the contrast between the two parts, the opening sentence of Chapter 8 is almost identical to that of Chapter 2. Thus, it seems justified to view the book as being composed of two parts, Chapters 1–7 comprising Part I, and Chapter 8 comprising Part II.

Chapter 8 contains two distinct sections. The first lists the subjects to be mastered by the aspiring poet, the qualities of a good poem, the procedure to be followed in writing a poem and in obtaining the frank advice of others during the process of composition, and the grammatical errors to be avoided. The second section, the famous treatise on rhetorical devices, has a brief introduction of its own in which the twenty devices are enumerated. There follows the discussion of the rhetorical devices, in which each is provided with a rather vague definition and a number of examples from the Bible and from Hebrew poetry, and occasionally from Arabic poetry as well.

The first five chapters of Part I follow a logical sequence of ideas if the contents of the chapters, not only the titles, are taken into account. Chapters 1 and 2, the answers to vague questions about rhetoric and poetry, offer no definitions of these terms, an omission which is remarkable, inasmuch as the standard definition of poetry found in most of the Arabic handbooks on the subject is presupposed throughout the book.[2] Chapter 1 opens by connecting rhetoric to logic and the Aristotelian Organon. Great emphasis is placed on the fact that rhetoric is found among all civilized peoples. Biblical Hebrew words for rhetoric and other types of speech are listed, as are a number of rhetorical passages in the Bible. Chapter 2 does not mention the connection between poetry and the Organon, but this has been done in passing in the preceding chapter. The chapter begins by distinguishing the elements of science and craft in poetry. Unlike the chapter on rhetoric, Chapter 2 does not offer examples of poetry in the Bible; however, it does survey the Hebrew and Arabic vocabulary for poetry. The chapter ends with an inconclusive discussion of the relative merits of poetry and prose.

The subject of the first two chapters, then, is not the definition of poetry and rhetoric but primarily the place of these arts among the

sciences, and, secondarily, the biblical equivalents for these two types of literature. These chapters adumbrate the theme of national poetry which dominates Chapters 3, 4, and 5.

Chapter 3 explains the Bedouin Arabs' undisputed talent for eloquence and poetry as a product of geographical, climatic, and astrological conditions in Arabia, of the Bedouin way of life, and of contact with the intellectually cultivated peoples of Persia and the fertile crescent. Although the Jews of antiquity also had the gift of eloquence, their literary abilities declined when, through exile and dispersion, they forgot much of the vocabulary of their language.

But did the Jews in ancient times also have poetry? Implicitly accepting the restrictive Arabic definition of poetry (the omission of which in Chapter 2 has been noted), Ibn Ezra denies in Chapter 4 that there is any poetry in the Bible, except for a few isolated verses resembling *rajaz*, a type of Arabic verse ranked below true poetry. Ibn Ezra does not know when the Jews did begin to write poetry, but he attributes their doing so to the process of linguistic assimilation that, beginning with the first exile, led them to neglect their own language and poetry.

The poetic attainments of the Andalusian Jewish community are outlined in the famous Chapter 5. The Andalusian Jews surpass all other Jewish communities because they are descended from the elite Judeans of Jerusalem. Having learned the Arab sciences, including grammar, from the Arab conquerors, and encouraged by certain Jewish courtiers, they refined their language and began to compose poetry. Ibn Ezra lists the Hebrew poets by generations (*ṭabaqāt*), giving attention not only to their literary abilities but also to their moral characters. He refrains from naming the many bad poets of each generation but lists the qualities of bad poetry and bad poets. Here, too, character judgements and literary judgements are intertwined.

Chapter 6, the answer to the request for a selection of opinions on poetry, is actually a lengthy ethical tract, exhorting the reader to accept the vicissitudes of fate and to suppress desires that cannot be fulfilled. The rueful, personal tone of much of the chapter seems to relate to Ibn Ezra's personal misfortunes. Some of the admonitions seem to be expansions of the criticisms leveled in Chapter 5 against the bad poets. Toward the end of the chapter, the author's admission that as a poet he may himself have been guilty of some of the faults with which he has charged the bad poets, such as exaggerated panegyric, satire, or self-praise, leads to a discussion of truth and falsehood in poetry, in the course of which the classification of poetry and rhetoric in the Organon is recalled, and the various types of speech treated in the last five books of the Organon are evaluated with respect to the degree of truth and falsehood in each Finally, the poet's power of fantasy is named as the source of poetic falsehood.

Chapter 7, the final chapter of Part I, takes up the philosophical prob-

lem of the source of poetic inspiration touched on at the end of Chapter 6, and is closely connected, through the passage on logic in Chapter 6, to the beginning of the book. The chapter, the subject of which is the question of whether poems may be composed in a dream, begins with scientific definitions of sleeping and dreaming. Dreams are of two types: true dreams, originating in the intellect, and false dreams, originating in the common sense. The former is connected with prophecy. Many accounts confirm that poems do occur to men in dreams; in most such cases, the dream originates in the common sense, since while sleeping the poet's mind continues to be engaged in his daytime occupation. Other dreams do seem to derive from the intellect.

Part I of the *Book of Discussion* thus treats three main themes: 1. The philosophical question of the place of poetry among the "spiritual crafts" and the sources of poetic inspiration. 2. The national question of the place of poetry in Arabic and Jewish culture. 3. The moral status of the poet. We shall see that these three problems are interrelated.

The *Book of Discussion* is not a general guide to the art of poetry in the tradition of Arabic *artes poeticae*. It lacks or accords the briefest possible treatment to many commonplace topics of Arabic poetics, such as the discussion of poetic themes and genres, of the prosodic system, poetic licenses, and errors in rhyme and meter. It omits the encomium on poetry which is a familiar feature of such works. Even the discussion of rhetorical devices is brief and, compared to the analogous discussions in the Arabic books available to Ibn Ezra, rather sketchy. The proportion of the book devoted to this subject (about one-quarter) is also considerably less than is usual in these Arabic works. Above all, the book is almost totally lacking what may be called poets' shop talk, in which lines of poetry by different poets dealing with similar themes are subjected to detailed comparison. These omissions cannot be justified by the need to answer exactly the friend's questions, as the sixth question, the request for a selection of opinions on poetry, was vague enough to permit the author to introduce whatever topics suited him. Furthermore, the author is not at all inhibited from digressing from a "question" to other subjects. And in the introduction, Ibn Ezra himself calls attention to the omissions, explaining that he feels justified in omitting certain topics which have already been thoroughly studied in the books of the Arabs. The reader can only conclude that our author has been selective in deciding what to include in the book, which can in no way be characterized as an encyclopedic work on poetry.

What, then, was Ibn Ezra's purpose in composing the *Book of Discussion,* and what principle guided him in his selection of the material to be included in it? It has been suggested that the book's purpose is the defense of Jewish culture, that the book is a work of apologetics written in the

context of the cultural dilemma which tortured the members of the Jewish courtier class of Muslim Spain.[3] These men lived and worked close to the centers of power in the petty Muslim kingdoms; they mixed rather freely with Muslims and were steeped in the dominant culture. Those who remained loyal to their own people suffered at the national humiliation of being a subject people with an intensity probably not felt by men who had not achieved as much as they. Yet the Jews had confronted the political aspect of the problem of the subjugation of the chosen people long before the rise of Islam, and various theological solutions were well established in Jewish tradition. The courtiers had to contend with a new aspect of this problem, the feeling of cultural inferiority arising from the spread of Arabic culture and the Arabs' aggressive propagation of the idea of the superiority of their own language and poetry. It was probably as a result of this very sensitivity that Arabic-style Hebrew poetry was first cultivated in Jewish courtier circles in order to realize in Hebrew the aesthetic and literary ideals which the courtiers had been trained to believe were the highest achievements of civilization. The role of Hebrew poetry in redeeming the honor of the Hebrew language is reflected in the earliest poetry of this type, and echoes of it are heard in Spain as late as the thirteenth century.

Much of the *Book of Discussion* may be read as a response to this problem. Chapter 5, with its catalogue of Andalusian Jewish poets, can be viewed as an attempt to prove that the Jews have shown themselves to be capable of producing poetry in Hebrew on a high level; Chapter 8, with its list of rhetorical devices and examples taken from the Bible, may be an attempt to show that the Hebrew revelation is no less eloquent than the Quran or Arabic poetry and as further evidence that the Hebrew language is capable of the kind of rhetorical elaboration which in eleventh-century Andalus was considered the mark of cultivated taste.

One objection to this interpretation is that it accounts only for Chapter 5 and parts of Chapters 3, 4, and 8. What remains appears to be a hodgepodge of miscellaneous information which must then be excused by the claim that the book follows the Arabic tradition of *adab* books intended for instruction and amusement, shifting from one subject to another and often losing the theme in extended digressions. But a weightier objection arises from the assumption, upon which this interpretation is founded, that Ibn Ezra accepts completely the general admiration for poetry, particularly Arabic poetry, and is arguing that the Jews are just as capable of producing it as the Arabs. This assumption is contradicted by the many negative judgements on poetry scattered throughout the book.

The opening sentence of Chapter 1, in which rhetoric is classed among the branches of logic, starts the book on a negative tone by stating that rhetoric is one of the persuasive arts, lower in rank than dialectic. Speak-

ing of the Arabs' particular talent for this art, the author singles out their ability to make the ugly seem beautiful and the beautiful, ugly, falsehood like truth and truth like falsehood. Discussing the relative merits of poetry and prose, the author at first seems to favor poetry, but mitigates this judgement by stating that poetry has become degraded since poets began using it to earn their living. Explaining in Chapter 3 the Bedouin's special talent for poetry, Ibn Ezra makes full use of *Shuʿūbī* arguments to denigrate Bedouin civilization in general, implying that poetic aptitude is no mark of cultural superiority. Introducing his list of the fields of knowledge required of a beginning poet, he says that poetry requires so little knowledge of the sciences that it can hardly be called a science at all. And, in a personal reminiscence in the ethical treatise of Chapter 6, Ibn Ezra recalls that in his youth he used to think poetry a prestigious enterprise, but later abandoned it for more worthwhile occupations. In view of the absence of a chapter, or even a single unequivocal statement in praise of poetry, these explicit negative judgements on poetry must not be overlooked in assessing Ibn Ezra's views.

These disparaging comments might be seen as part of an attempt to rescue the honor of Jewish culture by denigrating the Arabs' greatest native cultural institution, were it not for three considerations. First, Ibn Ezra was a poet of first rank, who, because of the quantity and quality of his poetic production, is counted among the four greatest Hebrew poets of the Golden Age. While he may have come to entertain misgivings about poetry, it does not seem likely that he would have gone so far as to attempt to enhance the Jews' self-image by denouncing poetry as a worthless endeavor. Nor did he actually renounce the composition of poetry in his old age, as did some other Arab and Jewish poets. Second, Ibn Ezra recalls the achievements of the Hebrew poets of Andalus with considerable pride, emphasizing the moral uprightness of the best of them. Finally, since Ibn Ezra's express intention in Part II is to show the reader how to become a poet, he seems to be encouraging the practice of poetry, while granting that it is not a native Jewish art.

These indications of Ibn Ezra's approval of poetry are at odds with the explicit and implicit negative judgements, bespeaking a complex, ambivalent attitude which cannot be explained away by defining the book as an *adab* work or an anti-Arab polemic.

Classifying rhetoric and poetry as branches of logic, Ibn Ezra begins his book by noting that, measured by the standard of truth, poetry is deficient. This judgement is repeated at the end of Chapter 6, where, in connection with hyperbole and other figures of speech, the familiar aphorism "the best poem is the most false" is applied to figurative language. Here, Ibn Ezra emphasizes that it is the language of poetry, rather than the contents, that is false, by giving a slight twist to the classification of the

types of proof studied in the last five books of the Organon according to degrees of truth and falsehood:

true = demonstration
more true than false = dialectic
equally true and false = rhetoric
more false than true = speech of the sophists
false = "the style of the poets, not the content of their speech"

There follows a paraphrase of a passage from al-Fārābī's *Enumeration of the Sciences*,[4] in which the psychological basis of the appeal of poetry is stated to be fantasy, which bears the same relation to poetry as opinion to dialectic and knowledge to demonstration. At the end of the paraphrase, Ibn Ezra warns the reader against acting in accordance with fantasy, which is always false.

Since this warning ends the chapter, the reader is left with the distinct feeling that Ibn Ezra is morally opposed to poetry, and almost expects to encounter a denunciation of it in the next chapter. It is instructive to compare Ibn Ezra's remarks with those of another learned Andalusian poet, the Muslim jurist and theologian Ibn Ḥazm. Writing about a century before Ibn Ezra, in his curriculum entitled *The Ordering of the Sciences*,[5] Ibn Ḥazm condemns all poetry except ascetic and religious verse. Poetry of love and war, satire, and descriptions of foreign lands and deserts he simply declares immoral. Panegyric and eulogy, on the other hand, are not absolutely forbidden, but only "reprehensible" (a technical term in Islamic law). They are permitted because they name the good qualities of the person eulogized, and therefore have the power of instilling these qualities in one who recites them; but they are "reprehensible" because most of their contents are false, "and there is no good in falsehood." Anticipating the argument that his disapproval of poetry is the result of his own ignorance of it or lack of poetic talent, Ibn Ḥazm permits himself to recall with satisfaction his own poetic achievements. Well may Ibn Ḥazm have anticipated his charge, for two centuries later an Andalusian Muslim philosopher, Ḥāzim al-Qartajannī was to explain the theologians' dislike of poetry as a product of their ignorance of poetic practice.[6] Apart from the accusation of ignorance, however, the passages from Ibn Ḥazm and Ḥāzim al-Qartajannī are interesting, because they demonstrate that the misgivings about poetry entertained by Muslim theologians from the earliest period of Islam were still troublesome in medieval Andalus. The passage from Ibn Ḥazm is particularly instructive, because it states the objection to poetry not merely in terms of poetry's morality, but also in terms of its veracity. A similar attitude is expressed in Ibn Ḥazm's book on logic[7] where poetry is said to be entirely false. That this assertion refers to the contents, rather than to the language and imagery, is apparent from Ibn Ḥazm's example of verses which are true, therefore ludicrous:

Day is day, dark is dark;
Dove is dove, lark is lark;
Mouse is mouse, louse likewise;
Both are rather small in size.[8]

It seems, therefore, that Ibn Ezra is responding to some such objection to poetry by insisting that, while the language and imagery of poetry are necessarily false, the contents need not be. Ibn Ezra's concern with the truth of the contents of poetry may help to explain the brief passage on the relative merits of poetry and prose.[9] Poetry, he says, has the advantage over prose in that it is quicker to get attention and remains longer in memory, but its status has fallen below that of prose ever since people began to make it their profession by writing panegyrics for money. When Ibn Rashīq[10] blames poets for making their living in this way, his reason seems to be only that it is not a dignified profession. But, in the context of the *Book of Discussion*, it seems as if the objection to poetry as a profession is rooted in the consideration that a professional writer of panegyric is actually making his living by lying. Taken together, these passages from the *Book of Discussion* seem to be saying that, though the imagery of poetry may be necessarily false in a logical sense, the contents of poetry need not be false or immoral, an assertion which would seem to be directed against a critique of poetry motivated by philosophical and moral considerations.

Several times in the course of the *Book of Discussion* Ibn Ezra mentions the distinction between the natural and the conventional sciences. At the beginning of Chapter 2, he says that poetry belongs to the former with respect to meter, and to the latter with respect to language and grammar. This distinction receives some further clarification at the beginning of Chapter 8:

. . . the science of speech and language is not one of the natural sciences . . . like arithmetic, geometry, and music . . . but is rather conventional; its rules are valid only for those who have adopted them, i.e., the people who speak that particular language. If these rules were transferred to people who speak a different language they would not be entirely valid. But the principles and proofs of the natural sciences are no different for the scholars of one nation than for another, nor are they less valid, though they [i.e., the scholars] differ in language.

Speaking of the form of poetry, rather than of the content, Ibn Ezra thus stresses that the language and grammar of poetry vary from one nation to another, while meter, as a branch of mathematics, is universal. That his purpose in opening the discussion of poetry with this distinction is to lay the foundation for a discussion of the universality of poetry is apparent from the fact that the statement in Chapter 2 just referred to is immediately followed by the comparative lexicographical study of words

for poetry in biblical Hebrew and Arabic. But there are other indications that the universality of poetry is one of his main concerns. In the course of a digression in Chapter 1, we learn that a property may be possessed by a thing, either by virtue of the thing's nature or essence. The former type – an example is the heat in fire – may also exist in other things as an accident.[11] Then, in Chapter 8 we read that metrics is not entirely a conventional science, but a natural one as well, since its basis is something that can be perceived by sensation.[12] Combining these two statements, we can only conclude that Ibn Ezra means to imply that it is not inherently impossible to transfer to Hebrew the metrical system "natural" to the Arabic language. The incongruity of the Arabic meters with Hebrew is a problem which was raised as soon as these meters were introduced into Hebrew in the tenth century; an issue was still being made of it in the twelfth century by the poet Judah Halevi.[13] Ibn Ezra seems to be urging the diehard opponents of Arabic prosody to take a broad view of the problem: as a branch of mathematics, meter, like music, should be transferable from one language to another. In any case, Hebrew and Arabic are closely related languages, a fact which had been established by Ibn Ezra's time by grammarians to whose works Ibn Ezra refers both in this context and in Chapter 5.

The conventional element in poetry amounts to nothing more than grammar and vocabularly. While each language has its own grammar and its own vocabulary, there is no reason to think one language intrinsically superior to another, since all language is merely the conventional application of words to things. Ibn Ezra refuses to take sides between the opinions he cites regarding the relative superiority of Greek and Arabic.[14] This, too, seems to be the point of the anecdote at the end of Chapter 3: when a Muslim scholar tried to convince Ibn Ezra of the superiority of Arabic to Hebrew by asking him to translate the Ten Commandments into Arabic, Ibn Ezra replied by asking the Muslim to translate the opening of the Quran into Latin.

Yet even if a nation's language need not prevent it from composing poetry, perhaps it can be constitutionally unsuited for doing so. It was universally agreed by Ibn Ezra and his contemporaries that the Arabs had excelled in eloquence and poetry from earliest times, while the Jews had no comparable achievement dating farther back than the tenth century. Perhaps then, the poetic efforts of the Andalusian Jews were an affectation doomed to the same artificiality and failure as the poetic efforts of an individual who lacks native ability. It is in the context of such arguments that Chapters 3, 4, and 5 must be read. The purpose of these chapters is not so much to defend the honor of the Jews, in the face of charges by Arabs that they are a backward, uncultured people, as it is to demonstrate to Jews opposed to the application of Arabic poetics to

Hebrew that neither tradition, logic, nor national character need place any obstacle in the way of such accommodation.

Unable to regard as poetry any literary composition not conforming to the rules of Arabic prosody, Ibn Ezra could not respond to this charge by adducing the Psalms or the prophets as evidence that the ancient Jews had written poetry; for the same reason he does not refer to the vast production of pre-Golden Age Hebrew liturgical poetry. He does mention twice the opinion of some commentators that I Kings 5:12 attributes Arabic-style *qaṣīdas* to King Solomon,[15] but he does not seem to accept this interpretation.

That the ancient Jews were concerned with eloquence and literary style, despite the fact that they did not actually compose *qaṣīdas*, Ibn Ezra proves by citing verses from Isaiah and Proverbs.[16] A verse from Amos shows that Jews of Biblical times possessed the ability, highly prized by the Arabs, of improvising poetry.[17] This ability is also attributed to Saul.[18] One of the purposes of the identification of biblical words with Arabic words denoting poetry, song, etc., may be to suggest that Jews of Biblical times did, in fact, have literary talent, even though in the world of Arabic culture these compositions could not really be counted as poetry. Finally, the list of rhetorical devices in Chapter 8, with its examples from the Bible, is proof that Scripture was concerned with rhetorical perfection no less than were the Arab poets. While one of the reasons given by Ibn Ezra for adducing biblical examples is to counter the notion that the Jewish revelation is defective by literary standards, the author also cites his intention of allaying Jewish misgivings about the propriety of employing Arabic style in Hebrew.[19]

Ibn Ezra's reference to Saul shifts the argument into a new direction. When, in I Samuel 10, Samuel and Saul part, Samuel fortells that Saul will meet a group of prophets and will prophesy with them. When Saul did so, some bystanders asked, "Is Saul too one of the prophets?" whereupon other bystanders replied, "And who are their fathers?" Quoting Saadia,[20] Ibn Ezra explains the reply as meaning that, since the others had not inherited this power from their ancestors, it is not remarkable that Saul should have it, too. Ibn Ezra's insistence that poetic skill is not inherited is certainly to be combined with his remarks in Chapter 3 on the source of this skill among the Arabs. Most of this chapter is devoted to explaining the Arabs' literary abilities as a product of the geographical, climatic, and astrological conditions of their homeland, and Ibn Ezra does not fail to take advantage of the implication of this type of explanation that anyone who is subject to the same conditions would acquire the same ability. A convincing example was available in those Arabian Jews of pre-Islamic times, such as Samau'āl Ibn 'Adiyā', who were famous poets of no less ability than the contemporary Arabs and whose poems were anthologized and praised by Muslim connoisseurs.[21]

The story of Saul leads us to the question of the source of poetic powers. Like all Arab theoreticians of his time, Ibn Ezra believed that the ability to write good poetry was a product of both talent and diligent study.[22] The instructions to the aspiring poet given in Chapter 8 make clear that the craft is not easily acquired, even by one who possesses the requisite talent. Similarly, in Chapter 3, Ibn Ezra points out that even those master poets, the Arabs, acquired their ability only by a slow process of development "until it came to be like a natural quality in them." Nowhere in the book do we read of a poet improvising a poem under the influence of a burst of emotion.[23] Nowhere in the book do we encounter the idea of inspiration by tutelary spirits, along the lines of Ibn Shuhaid's *Treatise of Familiar Spirits and Demons*.[24] In short, while granting that native aptitude is a prerequisite to becoming a good poet, Ibn Ezra attributes the composition of good poems mainly to hard labor and perseverence on the part of the poet in perfecting his craftsmanship.

The story of Saul, as interpreted by Ibn Ezra, does, however, introduce the idea of inspiration. In retelling this story, Ibn Ezra substitutes for the Hebrew word *nāvi* (prophet) the Arabic word *shā'ir* (poet), and for the Hebrew *ve-hittnabbiā* (you will prophecy) the Arabic *tartajilu 'sh-shi'r* (you will extemporize poetry). Thus, Ibn Ezra sees Saul as a poet, and, seeking to attach this interpretation to an authority, attributes it – falsely – to Saadia. But what sort of poem did Saul extemporize? Surely Ibn Ezra cannot have meant that Saul recited a *qaṣīda*, for, as we have already seen, he considers and rejects the idea that such poetry was known to the Jews in biblical times. However, Ibn Ezra conceived of the form of these utterances, he certainly understood them to be a kind of prophecy. This story demonstrates that the pains Ibn Ezra takes in Chapters 1 and 2 to point out the Hebrew equivalents for Arabic words denoting poetry is not merely an interesting philological exercise, but a clue to his conception of Israel's literary history.

The Arabic word *shi'r* (poetry) Ibn Ezra explains as derived from a root which signifies both "knowing" and "informing." In the latter meaning, it is synonymous with the root of the word *nabi* (prophet), one who proclaims information given to him in private by God. The Arabic word *shā'ir* (poet) corresponds to the Hebrew *qōsēm* (soothsayer) and *nāvi* (prophet). The Hebrew *nāvi* (prophet) corresponds to Arabic *munajjim* (astrologer) and *shā'ir* (poet, diviner). What this set of correspondences boils down to is that the Arabic word for poet and the Hebrew word for prophets are associated both with the mantic arts and with poetry.

Now, Ibn Ezra has much to say about divining and soothsaying in Chapter 3, where he tells us that, together with poetry and tribal history, they are among the skills with which the Bedouin were gifted. But he also disparages this art, which he says amounts to little more than weather forecasting and which the Bedouin acquired only thanks to their famil-

iarity with desert conditions. "It is not a true science" he says, meaning that it is merely a technique, like poetry, which, because of the peculiar circumstances of the Arabs' environment, they happen to do well.

The knowledge of the future to which the Arabs have access is knowledge of a lower sort, but the Jews, at least in ancient times, had direct access to true wisdom through prophecy.[25] This divine knowledge is explicitly contrasted with the soothsaying of the Bedouin. It would therefore seem to follow that the "poetry" attributed to Saul, and, through the lexical equivalents cited above, to all the Biblical prophets, is simply the inspired expression of God's word, which, of course, does not necessarily take the forms dictated by the conventions of Arabic prosody and which is the type of literary expression native to the Jews.

The accounts of both Muslim and Jewish poets who composed poetry in dreams could be adduced as evidence that Arabic poetry (and the Hebrew poetry composed in imitation of it) is actually the product of inspiration, rather than a mere craft. From the work of Ibn Shuhaid mentioned earlier we may infer that this conception was in vogue in Muslim circles in eleventh-century Andalus. It is against this conception that Chapter 7 is directed. This chapter, which discusses whether poetry can be composed in a dream, seems to have so little to do with the six preceding chapters that one of the published outlines of the *Book of Discussion* does not even trouble to assign it a separate heading; but, if our reading of the book is correct, it is actually a useful appendix to Part I, at the end of which it stands.

Rather than deny the authenticity of the stories ascribing poems to dreams, Ibn Ezra explains them away by providing them with a scientific explanation. Dreams are of two types: those that come to the good man from the intellect and the rational soul and those that everyone experiences, which have their ultimate origin in sense-perception, and which take the form of dreams through the activity of the imaginative faculty and the common sense. The former are called "true dreams," or prophecy; the latter represent merely the influence of the dreamer's daytime activities and have no particular significance. Just as any craftsman may dream about his work, so a poet may dream about his, resulting in a dream poem. Ibn Ezra does, incidentally, allow for the occasional poem which comes to the poet in a true dream. He has no need to deny in principle the possibility that prophecy may occur in the form of a dream-poem. He only wants to keep such occurrences to a minimum, in accordance with his position that the ordinary poetry of Arabs and Jews alike is merely a craft with no claim to higher inspiration.

From what has been said it will appear that the book embodies two opposing tendencies: disparagement of poetry and admiration for the poets

themselves and their poems. The contradiction can be explained only with reference to the peculiar cultural situation of Ibn Ezra's circle.

Traditional Talmudists opposed the Arabicizing of Hebrew, feeling that the use of the holy tongue for secular purposes was no less an affront than the use of the Song of Songs as a love poem, expressly prohibited by Jewish law. This sensitivity is manifested by Ibn Ezra himself when, in the course of one of his several tirades against satirical poetry, he gives as one of the reasons for his rage against its practitioners the desecration of the biblical verses from which the poetic vocabulary is derived.[26] Although there is little direct testimony to the opposition of traditionalists to poetry and to the Arabicizing style of the courtier class in general, there is sufficient indirect evidence to justify the assumption that such opposition did exist. It is alluded to several times by Ibn Ezra himself.[27]

Another reason for the opposition of traditionalists to Arabic-style poetry would have been the sensual way of life with which it was inextricably bound and the social setting which is both its *Sitz im Leben* and its content. Muslim religious thinkers like Ibn Ḥazm opposed it for the same reason, fearing that it could only lead to a life of frivolity and immorality. A hint of this type of opposition survives in the apologetic note prefaced to the *dīwān* of the great Jewish courtier-poet Shemuel ha-Nagid by his son Yehosef:

Though some of them [i.e., these poems] include erotic themes, he believed these to be metaphors for the community of Israel and the like, just as is found in some of the writings of the prophets. God will reward him for his intention. Anyone who interprets them in a way contrary to his intention will bear his own guilt.[28]

Although Ibn Ezra does not warn the poet of the dangers of participating in soirées and wine-parties or romantic attachments with young girls or boys, he does emphasize repeatedly the high moral standards in interpersonal relations which he demands of the poet. He is particularly troubled by the power of satyric poetry to harm the reputations of others. But the danger is inherent, not in poetry, but rather in the poet, and Ibn Ezra recalls with considerable self-satisfaction that in his own career he never succumbed to this danger.

A final reason for traditionalist opposition to Arabic-style poetry is the argument of cultural superiority already mentioned. Faced with the ideal of ʿ*arabīya*, the utter perfection of classical Arabic and its poetry, together with the religious doctrine of the inimitable perfection of the Quran, which put the idealization of Arabic on a religious basis, many Jews must have felt that any attempt to subject Hebrew to the patterns of Arabic was a kind of subversive act, a celebration in Hebrew of the culture which the Arabs boasted proved their own superiority.

This problem of the legitimacy of Arabic-style Hebrew poetry is the

real national problem in the *Book of Discussion*. Ibn Ezra is not primarily concerned with bolstering Jewish morale against claims of cultural backwardness, although much of his material could serve this purpose equally well. That much of his argument is capable of double applicability is due to its resting on the notion that medieval Arabic poetry and the Hebrew poetry which imitates it is a relatively unimportant phenomenon, hardly more than a craft, which is dangerous only if put to bad use. Arab claims of divine inspiration for poetry are absurd, for only prophecy is of divine origin. That such prophecies as are recorded in the Bible were occasionally expressed in forms which exist also in Arabic shows that Hebrew is capable of employing these forms, confirming in practice what logic also demonstrates, that languages are not inherently superior or inferior to each other.

Taken to an extreme, this philosophic approach could lead to the total denial that poetry is a legitimate activity, for if speech is evaluated by a strict standard of truth, poetry must be accorded a very low place in the hierarchy of human endeavor. This extreme claim Ibn Ezra attempts to refute by arguments similar to those used against the traditionalists. It is only the language of poetry that is false; the contents depend on the poet.

But Ibn Ezra does not fight the views of the philosophers too vigorously, and the reader cannot help but feel that his deeper sympathies are with them. If the reader is left with a feeling of ambivalence, this is because the author is defending Hebrew poetry by denigrating all poetry. The nature of his defense against the claims of uncultured theologians and against an extreme philosophical view shows a full awareness of poetry's weaknesses and an inclination, after all is said and done, to regard it as a pleasant but useless activity, not a truly dignified occupation for a serious person. As many Muslim poets did, he repents in old age the frivolities of his youth, including poetry, and turns to deeper wisdom.

But Ibn Ezra, unlike the Arab connoisseur of poetry abū 'Amr Ibn al-'Alā', did not burn his works; and, unlike his friend Judah Halevi, he did not undertake to stop writing poetry. For it was to philosophy that Ibn Ezra turned in his old age, not religious asceticism, and as a philosopher he preached moderation in all things, including wisdom.[29] Thus, he offers the reader both a critique and a defense of poetry and leaves the rest to human frailty.

## NOTES

1. *Kitāb al-muḥāḍara wa 'l-mudhākara*. The complete Arabic text, edited by A. S. Halkin, is soon to be published for the first time. References to the *Muḥāḍara* in this paper are to the Hebrew translation by B-Z. Halper, entitled *Shirat Yisrael* (Leipzig, 1924).
2. "Metrical, rhymed speech expressing a certain meaning," Qudāma Ibn Ja'far, *Naqd ash-shi'r*, ed. S. A. Bonebakker (Leiden, 1956), p. 2. The

words "metrical" and "rhymed" refer to the prosodic system peculiar to Arabic.

3. See Abraham Ibn Daud, *Sefer ha-Qabbalah: The Book of Tradition*, ed. and trans. G. D. Cohen (Philadelphia, 1967), pp. 146, 267.

4. *Muḥāḍara*, pp. 2, 158.

5. *Iḥṣāʾ al-ʿulūm*, ed. ʿUthmān Amīn, 2nd ed. (Cairo, 1949), pp. 67–68.

6. *Marātib al-ʿulūm*, in *Rasāʾil ibn ḥazm al-andalusī*, ed. I. R. ʿAbbās (Cairo and Baghdad, n.d.), pp. 59–90.

7. *At-taqrīb li-ḥadd al-manṭiq wa ʾl-madkhal ilaih*, ed. I. ʿAbbās (Beirut, n.d.), pp. 206–07.

8. Literally: "Night is night, day is day;/ Mule is mule, donkey is donkey;/ Rooster is rooster, so the dove;/ Both are birds with beaks."

9. *Muḥāḍara*, p. 46; see also p. 89.

10. Ibn Rashīq, *ʿUmda*, ed. M. M. ʿAbd al-Ḥamīd (Beirut, 1907), I, 80–81.

11. *Muḥāḍara*, p. 41.

12. *Ibid.*, p. 110.

13. Judah Halevi, *Sefer ha-kuzari*, ed. H. Hirschfeld (Leipzig, 1887), pp. 128–31.

14. *Muḥāḍara*, p. 54.

15. *Ibid.*, pp. 42, 57.

16. *Ibid.*, p. 55.

17. *Ibid.*, p. 31.

18. *Ibid.*, p. 45.

19. *Ibid.*, pp. 157–59.

20. *Commentaire sur le Sefer Yesira ou Livre de la création par le gaon Saadya de Fayyoum*, ed. M. Lambert (Paris, 1891), p. 17 (Arabic text).

21. *Muḥāḍara*, p. 51.

22. *Ibid.*, p. 111.

23. A common theme in Arabic works on poetics known to Ibn Ezra. See Ibn Qutaiba, *Kitāb ash-shiʿr wa-ʾsh-shuʿarāʾ: al-muqaddima (Introduction au livre de la poésie et des poètes)*, ed. M. Gaudefroy-Demombynes (Paris, 1947), pp. 17–19; Ibn Rashīq, *ʿUmda*, I, 204–15.

24. *Risālat at-tawābiʿ wa ʾz-zawābiʿ*, trans. J. T. Monroe (Berkeley, 1971).

25. *Muḥāḍara*, p. 51.

26. *Ibid.*, p. 80.

27. *Ibid.*, pp. 159–60.

28. *Dīwān Shemuel ha-Nagid: Ben Tehilim*, ed. D. Yarden (Jerusalem, 1966), p. 1.

29. Proverbs recommending moderation turn up with notable frequency in the *Book of Discussion*. See *Muḥāḍara*, pp. 36–37, 110, 142–44.

# Literary Problems of
# Hagiography in Old French

## PETER F. DEMBOWSKI

It is the contention of this article[1] that hagiography in Old French is important and that the study of that genre has been unjustifiably neglected. This state of affairs has also resulted in neglect of certain important problems of Old French literature. Except for such early examples of French literary language as the *Saint Eulalie* or the *Passion of Clermont* and such masterpieces as the *Saint Alexis,* all of which have been studied extensively for their philological and literary importance, most of the thirteenth- and fourteenth-century hagiographic literature remains little known. A number of works in verse and in prose are still unedited or have been edited carelessly. This situation is particularly true in regard to the continental Old French hagiography. Anglo-Norman texts have fared better. Thanks to the fact that the corpus of what is considered Anglo-Norman literature is not too extensive and that hagiographic narratives constitute an important part of this corpus, several texts have been published, not necessarily, I suspect, because they are hagiographic, but because they are deemed Anglo-Norman.[2]

Apart from these specifically insular interests, the only important general study of hagiography in Old French is Paul Meyer's pioneering, fact-finding manuscript research.[3] Other works are rare and, on the whole, introductory. They owe much to Paul Meyer's investigation, and, since they are all we have, testify to the neglect of the genre.[4]

The main reasons for this neglect are, as we shall see, purely literary. They are to be sought in the very nature of the genre. Nevertheless, in the past there were other "external" factors contributing to this neglect which should be pointed out first, for they constitute an important part of the history of Old French literary scholarship. In today's pro-medieval atmosphere, it is possible to state, without the risk of reopening a painful and unproductive debate, that between about 1850 and the Second World War, in the era of the spectacular growth of our discipline, a majority of scholarly opinion was favorable neither to hagiography nor to hagiographic elements in Old French literature. The nineteenth-century positivistic scholar and his twentieth-century descendent seemed to find certain aspects of medieval literature perplexing. They frequently found

the "patriotism" of the *Roland* splendid, the "realism" of Joinville touching, and the "simplicity" of verse-romances charming, but it was difficult for them to take seriously such fundamental "hagiographic" aspects of medieval culture as the heroic Caesaropapism of the *Roland*, the deep personal piety of Joinville, and the monastic and eucharistic implications of *Perceval* and its continuations. The prevailing positivistic mode of thought (not to mention its "secular arm," the political ideology of anti-clericalism) was not conducive to objective and systematic study of hagiographic literature. The activity of the "defenders" of traditional hagiography was also counter-productive. This minority was often frankly conservative, nostalgic, and anachronistic and tended to exasperate further the positivistic scholar. The confrontation between the anti-medieval majority and the pro-medieval minority appeared, for a long time, irreconcilable. In such a confrontation, certain genres fared better than others. Hagiography, and especially hagiography in the vernacular, always a touchstone of our attitude toward the medieval past, has suffered much from neglect by the positivist majority and from distortion by the apologetic minority.

And, even now, the Old French hagiography has not yet recovered its rightful place, a place warranted by its literary importance. Let us consider this importance under three separate but closely-interrelated headings: The problem of hagiography in the vernacular in relation to other Old French genres; the importance of hagiography in the history of Old French in general; the importance of Old French hagiography in itself and in relation to the general history of culture.

In order to deal with our three main headings we must recall certain basic facts concerning the nature of our genre. The literary models for the hagiographic works in Old French were chiefly the Latinized and, so to say, "codified" Byzantine and other Eastern Christian writings, as well as Latin hagiography, itself greatly influenced by the Eastern tradition. This heritage represents the "official" version of hagiography; that is to say, it represents the narrative writing about sacred history, about its apocryphal continuations and, more specifically, about the lives of saints, both ancient (often legendary) and contemporary (more authentic). Together with other documents of the old "official" learning, Latin hagiography has been carefully transmitted to us. It exists in countless manuscripts. It has been carefully edited and pruned from occasional strange accretions by that capable, old, ongoing historical enterprise, that is to say, by the Bollandists. In the last hundred years or so, their monumental *Acta sanctorum* have undergone scrutiny from various critical sources. What is important for us here is that in the radical critical assaults on hagiographic literature resulting from this scrutiny, hagiography in the Old French was scarcely touched. It seems as if the genre was not deemed important enough even by the most earnest debunkers.

But it is important, first of all in its relation to other genres of Old

French. The Lives of Saints and other hagiographic writings have never developed specifically different literary forms of their own. Thus, one of the oldest (ca. 1050) but most atypical of the hagiographic poems, the already-mentioned *Saint Alexis,* shows in its decasyllabic monoassonanced strophs, if not a direct influence of, at least a parallel development with, the epic songs. Later, in the thirteenth century – the Golden Age of hagiography in Old French – the hagiographic poems of France (imitated directly in Spain, Portugal, Italy, Germany, and Scandinavia, recomposed and composed in Anglo-French and in English) reflect not only the typical form of verse romances (rhymed octosyllabic couplets), but also, and above all, the prevailing novelistic tone of these romances. The elegant preoccupation with details, the desire to "interlace" the narrative gracefully, the desire to appear both new and recognizably traditional are shared by both genres.

Of special interest here is a specific influence of vernacular hagiography on other genres. In its close "coexistence" with the epic and novelistic poems, it influenced profoundly the very conception of the hero. Not only Charlemagne, Roland, Oliver, Guillaume d'Orange, but also, later, Perceval, Lancelot, Galahad, and others became, so to say, "canonized." In the case of Charlemagne such canonization could have been caused by reasons other than his position in the vernacular literature, but such could not have been the case for other epic heroes. Roland, Oliver, and Guillaume reached something like a half-way mark in this process. Without being formally proclaimed saints, their apocryphal graves were visited by countless pilgrims. What is important here is not the canonization of this or that epic hero in "real life," but the "hagiographization" of the hero in the literary work. The Christianization of vernacular literature meant above all the "hagiographization" of the hero. In the famous stained glass window of the cathedral of Chartres, we see Roland depicted twice in the same panel. He sounds his Olifant to summon the Christian armies and attempts to break his invincible sword Durandel. In both symbolic poses, he is wearing a halo. The thirteenth-century artist of the Chartres cathedral was not "naïve." He was listening to the *Song of Roland* perhaps more closely and more critically than many of our nineteenth- and twentieth-century casual readers, for if Roland did not win the halo in the historically-authentic but politically and morally uncertain combat at Rencesvals in 778, he certainly did gain it in the concrete, archetypal lines of the poem of 1050.[5]

Even more startling is the metamorphosis of the hero of the verse romances. These romances, originating some one hundred years after the *Roland,* featured at first a purely secular, mundane hero, either a Frenchified Greco-Roman or a Frenchified Celt. That first *matière de Rome* remained secular, but after a generation or so of success it disappeared from the literary scene. In the case of the *matière de Bretagne,* the situation is quite different. The hero of the "Breton" romances of Chrétien

seeks, at the beginnings of the genre, a worldly ideal of a distinctly chivalric kind. But very soon he becomes, even in the works of Chrétien, a seeker of an ideal which in fact resembles sainthood. This metamorphosis of Perceval, for example, is suggested by Chrétien in his unfinished verse romance. It is fully carried out in both verse and prose continuations written, for the most part, in the first half of the thirteenth century. In these various continuations and *rifacimenti,* at least half of the questing heroes do in fact achieve the status of a saint.

There are many differences between the "hagiographization" of the epic and the novelestic hero. These differences are inherent in the very concept of hagiography, for they deal with the very complex problems of historicity of the *matière.* The early epic songs were treated as real *myths.* The poet served the myth that he sang. Whatever problems of credibility existed in the mind of the singer and the listener, the heroes and their stories were treated in a straightforward, non-ironic manner. They were treated as *real* myths, that is to say, as the truth. It is for that reason that, until the early years of the sixteenth century, pilgrims used to pray at the grave of Roland and Olivier in the church of Blaye. The problem is more intricate if we look at the romance hero and his status of authenticity. It is true that the monastery of Glastonbury did have a grave of *Arcturus rex Britaniae,* but Arthur has never reached the rank of sainthood, and the relationship between the Glastonbury grave and the romance is far more complex than the relationship between the *Song of Roland* and the grave at Blaye. Other heroes of Arthurian romances, so profoundly sanctified in the later stages of the development of the genre, have never, as far as I know, obtained a place of burial which would subsequently become an object of pilgrimage. This absence of Galahad's grave, to take but one example, shows that the profoundly "hagiographized" romances represent a far greater degree of literariness than the "hagiographized" *chansons de geste,* for in the romances there is no real confusion of *Dichtung* and *Wahrheit.* The romance myth has become a legend (although the term was, as far as I know, never used), that is to say a *legenda,* things to be read.[6] A legend is "true" in its moral implications, but not necessarily in its provable, factual references to historical events.

Let us notice that hagiography of any kind operates with two attitudes towards the truth: its subject matter can be presented as the epic "myth-truth" (e.g., the *Life of Saint Thomas Becket* or as far more distant "legend-truth" (e.g., the *Life of Saint George*). It was probably such attitudes that prompted Thomas of C(h)obham to lump naturally together in his *Summa confessorum* (written ca. 1215) those "qui dicuntur ioculatores qui cantant gesta principium et vitas sanctorum."[7]

We have seen the influence of hagiography in the two main Old French narrative modes, epic and romance. Hagiography, taken in its broadest

sense, is at the very origin and essence of Old French dramatic literature. Here, the influence of hagiography is so preponderant that the secular, profane dramatic literature seems to have come about only as an appendix, so to say, to the religious, cultic theater. The special character of vernacular dramatic literature does require a special treatment.

Special also is the situation of the hagiographic element in vernacular courtly lyrics. Marian poems constitute a sub-genre of this immensely popular genre. In such lyrics, the exultant outpourings of sentiment accompanied by analytic insights are directed, not at a lady, but at Our Lady. It is one of the ironies of fate that the genre of courtly love poetry has not survived the Middle Ages (unless we consider Petrarchism as its legitimate heir), while Marian lyric poetry has had a far more enduring existence.

So powerful was the influence of hagiography in most of the literary genres of the vernacular that it created a real symbiosis of the sacred and profane. One finds echoes of this symbiosis in literature which seems at first glance completely different in spirit from hagiographic legends. Such echoes are to be found, for example, in the bourgeois "dionysian" fabliaux and in the animal epic *Reynard the Fox*.

The closeness of the sacred and profane worlds explains the literary process which is directly inverse to the "hagiographization" of originally secular themes. It happened quite often (particularly in the last decades of the twelfth and the first decades of the thirteenth centuries) that a hagiographic legend was elaborated as a secular tale. Such a "secularization" can be seen, for example, in the *roman d'aventures, Guillaume d'Angleterre*. This romance, is a *rifacimento* of the *Life of Saint Eustache*. Especially interesting is the case of the *chanson de geste, Ami et Amile*. An originally pagan story of twin brothers (perhaps a now-lost epic song) became a legend of Saints Amicus and Amelius and then was "resecularized" into the epic *Ami et Amile*. Both "hagiographization" and "secularization" testify again and again to the close coexistence of sacred and profane elements in the vernacular heritage. Ultimately, they testify to the importance of hagiography in the general literary culture of the Middle Ages.

This consideration brings us to our second point: the importance of hagiography in the history of Old French literature in general. If literary history is a legitimate study, then it is a legitimate subdivision of history in general. In the study of history we are struck with the aptness of the old topos "natura non facit saltus." In so far as history dwells within nature, "historia non facit saltus" either. Here, I know, the commonplace is less common than in the case of Nature but I do believe that literary history does not really make leaps and that, if such a leap does appear to have been made, it is not a real leap in history, but rather a lacuna in our knowledge of it. If in our contemplation of the history of Old French

literature we ignore hagiography (as happens in the popularly-slanted manuals), or if we relegate it to a separate and self-contained entity (as happens in more thorough presentations of literary history), then it appears that the French literature of the thirteenth century did make a leap.

As we know, the "Golden Age" of Old French literature begins in about 1160 and lasts to about 1220. The best epic and romance narrative poems were composed (or recomposed) in that "Golden Age." Afterwards, an important change takes place. Epic songs of serious, mythic dimensions become fanciful, marvel-ridden tales in which the initial grip on myth and history is lost. Such epics will be raised later to the rank of masterpieces, but that development will take place outside France. But in France in the thirteenth century, French epic songs cease to be "vital," that is to say, concerned with basic problems of our collective existence. The very "vital" chivalric romances undergo a different kind of change which very much resembles a leap. After about 1220, they either become heavily and overtly "hagiographized," as we have seen already, or they become simply "flippant." The adventures cease to have this vital *sens* which they have in Chrétien, they become anecdotic for anecdote's sake, sometimes funny, sometimes immoral, often unrealistic (in the psychological sense), and fundamentally "fluffy" and escapist in essence. A specific elegant strain in romances, the one which was heavily influenced by courtly love lyrics, undergoes about that time yet another change. The adventures cease to take place in the world and move into the dream, into the head. I am speaking here, of course, about the *Roman de la Rose.* If we set aside the vernacular drama, we can see that Old French literature appears to have made a leap. It appears to have ceased to concern itself with mimesis, with the direct, serious, and sustained representation of human reality.

Here lies the fundamental importance of hagiography for the history of Old French literature. When the epic becomes "woolly" and fantastic, when the romance becomes "fluffy" and flippant, or allegorical and abstract, the function of the literary presentation of reality in a serious vein is taken over by the hagiographic narratives.

The growth and spectacular popularity of those narratives (popularity well vouched-for by the many hagiographic works, manuscripts, and references made to this genre) could be explained from two different vantage points. First, as already suggested, this development could be explained by the autonomous, inner process of Old French literature. The simple art-sustaining mimesis, chased out from epic and romance, finds its home in an essentially new genre, in the octosyllabic saints' Lives. Such an explanation is plausible. It flatters the purist in a literary historian: it explains a development without going to "outside" causes. But given the mimetic nature of hagiography, its close relation with the "outside" reality, it

compels us to look at the development of this genre also from another vantage point.

Let us remind ourselves what was happening at the start of the thirteenth century. Medieval Western European culture was in the midst of a profound transformation. This transformation was multiform and had been developing for a long time. Let us consider only three of the many aspects of the transformation that we could profitably discuss: the establishment of the Franciscan order, the founding of the Dominican order, and the Fourth Lateran Council. Both the *fratres minores* and the *predicatores* were involved, from the very outset, in the activities directed to a great extent toward the secular, urban, and largely vernacular world. Francis and, especially, Dominic were reacting to the challenge of the Cathers, who used the vernacular as a matter of rule and principle. The practice of preaching and teaching in the vernacular soon received the official sanction of the various Church authorities. The desire to reform the Church and to involve every Christian in the personal work of conversion were the main themes of the deliberations of the Fourth Lateran Council of 1215. Among other far-reaching effects, this Council formally approved the role of the Dominicans as diocesan missionaries, provided for the appointment of specially-trained priests in localities with more than one language and rite, allowed the bishop to designate the preachers (and confessors) in their stead, prescribed the founding and the maintenance of cathedral schools, stressed the necessity of annual provincial synods, and provided for the publication of their decrees.[8] We know that these local synods dealt specifically with the desired improvement of the pastoral work, involving what amounted to an upgrading of the vernacular culture. Thus, for example, the synodal statutes of bishop Richard Poore of Salisbury (1217–1219) included a canon *De agnitione fidei*, which required that the priests be knowledgeable in faith, informed about the decrees, and of moral behavior, in order that those "sacerdotes, prout eis deus inspiraverit, parochianos suos instruant et eis illam expositionem frequentur domestico ydiomate sane inculcent. . . ."[9]

The calls encouraging the use of the vernacular in pastoral work and, by extension, in pastoral and devout literature were readily answered in French-speaking lands, perhaps because French literature, through its own internal development, was ready for the "hagiographization" of secular themes and for the development and popularization of proper hagiographic themes. Lack of space prevents me from presenting the full extent of hagiographic works in Old French in the thirteenth century. Let me simply recall that these works, initially verse narratives, were followed by various *rifacimenti*, first in verse, later in prose. In the first epoch they generally took the form of the most prevailing narrative genre, that is to say, the octosyllabic couplets. Let me briefly describe one such poem which is typical of the genre. I choose it not only because

it is typical, but also for personal reasons. I have just finished a critical edition of a verse of a saint's Life, as well as of all the known later versions (both in verse and in prose). The saint is called Mary the Egyptian.

The story told more or less uniformly in all the versions is briefly as follows. A beautiful girl born in a Christian family in Egypt, before the Muslim conquest, leaves her family at the age of twelve. She goes to Alexandria, where she becomes a very successful prostitute. After seventeen years (an important number in hagiography for it signifies one-half of the life of Christ), she begins to feel the tedium of success. Abruptly, she decides to join a group of Libyan pilgrims who are sailing to Jerusalem. On the ship she seduces everybody, not just the young and foolish, but also, so the story says, the old and wise. In Jerusalem she continues in her ways, until one day she goes to the Church of the Holy Sepulchre. There, on the steps leading to the temple, she is prevented from entering by some mysterious force and receives a veritable thunderbolt of conversion. She prays to the Virgin and hears the voice advising her to go to the desert beyond the Jordan. She becomes a hermit. She suffers temptations of the flesh (chiefly the desire for food, drink, and music), but, after seventeen years of penance, she becomes free from them. She spends another thirty years in perfect inner peace. She goes about naked and never sees anybody, not even a beast. Before her peaceful death, she is discovered by a perfection-minded monk, Zosima. Zosima (later Saint Zosima) is a fascinating antithesis to Mary. A pious, rigorous monk of fifty-three years' standing in the monastery, he tends to consider himself perfect. However, some lingering doubts as to his perfection still remain with him. In the search for a more complete ascetic exercise, he goes to spend the forty days of Lent in the desert. During his stay there, he discovers Mary and learns her story. Next year, he brings her the Communion, and the year after he buries her body with the help of an obedient lion. He returns to his monastery to tell to the brothers and to us the story of a true sinner and true penitent. He praises the Lord for having shown him and us the true perfection in a woman.

The oldest, the "original," version of this legend is attributed to Sophronios, who was to become the patriarch of Jerusalem. (It was during his tenure in that office, in 637, that the Muslim armies conquered the Holy City.) The story was composed or, rather, reassembled from various sources in the first years of the seventh century. The Greek prose legend was translated "officially" into Latin several times; the earliest known translation goes back to 790. In Sophronios's version the main hero is Zosima, and the principal message, the search for monastic perfection. Zosima the philosopher (as he is called here) learns the truth concerning human perfection, not from his fellow monks and their wisdom, not from books, but from an old naked woman. (Zosima gives her his cowl to cover her nakedness.) The finding of Mary is an episode –

important as it is, but still an episode – in the life of Saint Zosima. The Old French poem will change this.

It is quite easy to see why the Old French poet in the early thirteenth century would select this story for elaboration. The themes of confession, penance, and the Eucharist, so basic in the legend of Mary, were being debated and defined at that time. The Fourth Lateran Council required annual confession and Communion from all the faithful. The same Council defined the Eucharist in terms of transubstantiation.

But far more important for us is the way in which the vernacular poet treated his materials. The poem is, first of all, a *roman d'aventure* about a foolish and impetuous but ravishingly beautiful woman. In Sophronios and his Latin translations (more or less accurate), we hear Mary telling her own story to Zosima in an awkward first-person. In the vernacular poem, it is the poet who tells it all. Well steeped in the romance tradition, he does not have to be either timid or modest. We get all sorts of details of her perfect beauty and many romanesque details concerning her clothing, her behavior, etc., during her sinful years. It is true that the poet has a much more difficult task forty-seven years later, when Mary is old, shrivelled, and covered with hair like a wild beast, but even there the anti-beauty is presented as a splendid example of what later will be called Gothic art.

Let us briefly examine but one detail which certainly illustrates the difference in literary art between Sophronios and his thirteenth-century elaborator. The friendly lion which helps the old and weak Zosima bury the saint is presented by Sophronios in a stark documentary fashion. The Greek gives just enough "facts" to make the mystical symbol (lion = friendly Nature) functional. After a brief scene which permits Zosima to realize that the lion is a friendly beast, he asks him for help with the grave: "Leo cum brachiis fecit ipse foveam, quanta ad sepeliendum sanctae corpusculum sufficere posset." After some details: "Deinde recedunt pariter; et leo quidem in interiora solitudinis quasi ovis mansueta abscessit."[10] In the poem, on the other hand, there is a graphic description of the lion working madly in the earth, of the monk and the lion collaborating in putting the body into the grave, Zosima carrying Mary's body by the head, the lion, by the feet. Then the poet says:

> Quant en le tere ont mis le cors,
> Zosimas s'en est issu hors.
> Dont dist le conmendation,
> Sans adjutoire du lion,
> Cil ne li pooit faire aiue,
> Car il iert une beste mue.
> Mais quant ce vint al racovrer,
> Ne l'estut pas ammonester;
> Tote le tere raüna,
> Sor le saint cors le ramena.

Aprés quant il l'ot raünee,
S'obedience ot akievee,
A terre s'est agnollié,
Signe fist de prendre congié;
Dont s'en est arriere torné,
El grant desert s'en est alé.[11]

The lion in Sophronios is a simple *fact;* it supplies enough information to put the myth in motion. The lion of the thirteenth-century poem is that, too, but in addition it is also a "living" literary *artifact,* a mimetic creation, which, besides his basic role as a tenor of a mythic "metaphor," has his own, real literary role, independent, so to say, of the mythos and the ethos of our legend.

I believe that examples of such "literalization" of the old "official" legends can be found in most, if not all, hagiographic poems written in Old French in the thirteenth century. They supply, as I have explained, an element of simple, recognizable representation of reality often missing, temporarily at least, in other vernacular genres. Here lies, I believe, the chief importance of hagiography in relation to literary history.

Let us turn to the third aspect of the problem, that is to say, to the importance of hagiography in itself, seen in its own "internal" history, as well as to the importance of this genre in cultural history in general. For an historian of culture, hagiography in the vernacular expresses perhaps more clearly and more precisely than any other genre the new, post-Franciscan and post-Dominican religious sentiments and attitudes. It is a precious and, I am sure, still hardly-tapped source of our knowledge about the popular aspects of the cultural history of the Middle Ages. It represents a kind of necessary counterbalance to an "aristocratic" view, according to which only the clerical, Latin *maiores* are worthy objects of attention for a serious historian of medieval thought. Much more must still be done in assessing the role of these humble vernacular writers. This role was very important, but at times it seems to have been lost, not so much in the shadows of our ignorance as in the glare of spotlights directed at their superior, Latin colleagues.

The thirteenth century witnessed a great success of hagiography in the vernacular. Anonymous poets, as well as the best-known "professional" writers, were producing a steady stream of good, solid poems of this genre. But this steady stream of hagiographic Old French poems dwindles to a trickle in the fourteenth century. It is important to understand the causes of this development, which has, more than the "external" antipathy mentioned above, contributed to the negelect of the genre by modern scholarship. These causes are truly "internal."

Although there is plenty of novelistic force in such poems as our Life, this genre differs profoundly from the purely novelistic romances. In hagiography, as in the true epic, the myth does take precedence over

literature. In spite of numerous elements borrowed, as we have seen, from romances, in spite of descriptions of Mary's charms, in spite of the "humanization" and "literalization" of the lion, in the *Life of Saint Mary the Egyptian*, literature serves the myth. And this myth is simple, straightforward, quite unchangeable. All hagiographic narratives operate along straightforward biographical lines. They follow simple chronological order, offering the story of birth (usually unusual), childhood (usually foreshadowing the future), life of temptation and/or of sin, conversion (usually sudden), repentance (usually long and arduous) and death (always pious). The repentant sinner is dead: long live the saint! is *in nuce* the story of every saint. The very simplicity of this basic scheme is, in my opinion, the reason for the rather sudden disappearance of the hagiographic poems in the fourteenth century. In about 1270, Rutebeuf was still capable of recomposing our poem.[12] He wished to bring it more closely to its source, that is to say, to the prose of Sophronios, by upgrading the role of Zosima and his fellow-monks. But once the audience learned the central mythical facts concerning Mary's legend, once the "codified" legend became firmly established in the mind of the reader, nothing really new could have been added to it. Without the possibility of additions, of "continuations," hagiographic poems began to wither away.

The search for authenticity, for the "truth" in telling, also helps to account for the disappearance of hagiographic poems. During the thirteenth century there was a steady attack on the literature of imagination in general and on verse narrative in particular. Verse narratives were attacked because they narrated imaginary adventures. Verse is a lie; prose is truth! Such sentiments were expressed more and more often during the course of the thirteenth century and after. Thus, for example, Buoncompagno da Signa states it most forcefully in his *Palma* (ca. 1200): "Tota scriptura trahit originem a prosa. Nam rithmi et metra sunt quedam mendicata suffragia, que a prosa originem trahunt."[13] At about the same time (1202), Nicolas de Senlis expresses in Old French a similar sentiment in the prologue to his translation of Pseudo-Turpin's *Chronicle*, dedicated to the Countess of Saint-Pol: "Maintes gens si en ont oï conter et chanter, mes n'est si mençonge non ço qu'il en dient e en chantent cil chanteor et cil jogleor. Nus contes rimés n'est verais; tot est mençongie ço qu'il dient; car il n'en sievent riens fors quant por oïr dire. . . . [La comtesse] si me proie que je le mete de latin en roman sans rime. . . ."[14] Whether such statements as these expressed a real moral concern, a conventional literary topos, or, as I suspect, a combination of the two, the fact is that, from about 1250 on, hagiographic poems began to have serious competitors. Two new kinds of hagiography appear more and more: 1. prosifications of poems and 2. translation (in prose) of the Latin "official," more "authoritative" sources. Both kinds of this new, "more authentic" prose hagiography

show, with a few exceptions, the virtual absence of the specifically novel-
istic devices which give literature its own life, a life independent of the
myth that it carries. The prose Lives have a literary *Wahrheit*, what they
often lack is the *Dichtung*.

But it was not only this New Wave of prose narratives which entered
into competition with the hagiographic poems. Another process, also
typical in the second half of the thirteenth century, has greatly contrib-
uted to the weakening of the genre. I have in mind compilations of the
Lives. Lives ceased to be considered as independent works and began to
be reworked as items in the collections. Such collections, or legendaries,
had a most natural tendency to abridge each Life (*abreviatio* was one of
the common composition devices taught), particularly since most of
them were known to everybody. Certain collections did continue the
verse form. They were, above all, the *Miracles of Our Lady*, containing
many saints' Lives in which the conversion and the subsequent pious
death were treated as miracles performed by the ever merciful Mother.
But most of the legendaries were in prose. Particularly revealing are those
in which the readings were arranged in the order of the liturgical year
(most of them dating from the fourteenth century). They very often
present a severely-abridged form of each Life. The best known and most
widely translated, imitated, expanded, and elaborated in the fourteenth
century is that best seller par excellence, the *Legenda aurea*, written in
Latin (ca. 1260) by the blessed Iacopo da Varazze (Jacobus de Voragine),
O.P. It is a *breviary* for the layman, and this term tells us everything
about its literary character. In the *Legenda aurea*, translated several times
in Old and Middle French, the *Life of Saint Mary the Egyptian* is reduced
to about three pages of print! To appreciate the beauty of this legend in
Jacobus's version, one must know it beforehand. He does not really
narrate the story, he does not move his reader, he offers a resumé, he
calls on us to contemplate the story that we already know.

Here lies the secret of both the triumph and the defeat of the genre.
The thirteenth-century poems were responsible for the widespread pop-
ularization of the hagiographic legends. But, since they did become so
well-known through the power of poetry, and since this very power
began to be treated as harmful to truth, there was no need to tell them
again, but only to remind us of them. They became part of the collective
conscience. Much later, in François Villon, for instance, the mythic
narrative becomes a simple topos. In the "Ballade to Pray Our Lady,"
when Villon said: "Pardonne moy comme a l'Egipcienne," his con-
temporaries still felt, I am sure, the whole impact of that myth. For most
of us today, however, this line requires a footnote.

The problem of myth and its literary representations is a perennial one.
I think that closer attention to Old French hagiography can teach us in a
very concrete manner how a vital *materia mythica* is exploited by litera-

ture, how it can give life to literature, and how it can stifle the very life it created. We can learn that in literature the myth is not enough, that hagiography in the vernacular ceased to be vital and productive, but not because people ceased to admire the saints. This lesson applies to other ages. No matter how "relevant" certain myths might appear to certain people in certain times, this relevancy does not guarantee the artistic power of the literature serving it. The myth alone does not suffice to assure the artistic potency of a genre.

In order to understand better the lessons which hagiography in Old French can teach us, we must convince ourselves, once and for all, that this genre is a legitimate and fertile field of study. We must convince ourselves that the proper study of literature must go beyond the examination of universally-recognized masterpieces to other, more humble genres. We are no longer hampered, I hope, by old hesitations and by past prejudices. Let us therefore turn to the study of hagiography in Old French freely and with fresh literary and historical insights. The first step in such a new appraisal of this genre must be, I am sure, a preparation of good, philologically-sound critical editions of hagiographic texts.

## NOTES

1. A shorter version of this paper was read at the Annual Meeting of the Mediaeval Academy held at Cambridge, Mass., on April 18, 1975. I am grateful to Profs. Stephen Nichols and Michael Curschmann for their valuable advice in preparing the final version.
2. For an example of Anglo-Norman local "patriotism," in regard to hagiography, see the popularly-slanted essay of Alfred T. Baker, "Saints' Lives Written in Anglo-French: their Historical, Social and Literary Importance," *The Royal Society of the United Kingdom: Transactions*, no. 4, 1924, pp. 119–156. I do not wish to enter into any Continental versus Anglo-Norman "quarrel." Let me simply state that the problem is a part of a longer one, i.e., the dialectal localization of a given text. It is often very difficult to ascertain the Anglo-Norman, or Picard, or Champanois *origin* of a given text, as opposed to a specific dialectal character of a given redaction. For a discussion of what seems to me a typical case, see my "Le Poème anonyme sur sainte Marie l'Egyptienne est-il anglo-normand?", soon to appear in *Atti del XIV Congresso internazionale di linguistica e filologia romanze*, Naples.
3. "Légendes hagiographiques en français," *Histoire littéraire de la France*, XXXIII, 1906, pp. 328–458. Paul Meyer has also published some other manuscript investigations of hagiographic literature in Romania, in the *Notices et extraits des manuscripts . . .* in the late nineteenth and early twentieth century.
4. See for example: J. D. M. Ford, "The Saints' Lives in the Vernacular Literature of the Middle Ages," *Catholic Historical Review*, XVII, 1931, pp. 268–277; Paul J. Jones, *Prologue and Epilogue in Old French Lives of Saints before 1400* (University of Pennsylvania dissertation), 1933; J. Merk, *Die Literarische Gestaltung der altfranzösischen Heiligenleben bis Ende*

*des 12. Jhds.* (University of Zürich dissertation), 1946; Willis H. Bowen, "Present Status of Studies in Saints' Lives in Old French Verse," *Symposium*, I, 1947, pp. 82–86.

5. Some scholars see a possible generic relationship between hagiography and epic. They believed that hagiography could very well lie at the origin of the *chansons de geste*. Such arguments have been used, for instance, by "literalist" Belgian school (M. Delbouille, M. Tysens, *et. al.*) in their controversies with the "oralist," "popular" camp. The clearest and the most specific recent expression of this generic relationship is to be found in Friedrich Ohly, "Zu den Ursprüngen der *chanson de Roland*," *Mediaevalia litteraria: Festschrift für H. de Boor*, Munich, 1971, pp. 135–153.

6. The complex relationship between the romances and the hagiographic legends is discussed most interestingly by Max Wehrli, "Roman und Legende im deutschen Hochmittelater," *Formen mittelalterlicher Erzählung. Aufsätze*, Zurich–Freiburg i. Br., 1969, pp. 155–176. Although his examples are drawn chiefly from German sources, the conclusions concerning the literary symbiosis of the sacred and the profane apply to Western European literature in general.

7. F. Broomfield, ed., in *Analecta Mediaevalia Namurcensia*, 25, Louvain–Paris, 1968, p. 292. These good singers of princes and saints "faciunt solatia hominibus vel in egritudinibus suis vel in angustiis suis et non faciunt nimias turpitudiness . . ." They are contrasted with the evil "genus histrionum" whose members "frequentant publicas potationes et lascivas congregationes ut cantent ibi lascivas cantilenas, ut moveant homines ad lasciviam, et tales sunt damnabiles sicut et alii" (*ibid*).

8. Cf. J. Hefele and H. Leclarc, *Histoire des conciles* . . . , V, Paris, 1913, pp. 1334–1340. Many critics and historians stress the general impact of the Lateran Council and of the subsequent local synods on the development of the vernacular religious and didactic literature. See, for example, M. D. Legge, *Anglo-Norman Literature and its Background*, Oxford, 1963, pp. 206–242. Miss Legge discusses only the Anglo-Norman scene, but her views apply also to the Continental vernacular.

9. F. M. Powicke and C. R. Cheny, *Councils and Synods* . . . , II, Oxford, 1964, p. 61.

10. *Patrologia latina* . . . , LXXIII, 1879, pp. 689–690.

11. P. F. Dembowski, ed., *La Vie de sainte Marie l'Egyptienne. Versions en ancien et en moyen français*, Publications Romanes et Françaises, Paris–Genève, 1976, Version *T*, p. 65, vv. 1467–1482.

12. Because of the importance of Rutebeuf himself, this work, contrary to most Old French hagiographies, has had two recent editions: B. A. Bujila, *Rutebeuf: La Vie de sainte Marie l'Egyptienne*, Ann Arbor, Mich., 1949, and E. Faral and J. Bastin, *Oeuvres complètes de Rutebeuf*, II, Paris, 1960, pp. 9–59.

13. C. Sutter, *Aus Leben und Schriften des Magisters Buoncompagno*, Freiburg i. Br.–Leipzig, 1894, p. 106 (I am grateful to my friend Harry Wohlmuth for pointing this citation out to me).

14. G. Doutrepont, *Les Mises en prose des épopées et des romans chevaleresques du XIVe au XVe siècles*, Bruxelles, 1939, p. 385. (Doutrepont discusses other examples of the identification of prose with truth on pp. 380–413, but his attention is drawn chiefly to the fourteenth and fifteenth centuries.)

# Magic that Does Not Work

## HELEN COOPER

The interest that the marvellous and the supernatural held for the authors of medieval romances is immediately apparent to any reader. It is almost equally obvious that the best chances of creating a sense of wonder or fear are frequently thrown away, as if the poets, having once introduced the requisite supernatural element, did not know what to do with it. The problem is particularly striking in the case of magic objects, talismans, and so on, where the reader's expectations are often baffled in ways which seem quite perverse. There is frequently – indeed, normally – a lack of excitement in the treatment of such talismans, and this is often reinforced by the minimal part they play in the plot itself. Every reader will remember cases of the hero's being given a magic ring – Richard Coeur de Lion even gets two, one to protect him against water, one against fire – which is just never mentioned again.[1] Chaucer assembles a fine collection of magic objects in the "Squire's Tale," and then stops short, as if, having once gathered all these marvels together, he was not really interested in developing a plot from them: indeed, it is hard to think of any kind of parallel plot in medieval romance that suggests how he could have done them justice. Of all the magic objects in the *Morte Darthur*, one whose magic power is among the most emphasized is the scabbard of Excalibur, which prevents its wearer from losing blood; but Arthur himself never has the opportunity of using it, and it is thrown away irrecoverably into a lake after it has only had one chance to show its virtue, and then on another man's behalf.[2] We had been led to expect that the scabbard would play an important part in the romance, but it is lost forever, without so much as a samite-clad arm in the water to receive it back. In addition to instances of this kind, where our expectations are frustrated in one way or another, there is a large group of talismans, characterized largely by their presence in the greatest of the romances, where the magic object is introduced with all the emphasis appropriate to it, and then, when the critical moment arrives, it fails to work.

A single example – fictitious in every detail but based on actual romance situations – will show just how strange a process this is. Suppose that the lady has presented her knight with a magic carpet. She has now been

carried off and is enclosed in a tower of Babylon in dire peril; and if the knight does not arrive within six hours she will be burnt alive, or married, or meet some equally dreadful fate. The hero has at his disposal the carpet, and also an airline ticket for a scheduled flight from London Airport (this is important: it is generally only in fairy-tales, as distinct from romances, that the magic is forced on the hero – that he rubs the lamp and the genie appears, whether he wants him or not. In romance he has the option of refusing the magic). It might now be expected that the poet would next describe the hero's astonishing and extraordinary flight through the air on his carpet; but this happens surprisingly seldom, even if those romances are included where the equivalent of the journey by carpet is as routine as the scheduled flight. It is much more likely that the hero will get onto the carpet – and nothing will happen. He has to flag down a taxi, rush to the airport, and arrive both there and at Babylon after everyone thinks he is too late. That the poet may mention later that the carpet was only programmed to fly to Camelot does not enhance its reputation as magic in the reader's eye. Alternatively, the lady may have given the hero the carpet with stern warnings about what will happen if he carries more than twenty kilos of baggage on it. In the excitement of the moment, he loads on two spare suits of armour and his horse; the carpet operates as promised, and all that happens afterwards is that the lady tells him he should not have taken the risk. There is also the possibility – perhaps the most frustrating of all – that the poet will state the initial situation and then, in the next sentence, present his hero safely arrived in Babylon and carrying on with his adventures, but with no mention at all as to which method of transport he used.

Ludicrous as these situations sound, they can all be paralleled many times over from medieval romances, and indeed from the romances of Chrétien de Troyes alone. The carpet that will not take off because the programming is wrong is Lancelot in the *Chevalier de la Charrette*, who finds himself trapped by a portcullis; he accordingly gazes on the ring that will protect him against enchantment. But the trap is quite natural; nothing whatever happens, and Lancelot has to fight his way out by ordinary means.[3] Was the ring really magic? We have to take Chrétien's word for it; but it is perhaps not asking too much of an author that his magic should not only exist but be seen to exist. The excess baggage warning is found in the strange incident in *Yvain* when a damsel smears the hero all over with a magic ointment when she has been strictly instructed only to put a little on his temples; she throws the box away, telling her mistress she dropped it; the lady expresses bitter regret, and that is the end of the matter.[4] The audience's expectations have been aroused and then let down, for no apparent reason. As for not knowing what happens, whether the magic has worked or not, Yvain is given a ring by Laudine that will protect him against all evil, sickness, and im-

prisonment, and so on; at the end of a year, when the ring is taken back, he is certainly still healthy and free, but whether the ring had anything to do with it we are simply not told.[5] Once again, it may be magic, but it is not being seen to be done.

The fact that Chrétien does theorize a little about the principles of romance has probably encouraged critics to push him too far for meaning in places where all that exists is plot – to find a *sens* crouching under every bush of *matière*. But a writer who thinks enough about his art to theorize at all should not be quite so careless as this. We are certainly entitled at least to ask what is going on – whether, since the magic in the events in question has little or no narrative function, it has any emotional or "moral" one, or whether we are facing a genuine cultural gulf: that perhaps Chrétien's audience preferred their magic not to work, or at least did not mind if it did not. Only one of these three incidents would seem to have a sufficiently strong and clear significance not to be bathetic, and that is the last – Yvain's protective ring. Laudine gives it to him after their marriage, when Yvain requests leave of absence to maintain his *los* in the chivalric world. She grants this on condition that he return in a year's time, the penalty being that he will lose her if he fails. He is horrified by the thought that he might be sick, or wounded, or in prison, and so lose her against his will; and she gives him the ring to protect him against all such eventualities.

> Neporquant bien vos promet,
> Que, se Des de mort vos deffant,
> Nus essoines ne vos atant
> Tant con vos sovandra de moi.
> Mes or metez an vostre doi
> Cest mien anel, que je vos prest.
> Et de la pierre, ques ele est,
> Vos dirai je tot an apert:
> Prison ne tient ne sanc ne pert
> Nus amanz verais et leaus,
> Ne avenir ne li puet maus,
> Mes qu'il le port et chier le taingne
> Et de s'amie li sovaingne,
> Einçois devient plus durs que fers.
> Cil vos iert escuz et haubers.
> (2596–610)

Yvain will be protected by two things: the ring itself and his love for Laudine: the first is only guaranteed by the second. The meaning is clear: the only thing that will prevent Yvain's return is Yvain himself. Every physical barrier has been removed in advance. In fact, he forgets; the ring is taken back, and the knight, faced with the basic disloyalty in himself and himself alone, goes mad – a kind of literal acting out of the state he is already in. He now has to fight his way back to wholeness,

and to Laudine, under his own strength. The magic of the ring has served no plot function in itself, and we have never seen it in action; but its very existence serves to highlight something in Yvain, to tell us about the nature of his failure and the nature of his recovery.

The idea behind all this seems to be that while "ordinary" magic – magic that works – may be of some use for the plot, it does not add anything of genuine significance; it may be appropriate for ballad or fairy-tale, but the process of turning tale into romance requires something more. Magic that does not work, by definition, has little to do with plot; but it can be used in a different way – used psychologically, rather than magically. It is, in fact, characteristic of the best romances that the super-natural that fails to work should be used to measure and define the human. Later writers seem to use this almost as a formula; Chrétien, on the other hand, still seems to be struggling to find the right way of expressing it. Even this incident of the ring, where the magic does seem to have a genuine structural function, is muddled by the conditions attaching to it: since its magic depends on Yvain's remembering Laudine, and since he in fact forgets her, does the magic still operate, or it is rendered useless? Is he saved from sickness and imprisonment by wearing it, even though he does not fulfil the condition of thinking of her? Happily, the ring is never put to the test by Chrétien – it will not take such logical analysis. It makes one point – the point of Yvain's inner failing – and that is enough.

By contrast, many of the leading romance writers do use the magic that does not work very well indeed, with none of Chrétien's experi-mental uncertainty. The wonder that one might expect to expend on the magic is transferred to the emotional meaning it points to; and the frustra-tion of plot, in the talisman that never operates, is transmuted into a de-velopment of the inner significance that could never be so simply and clearly achieved in any other way.

It follows from this that it will be poets with the greatest interest in human emotion who will use the formula best; and, not surprisingly, one of the earliest writers to exploit the theme is Marie de France. The ro-mance demands a certain emphasis on plot and event such as perhaps calls for a more functional kind of magic, but Marie's *lais* transfer the interest from the external event to the internal, the emotional. Her *lai* of the two lovers, *Les Deux Amants*,[6] can be taken as a definitive example of magic that fails to work magically but that does work for the poem. Here, the heroine's father has laid down that no one shall marry his daughter unless he carries her in his arms up a steep mountain – a task that is in human terms impossible. A number of suitors try, and inevitably fail; but finally, a young nobleman falls in love with her, and she with him. In order to enable him to pass the test, she sends him to her aunt, who is skilled in herbs and medicines, to get a potion that will give him the necessary strength; a potion, in other words, that will give him super-

human powers. He obtains the potion; but on the day of the test he is so overjoyed to see his lady that he forgets to drink it. As he climbs with her she notices his strength failing and urges him to drink, but he refuses, twice. He completes the climb under his own strength; but when he reaches the top, he dies. She tries to revive him with the potion, but without success, and she breaks the vessel and spills it. The lady dies on her lover's body, and they are buried in a single tomb.

A man needs more than human strength to surmount this barrier to love: the drink is provided as the necessary supernatural means, but in fact the superhuman power is to be found in his love itself. The supernatural properties of the potion are transferred to his emotion – they become the means of revealing the potential of the human. The magic object becomes the focus, the measure, and the means of definition of heroic ideals and sublime emotions. As magic, it is useless; but then, magic is not what is at issue here. The potion is used to make a point, not about the nature of the supernatural, but about the nature of love.

This basic pattern, the supernatural used to measure the human, and its properties transferred to the human, recurs many times, especially in the first great flowering of the romance in late twelfth-century France; but it is used many times again by writers working in different centuries and different languages. It seems unlikely that its wide diffusion can be accounted for by coincidence – that it is part of the "matter" of a series of different stories – for then the emphasis on the human aspect would not be so consistent. Also, it is almost of the essence of magic that does not work that it is not part of the plot, and so not part of the basic outline of a story such as is likely to be preserved in oral tradition or in repeated treatments of the same material. It is typical of courtly romance; it is almost unheard of in popular romance or ballad or folktale. It seems to belong solely to writers with a conscious sense of literary purpose, even to have been part of the stock-in-trade of the good romance poet. Magic in popular romance either works or else it is forgotten, and in either case its interest generally stops there. In the great romances, the magic that fails to work opens the way towards the realization of human ideals.

That such magic is not essential to the plot, and is only found in the more courtly, or more thoughtful, treatments of a story, is illustrated by a number of romances. *Horn* is one example where it is possible to see the process in action. Here, the magic object is a ring– one of the most widespread talismans of romance and folktale of all ages – and it is used, or rather it can be used, in just the same way as the potion in *Les Deux Amants*, as a means of defining the emotional statement at the heart of the poem. It seems highly probable that, unlike the great majority of English romances, *Horn* was originally composed in English, and the Anglo-Norman version is based on an English source. The earliest surviving English redaction, the thirteenth-century *King Horn*, probably

represents the original most closely.[7] It is in this version that the ring functions most effectively as a symbol and least effectively as magic. It is introduced in the course of Rymenhild's wooing of the hero. He refuses to become her lover until he shall have proved himself in battle; and thereupon she gives him the ring.

> Tak nu her þis gold ring,
> God him is þe dubbing;
> Þer is vpon þe ringe
> Igraue Rymenhild þe ȝonge.
> Þer nis non betere anonder sunne
> Þat eni man of telle cunne;
> For my luue þu hit were
> And on þi finger þu him bere;
> Þe stones beoþ of suche grace
> Þat þu ne schalt in none place
> Of none duntes beon ofdrad,
> Ne on bataille beon amad.
> Ef þu loke þeran
> And thenke vpon þi lemman.
> (C 563–76)

The effect is rather spoiled by the next two lines:

> And sire Aþulf, þi broþer,
> He schal haue anoþer,

but the poet recovers enough tact not to refer to this one again. Horn's ring, however, is mentioned frequently. Whenever he is in battle against heavy odds,

> He lokede on his ringe,
> And þoȝte on Rymenhilde,
> (C 613–14, 873–4)

and each time gains the victory. This could hardly be less convincing as magic. If he remembers to look at the ring – and he certainly makes a habit of it before fighting – then, of course, he is thinking of her; and it is a courtly commonplace that a knight who sets his thoughts on his lady in battle fears no blows and emerges victorious. There needs no magic ring to tell us this; and indeed, if it were not for Rymenhild's specific statement that it is the special "grace" of the stones that makes him think of her and keeps him steady in combat, it would never occur to us that magic was involved at all. In effect, magic is not involved; the ring becomes simply a symbol of their love. The condition of thinking of his lady to make the magic work – the condition that causes the crucial confusion in *Yvain* – here becomes the very point of the story. The *Horn* poet does not indulge in the fine analyses of courtly emotion such as Chrétien loves: the issue is presented in the ring alone, and it is left to the listener to draw his own conclusions.[8]

Other versions of *Horn* show what happens when the story is popularized, or even when such a delicate use of magic passes into a different poet's hands. The Anglo-Norman *Horn*, courtly as it is, loses much of the symbolic power of the ring by making it more specifically magic. Its introduction into the poem is weakened by the fact that it is the third occasion on which Rigmel has offered Horn a ring: once he refuses, the second time he accepts the same, non-magic, ring as a love token, the third time Rigmel exchanges this for the magic ring. This second ring will protect the wearer from death by fire, water or battle (ll. 2055-9) – and while this is clearly useful for Horn, if the poet made too much of it, it would detract from his prowess: it is hard for a hero to prove his heroism if he knows he is invulnerable. It is accordingly only mentioned once in the course of a battle, in Horn's combat against Rollac, the pagan who had killed his father; and then it is made clear that it is that fact, rather than love of Rigmel, that most fiercely spurs Horn on (ll. 3166ff.). The main function of the ring is as a recognition token when Horn returns to Rigmel in disguise: it serves as a plot device, not as magic. The same recognition scene occurs in *King Horn*, but there, where the ring has already acquired its quiet potency as a symbol of love, the incident becomes much more charged with meaning; it is the power of love signified by the ring, as much as the object itself, that reveals Horn to Rymenhild.

There are two other versions of the story, the romance of *Horn Childe* from the Auchinleck manuscript and the ballad *Hind Horn*,[9] where the magic ring is essential to the plot. Its property in both these versions is that its stone turns pale if the heroine's love fades. Horn notices the pallor of the stone while he is absent and hurries back to prevent her from being married to another suitor. The magic works magically; and the essential quality of *fin' amor* of the earlier version is lost. What had been the symbolic projection of a courtly and emotional truth becomes a piece of supernatural mechanics. *Horn Childe* may itself be a romance created on the basis of a story current in oral tradition, and the ballads were certainly orally transmitted; it is only the rare individual poet who can raise magic to the level of symbol. Magic that works, magic that is part of the plot, is preserved through any retelling of a story; it is a single poet writing for an audience of some culture or sensibility who can create a higher level of meaning. It would seem likely that the original ring was of the *King Horn* type, and the popular versions have substituted a different folklore motif in an attempt at rationalization;[10] but in doing so they have lost much of the distinction of the original. The point of remarks such as Chrétien's address to his audience at the beginning of *Erec et Enide* becomes clear in this kind of context: high romance makes demands of a different order on its readers and works in a different way from a mere story, and "cil qui de conter vivre vuelent," professional story-tellers, usually spoil and corrupt their stories.[11]

Both types of rationalization – the Anglo-Norman poet's desire to explain in what way the ring is magic, the more popular versions' change of the ring's function – detract markedly from the romance. The heroine's love has to weaken, even if only temporarily and by mistake, for the ring to become pale; and Horn's bravery loses its edge if he is invulnerable. The talisman of invulnerability always presents problems of this kind, and it needs a fairly drastic convolution of plot to make such an object interesting. The scabbard of Excalibur is a striking instance of this: in the one episode in which it plays a part, it has been stolen by Morgan le Fay for Accolon to use in his combat with Arthur. The King has to prove his heroism, not while he is protected by the scabbard and fighting with the never-failing sword, but when his opponent has them; he has to fight against supernatural odds, and yet he wins. The magic in this instance does at last work, but not in the way the plot had seemed to promise, and the effect is to make the reader wonder, not at the magic itself, but at Arthur's courage and skill. The point that emerges is the same as in *King Horn* or *Les Deux Amants:* human qualities at their highest can only be measured by comparison with the supernatural.

There is another talisman of invulnerability, again a ring, in *Floris and Blauncheflour,* and again it is used not to protect the protagonists by its virtue but to illustrate their own inner qualities. The earliest surviving version of *Floris* was composed in French in about 1160–70; an English version based closely on this was made in the thirteenth century, and, as the passages concerning the ring are essentially similar, the English is quoted here. The ring is given to Floris by his mother, the Queen, when he sets out to search for his sweetheart Blauncheflour:

> Of hur fynger she brayde a ryng.
> "Haue now þis ylke ryng.
> While it is þyn, douȝt noþing
> Of fire brennyng ne water in þe see;
> Ne yren ne steele shal dere thee."[12]

He eventually finds Blauncheflour in the tower of the Amiral of Babylon; the catastrophe is precipitated when the Amiral finds them in bed together, and they are taken out to be burnt.

> Florys drouȝ forþ þat ryng
> Þat his moder him gaff at her partyng.
> "Haue þis ryng, lemman myn;
> Þow shalt not dye while it is þyn."
> Blaunchefloure seide þoo:
> "So ne shal it neuer goo
> Þat þis ryng shal help me,
> And þe deed on þe see."
> Florys þat ryng hur rauȝt,
> And she it him agayn betauȝt.
> Nouther ne wyl other deed seene;

> Þey lete it falle hem bytwene.
> A king com after; a ryng he fonde,
> And brouȝt it forth in his honde.[13]
>
> (E 966–79)

All the onlookers except the one who matters, the Amiral himself, are filled with pity. The king who picked up the ring also "wolde hem saue to þe lyf,/ And told how for þe ryng þey gon stryf" (1000–1); and he manages to persuade the Amiral to recall Floris for questioning, twice, so that finally the whole story comes out and everything ends happily, with the Amiral marrying Claris, Blauncheflour's companion, and Floris becoming King.

Looked at literally, this romance poses the question: is it the ring that saves them? does it, by a special extension of its magic powers, protect them both, even though neither is wearing it? The repetition of "þat ilke king *þat þe ryng fonde*" whenever he intervenes to delay the lovers' deaths suggests that perhaps it does. But the question is, of course, irrelevant to the central issue. What saves them is their total faithfulness and courtesy towards each other, and the ring does nothing so much as epitomize the absoluteness of their love.

It is an absolute in emotional terms, like the potion of *Les Deux Amants*, not in magical terms: in neither case do we see the magic working magically. It is perhaps worth mentioning, as a further indication of the *Floris* poet's priorities, that the other magic items in the romance are treated very perfunctorily. In the Amiral's garden is a Tree of Love; pure maidens (distinguished by a magic stream alongside that yells whenever an unchaste girl washes in it) are brought underneath it, and a flower falls on the one who is to be the queen. Moreover,

> Ȝif any mayden þer is
> Þat þe Amyral telleþ of more pris,
> Þe flour shal be to her sent
> Þrouȝ art of enchauntement.
> Þe Amyral cheseþ hem by þe flour,
> And euer he herkeneþ after Blancheflour.
>
> (E 637–42)

In other words, the magic can be arranged to suit the Amiral's own preference; the "supernatural" tree has no part in the choice. As a purely magic object, only the stream is left, and that is described briefly and never plays any part in the plot. The author, obviously, is not in the least interested in magic for its own sake. What interests him about the tree is that the Amiral is particularly fond of Blauncheflour; what interests him about the ring is that it is a means of showing how much the lovers care for each other.

The principle that magic that fails to work emerges only in individual courtly treatments of a story still generally holds good for *Floris;* but the

matter is especially complicated because of the unusually wide dissemination of this romance and the still unsettled debate as to which versions derive from what. The romance is found in two distinct French versions, known as the "roman idyllique" (or "aristocratique" – the earliest extant) and the "roman d'aventures" (or "populaire"); and also in English, Middle High German (by Konrad Fleck), Low German, Dutch (by Diederik van Assenede), Norse, Swedish, Italian, Spanish, Greek and a few other languages and dialects, each deriving ultimately from one or other of the French redactions or their lost common source.[14] One group of versions, including the English, Fleck's, and Diederik's, derives from the "roman idyllique" and does preserve the ring and its non-magical operation. The second French version, however, contains no ring at all; a third group, consisting of the Italian *Cantare di Fiorio e Biancifiore*, Boccaccio's *Filocolo*, and the Spanish romance, contains two rings. The first is given to Floris by Blauncheflour, and its property is to turn pale if she is in trouble; it functions, correctly and magically, in an episode of false accusation prior to her removal to Babylon. The second ring has the same properties as the one in the "roman idyllique," but here it works: the lovers each try to give it to the other, then they both hold it, and they are preserved in the midst of the flames.[15] In the *Filocolo* they call on the gods for help in addition; and the gods step in to save them, though Boccaccio admits that the intervention was superfluous – "assai gli aiutasse l'anello."[16] For him, the ring really is magic, not symbol; but he seems to feel that something is missing and tries to supply the lack by providing divine support for the faithful lovers. The northern versions also have the ring work magically, but in a different way: Floris offers to prove their innocence by combat, and the ring ensures his victory.[17] The same critical point emerges from all these variations: that magic that works cuts through the knot of the plot and provides a brief moment of wonder; magic that fails to work matters much less for the *matière*, but is enormously important for the *sens*. The love that refuses to save itself at the cost of the lover's life is a far more profound thing than a piece of supernatural plot mechanics.

A similar process of rationalization, of making the magic work, is sometimes illustrated in the course of the transition from the poetic to the prose romance in France in the early thirteenth century. Lancelot's ring in the *Chevalier de la Charrette* seems to be at least halfway towards the inwardly significant kind of magic; in the prose *Lancelot* it works magically, though without much significance even for the plot. He uses it twice in each romance. In the Vulgate version, the first occasion comes in the course of his trials at the Val sans Retour, where, after overcoming the dragons who guard the place, he is faced with a plank kept by two knights; when he looks at the ring, both plank and knights disappear – "lors sot il bien que cest enchantemens si en est moult dolans."[18] His grief

seems to be caused not by the fact that he is in opposition to supernatural forces, but because he has been foiled of an opportunity for showing his own strength; and the strange passage in Chrétien that roughly corresponds to this, the non-enchanted portcullis, had at least retained the test of Lancelot's prowess. The supernatural removal of magic opposition, like invulnerability itself, does not show the hero in a particularly heroic situation. The second use of the ring in both versions occurs at the sword-bridge, when Lancelot sees the lions awaiting him on the other side. In Chrétien, he crosses the bridge and finds that the lions have vanished; he looks at the ring, and the lions remain vanished – in other words, they are genuinely not there, they have not been rendered invisible by enchantment. In the prose version, Lancelot fights the lions but cannot hurt them; finally he looks at his ring and they disappear.[19] It makes a more exciting story – Chrétien's account is markedly bathetic as far as the plot is concerned; but his lions do contain a rich suggestion of being psychologically symbolic phantoms, the creation of Lancelot's overwrought imagination, and this the later version loses. Chrétien's ring may have no startling effects, but it makes the audience think.

There are none the less a few occasions when it is possible to see the opposite process in action: to see an individual great poet working on the magic of his source and transmuting it into symbol – into magic that does not work. It seems likely that the "Franklin's Tale" belongs here. Although no precise source for the story is known, the closest analogue, by chance again from the *Filocolo* (where it forms a part of one of the long digressions),[20] has the magic working: the suitor to the heroine hires a magician to produce a beautiful garden in January, the garden is conjured up, the lady and her companions walk through it. By contrast, the rocks as actual physical objects are remarkably unimportant to Chaucer. They are significant because they represent Dorigen's fears for her husband; and when it comes to the point, Chaucer does not actually state that they disappear – "it *semed* that alle the rokkes were aweye."[21] It is of no consequence at all whether they are really still there or not; nobody in the tale apparently goes to look. The question at issue is not whether the magic has worked or not, but how this will make everybody behave. Like Floris's ring, but much more explicitly, it makes everyone emerge in a much better and clearer light than they could have done without such a catalyst. The vanishing of the rocks constitutes a trial, a kind of moral *épreuve*, through which each of the characters must pass; and each of them wins through. It is another detail which helps to bring the poem closer to the genre of the Breton *lai*, as the Franklin claims it to be: even the most striking incident of the poem is something of a non-event physically, and it is the emotional and human significance that counts. The emphasis moves from the narrative stress of the romance – *Horn* and *Floris* contain plenty of adventures apart from the ring episodes, and even

the story of the garden in the *Filocolo* puts much more emphasis on events and objects – towards the kind of emotional statement made by the greatest of the *lais*.

There is another possible instance of this kind of elevation of the human at the expense of the magic in Gottfried von Strassburg's *Tristan*, in the episode of the magic dog Petit-creiu.[22] The lovers are undergoing one of their periods of separation, and they are desperately unhappy. Tristan, who has withdrawn to Wales, defeats the giant Urgan in order to win the animal, which has two remarkable properties: its fur is of every conceivable colour; and from its collar hangs a bell whose sound banishes all sadness. Tristan wins it, not to solace himself but to send to Isolt, who has it carried around with her everywhere. Up to this point, Gottfried is certainly following his source, Thomas's *Tristan*, for the other versions based on that, the Norse *Saga* and the English *Sir Tristrem*, both contain the incident.[23] But in the conclusion to the episode, which only Gottfried's contains of all the surviving versions, Isolt breaks the bell off its chain, for she has no wish to be happy while Tristan is suffering; and the animal's constant presence increases her grief by reminding her of her lover's absence:

> Si tetez, als uns diz mære seit,
> ze niuwenne ir senede leit
> und ze liebe Tristande.
>
> (16352–54)

The magic that was designed to bring happiness results in greater sorrow. Whether Gottfried found this passage in Thomas it is impossible to be certain. That it is not contained in the other versions proves nothing, for it is in the nature of this kind of magic to be lost in repeated retelling. It would take a courtly writer such as Gottfried to preserve it, or to invent it. Whether the ending is included or not, the basic story outline is not changed at all: it is not necessary to the plot, and can be dropped without leaving a noticeable gap. Once again, the magic that does not work, the happiness-bearing bell that increases sorrow, has nothing to do with *matière* and everything to do with *sens*. As a story, the romance stands still while the incident is acted out; as a presentation of *fin' amor*, it takes a great leap forward.[24]

This is the only episode known to me where the protagonist deliberately puts the magic out of action; and as such it is a particularly striking illustration of the point mentioned earlier, that the protagonist has the option of using the magic or not – it does not just happen. Horn looks at his ring, he does not just catch sight of it on his hand; Yvain fails to fulfil the condition of Laudine's ring by never thinking of her; Floris and Blauncheflour each try to renounce the magic available to them; the lover of *Les Deux Amants* is reminded of the potion, but he still refuses. Even in *Perceval*, Perceval's failure to ask the question is never presented

as bad luck on his part: that he does not set in motion the supernatural processes for the healing of the Fisher King is clearly implied to be the result of a chivalric and moral failing for which he has to atone. He is not yet sufficiently "superhuman" to be able to use the supernatural. The great exception in all medieval romance to this deliberate use of, or refusal to use, magic, is Tristan's love-potion – magic that most emphatically does work, and without which the story would be unthinkable; at the least, it would be a different story. Both its importance for the plot, and the fact that the lovers drink it entirely accidentally, suggest that its origins lie outside the bounds of courtly romance. Even here, however, the writers with the clearest artistic sense of the romance can be seen working to transform the magic, to make it less a matter of story and more a matter of emotion. The potion tends to be least effective in terms of romance when it is most obviously a magic device, in the versions (probably including the original of all the extant redactions[25]) where its effect diminishes after three or four years. There is no question of such a time limit in Thomas or Gottfried, however. There, the love is insuperable, inseparable, and singular, so the potion must act accordingly: the magic must obey the demands of courtly feeling, and the plot must follow behind. Even before Gottfried's lovers drink, they are clearly on the edge of the precipice of love, even though neither of them recognizes it: the potion stands almost as much for the moment of realization as for the cause of their passion. It guarantees that their love is beyond any rational control and puts the lovers outside any normal moral context; but Gottfried in particular is concerned to bring out its symbolism – these are the effects of love at its highest and the greatest love acts *as if* it possessed supernatural force. The magic, once again, is being used as an image of a courtly truth, as a way of transferring supernatural effects onto superhuman emotions. It is this, the symbol rather than the potion itself, that Criseyde is referring to when she asks, "Who yaf me drynke?"

Most romances give the impression, however, that it is harder to draw such richly symbolic conclusions from magic that does work than from magic that does not. If it works, that in itself seems to be enough to satisfy author and audience; obviously it has a higher sensation value than the supernatural which is never proved to be so, as well as being much more useful for plot. But how to coax a convincing moral or emotional meaning out of what often seems to have been rather crude source material, or at least material that possessed no inner courtly *sens*, must have presented a perennial problem for the romance poet, and to have magic that works on the emotional level is a useful solution of the difficulty: a transformation of narrative and action into an ideal of the mind and heart.

In none of the examples I have discussed are we seriously invited to question whether the magic would work if it were given the opportunity. Several of the authors are at pains to confirm that it would: Tristan gets

the idea of winning Petit-creiu for Isolt because it makes *him* feel happy; the vegetation around Marie's mountain grows thick where the potion is spilt; Floris and Blaunchflour are indeed saved, and Horn does fight better for looking at the ring. But in *Sir Gawain and the Green Knight*, a romance that uses every technique or convention of the genre in brilliant and totally unexpected ways, we find that the question has already been asked. When the poet gives us a situation that looks identical – the talisman that has magic properties ascribed to it and that does not work in the manner that the reader has been led to expect – the problem is in fact reversed: for the object in question, the green lace that the lady gives to Gawain, is the only instance in romance where one assumes that the magic does not work, even that it is not magic at all, and where the lingering question at the back of one's mind afterwards is that perhaps it may have been magic, after all. The lady assures Gawain that he will not be killed while he is wearing the girdle, just as Floris's mother assures her son of the properties of the ring, and certainly neither hero is killed; but there must be very few readers who seriously believe that Gawain survives because of the girdle. The Gawain-poet's solution of the problem of making a talisman that bestows invulnerability interesting is peculiarly drastic. It is a talisman that even Gawain does not put too much faith in (he would not be so scared if he really thought he was invulnerable) and that turns out to have just the opposite qualities of those ascribed to it, so that the lace becomes not the reason for his survival, but the reason for his injury. That the hero has the option of using the talisman or not becomes the central issue of the romance: for, presumably, if Gawain had maintained his *trawþe*, his integrity, and had either refused to accept it or else had handed it over to the lord, he would not even have been wounded. So much, at least, the Green Knight implies;[26] but it is only his word against the lady's, and it is no more possible to prove that it is he who is speaking the truth than that it is the power of the stones in Horn's ring that gives him strength. Neither poet wants to close the issue.

As well as turning the idea of the talisman of invulnerability inside out, the Gawain-poet also gives it a meaning directly opposite to the normal significance of the magic object: it symbolizes, not Gawain's achievement, his attainment of the superhuman absolute, but his failure, and his failure on that very same issue – that he is not, after all, superhuman, but human and therefore fallible. Perceval, too, was fallible, but his story is the story of the attainment of perfection. For Gawain, the code of the pentangle has eliminated all imperfection from every action within his conscious control; but it does not take into account the final and basic human instinct, the instinct for survival. The magic lace, the straw Gawain catches at in the hope of staying alive, is used to identify him, not as the hero who can reach out beyond normal human (or courtly) experience, but as the hero who is ultimately and essentially a man.

The romance is a genre that is easier to describe than to define, but the

idea of magic that does not work gives some indication of how some of the leading poets understood their task. The romances may be good stories, but that is not their point: they are about meaning *within* action. The concept of magic that works symbolically is one way in which the idealism essential to the romance form can be expressed: to crystallize the absolute in a supernatural object, and yet to realize that absolute in human terms. Marie de France and Gottfried and the anonymous poets of *Horn* and *Floris* use it to express the ideal within the human; the Gawain-poet, to express the human within the ideal.

# NOTES

1. *Der mittelenglische Versroman über Richard Löwenherz*, ed. Karl Brunner, Wiener Beiträge zur englischen Philologie, 42 (Vienna, 1913), ll. 1637–46. For other examples, see e.g. *Sir Eglamour*, ed. F. E. Richardson, EETS, 256 (London, 1965), ll. 616–21; *King Horn*, ed. Joseph Hall (Oxford, 1901), C 577–8 (see note 7).

2. *The Works of Sir Thomas Malory*, ed. Eugene Vinaver, 2nd ed. (Oxford, 1967), pp. 54, 140–51. Malory is working from the French prose *Merlin* (ed. Gaston Paris and Jacob Ulrich, SATF [Paris, 1886], II, 179–222), but he omits any mention of the eventual recovery of the scabbard given in the French.

3. Ed. Mario Roques, CFMA (Paris, 1958), ll. 2335–55.

4. Ed. T. B. W. Reid, corrected ed. (Manchester, 1967), ll. 2946–3011, 3090–130.

5. See ll. 2596–610 (quoted below), 2767–80.

6. *Lais*, ed. A. Ewert (Oxford, 1944), no. VI, pp. 75–81.

7. *The Romance of Horn*, ed. Mildred K. Pope and T. B. W. Reid, Anglo-Norman Text Soc., 9–10, 12–13 (Oxford, 1955, 1964), II, 20, and M. K. Pope, "*The Romance of Horn and King Horn*," *Medium Ævum*, XXV (1956), 164–7. My references to *King Horn* are to Hall's edition (see note 1).

8. If this kind of magic is typical of the sophisticated or courtly romance, rather than the popular, it is perhaps necessary to justify the classification of this version of *Horn* as courtly. The whole action is based on the concept that Horn must prove himself at every stage before he will accept any of Rymenhild's favours, culminating in his determination to win back his kingdom before he will consummate their marriage. Horn is a hero whose parentage is unknown, like Tristan or Perceval, and who wins recognition, and the audience's respect, through his high chivalric prowess and his ideals. This is not the kind of thing that is produced for an exclusively popular audience, nor for a noble audience's less refined sensibilities – and neither is the rather subtle treatment of the magic of the ring.

9. *Horn Childe* is printed by Hall as an appendix, pp. 179–92; the ballads of *Hind Horn* are in *The English and Scottish Popular Ballads*, ed. Frances James Child (1882–98; reprinted 5 vols., New York, 1965), I, 187–208 (no. 17).

10. See the ring motifs in Stith Thompson, *Motif-Index of Folk-Literature*, revised ed. (Copenhagen, 1955–58), D 1076, D 1310.4.1, D 1344.1, H 433.1, H 94, and H 94.4, though as several of the references cited by Thompson are to the *Horn* romances, the argument becomes somewhat circular. Even

so, the indirect bestowal of prowess found in *King Horn* does not fall under any of Thompson's headings, a further indication of the poet's distance from popular literature.

11. Ed. Mario Roques, CFMA (Paris, 1953), ll. 1–22.

12. *Floris and Blauncheflur*, ed. F. C. de Vries (Groningen, 1966), E 374–8. The French MS to which the English most closely corresponds, MS B of the "roman idyllique," is edited by Margaret Pelan, Pub. de l'Université de Strasbourg (Paris, 1937), see ll. 1010–19.

13. Cf. Pelan, 2586–7, 2597–605.

14. De Vries's division of the versions by their derivation from the two French versions (*Floris*, pp. 54–60) is very much over-simplified; Gaston Paris's review of Crescini's work, cited in note 15 below, in *Romania* XXVIII (1890), 439–47, probably represents the true situation better. He does not consider the protective ring in drawing up his scheme of relationships. The French "roman d'aventures" is edited by Margaret Pelan, *Floire et Blancheflor: Seconde Version*, Pub. de l'Université de Strasbourg (Paris, 1975). The ballad of *Blancheflour and Jellyflorice* (Child, V, 175–6, no. 300), contains almost nothing of the original romance, including the ring.

15. See Vincenzo Crescini's account of the various versions in his edition of the *Cantare*, Scelta di Curiosità Letterarie, 233, 249 (Bologna, 1889, 1899, reprinted 1969), I, 437–40; the episodes occur in II, stanzas 23–4, 36, 91, 132–4.

16. Ed. Salvatore Battagli, *Boccaccio: Opere 1, Scrittori d'Italia* no. 167 (Bari, 1938), p. 427; the properties of the ring are described on p. 274.

17. See Crescini, I, 438, and *Flóres Saga ok Blankiflúr*, ed. Eugen Kölbing, Altnordische Saga-Bibliothek, 5 (Halle, 1896), xxiii (p. 74).

18. *The Vulgate Version of the Arthurian Romances*, ed. H. Oskar Sommer, Carnegie Institute of Washington, 7 vols. (Washington, 1900–16), IV, 120, lines 38–9. The ring is given, and its properties described, at III, 123, lines 31–3.

19. *Chevalier*, 3118–28; *Vulgate*, IV, 201, lines 2–4.

20. *Filocolo*, Bk. IV, qu. iv (pp. 311–25).

21. *The Works of Geoffrey Chaucer*, ed. F. N. Robinson, 2nd ed. (London, 1957); *Canterbury Tales*, V (F) 1296.

22. Ed. Gottfried Weber (Darmstadt, 1967), lines 15791–890, 16333–402.

23. See *Le Roman de Tristan par Thomas*, ed. Joseph Bedier, SATF (Paris, 1902–5), I, 217–31 (ch. xxv). Bedier argues in a long note (pp. 226–229) that Gottfried also found the conclusion to the episode in Thomas; since the whole incident was apparently not in Thomas's source, the point under discussion remains the same whether Thomas or Gottfried invented the ending. On the whole episode, see Louise Gnädinger, *Hiudan und Petitcreiu* (Zürich, 1971), esp. pp. 26–8.

24. The magic dog and bell may be Celtic in origin, but in all the known analogues the magic works: see Gertrude Schoepperle, *Tristan and Isolt*, 2nd ed. (New York, 1960), pp. 322–5, and A. H. Krappe, "Petitcrû," *Révue Celtique*, XLV (1928), 318–19.

25. See Schoepperle, pp. 75–7, and Eugène Vinaver, "The Love Potion in the Primitive Tristan Romance," in *Medieval Studies in Memory of Gertrude Schoepperle Loomis* (Paris and New York, 1927), pp. 75–86.

26. Ed. J. R. R. Tolkien and E. V. Gordon, 2nd ed. revised by Norman Davis (Oxford, 1967), lines 2354–7. Nothing resembling the episode of the lace is found in any of the poem's analogues.

# Two Verse Commentaries on the Ending of Boccaccio's Filostrato

## PAUL M. CLOGAN

Much of the criticism concerning the ending of Chaucer's *Troilus and Criseyde* has been based upon the supposition that the ending of Boccaccio's *Il Filostrato*, generally considered the main source[1] of *Troilus and Criseyde*, had no textual variation or commentary. In 1938, Vincenzo Pernicone described fifty-three manuscripts and some editions of *Il Filostrato* and classified them into three groups with subdivisions; his text was modified and corrected by Gianfranco Contini.[2] In 1958, Vittore Branca identified seventeen new and nine non-extant manuscripts, and in 1964 he again identified six additional new manuscripts.[3] Among these manuscripts of *Il Filostrato*, there are at least three which contain verse commentaries on the ending of Boccaccio's poem:

Firenze, Biblioteca Nazionale Centrale, MS. II, II, 38 (Magliabechiano VII, 955 and 1021; Strozziano 222 and 885); dated 23 October 1397; fols. 107–8.[4]
Madrid, Biblioteca Nacional, MS. 10.080 (Zelada 329); dated 10 December 1473; fols. 122ᵛ–4ʳ.
Venezia, Fondazione Giorgio Cini, MS. Ginori Contini 115 (Cod. F. G. C.); fols. 177–8.

I have been studying in some detail the text of the Firenze and Madrid manuscripts, but the Venezia manuscript has been unavailable for some time. The two texts of the verse commentaries, edited here for the first time, may shed some new light on the ending of Boccaccio's poem and perhaps the disowning of pagan and earthly love in *Troilus and Criseyde*, V, 1835–55, as well as the general mode of the epilogue. Further examination of all the manuscripts of *Il Filostrato* may well increase the number of Italian–English parallels which have not been evident in Pernicone's edition. The texts are transcribed here with a minimum of emendation and punctuation. When it is necessary to add a word, I put it in parentheses. The Firenze manuscript contains the complete text of *Il Filostrato*, which is immediately followed by the verse commentary consisting of five stanzas of seventeen verses and a final stanza of thirteen verses. The Firenze manuscript was copied by the hand of Rigo d'Allessandro Rondinelli and finished on 23 October 1397. The Madrid manuscript also contains the text of *Il Filostrato*, which is followed by a canzone consist-

ing of three stanzas of seventeen verses each, one stanza of nine verses, and a final stanza of fourteen verses. The Madrid manuscript was copied and completed by a Remasi or Temasi on 10 December 1473.

Firenze, MS. II, II, 38

1

Cruda selvaggia fuggitiva e fera
negli atti e nel parlare, e nella mente
timida, troppo dura e disdegnosa,
vaga leggiadra giovinetta altera
ch'à' disamato amore che t'el consente;                    5
cruda di te medesma e non piatosa,
non pensi all'età tua, dolcevezzosa,
non pensi al tempo che ti mena al varco
dove l'amoros'arco
si diserra e vanne a cor gelato;                          10
non vedi ch'ogni dí cangi lo stato
del fior di tua bellezza,
e che tua giovinezza
a torto il frutto di sua stagion perde?
Già l'albero della vita ha secco il verde                 15
di molte ch'alla fine si sono pentute
che lo bellezze non han conosciute.

2

Per forza di pianeto o d'altra stella
non fu giammai in donna cor di sasso
che non potessi conceper pietate:                         20
qual dunque natura o qual fu quella
villana coperassion o ciel sí basso,
o colui che le membra à più gelate;
che ti misse nel cor, ch'amor né fate
né forza di piacer giamai ti scalda,                      25
ma stai pur ferma e salda
come diaspr'o insensibil marmo?
Ahi, lasso a me, che con più saldo m'armo
d'amorosi dersiri!
Ma non senti i sospiri                                    30
le lagrime ei pensieri che mi disfanno?
Così piango i disii l'angoscie e 'l danno
de' dí perduti, disiando invano
all'ombra della tua spiatata mano.

3

Deh, per Dio, corri e allegra ti spechia,                 35
contemplando te stessa e imaginando
con un caro piacer le tue bellezze.
E per tua compagnia prendi una vechia

1 e fera] effera   5 che t'el] chettel   8 che ti] chetti   10 a cor] acchor   13 tua] tuo
14 a torto] attorto   15 ha secco] assecco   17 che lor] chellor   23 che] cha
24 che ti] chetti   26 e salda] essalda   28 a me] amme   30 ma non senti] maconsento

che si ricordi il dolze tempo, quando
la prese amor nelle prime vaghezze.                              40
E tu raguarda ben le tue fattezze,
le sue parole ascolta e' sospir suoi,
e al tuo specchio poi
ritorna e guarda i tuoi biondi capelli,
le bianche rose e' freschi fiori e' gigli,                       45
che 'n torno a' tuo' begli occhi
vedi che par che fiocchi
di paradiso un ciel di nuove stelle,
la tua candida gola e le mammelle,
che 'n su bel petto par ciascuna un fiore,                       50
po' pensa ben che tu vai sanz'amore.

### 4
Guarda che fa la rutilante Aurora,
che 'l vago suo giamai non abandona,
il contemplar di Marte e Citerea.
Or poi che 'l ciel per amor s'inamora,                           55
e tu, sol di biltà, à' la corona,
perché tien contro a te vita sirea?
O specchio de' mortali, o vaga iddea,
gusta del dolze ufizio di natura:
la scusa t'assicura                                              60
dall'età degli iddei e delle genti.
Vedesti tu giamai viver contenti
sanz'amor, se non grame,
giovin donzelle e dame?
Perché trapassi invan tanto bel tempo?                           65
Se t'innamori, ancora arai per tempo
gioco, diletto, giogia e piacer tanto
che per dolcezza non saprai dir quanto.

### 5
Ma se tu vivi più in tanta disgrazia,
disamorata in fin che 'l capel bianco                            70
ti faccia per vergogna andar velata,
non ti varrà pentere né tua audazia
d'acostart'al bel viso e giovin fianco,
né forza di vertú d'amor celata:
girai come fantasma, disperata,                                  75
maladicendo Ipolito e Narcisso;
terrai il viso fisso
a bestemmiare te stessa, amore e Dio;
sospirerai per l'antico desio
per te mal conosciuto;                                           80
vorrai d'amor l'aiuto
là dove ogni biltà ti sia fuggita.
Per Dio, del fiore della tenera vita

39 che si] chessi   40 amor] amore   41 E tu] Ettu   ben] bene
47 che fiocchi] cheffiocchi   52 che fa] cheffa   55 ciel] cielo
57 perché tien] perchettien   a te] atte   65 invan] inuano   69 Ma se tu] Massettu
78 stessa] stesso   e Dio] eddio

conosci il frutto e disiando l'usa,
ch'al conosciuto mal non vale scusa.                                    85

### 6

Canzon, in compagnia d'un franco vero
vanne a colei ch'ogni biltà schiva,
– fredda morta e non viva
a conoscer di quello che l'è mestero –,
e dí che quando amor vuol pur l'uliva                                   90
del suo bel viso, ch'ogni cor severo,
per forza o per preghiero,
gli vien dinnanzi (sí la mente orriva
e contro a suo diletto dotta e priva);
e nel pensier distilla                                                  95
dicendo: "I' son l'ancilla
di cui la sua biltà tanto innamora,
che quasi morto in ginochio l'adora."

Finito tutto il libro, cioè il Filostrato, compilato
per Messer Giovanni di Boccaccio da Certaldo, scritto
per mano da Rigo d'Allessandro Rondinelli. Finito
di scrivere a dí XXIII d'Ottobre MCCCLXXXXVII. . . .

*Deo Gratias*

Madrid, MS. 10.080

Canzon di messer Francesco Frat., per confermatione
del venerabile, onorevoli e manifico poeta
Messer Johanni Bocacio, tractatore di questo libro,
mostrando come gli uomini si debino guardare
da pericoloso amore, e se pur s'enamora, s'enamori
di persona che non sia distructo e disfacto.

### I

L'autore, che parla come avete udito,
in questa sua canzone mostra con versi
degli uomini somersi
che s'enamorano tanto de legiero
cercando con preghiera l'alto sito                                      5
del terzo cielo con verace dolersi;
e si credon potersi
ch'al primo passo è lor voler altiero
che fornita sia con motto intiero
l'acuta volantà così bramosa,                                          10
la qual puoi non si sposa
quando ha gustato de tal pomo el fructo,
se 'l perdimento ne riman destructo,
chiamando l'alma misera, dogliosa,
la qual se fa gilosa                                                    15
d'altro periglio o d'alcuno altro inganno,
sempre pensando nel futuro danno.

85 mal] male  89 che l'è] chelle  90 amor] amore  93 sí la] silla  94 a suo] assuo
95 pensier] pensiero  9 fornita] fornito

**2**

Quanto exercitio vol, quanta fatiga,
questo cocente fuoco decto amore!
È comme strengie el core                                    20
a tali amanti ponti de suoi armi
ben se pò dir: la sua mente, mendica
d'ogni alegrezza, è piena de dolore
vivendo in tale erore.
Vero ch'alquanti vogliano demostrarmi                      25
conte parolle e figure per farmi
creder che vivin sempre mai contenti:
lor parolle son venti,
ben che talora si senta alcun dilecto.
Ma poco pò durare cotale efecto,                           30
e quinci vengono tucti gli argumenti
a far che siate lenti
d'innamorarvi, e sempre immaginando
comme tal fuoco va l'om consumando.

**3**

Ben dimostra el poeta apertamente                          35
in questi doi amanti asicurati
di qua dietro contati:
Troilo del re Priamo, e sì Arcita,
a cui amore inemichevolimente
el pecto rescaldò con tristi fati.                         40
Ahi quanti sventurati
ha messi amore in pericolosa vita,
quanti n'han già la lor vita finita,
con greve doglia e con ferma fama.
Ahi, ferocie brama,                                        45
ch'è ['n] ciascuno con falso piacere –
e proffera dilecto nel parere – ,
facendo nostra vita trist'a chi ama;
e quel che più ti chiama,
ben se pò dire che egli e tu sia ceco,                     50
e quantunque ne meni amore con teco.

**4**

Canzon mia, quanto puoi va' riverente
tanto che trovi l'alma del poeta:
con reverentia lieta,
cortese t'enginochia a lui dinante,                        55
per da mia parte el prega umilimente
afermando el suo dire in quel che scrivo:
che non mi facia privo
d'una preghiera innanzi al suo Apollo,
che stenda el braccio suo sopra el mio collo.             60

**5**

Gli antichi e bei pensier convien ch'io lassi,

61 pensier] pensieri

e 'l gran desio e la speranza mia,
e quella usata e tanto bella via,
e ['l] lungo remirare e i lenti passi;
e la finestra ove or più non fassi                                65
el so de gli ochi belli che m'uccidia
quando con seco solo sordia,
con mille altri piacer che già ne trassi;
e 'l seguir ch'io solea de le di lei orme,
quando pasava, pronto in ogni canto,                              70
e 'l ragionar de lei e de sue forme;
e le lagrime ancor ch'io sparsi tanto,
mosse da quel signor ch'ancor non dorme,
e 'l sonar per vaghezza, alzare el canto. Francesco.

66 sol de] sol che   68 piacer] piaceri   69 solea] soleva   orme] ormi

# NOTES

1. See F. N. Robinson, ed., *The Works of Geoffrey Chaucer*, 2nd ed (Boston, 1957), pp. 811–12.
2. See Pernicone, "I manoscritti del *Filostrato* di G. Boccaccio," *Studi di Filologia Italiana* (Bullettino della R. Accademia della Crusca), 5 (1938), 41–83. See also Pernicone's edition of *Il Filostrato* (Bari: Laterza, 1937) and Contini's review in *Giornale storico della letteratura italiana*, 112 (1938). For a consideration of the classification of the manuscript of *Il Filostrato* used by Chaucer, see Stanford B. Meech, *Design in Chaucer's Troilus* (Syracuse, 1959), pp. 430–1.
3. See *Tradizione delle opere di G. Boccaccio* (Roma: Storia e Letteratura, 1958), pp. 41ff; and *Tutte le opere di Giovanni Boccaccio*, vol. 2 (Milano: Arnoldo Mandadori Editore, 1964), pp. 839–44, in which Branca reproduces Pernicone's edition of *Il Filostrato* and incorporates Contini's suggestions.
4. See A. Bartoli, *I manoscritti italiani della Biblioteca Nazionale di Firenze* (Firenze, 1879), I, 323–5. I am indebted to Giovanni Sinicropi for information and help.

# Chaucerian Confession:

## Penitential Literature and the Pardoner

### LEE W. PATTERSON

Despite a substantial critical commentary, the basic terms for the interpretation of the "Pardoner's Prologue and Tale" remain in dispute. We are typically urged to understand the Pardoner's self-revelation in terms of either medieval convention or modern psychology, and yet neither category is wholly satisfactory: the appeal to convention is too blunt a response to Chaucer's careful observations, while we cannot help but mistrust our modernity.[1] But, in fact, this is a false dilemma, for there is further medieval material we can bring to bear on Chaucer's text that can preserve both its complexity and its historicity. I refer to the vast literature of instruction and exhortation that grew up around the sacrament of penance, and in particular to the discussions, both poetic and theological, of the meaning and dynamics of confession. The point is not that the Pardoner's self-display is a confession in any sacramental sense,[2] but that the literature of confession can explain both the spiritual condition out of which he speaks and the complicated meanings he imparts. Our problem with the Pardoner's self-revelation, after all, is less with content than with the significance of form, not so much what he says but the meaning of his act of speaking. Hence it is contemporary discussions of the act of confession itself that can perhaps provide us with guidance. As for specific texts, this means that we shall put aside works that are merely adjuncts to the sacrament, such as the numerous versions of the *forma confitendi*,[3] in favour of those that, while originally deriving from the sacrament, move beyond it to explore the inner dynamics of the act of confession itself. In Middle English, this self-regard is found both in the penitential lyric and in the confession of the Sins in *Piers Plowman*, and it is these works that can provide for us a literary context for the "Pardoner's Prologue and Tale".[4] Theologically, our concern is with discussions of the psychology of confession, and specifically of the penitential motive of contrition and its dark semblance of despair. And it is here that writings both patristic and medieval can furnish a terminology and an imagery that will reappear in the Pardoner's self-portrait; indeed, we shall see that Chaucer has, with typical economy, taken the defining terms of the Pardoner's character from the very penitential system of which he is an agent.

The range of the Middle English penitential lyric includes both the exemplary and the analytic. The *forma confitendi*, for example, appears both in a complete form, so that the reader can check every category, and in a more selective and subtle way as the structure of a dramatized and personal act of penitential reflection.[5] Similarly, many of the poems are frankly instructive of doctrine or, more usually, emotion, providing the reader with a pattern of penitential feeling.[6] But others qualify this severe impersonality with an implicit psychological dialectic: they seek not simply to arouse or even express sorrow but to show it transformed and made fruitful by confession. A good example is the Harley lyric "God, þat al þis myhtes may."[7] By his sin, the speaker has alienated himself from God – "ichabbe be losed mony a day, / er ant late y-be þy foo" (3–4) – and is now overcome with self-disgust: "when y my-self haue þourh soht, / y knowe me for þe wrst of alle" (15–16); "Ich holde me vilore þen a gyw" (29). His feelings, then, are perilously near to despair, but the remainder of the poem provides a rescue. These very feelings are transformed into an offering, the broken and contrite heart that, says the Psalmist, the Lord will not despise.[8] The speaker remakes the broken relationship with God not by petition – "louerd crist, whet shal y say?" (50) – but by assuming the language and posture of penance: having been set against God in his arrogance, the sinner now kneels before Him in humility and supplication. Seen penitentially, self-disgust becomes contrition, and hence an advocate for salvation, so that the first line of the poem that originally threatened judgment can be repeated at the end as a warrant of mercy: "In þy merci y me do, / god, þat al þis myhtes may" (55–6). The poem ends, in short, in prayer: *confessio peccati* is fulfilled in *confessio laudis*.[9]

Prayer is the most common of the resolutions towards which the speaker of the penitential lyric directs his sorrow, but moral generalization also appears frequently. By understanding his life as an instance of a moral law, the penitent not only grants it a certain significance, however dismaying, but is able to use his new understanding as a sign of his conversion from the past. The *sententia* in which he generalizes his personal experience completes both his poem and his life of sin: possessed of bitter wisdom, he is self-evidently no longer the man he once was, and in the very course of the poem he becomes less a penitent than a sage, directing his words to an audience that has not yet learned the lesson he now knows so well. Hence a poem that begins, "In my ȝowþe fulle wylde I was," and includes a carefully individualized confession can end in a tone of severe impersonality:

> Man take hede what þu art!
> But wormys mete þu wote wel þis!
> Whanne þe erthe hath take his parte,
> heven or helle wolle haue his.

Yf þu doest welle þu goest to blis;
Yf þu do eville vnto þy foo;
love þy lorde, and thynke on þis,
Or wite þy self þyn owne woo![10]

Most relevant to the "Pardoner's Tale" are the numerous poems in which the penitent is an old man. At times the speaker fears he has repented too late, that his profession in old age of the values he abused in youth is belated and unwelcome.[11] As the speaker of the *Poema Morale* says,

Wel late ich habbe me bi-þouht bute god do me mylce . . . .
Ich myhte habbe bet i-do heuede ich eny selhþe
Nv ich wolde and i ne may for elde ne for vnhelhþe;
Elde is me bi-stolen on er þan ich hit wiste . . . .
Þe wel nule do hwile he may ne schal he hwenne he wolde.[12]

Age is at once a symbol of sinfulness, the sin itself,[13] and, final irony, the punishment, a cheerless decay that stands as nature's mocking parody of the spiritual change that will now never be achieved. Here, the old man turns from his anguish into an exhortation to others to do penance; in other poems he finds relief simply by understanding his sorrow within a penitential context, by turning regret into contrition. This pattern can best be illustrated by comparing two of the best known poems, "Le Regret de Maximian" and the so-called "Old Man's Prayer."[14] Maximian's complaint is uncompromising in its despair. He hates not only the old man he now is but the youth that brought him to it, and the poem is an act of self-annulment, a betrayal of the past to the bitterness of the present: even if he had his youthful strength back, he can think of no other use for it than to silence his badgering wife. The most serious negation is his failure to arrive in the poem at a prospect from which his experience, however sad, can become significant. "Wat helpeþ al itold?" (80) he asks; he has no *sententia* with which to redeem the past: "Deþ ich wolde fawe, / For I ne may tellen no sawe" (199–200). Hence, the lament lacks both structure and direction and sinks sullenly to a closing obsession with the present: retrospection is not possible for the self-absorbed mind.

While "An Old Man's Prayer" also opens in an embittered tone, it revises the feelings and materials of lament in a penitential direction. God has created man both as a lover of "murþes" and a victim of time, and the paradox baffles and grieves the poet. He used to be a man of "semly sawes" (10) but now he does not know "whet bote is beste" (26). His remedy, interestingly, is not a new saw but redefinition of the "murþes" that have been lost: the speaker changes his poem from lament to a confession by describing his youth in terms of the seven deadly sins:

whil mi lif wes luþer & lees,
glotonie mi glemon wes,

> wiþ me he wonede a while;
> prude wes my plowe-fere,
> lecherie my lauendere –
> wiþ hem is gabbe & gyle –
> Coueytise myn keyes bere,
> Niþe ant onde were mi fere,
> þat bueþ folkes fyle,
> Lyare wes mi latymer,
> sleuthe & slep mi bedyuer,
> þat weneþ me vnbe while.
>
> (52–63)

This penitential perspective redefines both youth and age. The "murþes" of sin are now well left behind, and age is not a betrayal but a merciful respite in which the penitent can bewail his sin: "Monne mest y am to mene, / lord, þat hast me lyf to lene" (66–7). Now the poet knows both that "Murþes helpeþ me no more" (92) and "whet ys þe beste bote": to "heryen him þat haht vs boht, / vre lord þat al þis world haþ wroht, / ant fallen him to fote" (100–2). The poem thus completes its transformation from lament through confession to prayer:

> Nou icham to deþe ydyht,
> y-don is al my dede,
> god vs lene of ys lyht,
> þat we of sontes habben syht
> ant heuene to mede!
>
> (103–7)

The old man's anguish is resolved, not merely by the hope of salvation, but by the prior and larger step of being understood within the penitential process in the first place: the sorrow of old age becomes the sorrow of contrition and, with the closing prayer, the poem becomes itself an act of penance.[15]

The explicitness of "An Old Man's Prayer" helps us to recognize that contrition is at the heart of the penitential lyric as a whole, whether it is resolved into the hindsight of wisdom or the forward movement of prayer. The poems function to prevent the sorrowful mind from sinking in on itself, as in "Le Regret de Maximian," and to direct it rather towards patterns of action and language in which sorrow becomes fruitful. In the confession scene of *Piers Plowman*, the most accomplished piece of penitential literature of the fourteenth century, Langland explores the same themes, and it is worth inquiring how he disposes his inherited material in order to open up these inward areas. For in the vernacular treatises on which he draws, sinfulness is presented not as a condition of the soul but as a deed, or at most a habit: the sinner recognizes himself, not by what he is, but by what he has done. Even when personified and allowed to describe themselves, as in Deguilleville's three *Pèlerinages* or

the Morality plays, the sins remain exteriors, dutifully rehearsing the things that have been said about them: their speeches are hardly more than identifications, *tituli* to stand beside the crude allegorical image. Although often they speak for no reason or in defiance of reason – Deguilleville's Treason carefully unfolds her devices to the pilgrim she is about to attack – their self-revelations are not removed from human range simply by being unmotivated. Belial's "Ho, ho, be-holde me!" for example, springs from a manic self-delight that in its consistent display throughout the play stands as sufficient motive; and Faus Semblant's self-exposure in the *Roman de la Rose* is compelled by the God of Love. But this motivation does not proceed from the sinfulness that is both embodied and expressed, so that Jean de Meun, for instance, accords to the paradox of the sincere hypocrite only a passing acknowledgement, rather than allowing it to complicate Faus Semblant's self-revelations. The autobiography of medieval allegory, in other words, habitually severs the link between character and language that helps us to recognize the intention and ultimately the significance of human speech. In Langland's confession scene, on the other hand, the challenge of the allegorical form is accepted: he restores the link between self-revelation and the self revealed. By forcing upon the Sins the confessional occasion they are designed to serve in others, not only does he give them the best of all Christian reasons to speak, but he allows them to speak to and from their sinfulness. In a sense, Langland's innovation is simply to take the short step from confession in terms of the sins to confession *by* the sins; in a larger sense it is to combine the didactic and hortatory substance of one tradition with the literary purposes of another, to fuse content (the nature of Avarice) with form (have I committed avarice?). In Langland's scene, Avarice confesses to itself, so that the well-worn literary details become now the symptoms of an inward and hopefully problematic human condition. It is from this grounding of speech in the self, rather than vividness or energy, that the force and originality of Langland's scene derive.

The scene is based on a paradox, for by confessing to itself, the Sin calls into question its very existence. "Ich, Pruyde, pacientliche penaunce ich aske" (C.VII.14), but, once patient, he is no longer prideful; " 'I haue ben coueytouse,' quod this caityue, 'I biknowe it here' " (B.V.200), but if he was Couetyse (or coueytouse), who is he now? The scene turns not just on a quirk of the allegorical confession but on the mystery of spiritual rebirth that is at the heart of penance. As the Sin confesses, he is caught in the middle of a transformation from the old self that is extinguished in the words he speaks to the new self he hopes to become. He can, of course, speak without understanding, and it is precisely by their bland obtuseness that several Sins erode the force of their confessions: Couetyse of the B-Text, when asked if he has made restitution, proudly

describes robbing merchants while they were at *rest*, and when corrected complains that he doesn't know any French. But while the Sins do on occasion play the fool, the scene as a whole is not primarily satiric in intention. Langland stresses the anguish of sin as much as its hardened impenitence: the self-consumption of Enuye, the endless rage of Wrathe, and the despair of Sloth are traditional attributes here raised to the level of motive.[16] The purpose is not to portray the Sins as moved by contrition but to trace the vicissitudes of contrition itself within the sinful soul. "Enuye with heuy herte asked after shrifte, / And criede *'mea culpa'* corsynge alle hus enemys" (C.VII.63–4): the sorrow for sin and desire for amendment of contrition are overwhelmed in the last half-line by the anguish and obsessions of envy. Again, Repentaunce asks him if he is sorry: " 'Ich am euere sory,' sayde Enuye, ich am bote selde other;/ That maketh me so megre for ichne may me auenge' " (93–4). Enviousness suborns and appropriates the contrition that is its only cure; the pain caused by the sin overwhelms the pain by which sin is cleansed. The same question is asked of several of the other Sins. Can contrition survive Wrathe's fury? Is Gloton contrite or hung over? Can Couetyse worry about his soul when he has to worry about his money?[17] Langland's scene demonstrates how sin destroys its own cure, and so condemns itself to itself. By subverting the contrition that would annul them, the Sins succeed in prolonging a life of anguish, condemning themselves to damnation, a death without death and an ending without an end.[18]

Langland's interest in the dynamics of contrition is confirmed by the processes of his own revision. In the B-Text the comically stupid Couetyse falls into *wanhope* and needs the comfort of Repentaunce's words about the breadth of God's mercy. But the C-Text goes beyond this negative point to show contrition in its positive workings: the reductive humour gives place to Couetyse's own careful explanation of how the anxiety of the miser overcomes care for his soul. Having so explicitly established the power of sin to nullify its antidote, Langland then preserves the balance of the scene by similarly strengthening the claims of Repentaunce: he replaces the abstract arguments against despair with the living proof, as it were, of ʒeven ʒeld-aʒeyn and Robert the ryfeler.[19] The effect of this revision is not only to gain vividness and persuasion but to express the ontological paradox of the literary form and of penance itself. Having demonstrated his contrition by accepting the demands of satisfaction (*Reddite quod debes*), Couetyse is freed from himself and allowed to become a man who can be saved, whether ʒeven or Robert. They are arguments against despair less by their typology than by their participation in the *salus animarum* of the Christian dispensation, a dispensation from which a being who is Couetyse (or coueytouse) is forever excluded. This is, then, Langland's rendering of personal change through penance,

the articulation into the inward complexities of human experience of some of the central concerns of medieval penitential theology.

At the centre of the Christian dispensation stands the idea of a radical transformation of the self, literally of its "reformation" according to the pattern (*imago Dei*) in which it was originally created and from which it has defected through sin.[20] The process begins with the inward turn of self-confrontation. "Quid te foris circumspicis, et non intus inspicis? . . . . Intus inspice, quid transis te? Descende in te."[21] The sinner must set himself before himself, face to face with the defilement he has become: no longer the *imago Dei* he is now the *imago terreni hominis* (1 Cor. 15.49). "This image if thou behold it wittily," says Walter Hilton, "is all belapped with black stinking clothes of sin, as pride, envy, ire, accidie, covetise, gluttony and lechery. . . . This image and this black shadow thou bearest about with thee where thou goest."[22] A true knowledge of himself humiliates the sinner, and he cries out to the Lord, "In Thy truth Thou hast humbled me."[23] Gratefully, he abandons his corruption to the gnawings of the worm of conscience, receiving in his present pain a warrant against eternal agony.[24] Now is the moment for the crucifixion of the old Adam, the annihilation of the man of sin, the pulverizing force of contrition that destroys the dying to bring forth life.

Whether called *compunctio* or *contritio*, the impulse which gives rise to penance is complex and even conflicted. In the authoritative *Summa de casibus poenitentiae*, St. Raymound of Pennaforte lists the six causes of contrition:

Causae inductiuae contritionis sunt sex, cogitatio,[25] et ex ea pudor de peccatis commissis: detestatio vilitatis ipsius peccati: timor iudicij, et poenae gehennae: dolor de amissione patriae caelestis, et multiplici offensa Creatoris: et spes triplex, veniae, gratiae, et gloriae.[26]

Contrition is an uneasy balance of negation and assertion, a radical self-hatred and fear of God that is paradoxically joined to *spes triplex* and a reliance on divine mercy. "Idcirco te alloquor, ut sperare doceam et timere," says Augustine to Petrarch in the *Secretum Meum*, and he warns him against excesses of both hope (*praesumptio*) and fear (*desperatio*).[27] Presumption and despair are the Scylla and Charybdis of the spiritual life, the Devil's greyhounds, in the words of the *Ancrene Riwle*, "igedered to gederes . . . nexst þe ȝete of helle."[28] Despair is both the more interesting and the more apposite of these false ways. For, while presumption removes the sinner from the penitential context entirely, despair not only arises from the self-confrontation that initiates penance but is tragically close to the genuine spiritual impulses that lead to salvation. It is not simply one of the *impedimenta* to contrition or even its obverse, for its terrors and self-negations are themselves an important part of the penitential

motive. Five of the six *causae* listed by Pennaforte, for instance, are also characteristics of despair; and, in his influential discussion of penance, William of Auvergne lists ten "motus virtutis confringentis veterem hominem, ac funditus, ac radicitus mortificantis:" *timor, pudor, dolor, ira, indignatio, abominatio, horror, odium, execratio, detestatio* – a virtual litany of despair.[29]

The dangerous instability of these negative feelings had long been recognized by writers on the spiritual life. According to St. Paul, there are two kinds of sorrow over sin, *tristitia secundum Deum* which works repentance unto salvation and *tristitia secundum saeculum* which works death (2 Cor. 7.10). For Augustine, *tristitia* is so unstable that he admits, even in the midst of an attack on Stoic apathy, that "scrupulosior quaestio est, utrum inveniri possit in bono."[30] And, says Cassian, whereas Godly sorrow secures for the soul all the fruits of the Holy Spirit, its obverse is "impatiens, dura, plena rancore et moerore infructuoso, ac desperatione poenali, . . . fructus spirituales evacuans, quos novit illa conferre."[31] Warnings against the danger of contrition deteriorating into despair are common in discussions of penance,[32] and more personal accounts in the literature of the fourteenth century show it to have been one of the hardest passages of the spiritual life. Julian of Norwich warns that "the beholding of [our sinfulness] maketh us so sorry and so heavy, that scarsely we can find any comfort. And this dread we take sometimes for a meekness, but it is a foul blindness and a weakness."[33] Margery Kempe begins her autobiography and her spiritual life with the story of how her conscience and her confessor drove her from contrition to despair and then to madness.[34] And Henry of Lancaster presents a homeopathic explanation for the double effect of *tristitia*: it is a *triacle* drawn from the venom of sin itself, and, while in some it cures, in those too deeply infected it adds its force to the sin already present.[35] In sum, if the ulcerous sinner is cleansed by the worm of conscience, he may also be killed by it:

> Cest de conscience le ver
> Qui a les dens durs comme fer
> Si cruel est et si mordant
> Si poignant et si trespercant
> Que sil nauoit qui le tuast
> Qui le ferist ou assommast
> De tant runger ne fineroit
> Jusques son maistre oscist auroit.[36]

In destroying its victims, despair operates in two ways. The most dangerous is simply the working out of its own internal dynamic. A sin not of commission but feeling – Donne's "sin of fear" – despair is efficiently self-fulfilling: thinking himself lost, the man in despair refuses to ask for mercy; refusing to ask, he cannot receive; and not receiving, he becomes lost in deed as well as thought. In practical terms this means that the man

in despair avoids confession: "Non confitetur autem qui desperat de misericordia Dei," says Gregory flatly, and the confessional manuals are virtually unanimous in warning against despair.[37] And yet, of course, the bitterest irony is that it is only by confession that despair is finally conquered.[38] The other way is through the excesses of desperation and final impenitence. According to Augustine, the despairing man is like a gladiator doomed to the sword: "Jam peccator sum, jam iniquus, jam damnandus, nulla veniae spes est; cur jam non faciam quidquid libet, etsi non licet? Cur non impleam, quantum possum, quaecumque desideria, si post haec non restant nisi sola tormenta?"[39] And a well-known Gregorian text describes the hidden anxiety and inner torment of the despairing impenitent:

Quia dum feriri se undique insidiis credit, salute desperata, semper ad nequitiam excrescit. Aliquando vero iste perversus etiam superna judicia attendit, et super se haec venire metuit. . . . Sed a malo non avertitur, ut etiam ipsa quoque ab ejus interitu valeat averti. Accusante se autem conscientia feriri metuit, sed tamen semper auget quo feriatur. Contemnit reditum suum, desperat veniam, superbit in culpa; sed tamen testem suae nequitiae intus habet timorem. Et quamvis prava videatur foris audacter agere, de his tamen apud semetipsum cogitur trepidare.[40]

Licentiousness is a vain attempt at distraction, and beneath a reckless bravado works the anxiety of despair, tormenting the sinner with a foretaste of the eternal punishment that awaits him.

But hope must never be abandoned for the man in despair. Even if contrition does collapse into despair, the process can be reversed: in DeGuileville's language, the worm of conscience can be broken by the hammer of contrition, and the lesson of the triumph of Mercy at the close of the *Castle of Perseverance* is not so much to cast out despair as to convert it to the work of penance.[41] The mystical writers tend to see despair as an early stage in the soul's progress towards God, the necessary *siccitas* of the dark night rather than the *accidia* of sin, and they accept its scourges and corrosion as both the punishment for sin and the pain by which the old Adam is destroyed that the Christ within may live.[42] Although the acts of desperation to which despair gives rise are perilous in the extreme, its negations are an important part of the penitential process, and any impulse that forces upon the sinner the reality of his condition can prove in the event to have been useful. The emotions that excite penance are complex, and no matter how refractory or self-regarding the initial motives, they can be transformed by the penitential act itself into an offering acceptable to God. Putting aside the ontological changes effected *ex opere operato*, simply at the level of psychology the movement of the sinner towards contrition is understood to be a gradual and even hesitant process.[43] Similarly, the act of confession itself can excite in even the impenitent fruitful spiritual motions. "Multi enim accedunt

indevoti," says Jacques de Vitry, "qui cum lachrymis et devotione recedunt,"[44] and according to Walter Hilton,

> Though the ground of forgiveness stand not principally in confession, but in contrition of the heart and in forethinking of sin, nevertheless I expect that there is many a soul that should never have felt very contrition, nor had full forsaking of sin, if confession had not been. For it falls oft times that in time of confession grace of compunction comes to a soul that before never felt grace, but aye was cold and dry, and far from feeling of grace.[45]

In the confession scene in *Piers Plowman* Langland revises earlier forms to bring into poetic focus the nature of contrition and its relation to sin, penitential concerns characteristic of medieval, and especially fourteenth-century, religious thought. In the "Pardoner's Prologue and Tale" Chaucer's revision of his inherited materials is in the same, inward direction. The one-dimensional monologue of allegory is deepened, not by functioning as the Pardoner's confession, but by becoming part of a larger sequence of involuntary self-exposure that is fulfilled only in the tale; and the tale is, in turn, transformed by the context of its telling from an *exemplum* about avarice into a psychological allegory that reveals the Pardoner as a man in despair. The confession of despair, like that of Pruyde or Couetyse, is a theoretical impossibility, and it is this paradox that requires the transformations of genre: the direct self-revelation of autobiography is distorted by strategies of manipulation and concealment, and the negatives of his condition are visible only in the displacement of fiction. It may well be that his oblique confession brings sacramental healing no closer to the Pardoner, but, if we are to understand why he speaks and what he is saying, we must recognise the penitential context.

The ironic smile with which the God of Love accepts Faus Semblant's pledge of loyalty is Jean de Meun's perfunctory gesture towards the discontinuity between character and speech implicit in the paradox of the truthful hypocrite. But the Pardoner's illegitimately-assumed role of the professional speaker places this discontinuity at the centre of his characterization. Language is the means by which he creates himself for others, whether it be the cocksure prattle with which he disguises his eunuchry or the witty and learned sermon, liberally embellished with impressive *exempla*, with which he establishes his authority before the "lewed peple." The "*Prologue*," for all its apparent candour, is part of this image-making. Recent critics have rightly argued that the pardoner of the Prologue, a monster who cheerfully anticipates his victims' damnation and steals food from the mouths of starving children, is a gross and deliberate parody of sinfulness.[46] At once offending the censorious *gentils* and titillating the raucous lower elements represented by Harry Bailly, he plays to the full the role of the diabolical sinner, the man who has chosen with open eyes the path to his own damnation. Always the rhetorician,

he speaks in the uncompromising tone of allegory, sounding at times like DeGuileville's Avarice, who tells *her* pilgrim-victim that

> Souvanteffois par le pais
> Faulx sainctuaires et fainctiz
> Va moustrant a la simple gent
> Pour faussement tirer argent.[47]

But the similarities are only on the surface, and the differences in detail and dramatic energy between allegorical self-exposure and the Pardoner's "*Prologue*" spring ultimately from a deep difference in intent. The allegorical figure speaks in order to be fully known, while the very excess of the Pardoner's revelations hide him from us: rather than being created by the conventions of medieval allegory, he himself exploits them.

This is not to say that there is no controlling convention here, but that we must find its source elsewhere. I would suggest the false or uncontrite confession of satiric literature, what in the *summae confessorum* is called the liar's confession or *confessio ficti*.[48] Instances in Middle English include Lady Meed's confession to the friar and the Devil's confession with which Robert of Brunne closes *Handlyng Synne*,[49] but its most common appearance is in the Renart story. In the French version Renart confesses no less than five times in all, and his habit of misusing the sacrament led at least one cleric to label the perfunctory or uncontrite confession a *confessio renardi*.[50] The instance closest to Chaucer's poem, and one which he almost certainly knew, is Renart's confession to "frere Huberz" the kite.[51] Desperately hungry, Renart lures the kite within striking distance by confessing, apparently truthfully, that he has in his gluttony devoured even Hubert's children. He begs the horrified kite to forgive him, but when Hubert leans forward for a kiss of peace Renart gobbles him up. The parallels between this scene and Chaucer's poem are striking: the confession as a trap, the extravagant sinfulness, the crucial role of the kiss of peace, and the ambiguity of both confessions – in neither case can we easily separate truth from fiction. Whether this episode is a specific source for Chaucer or not, the analogies suggest that, in revising the allegorical monologue, Chaucer moved in the direction of the rogue's confession. "ʒa, whanne þe fox prechyth, kepe wel ʒore gees!" is a cautionary proverb that applies in the first instance to the "lewed peple"; by giving his Pardoner a confessional prologue Chaucer wittily brings it to bear upon the pilgrims as well.

By choosing as his speaker an habitual sinner like Renart, rather than a hypocrite like Faus Semblant, Chaucer has avoided the stock satire of the mendicant controversy. In his further revision, however, he also avoids the irrepressible cynicism of the *Roman de Renart*. Renart is a cheerful outcast who remains always in control of his language and his victim, but Chaucer's reaccenting of the same narrative elements creates a char-

acter who is anxious and dependent. For not only does his trap close on the Pardoner himself, but the whole relationship between his real and his created selves is less controlled and deliberate than with Renart. From the pilgrims the Pardoner covets not money, but admiration: his confession is designed to extract from the *gentils* a shocked respect and from Harry Bailly and his ilk the dubious title of "a good felawe." But, in fact, he goes too far and defines himself as a man outside the human community, making his ultimate rejection inevitable and revealing a pattern of self-destruction that surfaces in the offer of the relics. More significant than this misjudgment of others' cynicism, however, is the genuineness and even vulnerability that the Pardoner reveals. While insisting early and often that his motives are brazenly simple (403–4, 423–4, 432–3, 461), he also claims – and repeats the claim – that he is doing good works:

> But though myself be gilty in that synne,
> Yet kan I maken oother folk to twynne
> From avarice, and soore to repente.
>
> . . . .
>
> For though myself be a ful vicious man,
> A moral tale yet I yow telle kan.
>
> (429–31, 459–60)

These hints are made all the more telling by the Pardoner's own response to them. In both cases he hastily withdraws from the disturbing complications he has raised to the comforting simplicity of avarice: "But that is nat my principal entente; / I preche nothyng but for coveitise" (432–3), and his moral tale is only a device "for to wynne" (461). And in both instances he cuts off his line of thought with a misdirected and defensive conclusion: "Of this mateere it oghte ynogh suffise" (434) – although he himself continues to worry at the subject; and, "Now hoold youre pees! my tale I wol bigynne" (462). This fugitive and embarrassed self-defense shows the Pardoner acknowledging in his spirit the values he subverts in his working, a complication that appears again in the benediction with which he closes the tale. In sum, he is by no means unambiguously impenitent, and his attempt to reduce himself to the simplicity of allegorical evil is best understood as an attempt to escape from a consciousness that is too painfully divided. The "Prologue," then, by turns derisory and hesitant, vaunting and awkwardly candid, reveals in its very lack of clarity a spirit in conflict.

In fleecing his victims, the Pardoner in fact proffers both wisdom and an opportunity to perform the penance of alms-giving; and, doubtless, the knowledge that God turns even the wicked to His purpose encourages these gingerly efforts at self-justification. But are they not simply further instances of his presumption? Our answer to this question, and indeed our final judgment of the Pardoner, depends in large part upon our understanding of his eunuchry. Current opinion generally follows Robert

Miller's exegetical reading that identifies the Pardoner as the *eunuchus non Dei:* "Instead of cutting himself off from evil works, he cuts himself off from good works. He refuses offered grace. In short, he is the presumptuous man who, by his act of will, commits the unpardonable sin, not for the sake of, but in despite of, the kingdom of heaven."[52] This reading is uncompromising in stressing the Pardoner's damnation and encourages us to see him as an instance of pure evil, Chaucer's "one lost soul," in Kittredge's too memorable phrase. It is quite true that in this case an exegetical approach is probably the right one, especially as it accords with the larger strategies of the poem. But I would propose a different pattern of scriptural imagery, that of the *arbor infructuosa.* Not only does the symbol of the withered tree allow for a less absolute reading, but it offers distinct critical advantages. For one thing, it is a far more common image than the *eunuchus non Dei* and has a wide currency in medieval art and literature.[53] For another, it has a striking presence in the tale in the "ook" where the rioters find death, the *radix malorum* that bears the bitter fruit of three corpses. The appropriateness of this biblical imagery to the Pardoner is obvious. He is like the fig tree of Matthew 21.18–21 that offers to the hungry Lord not fruit but foliage and is withered with His curse: according to the exegetes the foliage shows that the tree glories in vain words (*pompa locutionis*), while lacking the fruit of good works.[54] The Pardoner is one of those "qui verba habent, et facta non habent,"[55] and his need is for precisely the "fructum dignum poenitentiae" (Matt. 3.8) that can alone save him from the fire of judgment: "Iam enim securis ad radicem arborem posita est: omnis ergo arbor quae non facit fructum bonum exciditur et in ignem mittitur" (3.10). Yet, for all its judicial gravity, this sequence of biblical imagery includes a controlling message of mercy in the parable of the sterile fig tree (Luke 13.7–9). The *paterfamilias* commands that the tree be uprooted and destroyed, but the *cultor* advises that it be ditched and dunged and given one last chance; according to the exegetes, the ditch is "humilitas poenitentis" and the dung "memoria peccatorum," "cordis luctus et lacrymarum."[56] "Non potest arbor mala fructus bonos facere" (Matt. 7.18) remains an inviolable principle, but, as Augustine (among others) insists, each righteous Christian has been *made* a fruitful tree: "Quisquis igitur homo hodie bonus est, id est, arbor bona, mala inventa est et bona facta est."[57] The *radix arboris,* the human will, can be changed by penance from *cupiditas* to *caritas:* "ut in semetipsum oculos convertat, in se descendat, se discutiat, se inspiciat, se quaerat, et se inveniat: et quod displicet, necet; quod placet, optet et plantet."[58]

Perhaps the "hogges toord" in which the Host would enshrine the Pardoner's non-existent "coillons" is a last, bitter reminder of the *cophinus stercoris* by which the sterile tree can be made fruitful, a dung also nastily brought to our attention by the Host's comment about the "fundement"

with which the Pardoner is supposed to paint his "olde breech." At any rate, it is in the "Tale" that the penitential contradictions of the Pardoner's condition are most fully revealed to us, although we must avoid the temptation to misread it that the Pardoner himself puts in our way. Taken literally, as he recommends, it is an exemplum meaning *Radix malorum est cupiditas;* but, read spiritually, it is a moral allegory about the Pardoner himself, and it figures not avarice but despair. On the one hand, the rioters enact the Pardoner's life of self-damnation. Brazenly impenitent ("And ech of hem at otheres synne lough" [476]), they are perverse *imitatores Dei* both in symbol ("we thre been al ones" [696], "the yongeste of hem alle" [804] serves bread and wine) and action ("Deeth shal be deed, if that they may hym hente!" [710]).[59] And when, like the Pardoner, they issue from their tavern to do God's work, they receive their deserts with the terrifying efficiency of final judgment.[60] These are, as it were, the facts of the Pardoner's case, his history both past and future. But the human meaning of that history is expressed in the emotional centre of the tale, the old man. Rather than the saintly wise man of the analogues, a philosopher or hermit or even Christ, the Pardoner presents a figure who accurately reflects his own irreducible contradictions. Like the Pardoner, the old man proffers advice both needful ("Agayns an oold man, hoor upon his heed, / Ye sholde arise" [743–44]) and perilous: "turne up this croked wey" (761). Also like the Pardoner, he knows the truth but is unable to use it. In the terms of the story, he knows where Death is to be found but cannot find him himself, while tropologically he has won through to a gentle wisdom that has done little to relieve his suffering: hence he too offers a closing benediction – "God save yow, that boghte agayn mankynde, / And yow amende!" (766–67) – that is in the event self-excluding. For the old man's fate is to remain ever unregenerate, whether this be expressed in the fairy-tale (or allegorical) terms of exchanging age for youth or in the theological terms of exchanging the "cheste" of his worldly goods for the "heyre clowt" of penance.[61] As we should remember, he speaks with a voice traditional to the penitential lyric, that of the sinner whose repentance has come too late and whose wisdom is bought at the price of endless anguish: "Deþ ich wilni mest, / Wi nis he me I-core?"[62] These are "Maximian's" words in his "Regret," and it is precisely Maximianus's first elegy that Chaucer drew upon for this portrait and that directs us to the context of failed penance which helps to explain the old man. "Vivere poena mea," says the speaker of Maximianus's poem, and it is this penance that the old man now suffers. Like the sterile *quaestor* whom he faithfully expresses, he is condemned to a life-in-death of Cain-like wandering, and in his fruitless penitential yearnings he has descended into the hell of despair.[63]

It is not difficult to see how the condition that is expressed symbolically in the old man should function literally in the Pardoner himself, for the

mechanism that Chaucer provides is astonishingly precise. In detailing the Pardoner's eunuchry Chaucer renders it, as we know, meaningful in the medieval languages of both science and religious symbol. But the Pardoner egoistically misreads himself, and, like the rioters of his tale, takes letter for spirit, fleshly understanding for spiritual. As we have seen, contrition includes a powerful, at times overwhelming negative movement, its separate aspects traditionally termed *pudor, detestatio, dolor,* and *timor.* In obvious ways, each of these feelings is known to the Pardoner, but he misuses and misapplies them: his obsessive self-regard is directed not to his sinful acts but to his physically-maimed body. Ashamed of his literal eunuchry, he hides behind a far more shameful spiritual sterility; fearing exposure to his companions, he mocks the judgment of God; his sorrow is not *de amissione patriae celestis, et multiplici offensa Creatoris* but simply *de ipso;* and his hatred is not *vilitatis peccati* but for the vileness of his body. In the "Parson's Tale" Chaucer quotes St. Paul's famous lament, "Allas, I caytyf man! who shall delivere me fro the prisoun of my caytyf body?" (X.344) In a sense that exceeds his comprehension, this is the meaning of the Pardoner's words, and it is only in the symbolic displacement of the "restelees kaityf" that he finally reveals himself to us.

Change, of course, remains possible, even for the Pardoner, although his vain and self-indulgent literalism, his "ariditas litterae," seems to forestall any real conversion. As we remember, the fatality of despair is its ability to destroy its own cure.[64] At once defiant and self-hating, wretched in his licentiousness and yet hardened in sin, the Pardoner yearns towards the release of confession but is unable to bring himself to it. The distortions and displacements of his speaking, then, are not superficial awkwardnesses or vestiges of irrelevant conventions but the essence of his paradoxical meaning. The "Prologue" presents inflated self-advertisements and fugitive glimpses of a more genuine self; the "Tale" displaces into fiction the Pardoner's deepest self-understanding, while hiding its meaning from the man who speaks. Finally, the offer of the relics comes as the fitting conclusion to this sequence, an elliptical and compact gesture that is as contradictory as the Pardoner's previous utterances. On the one hand, he asks for inclusion, either in the fellow-feeling of a jest or the earnest respect due a "suffisant pardoneer"; on the other hand, he invites exclusion, even punishment. The punishment that is, in fact, inflicted is exquisitely apt; it clarifies what had previously been garbled and makes explicit the fruitlessness that only true confession can finally cure. In its full dimensions, then, as an invitation to be hurt and forgiven, the epilogue exactly fulfills the post-confessional part of penance: it provides a satisfaction that fits the sin[65] and a gesture of absolution: "Anon they kiste, and ryden forth hir weye." Penitential theology has provided Chaucer not only with one of his subtlest pilgrims, but also with one of his finest structural achievements: a "Prologue" and "Tale"

that are related at the deepest levels of language and doctrine, and for an epilogue a dramatic gesture which, while participating in these levels of meaning, provides emotional release from the problems raised.

## NOTES

1. For the appeal to convention, see G. G. Sedgewick, "The Progress of Chaucer's Pardoner, 1880–1940," *MLQ*, 1 (1940), reprinted in Edward Wagenknecht, ed., *Chaucer: Modern Essays in Criticism* (New York, 1959), pp. 128–9. This view was attacked as early as Kittredge's famous article in the *Atlantic Monthly*, 72 (1893), reprinted in Wagenknecht, *Chaucer*, pp. 117–25. He urged a reading in terms of dramatic context and common sense psychology: the Pardoner speaks because, "he is too clever a knave to wish others to take him for a fool. Hence the cynical confessions at the outset" (p. 121). Kittredge's approach has become the standard alternative, although, of course, the specific terms have varied widely.

2. For a caveat, see Paul E. Beichner, "Chaucer's Pardoner as Entertainer," *Mediæval Studies*, 25 (1963), 171, responding to the suggestion of Robert P. Miller, "Chaucer's Pardoner, the Scriptural Eunuch, and the Pardoner's Tale," *Speculum*, 30 (1955), 190, nn. 38, 43.

3. The *forma confitendi* is the bare list of topics on which the penitent is examined: the seven sins, the five wits, the deeds of mercy, and so on. Occasionally, the *forma* is transposed from an interrogative into a declarative mood and, duly expanded, presented as the confession of an individual penitent. For Middle English instances of each kind, see Carl Horstmann, *Yorkshire Writers: Richard Rolle of Hampole and His Followers*, 2 (London, 1896), pp. 340–3, and R. H. Bowers, "The Middle English *St. Brendan's Confession*," *Archiv für das Studium der neueren Sprachen*, 175 (1939), 40–9. The function of the *confessio* is explained by the author of the fourteenth-century *The Clensyng of Mannes Sowle:* "in this forme of confessioun whiche I write I schal schewe ʒow diuers spices of ech of hem which in general ben cleped þe seuene dedely synnes. Scheweth tho in which ʒe ben gilty and leueth the remenaunt" (MS Bodley 923, fols. 73v–74r).

4. Of course, the influence of penitential ideas is not limited to a single genre; see John Burrow, *Ricardian Poetry* (London, 1971), pp. 106–9.

5. For poems that use the complete *forma*, see Carleton Brown and R. H. Robbins, eds., *Index of Middle English Verse* (New York, 1943), 271, 965, 1602, 1959, 1969, 3231, 3233, 3483; for its more subtle use, 253, 374, 1511, 1732, 1839, 2390.

6. *Ibid.*, 1732, 2073, 2390, 2483.

7. *Ibid.*, 968; printed in Carleton Brown, *English Lyrics of the XIIIth Century* (Oxford, 1939), pp. 156–8.

8. Psalm 50 (51). 19.

9. Augustine, *Confessiones* 1.1.1.; 10.3.4; Alanus de Insulis, *De sex alis cherubim* (PL 210:273); Bernard, *Epistolae* 113.4. (PL 182:258). For other Middle English lyrics that use this theme, as in the refrain "Ay Merci, God, And graunte Mercy," see *Index*, 374, 2390, 2483, 2687. Cf. Peter von Moos, "Gottschalks Gedicht *O mi custos* – eine *confessio*," *Frühmittelalterliche Studien* 4 (1970), 201–230, 5 (1971), 317–358.

10. *Index*, 1511; printed in F. A. Patterson, ed., *The Middle English Penitential Lyric* (New York, 1911), pp. 57–9. Another manuscript contains the same

poem with an additional sixty-four lines of moralization: F. J. Furnivall, ed., *Hymns to the Virgin and Christ*, EETS, o.s. 24 (London, 1867), pp. 35–9.

11. Although even a death-bed repentance is considered valid, it is nonetheless an anxious and insecure way to salvation: "Parson's Tale" X.94; see also "*The Castle of Perseverance*," lines 2969–3007, Mark Eccles, ed., *The Macro Plays*, EETS, o.s. 262 (London, 1969), pp. 90–1. Middle English lyrics on old age that focus on penitential themes can be found in *Index*, 718, 880, 349, 1115, 1216, 1272, 1454, 1511, 2272.

12. *Index*, 1272; printed in Richard Morris, ed., *An Old English Miscellany*, EETS, o.s. 49 (London, 1872), lines 8, 16–18, 36, pp. 58–9.

13. "Thanne comth the synne that men clepen *tarditas*, as whan a man is to laterede or tariynge, er he wole turne to God; and certes, that is a greet folie. He is lyk to hym that falleth in the dych, and wol nat arise." "Parson's Tale" X.718; see also *Index*, 1454.

14. *Index*, 1115 and 1216; I quote from, respectively, Brown, *XIIIth*, pp. 92–100, and Carleton Brown, *Religious Lyrics of the XIVth Century*, 2nd ed. (Oxford, 1952), pp. 3–7.

15. For poems which explicitly present themselves as acts of penance, see *Index*, 773, 775, 893, 1066, 3533, 3774.

16. In her useful discussion, Greta Hort stresses the sorrowfulness of the confessions: "The keywords of these confessions are not payment, money, but sorrow, shame, and purpose of amendment." *Piers Plowman and Contemporary Religious Thought* (London, [1938]), p. 144. As the author of one of the vernacular treatises says, "What likyng haþ þe envious of his enemy or þe irous of his wraþþe or hate or elles þe coueitous; certes now[t] but payne" (Bodley MS Eng. th. c. 57, fol. 8r.).

17. In *Pupilla oculi* (1384), a revision of William of Pagula's *Oculus sacerdotis*, John Burgo distinguishes between the pain of contrition and the pain of sin: "Ita cor hominis conteri dicitur, quando affectus peccati secundum omnem sui partem in eo confringitur et totaliter a peccato resilit. Et dicitur huiusmodi contritio dolor voluntarie assumptus: ad differentiam doloris naturalis qui nec est meritorius nec demeritorius pro peccatis ponitus ad differentiam inuidie que est dolor voluntarius de bono alieno." 5.2.B (Rouen, 1510).

18. For Middle English descriptions of damnation as a deathless dying, see Georgiana Lea Morrill, ed., *Speculum Gy de Warewyke*, EETS, e.s. 75 (London, 1898), p. 14, and W. Nelson Francis, ed., *The Book of Vices and Virtues*, EETS, o.s. 217 (London, 1942), p. 71: "And þerfore wiþ good riȝt is þat penaunce cleped deeþ wiþ-outen ende, for euere-more a man or womman lyueþ [þere] dyenge, and dyeþ euermore lyuynge."

19. There is, however, a loss in this revision, for when Robert is removed from his position in the B-Text, following the final confession of Gloton, he is no longer able to counter the despair aroused by the whole penitential sequence. See Elizabeth Kirk, *The Dream Thought of Piers Plowman* (New Haven, 1972), pp. 62–3.

20. Augustine, *De civitate Dei* 14.13.1 (*PL* 41: 420–1), *Contra Secundinum Manichaeum* 1.15 (*PL* 42:590); see also Gerhard B. Ladner, *The Idea of Reform: Its Impact on Christian Thought and Action in the Age of the Fathers* (Cambridge, Mass., 1959).

21. Augustine, *Sermones* 145.3 (*PL* 38:792).

22. *The Scale of Perfection* 1.52, Evelyn Underhill, ed. [and trans.], 2nd imp. (London, 1948), p. 126; see also Julian of Norwich, *Revelations of Divine*

*Love* 40, Grace Warrack, ed. [and trans.], 13th ed. (London, 1949), pp. 81–2.

23. Psalm 118 (119). 75, quoted by Bernard, *Sermones in Cantica Canticorum* 36.5 (*PL.* 183: 969–70).

24. The *vermis conscientiae* is discussed at length by Guillaume DeGuilleville, *Le Pèlerinage de l'âme*, ed. J. J. Stüringer, Roxburghe Club (London, 1895), pp. 45–51.

25. Pennaforte clarifies the nature of this recognition with a reference to Isa. 38.15: "Recogitabo tibi omnes annos meos in amaritudine animae meae." Cf. the "Parson's Tale," X.135.

26. 3.9 (Rome, 1603), p. 443.

27. *Opera omnia* (Basle, 1554), p. 377.

28. Mabel Day, ed., *The English Text of the Ancrene Riwle*, EETS, o.s. 225 (London, 1952), pp. 150–1. For an excellent discussion of despair, see Susan Snyder, "The Left Hand of God: Despair in Medieval and Renaissance Tradition," *Studies in the Renaissance*, 12 (1965), 18–59.

29. *De sacramento poenitentiae* 1.6, Opera omnia, t. 1 (Paris, 1674), p. 465. It should be pointed out that these *motus* are not themselves contrition, but only preparatory to it (see pp. 466–7).

30. *De civitate Dei* 14.7.2. (*PL* 41:411).

31. *De coenobiorum institutis* 9.11 (*PL* 49:359); see Snyder, 58 and passim.

32. Isidore, *Sententiarum libri tres* 2.14.3. (*PL* 83:617); Caesarius of Heister-bach, *Dialogus miraculorum* 2.6, 2.7; Aquinas, 4 *Sent.* 17.2.4.2.

33. *Revelations* 73, p. 149.

34. S. B. Meech and H. E. Allen, eds. *The Book of Margery Kempe*, EETS, o.s. 212 (London, 1940), pp. 6–11. For a prayer against despair, see *Index*, 1666.

35. *Livre de Seyntz Medicines*, E. J. Arnould, ed. (Oxford, 1940), pp. 56–7. Walter Hilton uses the same figure in his treatise, *The Mixed Life*, printed by George G. Perry, ed., *Early English Prose Treatises of Richard Rolle of Hampole*, EETS, o.s. 20 (London, 1866), p. 38. J.-C. Payen, *Le Motif de repentir dans la littérature française médiévale (des origines à 1230)* (Geneva, 1968), mentions "le dit pieux *du triacle et du venim*, que nous avons lu dans le MS BN fr. 12471, f. 47: ce dit est une allégorie de la pénitence" (p. 559, n. 8).

36. *Le Pèlerinage de l'homme* (Paris, 1511), fol. 16r.

37. Pseudo-Gregory, *In Septem psalm. poenit. expositio* 7.9 (*PL* 79: 649); F. J. Furnivall, ed., *Handlyng Synne*, EETS, o.s. 123 (London, 1903), pp. 386–7; W. O. Ross, ed., *Middle English Sermons*, EETS, o.s. 209 (London, 1940), pp. 275–6; "Parson's Tale," X.1070–5; etc.

38. As one example from among many, this is the account of despair in the *Speculum Christiani*, G. Holmstedt, ed., EETS, o.s. 182 (London, 1933), p. 72: "Iudas offended more god in that he henge hym-selfe, than in that synne that he be-trayede Cryste. Therfor in verray confessyon knowleche ȝoure synnes and dooȝ penaunce, [and] the kyngdom of heuens schal come nere ȝou."

39. *Ennarationes in Psalmos* 101.10 (*PL* 37:1301); see also *In Joh. Evang.* 33.8 (*PL* 35:1651).

40. *Moralia* 12.40–1.45–6 (*PL* 75:1007–8); see also *Moralia* 31.3.3 (*PL* 76:573).

41. *Macro Plays*, pp. 91–111; see also the conclusion to *Mankind*, pp. 180–4.

42. Walter Hilton, *Bonum Est, Minor Works of Walter Hilton*, Dorothy Jones, ed. (London, 1929), p. 177; Julian, *Revelations* 39, p. 79; Paul Molinari, S.J., *Julian of Norwich* (London, 1958), pp. 78–84; Siegfried

Wenzel, *The Sin of Sloth: Acedia in Medieval Thought and Literature* (Chapel Hill, 1967), pp. 60–3; and see the texts collected by R. Garrigou-Lagrange, *Les Trois Âges de la vie intérieure*, 2 (Paris, 1938), pp. 38–50.

43. The full complexities of penitential theology are beyond the scope of this article, but two points should be made. First, despite the patristic rejection of *timor gehennae* as a legitimate part of contrition, later writers insisted that the psychological movement towards contrition is gradual and can usefully include self-regarding feelings: *cf.*, for instance, the discussions of *timor gehennae* by Jerome (*PL* 26: 874) and Augustine (*PL* 36: 161) to that by Alanus de Insulis (*PL* 210: 290). When joined to sacramentalism, as by William of Auvergne, this gradualism gave rise to the doctrine of attrition; and by the fifteenth century it was possible to organize the sinner's progress, from faint stirrings of apprehension through to *timor filialis*, into ten distinct steps: E. Jane Dempsey Douglass, *Justification in Late Medieval Preaching* (Leiden, 1966), p. 141, n. 1. Second, fourteenth-century nominalism tended to call into question the sacramentalism of the scholastics and proposed a return to the contritionism of earlier times: see Gordon J. Spykman, *Attrition and Contrition at the Council of Trent* (Kampen, 1955); Heiko A. Oberman, *Archbishop Thomas Bradwardine* (Utrecht, 1957); Gordon Leff, *Bradwardine and the Pelagians* (Cambridge, 1957), pp. 203–6. Greta Hort, *Piers Plowman*, pp. 130–155, convincingly demonstrates Langland's contritionist bias, but her suggestion that his opinions were self-consciously on the verge of heresy seems wide of the mark. Wyclif's rejection of auricular confession and his bitter attacks on the *ars absolvendi* are not so much the carrying of a contemporary tendency to an heretical extreme as the extension of his basic antisacramentalism to include penance.

44. *In capite ieiunii*, quoted by P. Amédée Teetaert, *La Confession aux laïques dans l'église latine* (Paris, 1926), p. 288, n.4. As Father Teetaert shows, the validity of confession to a layman depended upon the psychological impact of the act itself (469).

45. *Scale* 2.7, p. 247.

46. James L. Calderwood, "Parody in *The Pardoner's Tale*," *English Studies*, 45 (1964), 302–9, and John Halverson, "Chaucer's Pardoner and the Progress of Criticism," *Chaucer Review*, 4 (1970), 184–202. This interpretation is very close to the more familiar one that sees the Pardoner as an entirely self-conscious entertainer: Beichner, "Pardoner as Entertainer," pp. 160–72, and Ralph W. V. Elliott, "Our Host's 'Triacle': Some Observations on Chaucer's 'Pardoner's Tale,'" *Review of English Literature*, 7 (1966), 67–8.

47. *Le pèlerinage de l'homme*, fol. 70v; cf. *Canterbury Tales* VI. 953 and I. 694–706.

48. See John of Freiburg, *Summa Confessorum*, 3.34.66: "Vnde non tenetur iterare confessionem qui fictus accedit. Sed tenetur postmodum fictionum suam confiteri" (Lyon, 1518), fol. 191r.

49. *Piers Plowman*, B.3.35–63; *Handlyng Synne*, pp. 392–6.

50. T. F. Crane, ed., *The Exempla . . . of Jacques de Vitry* (London, 1890), p. 125: "Hec est confessio vulpis, que solet in Francia appellari confessio renardi." See John Block Friedman, "Henryson, the Friars, and the *Confessio Reynardi*," *JEGP*, 66 (1967), 550–561, and J.-C. Payen, *Le Motif*, pp. 547–48, n. 65.

51. *Le Roman de Renart*, ed. Mario Roques, CFMA 88 (Paris, 1960), Branche XIV, pp. 37–55. As Charles Muscatine has shown, the name of Chaucer's Friar Huberd is almost certainly taken from the *Roman de Renart* and

most likely from this episode: "The Name of Chaucer's Friar," *Modern Language Notes*, 70 (1955), 169–72.

52. Miller, 184. In its development through the Middle Ages, the concept of the *peccatum in Spiritum sanctum* came to include two not always easily harmonized elements, personal impenitence (the "duritia cordis et cors impoenitens" of Rom. 2.5) and an attack on Christian truth and the fellowship of the Church: Augustine, *De Sermone Domini in monte* 1. 22.73–4 (*PL* 34:1266–7), *Epistola ad Romanos inchoata expositio* 21 (*PL* 35:2097, 2103), *Epistolae* 185.49 (*PL* 33:814), *Sermones* 71 (*PL* 38:445–67). The first element is usually defined by the terms *praesumptio, desperatio, obstinatio,* and *impoenitentia,* the second by *invidentia gratiae* and *oppugnatio fraternitatis.* While the relationship among these terms is never entirely settled, it is clear that *desperatio* plays a central role. It is not merely an aspect of the sin but a primary cause, and in some cases the sin itself: Bede, *In Matthaei Evangelium expositio* 2.12 (*PL* 92:63). In Lombard's authoritative discussion, this emphasis on despair is particularly marked: *Sententiae* 2.43.1 (Quaracchi, 1916), pp. 533–4; see also Aquinas, *ST* 2.2.14.2. Doubtless, it is this history, as well as the peculiar mutuality of despair and impenitence – despair as usual cause and inevitable effect – that accounts for the definition in several fourteenth-century English texts of the sin against the Holy Ghost as despair alone: "Parson's Tale" X.693–5; *Handlyng Synne,* pp. 386–7; *Middle English Sermons,* pp. 56–7; T. F. Simmons and H. E. Nolloth, eds., *The Lay Folk's Catechism,* EETS, o.s. 118 (London, 1901), p. 11. In sum, if we want to understand the Pardoner as "a man sinning vigorously against the Holy Ghost" (Miller, 190), then we should be particularly alert to evidence of the self-destruction of despair. For another, very different discussion of the Pardoner as a victim of despair, see Bernard F. Huppé, *A Reading of the Canterbury Tales,* rev. ed. (Albany, N.Y., 1967), pp. 209–220.

53. As, for instance, in Deguilleville's *Pèlegrinage de l'âme;* see Rosemond Tuve, *Allegorical Imagery* (Princeton, 1966), p. 150.

54. Hilarius, *Commentarius in Matthaeum* 21.6 (*PL* 9:1037); Augustine, *Tract. in Ioh.* 28.11 (*CCSL* 36, pp. 283–4); Drumarthus, *Expositio in Matthaeum* 48 (*PL* 106:1434); Rabanus Maurus, *Comment. in Matthaeum* 6.21 (*PL* 107:1044); Radbertus, *Expositio in Matthaeum* 9.21 (*PL* 120:714).

55. Augustine, *Ennarationes in Psalmos* 127.16 (*PL* 37:1688); see also *PL* 36:264 and, especially, 334: "Vide in verbis numerositatem, et in factis sterilitatem."

56. Augustine, *Ennarationes in Psalmos* 79.13 (*PL* 36:1027), *Ennar. in Ps.* 49.7 (*PL* 36:569); *Sermones* 72 (*PL* 38:467–70), *Sermones* 110 (*PL* 38:638–9); Gregory, *XL homiliarum in evangelia* 2.31 (*PL* 76:1229–30), *In librum I Regum* 1.2.3. (*PL* 79:51); Bruno Astens, *Commentaria in Lucam* 2.13 (*PL* 165:402); Haymo, *Homiliae de tempore* 132 (*PL* 118:698–9).

57. *Sermones* 72 (*PL* 38:467); see also *De sermone Domini in monte* 2.24 (*PL* 34:1305–6).

58. *Ibid.,* 468.

59. Eph. 5.1–4: "Estote ergo imitatores Dei, sicut filii carissimi: et ambulate in dilectione, sicut et Christus dilexit nos, et tradidit se ipsum pro nobis, oblationem et hostiam Deo in odorem suavitatis. Fornicatio autem et omnis inmunditia aut avaritia nec nominetur in vobis, sicut decet sanctos: aut turpitudo, aut stultiloquium, aut scurrilitas, quae ad rem non pertinent: sed magis gratiarum actio."

60. Stephen Barney observes that the plot shows how "the world properly

behaves *sub specie aeternitatis,* turning intangibles into tangibles and rendering justice at the end of time." "An Evaluation of the *Pardoner's Tale,*" in Dewey R. Faulkner, ed., *Twentieth-Century Interpretations of the Pardoner's Tale* (Englewood Cliffs, N.Y., 1973), p. 90

61. Miller identifies the old man as the *vetus homo* of sin, the antithesis of the *novus homo* who has been reborn, and he points out the old man's thwarted penance (197). While there is much to commend in this reading, the old man's ambiguity refuses to yield to any straightforward categories. For example, he meets the rioters "Right as they wolde han troden over a stile" (712) and seems to stand as the guardian-guide to a realm where their fleshly understanding will be baffled by a reality endowed with a second dimension of metaphor. Yet his own energetic personifications about youth and age and Mother Earth cast doubt upon his awareness by showing him speaking the rioters' language, the same language, furthermore, of the Pardoner's sermon itself, with its hyperbole pushed to the edge of personification. Other cogent qualifications of Miller's reading are offered by Christopher Dean, "Salvation, Damnation, and the Role of the Old Man in the *Pardoner's Tale,*" *Chaucer Review,* 3 (1968), 48, n. 28, and Alfred David, "Criticism and the Old Man in Chaucer's *Pardoner's Tale,*" *College English,* 27 (1965), 39–44.

62. Brown, *XIIIth,* p. 99.

63. For discussions that connect living death, wandering, and sterility to despair, see Gregory, *Moralia* 8.18.34–5 and 26.45 (*PL* 75:821–2, 829); Isidore, *Sententiarum libri tres* 2.14.2 (*PL* 83:617); Rabanus Maurus, *Comment. in Genesim* 2.1 (*PL* 107:506–7); *Glossa ordinaria* (*PL* 113:99); Aquinas, *ST* 2.2.20.1; Bernard, *Sermones* 42.4 (*PL* 183:989); Cassian, *De coenobiorum institutis* 9.11 (*PL* 49:359); Bonaventure, *Sermones in Dom. XIX post Pentecostem,* 2, *Opera omnia,* A. C. Peltier, ed., 13 (Paris, 1868), pp. 455–6; see Snyder, 56–8. For instances in the vernacular, see Richard Morris, ed., *The Pricke of Conscience* (Berlin, 1863), lines 7282–9, and Preface, p. xi; Robert Henryson, *Orpheus and Eurydice,* lines 310–16 and 607–9, *Poems and Fables,* ed. H. Harvey Wood, 2nd ed. (Edinburgh, 1958), pp. 139, 148. Chaucer's own use of the language of despair is usually in a romantic context, a common transference in medieval literature: *The Book of the Duchess,* lines 581–90; *Troilus and Criseyde* IV.279–80, I.603–9, II.526–32; and cf. the "Complaint Against Hope," Kenneth G. Wilson, ed., *University of Michigan Contributions in Modern Philology,* 21 (Ann Arbor, Mich., 1957).

64. Aquinas insists that the irremissibility of even the sin against the Holy Ghost derives not from the judicial gravity of the offense, but from the internal dynamics by which it destroys its own cure: *ST* 2.2.14.3; see also Augustine, *Epistolae* 185.11.49 (*PL* 33:814), and Lombard, pp. 535–6.

65. Discussions of penance almost always include the shame of exposure as part of the satisfaction for the sin: see Teetaert, *La Confession,* pp. 277, 297, and passim. It should also be remembered that the spiritual value of this shame stems in part from its role in bringing the sinner to genuine contrition.

# Some Aspects of
# Fourteenth-Century Philosophy

## ARMAND A. MAURER

In 1926 Etienne Gilson described philosophy in the fourteenth century as a virgin forest.[1] Today, some fifty years later, the forest can hardly be called virgin. Especially in the last few decades, historians in ever-increasing numbers have been trampling through it, breaking new paths and removing old ones. As a consequence, the geography of the forest is being charted more accurately, hills and valleys examined more closely, the taller trees identified, and even some of the underbrush cleared away.

Despite all this activity, the forest can scarcely be said to be conquered. In comparison with thirteenth-century philosophy, that of the fourteenth is relatively unknown. This is due in large measure to the fact that so many writings of the fourteenth century are still unpublished or available only in early printed editions. Unless one is a paleographer, inured to the reading of medieval manuscripts, or oblivious to the dust of incunabula, one can make little headway in this field. Some of the works of William of Ockham have not been printed since the fifteenth century, and a few are still extant only in manuscripts. The condition of the works of less important writers is often worse. A graduate student doing research in fourteenth-century philosophy with enterprise and paleographic expertise can in a short time confound his professor with facts the professor knows nothing about. This, incidentally, is not the least of the reasons why students in ever-larger numbers are concentrating in this area. More important, they have learned that without a knowledge of the late Middle Ages it is impossible to understand the beginnings of modern thought.

As one moves from the relatively well-cultivated field of thirteenth-century philosophy to the forest of the fourteenth, one is conscious of a new mood and atmosphere. He has a sense of the continuity of thought and expression between the two centuries: philosophy is still done in the scholastic manner, in Latin, with much the same vocabulary and citation of ancient and medieval authorities. But there is a new temper to the times, a distinctive spirit that distinguishes a fourteenth-century thinker from one of the thirteenth century as surely as a typical fourteenth-century work of art or manuscript is different from one of the previous century.

What are the most distinctive characteristics of fourteenth-century philosophy? I would suggest that they are:

1. relative to the preceding century, a more cautious and critical attitude towards the philosophy of Aristotle, especially at Paris and Oxford;
2. a greater interest in problems concerning what is possible, rather than what is actually the case;
3. more rigorous criteria of demonstration, with a consequent concern for probability and degrees of probability;
4. most important, the rise of nominalism and a greater emphasis on the individual in all areas of thought.

As we proceed, I hope it will become apparent that these four characteristics are not unrelated. Taken together, I believe, they created a climate of opinion in the fourteenth century that distinguishes its philosophy from that of any other period in the Middle Ages.

I have said, first of all, that the fourteenth century was marked by a shift in attitude towards Aristotle. Indeed, from the end of the thirteenth century, his influence was on the wane, until it was effectively extinguished in the seventeenth century, when Descartes filled the void with his new philosophy. The change in the status of Aristotelianism was bound to have far-reaching effects, for scholasticism was born with the discovery of Aristotle's works in the West at the end of the twelfth and beginning of the thirteenth century. Regarded with suspicion at first by Church authorities, his philosophy was gradually accepted and assimilated into Christian thought. With Albert the Great and Thomas Aquinas, Aristotelianism reached its apogee in the Middle Ages. But the rise of Averroism in the 1260's, and the condemnation in 1277 of Aristotelian naturalism at both Paris and Oxford – the intellectual centers of western Christendom – brought about a marked change in the evaluation and use of Aristotle's philosophy.[2]

I do not mean that Aristotelianism was no longer taught and read in the schools; indeed it was. The masters continued to regard Aristotle as *the* philosopher and to use his ideas and language. But his heyday was over. The masters increasingly found his philosophy inadequate to express their Christian thought. They stressed the limitations of his philosophy and sought to find, or to create, new vehicles for their theologies.

It must be remembered that most of the philosophers of the fourteenth century, as in the previous century, were primarily theologians. They did not separate philosophy from theology, but philosophized within theology and for theological purposes. Many treatises that appear to be purely philosophical have, in fact, a theological orientation. A notable example is Ockham's great work in logic, the *Summa Logicae*. In the preface he says that he wrote it to teach theologians logic, because they were falling into error through ignorance of the subject.[3] Throughout the work, Ockham is conscious of this purpose, and, when the occasion demands, he clearly distinguishes between the *intentio Aristotelis* and the

*veritas theologorum.*[4] In this respect, fourteenth-century philosophy was in continuity with that of the previous century: it was the work of philosophizing theologians and not of pure philosophers.[5] Averroists like John of Jandun were exceptions, in that they philosophized apart from religion, as Averroës himself and Siger of Brabant did before them. But, just because of this, they were out of tune with their contemporaries, who regarded them with suspicion and sometimes with outright hostility.

Because they were also theologians, most fourteenth-century philosophers did not ignore the condemnation of Aristotelian and Muslim naturalism at Paris and Oxford in 1277. That they took the condemnation seriously is clear from their constant citation of the proscribed propositions and from their efforts to disprove them. The condemnation was not entirely new: it crystallized the growing reaction of the theologians against the *errores philosophorum* – the errors of Aristotle and his Muslim commentators Avicenna and Averroës. After the solemn condemnation, the atmosphere in the universities was not the same: theologians were increasingly on the defensive against the pagan and Muslim philosophers, and they sought new and more adequate bases for their theologies.

Above all, the theologians felt the need for a more adequate approach to the existence and nature of God than the Aristotelians offered. To Thomas Aquinas, Aristotle's proof of the existence of God from motion was the most evident of all. We observe motion in the world, and because everything that is moved is moved by something else, and there cannot be an infinite series of movers, there must be a primary mover that is itself immovable, while it moves everything else. This primary mover, Aquinas baldly states, "everyone understands to be God."[6]

To this, Scotus adds the pertinent comment: but not properly the *Christian* God. The God of the Christians is not only the primary mover of the world, he is the primary being. He has not only infinite motive power, as Aristotle held, but he is absolutely infinite. Moreover, there is only one Christian God, but many Aristotelian primary movers. To reach the God of the Christians a physical proof is not sufficient; what is needed is a metaphysical demonstration, which Scotus provides in what is, no doubt, the most perfectly-elaborated proof of God's existence in the Middle Ages. The demonstration culminates in the proof of the existence of an infinite being. Scotus's method is worthy of notice: he first proves the *possibility* of an infinite being by showing that the notion contains no contradiction. He then demonstrates that an infinite being *actually exists* as the only reason for its possibility.[7]

Scotus was not the only theologian who looked for a more suitable philosophical vehicle of Christian truths than Aristotelianism. The mystic, Master Eckhart, encountered God in a realm beyond being, in a darkness and wilderness that he could best describe as non-being (*nihil*), or the One.[8] Neoplatonism, in his view, was a more appropriate guide into this

lofty region than the more mundane philosophy of Aristotle. Paradox, and even contradiction, are to be expected here: God is not a being, because he transcends everything we call being or reality; but he can also be called a being, because he is its creator.

The baneful effects of Aristotelianism was a dominant theme of Nicholas of Autrecourt, master of arts and bachelor of theology at Paris in the 1330s and 1340s. He was astonished to see some Christians studying Aristotle and Averroës for twenty or thirty years, right up to a decrepit old age. So preoccupied were they with Aristotle's logic that they forsook ethical questions and the care of the common good. Having examined almost a thousand conclusions demonstrated by Aristotle and Averroës, Nicholas concluded that their contraries can be held with just as much probability. The friend of truth (by which he means himself) may rise up and sound a trumpet to rouse these sleepers from their slumber, but this only angers them, and they rush upon him like armed men to deadly combat.[9] And indeed, they made him burn his books publicly at Paris in 1347. In place of Aristotle's physics, Nicholas of Autrecourt proposed to return to the atomism of early Greek philosophy. Atomism, in his view, accords better with Christianity, and it can be held as probable, at least until some other doctrine comes along to make it, in turn, improbable.

Other examples of fourteenth-century antipathy to Aristotle could be cited, but perhaps this is enough to show that his influence was in decline. The most active minds were looking for new philosophical paths, whether from the ancients or from their contemporaries, such as William of Ockham, as the Mertonian physicists were trying new methods in science, different from those of Aristotle.[10]

The second characteristic of fourteenth-century philosophy I should like to point out is its preoccupation with problems concerning what is possible, rather than what is actually the case. This type of problem was raised occasionally in the previous century, but by no means as often as in the fourteenth. Theologians and philosophers had a predilection for speculating about what is possible, given the absolute power of God. William of Ockham begins his Commentary on the *Sentences* with the remarkable question: "Is it possible for the intellect of a man in this life to have an evident knowledge of theological truths?"[11] This is an extraordinary introduction to a course in theology. Ockham asks whether God, by his absolute power (*per potentiam absolutam*), could give us the evidence of the mysteries of faith, which, in fact, we now know only in a dark manner. Throughout his Commentary, Ockham raises hypothetical questions of this sort. For example, can God give a person an intuition of a non-existent object?[12] Can he create a better world than the present one? Can he create many worlds, with natural species different from our own, even human beings of another species?[13] Can he justify a person without endowing him with a created quality of grace?[14] Similar prob-

lems of what is possible were raised throughout the fourteenth century; for example, can God undo the past, i.e. make what has happened not to have happened?[15] As far as I know, no one in the Middle Ages debated the question of how many angels can dance on the point of a pin; but the form of the question was familiar to the fourteenth century, and perhaps also the subject. A logical treatise of Pseudo-Campsall contains the statement that an infinite number of pure spirits can be present in the same place; for does not Scripture say that a legion of devils inhabited one demoniac? And if a legion, why not an infinity of demons?[16]

Why this concern for what can be, for what is possible? I suggest that this is a consequence of the notion of God as omnipotent and creatures as purely contingent. This, in turn, is connected with the anti-Aristotelianism I have just discussed. To Aristotle and Averroës, the world is eternal and necessary, both in its existence and its basic structure. It cannot not exist or be essentially different from what it is. Individuals come and go, and hence they are contingent, but the universe as a whole and its various natural species are eternal and necessary. No doctrine of Aristotle was more vigorously opposed in the fourteenth century. The Scotists and Ockhamists insisted that, unlike the God of Aristotle, the God of the Christians is an omnipotent and free creator. The universe exists only by his fiat; had he decided otherwise, it would not have existed or it would have been created differently. Even now, God could annihilate it if he wished. In short, he alone is a necessary being; contingency rules the whole order of nature and also the order of grace.

But if the world is utterly contingent, how is it possible to reach necessary truths about it? Are not all truths about what actually exists contingent, i.e. truths that may be otherwise? Now, the philosopher is not satisfied with contingent truths; he wants to know truths that are universal and necessary. In a contingent world he cannot do this by forming propositions about what actually is the case, but he can by framing his assertions in the mode of possibility. The possible is simply that which is not contradictory. For example, there is nothing contradictory about a plane figure having three sides and three angles; hence, a triangle is possible, even though none may actually exist. It is contingent whether triangles actually exist; it is necessary that they fulfill their definition if they do. Hence the possible, or non-contradictory, offers the mind a necessary object, and necessary propositions can be formed about it. That is why Scotus preferred to base his proof of the existence of God upon the possibility of an infinite being, rather than upon the actual, contingent fact that there are movers and causes in the world. Once he has shown that an infinite being is possible, he felt that he had a more solid, because necessary, basis on which to prove the actual existence of God.[17]

Another way fourteenth-century philosophers and theologians formed necessary propositions about the contingent world was to put them in

the hypothetical mode, that is, in the form "If . . . then." To an Aristotelian an assertion of identity, such as "Man is Man," is absolutely necessary; but to an Ockhamist this is a contingent proposition, because Man's existence itself is contingent. If God had not created Man, he would not exist, and even now God could annihilate all men. So Man's existence is not necessary, and neither is the proposition "Man is Man." However, if it is put in the hypothetical mode: "If Man exists, then Man is Man," it becomes necessary.[18]

This philosophical turn from the actual to the possible and the hypothetical cannot be explained solely by the Christian conviction in the absolute power of God. It is also a direct consequence of the conception of the complete contingency of the existing order of things. Thomas Aquinas was as certain of the omnipotence of God as Scotus and Ockham were, yet he believed that once God freely chose to create the world, spiritual beings like angels and human souls, and matter itself, existed with absolute necessity. This necessity flows from the nature God has given them in creation, which in his wisdom he would not violate.[19] In the view of Thomas Aquinas, accordingly, the world contains both contingent and necessary beings; created existence is not utterly contingent, as both Scotus and Ockham thought it to be. This doctrine of Aquinas profoundly scandalized Henry of Harclay, a Chancellor of Oxford and predecessor of Ockham. In ascribing absolute necessity to certain creatures, Harclay saw Aquinas making undue concessions to the pagan Aristotle, and he branded Aquinas a heretic.[20]

As Scotism and Ockhamism gained ground in the late Middle Ages, their notion of the contingency of created existence gradually penetrated the schools, with profound consequences for philosophy for centuries to come. Following Aristotle, Scotus defined the object of metaphysics – philosophy par excellence – as being *qua* being, but he insisted that the object of metaphysics was not the being of actual existence but the being of essence or quidditative being; in short, possible being. Actual existence was but a property or determination of the being that was the focal point of metaphysics.[21] Under these circumstances, even though actual existence was not disregarded, philosophy could not be fully existential. Its main concern was essences as possible bearers of existence.

In his own way, Ockham also contributed to the de-existentializing of late medieval philosophy. The actually-existing world, in his view, is composed of individuals, but these are not the primary concern of the scientist or philosopher. The philosopher's object is the universal, and universality is found only in terms, either conceived in the mind or spoken or written. Terms are the elements of propositions, so that Ockham can conclude that propositions are the object of philosophy. "Every science," Ockham writes, "whether real or rational, is concerned only with propositions as with objects known, for only propositions are known."[22] This

does not mean that science or philosophy in no way concerns the individual, or that the individual is unknown, but that scientific knowledge is directed primarily to universal terms and propositions. It treats of the individual only insofar as the terms of propositions stand for and signify them.[23] Thus, philosophy primarily and directly is a study not of the actually existing world, but of mental and verbal assertions. Centuries before the contemporary linguistic movement in philosophy, Ockham, the Oxonian, directed the study of philosophy to language.

A third factor shaping the philosophical atmosphere of the fourteenth century was the prevalence of dialectical reasoning, leading to probability, not certitude. Aristotle described this type of argumentation in his *Topics*, and it was used throughout the thirteenth century. Aquinas resorted to it, especially in matters we would today call scientific, when reasoning led to a conclusion that was *probabilis* or *rationabilis* but not *demonstrata*.[24] In the fourteenth century, many conclusions of natural theology or metaphysics were reduced to this status.[25] Ockham strictly limited the power of the mind to demonstrate truths in these matters. Criticizing the Scotist proof of the existence of God, he concluded that we cannot demonstrate attributes of God held on faith, such as his oneness or his omnipotence.[26] We can establish the existence of a primary conserving cause of the world,[27] but there may be many such causes, and they may be simply the heavenly bodies. We experience the effect of these bodies, such as the sun and moon, on our world; and it cannot be evidently proved that they have been produced by an efficient cause.[28] Neither can it be demonstrated that God is the final cause of the world,[29] or, indeed, that he has any knowledge of it.[30] Regarding Man, he denied that we can demonstrate the existence of an immortal, spiritual soul. These are matters of faith and not of philosophical demonstration.

The reason for the cult of probability and degrees of probability, by Ockham and his followers, takes us to the heart of their empiricism and nominalism. For them, the world is made up of individuals, no one of which has anything in common with any other. In this nominalistic world of individuals, the knowledge of one thing cannot lead to a knowledge of another: *una res non potest intelligi per aliam*.[31] Each thing must be perceived for itself. Hence, the difficulty of proving that one thing is the efficient cause of another. Only experience can assure us of this, "namely, that at its presence the effect follows, and in its absence it does not."[32] We can be sure of the evident intuitions of sense objects and our interior acts and feelings, also of the principle of non-contradiction and whatever can be directly reduced to it; beyond that lies a large area of probable knowledge.

From these principles, Nicholas of Autrecourt drew all the possible consequences. Except for the certitude of faith, he admitted nothing certain except the principle of non-contradiction and what is reducible to it;

for example, that a thing is identical with itself. Besides this, he allowed as certain what is directly verifiable in experience. This led him to cast doubt on the reality of substance and the faculties of intellect and will.[33]

No one could go further than John of Rodington in limiting the scope of pure human reason. Bruno Nardi published a remarkable treatise by this Franciscan, entitled: "Can one have certain knowledge of any truth from natural principles?"[34] Rodington's answer is, no, if by knowledge is meant a rational truth known so clearly that it cannot be doubted. "The intellect," he writes, "cannot naturally know something without being able to doubt that it knows it."[35] But, if we doubt, are we not certain at least that we doubt? Augustine appealed to this basic certitude in order to escape skepticism, as Descartes did later. Rodington's natural skepticism goes even farther, for he replies: ". . . absolutely speaking one can doubt that he doubts, because he is not completely certain that he does not doubt."[36] Rodington's skepticism was aimed at philosophers like Aristotle who relied on reason alone. It was they who, philosophizing without faith in Christ, did not reach the truth. Rodington did not doubt at all the truth of his religious faith. Natural reason alone may yield only probable conclusions, but he who enjoys a special divine illumination reaches a perfect knowledge of things.[37] Rodington's intention thus becomes clear: he downgraded natural reason and philosophy in order to exalt religious faith.

An incidental effect of the prevalence of dialectical reasoning was the tendency for disputations in the schools to run on at great length. It is the very nature of this kind of reasoning not to come to a certain conclusion, so there is no reason why it should end. John of Jandun recorded a public disputation he held in 1318 on the subject whether, given an eternal world, all possibilities will eventually be realized. Jandun and his opponent argue pro and con at great length, until one begins to suspect that in this interminable dispute all possible arguments will eventually be voiced. This, at any rate, seems to have been the fear of the students, for suddenly Jandun records that they were making so much noise that the disputation had to be halted. It began again, but, shortly after, Jandun was not able to hear the argument of his opponent "because of the outcry of the students, who were tired from having sat [so long]."[38] In those days, students had less command of university affairs; they were eventually subdued, for the debate continued with arguments that fill two more columns of parchment.

The most important development in philosophy in the fourteenth century was the nominalism of Ockham and others who, to a greater or lesser extent, shared his views. His relation to men like Adam Wodeham, Robert Holkot, Gregory of Rimini, and John of Mirecourt is currently being studied more closely, and new facts are coming to light that reveal them as individual thinkers, as well as adherents to common principles.[39]

Though they may hardly be called a school in the strict sense, they are at least united by what Wittgenstein would call "family resemblances."

As for Ockham, the principal figure in this movement, it is less fashionable than before to call him a nominalist; if the name is admitted, he is sometimes qualified as a "moderate nominalist," or "not a thorough-going nominalist."[40] For myself, I see no compelling reason to give up his traditional title. In the Middle Ages a nominalist was one who taught that universals, like "man" or "horse", exist only in the mind. In other words, they are nothing but names (*nomina*).[41] This is what Ockham taught, and he did so in as thorough-going a manner as possible. Universals, in his view, are either mental names (*nomina mentalia*), that is, concepts in the mind, or they are spoken or written names. General concepts are natural signs of individuals that more or less resemble each other; spoken and written words are conventional signs of the same individuals.[42]

Ockham revolutionized medieval thought by taking an absolute stand on this notion of universals and by drawing all its consequences for both philosophy and theology. It was generally agreed by the schoolmen of the thirteenth century that individual things in some way contain natures or essences which are the bases of our universal concepts. Ockham absolutely disagreed with them. It was axiomatic for him that reality is radically individual and in no sense common or universal.[43] Even words and concepts, insofar as they are realities, are individual; their universality consists solely in the fact that they are signs of many things. Ockham was fully aware of the novelty in his day of completely eliminating natures or essences from individual things. "All those whom I have seen," he writes, "agree . . . that there is really in the individual a nature that is in some way universal, at least potentially and incompletely, though some say that it is really distinguished [from the individual], some that it is distinguished only formally, some that the distinction is in no way in reality but only through reason and the consideration of the mind."[44]

Contrary to all the schoolmen Ockham had read, he proposed a new notion of reality as purely individual. So unique is each individual in his view that it has nothing in common with any other. Each is different not only in number, but also in essence.[45] It is rare in the history of philosophy to find someone who defines reality or nature in a new way and consistently draws from it all its implications. Ockham was such a philosopher.

It seems to me that we are here at the heart of Ockham's philosophy. Heidegger once said, "Each thinker thinks but one single thought."[46] The single philosophical idea that is at the center of Ockhamism is the notion of reality as purely individual.

As might be expected, this notion plays a pivotal role in every area of his thought. It underlies his innovations in logic, for example, his theory of signification and supposition of terms. It accounts for his new concepts

in physics, such as motion and quantity. It is found even in his political theory. If nothing is real, save the individual, there can be no social or communal reality: a society is nothing but the sum of individuals of which it is composed. This is clearly expressed in Ockham's notion of the Church and of his own Franciscan Order. No society, lay or religious, can be said to be a person – not even a fictitious one, as some canonists claimed.[47]

With his new conception of reality or being as radically individual, Ockham worked out a philosophy and theology whose influence was to last for centuries, indeed to our own time. To Leibniz, Ockham was "a man of the highest genius and of outstanding erudition for his time." The nominalist sect, which he revived, was "the one most in harmony with the spirit of modern philosophy."[48] Charles Sanders Peirce had little liking for Ockham's nominalism; he preferred the realism of Duns Scotus. But he was fully aware of the historical impact of Ockhamism. "Modern thought," he said, "has been extravagantly Ockhamistic."[49]

Thinkers of major stature, like Ockham, can be seen from the viewpoint of their influence on later generations, but they can only be understood in the context of their own time, as growing out of a tradition that they inherit and shape to their own liking. Ockhamism was a novelty in the fourteenth century: it epitomized the *via moderna;* but it was an answer to a centuries-old problem of how to use Aristotelianism and other non-Christian philosophies for the enrichment, and not the betrayal, of Christianity. It was also a Franciscan answer, the last in a long line that began with Alexander of Hales and Bonaventure and extended to Duns Scotus and William of Ockham.[50] Ockham, like his fellow Franciscans, had no intention of compromising the omnipotence and freedom of God by making undue concessions to the pagan and Muslim philosophers. Above all, he wanted to safeguard the first article of the Creed: I believe in one God, the Father almighty. In his view, Aquinas, and even Duns Scotus, had failed to uphold the complete contingency of creatures and the absolute liberty of God with regard to them. Working creatively within the Franciscan tradition, he devised his nominalist philosophy as his answer to this problem. Other fourteenth-century theologians, too numerous to mention, were engaged in the same enterprise. Among all of them, Scotus and Ockham were most successful in setting the style of thinking for the next few centuries.

## NOTES

1. See E. Gilson, *Revue d'Histoire Franciscaine,* 3 (1926), 129.
2. The text of the condemnation is in *Chartularium Universitatis Parisiensis,* ed. H. Denifle and E. Chatelain, I (Paris, 1889), pp. 543–58. For the significance of this condemnation, see E. Gilson, *History of Christian Philoso-*

*phy in the Middle Ages* (New York, 1955), pp. 402–10; F. Van Steenber-ghen, *La philosophie au XIII$^e$ siècle* (Louvain, Paris, 1966), pp. 483–93.

3. Ockham, *Summa Logicae*, ed. P. Boehner et al. (St. Bonaventure, New York, 1974), p. 6, lines 21–8.

4. *Ibid.* Pars I, c. 7, p. 24, line 55–p. 25, line 56. See Pars III–1, c. 31, p. 442, lines 73–82, Pars III–2, c. 7, p. 516, lines 34–9. In fact, Aristotle has said many false things: "Aristoteles . . . multa etiam falsa dixit." *Ibid.*, p. 614, lines 112–13.

5. See E. Gilson, *The Philosopher and Theology*, trans. C. Gilson (New York, 1962); A. C. Pegis, *The Middle Ages and Philosophy* (Chicago, 1963).

6. St. Thomas, *Summa Theologiae*, I, 2, 3.

7. See Scotus, *Ordinatio* I, d. 2, p. 1, q. 1–2; ed. C. Balic, vol. 2 (Vatican, 1950), pp. 125–221. Another version of the proof is found in his *De Primo Principio*, ed. E. Roche (St. Bonaventure, New York, 1949).

Before Duns Scotus, Henry of Ghent elaborated a metaphysical proof of the existence of God. See A. C. Pegis, "Toward a New Way to God: Henry of Ghent," *Mediaeval Studies*, 30 (1968), 226–47; "A New Way to God: Henry of Ghent (II)," *Mediaeval Studies*, 31 (1969), 93–116; "Henry of Ghent and the New Way to God (III)," *Mediaeval Studies*, 33 (1971), 158–79.

8. Eckhart, *Quaestiones Parisienses*, ed. A. Dondaine (Leipzig, 1936), pp. 7, 11. See V. Lossky, *Théologie Negative et Connaissance de Dieu chez Maître Eckhart*, (Paris 1960).

9. Nicholas of Autrecourt, *Tractatus Universalis Magistri Nicholai de Ultri-curia ad Videndum an Sermones Peripateticorum Fuerint Demonstrativi* (*Satia Exigit Ordo*), ed. J. R. O'Donnell, *Mediaeval Studies*, I (1939), 181. See J. R. O'Donnell, "The Philosophy of Nicholas of Autrecourt and his Appraisal of Aristotle," *Mediaeval Studies*, 4 (1942), 97–125.

10. For the Mertonians' new mathematical approach to nature, see M. Clagett, *The Science of Mechanics in the Middle Ages* (Madison, Wis., 1959); J. Weisheipl, *The Development of Physical Theory in the Middle Ages* (New York, 1959).

11. Ockham, *Scriptum in Librum Primum Sententiarum*, Prol. I; ed. G. Gál (St. Bonaventure, New York, 1967), I, p. 3.

12. *Sent.*, p. 38, line 15–p. 39, line 6.

13. *Sent.*, I, d. 44, q. unica; d. 42, q. unica; d. 43, q. 2.

14. *Sent.*, I, d. 17, q. 1. See P. Vignaux, *Justification et Prédestination au XIV$^e$ Siècle* (Paris, 1934), pp. 118–27.

15. John of Mirecourt was condemned in 1347 for teaching that God can make a past event not to have happened, but he defended himself against this charge. Gregory of Rimini did uphold this thesis. See W. J. Courtenay, "John of Mirecourt and Gregory of Rimini on Whether God Can Undo the Past," *Recherches de Théologie Ancienne et Médiévale*, 39 (1972), 224–56; 40 (1973), 147–74.

16. "Ista descriptio statim patet, tamen, quia infinita – non quanta – possunt esse in eodem loco, sicut patet quia legio fuit in uno demoniaco et, qua ratione legio, eodem ratione infinities infinita. . . ." Pseudo-Richard of Campsall, *Logica valde utilis et realis contra Ockham*, MS Bologna Univ. 2635, fol. 50v. See Mark 4: 9. I am indebted to Rev. Edward Synan for this quotation.

17. See E. Gilson, *Jean Duns Scot* (Paris, 1952), p. 143, and note 2.

18. L. Baudry, *Le Tractatus de Principiis Theologiae attribué à Guillaume*

*d'Occam* (Paris, 1936), pp. 28–9, 127–8. See P. Vignaux, *Nominalisme au XIV Siècle* (Montreal, Paris, 1948), p. 25. Ockham denied that in the strict sense it is true to say with Aristotle that "Everything that is must be when it is." (Aristotle, *Perihermenias* 19a23–32). "Sciendum est quod ista propositio: omne quod est quando est necesse est esse, de virtute sermonis est simpliciter falsa." *Expositio in Periherm. Aristot.* I, c. 6, ad textum: Esse igitur quod est, quando est (Bologna, 1496; reprint Gregg Press, 1964).

"Unde ista propositio 'Sortes est, dum est' vel 'Sortes movetur, dum currit' non est necessaria, sed poterit esse falsa. Verumtamen per tales temporales intelligunt condicionales, quae condicionales verae sunt." Ockham, *Summa Logicae*, II, c. 35, p. 355, lines 34–6.

19. St. Thomas, *In I Sent.* d. 8, q. 3, a. 2; *Contra Gentiles* II, 30, 55; *De Potentia* V, 3; *Summa Theologiae*, I, 9, 2.

20. See A. Maurer, "Henry of Harclay's Questions on Immortality," *Mediaeval Studies*, 19 (1957), 79–107.

21. See E. Gilson, *Jean Duns Scot* (Paris, 1952), pp. 79–80.

22. ". . . est sciendum quod scientia quaelibet sive sit realis sive rationalis est tantum de propositionibus tamquam de illis quae sciuntur, quia solae propositiones sciuntur." Ockham, *Sent.* I, q. 2, a. 4; II, p. 134, lines 7–9. Physics and metaphysics are "real sciences" because the terms of their propositions stand for real things; logic is "rational science" because its terms stand for mental concepts. The terms of the science of grammar stand for spoken or written words. See A. Maurer, "Ockham's Conception of the Unity of Science," *Mediaeval Studies*, 20 (1958), p. 100.

23. "Sed scientia isto modo est de rebus singularibus, quia pro ipsis singularibus termini supponunt.' Ockham, *Sent.*, p. 138, lines 3–4.

24. See, for example, St. Thomas, *In I De Caelo et Mundo*, lect. 22, n. 9 (Rome, 1886), III, p. 91; lect. 2, n. 7, p. 7.

25. Ockham, *Quodl.* I, q. 1; *Sent.* I, d. 2, q. 10; II, p. 354, line 16–p. 357, line 9. For the meaning of the term *probabilis* in the Middle Ages see Th. Deman, *"Probabilis,"* *Revue des Sciences Philosophiques et Théologiques*, 22 (1933), 260–90. As the word indicates, a proposition that is "probable" is susceptible of proof, but it is not the conclusion of a demonstrative, but a dialectical, syllogism. Reasoning is dialectical if it proceeds from opinions that are generally accepted, or accepted by the wise. See Aristotle, *Topics*, I, c. 1, 100a30–b23. Ockham uses the term *probabilis* in this sense. A "probable" conclusion may be necessary and true, but it is not self-evident or established by principles that are self-evident or evidently known through experience. See Ockham, *Summa Logicae*, III–I, c. 1, pp. 361–2. In a broader sense, a probable statement may seem to be true to many or the wise but, in fact, it may be false. See L. Baudry, *Lexique Philosophique de Guillaume d'Occam* (Paris, 1957), pp, 216–17.

26. Ockham, *Sent.* I, d. 2, q. 10; II, p. 354, line 16–p. 357, line 9; *Quaestiones in Lib. I Physicorum*, ed. P. Boehner, *Ockham: Philosophical Writings* (Toronto, etc., 1957), pp. 122–5. See L. Baudry, "Guillaume d'Occam, Critique des Preuves Scotistes de l'Unicité de Dieu," *Archieves d'Histoire Doctrinale et Littéraire du Moyen Âge*, 20 (1953), 99–112.

27. Ockham, *Quodl.* II, q. 1; *Sent.* I, d. 2, q. 10; *Quaest. in Lib. Physicorum*, I, q. 136; *Ockham: Philosophical Writings*, pp. 122–5.

P. Boehner claims that "what Ockham proves is the existence of the Christian God." "Zu Ockhams Beweis der Existenz Gottes," *Franciskanische*

*Studien,* 32 (1950), 61; reprinted in P. Boehner, *Collected Articles on Ockham* (St. Bonaventure, New York, 1958), p. 412. Fr. Boehner qualifies this statement by adding that the *concept* of the Christian God is not proven, because this includes the oneness of God. It is not clear, then, how Ockham proves the *existence* of the Christian God.

28. Ockham, *Quodl.* IV, q. 2.
29. Ockham, *Sent.,* I, d. 35, q. 2 D.
30. Ockham, *Quodl.,* I, q. 10; II, q. 1.
31. Ockham, *Sent.,* II, d. 15 ZZ.
32. *Sent.,* P. Ockham defines an efficient cause as follows: "Definitio causae efficientis est esse illud ad cujus esse sive praesentiam sequitur aliquid." *Quodl.,* IV, q. 1. "Sed quod aliquid creatum sit causa efficiens non potest demonstrative probari, sed solum per experientiam, per hoc, scilicet, quod ad ejus praesentiam sequitur effectus et ad ejus absentiam non." *Sent.,* II, d. 15. P.
33. See J. R. O'Donnell, "The Philosophy of Nicholas of Autrecourt and his Appraisal of Aristotle," *Mediaeval Studies,* 4 (1942), 97–125.
34. B. Nardi, *Soggetto e Oggetto del Conoscere nella Filosofia Antica e Medievale* (Rome, 1952), pp. 74–92.
35. *Soggetto,* p. 80.
36. *Soggetto,* p. 85.
37. *Soggetto,* p. 92.
38. John of Jandun, "Utrum omne generabile de necessitate generabitur," MS Florence, Bibl. Naz. Conv. Soppr. I. III, 6, fol. 110r.
39. See, for example, W. J. Courtenay, "Nominalism and Late Medieval Religion," *The Pursuit of Holiness in Late Medieval and Renaissance Religion. Papers from the University of Michigan Conference;* ed. C. Trinkaus and H. A. Oberman (Leiden, 1974), 26–59; H. A. Oberman, "Some Notes on the Theology of Nominalism with Attention to its Relation to the Renaissance," *Harvard Theological Review,* 53 (1960), 47–76.
40. See W. J. Courtenay, *Nom.,* pp. 34, 52.
41. See P. Vignaux, "Nominalisme," in *Dictionnaire de Théologie Catholique,* XI, 718–84; F. Pelster, "Nominales und reales in 13. Jahrhundert," *Sophia* (1946), 154–61. St. Albert's description of the *nominales* is typical: "Sunt tamen qui aliter ea quae dicta sunt, interpretantur dicentes, quod in solis intellectibus sunt illa [i.e. universalia] quoad nos, quae utrum sint quomodo esse habeant, solus scit intellectus. Et tale esse in intellectu universalia habere dixerunt illi qui vocabantur Nominales, qui communitatem (ad quam particularia universalium, de quibus dicuntur ipsa universalia, referuntur) tantum in intellectu esse dicebant." St. Albert, *Liber de Praedicabilibus,* Tract. II, c. II, (Paris, 1890), I, p. 19.

   Fr. Boehner preferred to call Ockham a conceptualist, because he did not restrict universals to words, but included concepts among universals. See P. Boehner, "The Realistic Conceptualism of William Ockham," *Traditio,* 4 (1946), 307–35; reprinted in part in *Collected Articles,* pp. 156–74. But the medieval notion of nominalism was not so restrictive.
42. For the expression *nomina mentalia,* see Ockham, *Quodl.* IV, q. 35; *Summa Logicae,* I, c. 3; ed. P. Boehner et al. (St. Bonaventure, New York, 1974), p. 11, line 27, p. 14, line 84.
43. Ockham *Sent.,* I, d. 2, q. 4–7; II, pp. 99–266. ". . . sed nulla res est realiter communis pluribus; igitur nulla res est universalis quocumque modo." *Sent.,* I d. 2, q. 6, p. 179, lines 24–6.

44. Ockham, *Sent.*, I, d. 2, q. 7, p. 225, line 17–p. 226, line 3. This makes it clear that Ockham had not read the twelfth-century nominalists, such as Abelard.

45. ". . . humanitas quae est in Sorte essentialiter distinguitur ab humanitate quae est in Platone." Ockham, *Sent.*, I, d. 2, q. 6, p. 184, lines 20–1.

46. "Jeder Denker denkt nur einen einzigen Gedanken." M. Heidegger, *What Is Called Thinking?* trans. F. D. Wieck and J. G. Gray (New York, 1968), p. 50.

47. The Franciscan Order, the Church, indeed any society, has no reality except the individuals who compose it. They have no personality, real, imaginary, or fictitious. Ockham, *Opus Nonaginta Dierum*, c. 62; *Opera Politica*, ed. R. F. Bennett, H. S. Offler, II (Univ. of Manchester Press, 1940), pp. 568–70. See G. de Lagarde, *La Naissance de l'Esprit Laïque au Declin du Moyen Age*, V (Paris, Louvain, 1963), p. 38.

48. Leibniz, *Dissertatio de Stilo Philosophico Nizolii*, 28; *Opera Philosophica*, ed. J. E. Erdmann (Berlin, 1840), pp. 68–9.

49. *The Collected Papers of Charles Sanders Peirce*, ed. C. Hartshorne and P. Weiss (Cambridge, Massachusetts, 1931–5), VI, n. 348.

50. "Après avoir donné à la philosophie scolastique les systèmes de saint Bonaventure, de Roger Bacon, de Raymond Lulle et de Duns Scot, sans compter ceux tous qui les préparent, les accompagnent ou les commentent, la pensée franciscaine pouvait à bon droit être considérée comme épuisée. Il n'en était rien cependant, et elle devait s'enrichir encore de l'oeuvre de Guillaume d'Occam." E. Gilson, "La Philosophie Franciscaine," *Saint François d'Assise: son Oeuvre, son Influence, 1226–1926* (Paris, 1927), p. 171. It is clear from Gilson's later writings that he is among those who do not consider Ockham's work to be what he calls a "true enrichment" of Franciscan thought. See E. Gilson, *The Unity of Philosophical Experience* (New York, 1937), ch. 3, pp. 61–91.

# Medieval Romance

## LILLIAN HERLANDS HORNSTEIN

John Stevens. *Medieval Romance: Themes and Approaches.* London: Hutchinson University Library, 1937. Pp. 255. $10.00

Readers of this series are well aware that in every period critical methods applied to medieval romance have been determined in the light of current critical assumptions. The early scholars' search for the best manuscripts (*cherchez le texte*) and accurate editing (EETS) were followed, though not superseded, in the first half of this century, by fascination with comparative folklore (L. H. Loomis, Vladimir Propp, M. Schlauch, Stith Thompson, F. L. Utley); motifs were then related to rituals (J. L. Weston, C. Moorman) or myths (R. S. Loomis, J. Campbell) or anthropology (J. Speirs), or recognized as Jungian archetypes (O. Rank, Northrop Frye); interest developed in method of publication and transmission (R. Crosby, A. C. Baugh, A. M. Trounce). To summarize this scholarly activity came such organizing efforts as Wells's *Manual of The Writings in Middle English,* J. B. Severs's revision, and Dieter Mehl's recent volume. While all scholars, regardless of their basic critical stance, were involved with a genetic view of romance, with sources and relationships, with species and differentia, recent critics have concentrated on close readings of the text – whether viewed through the focus of the exegetical commentaries (D. W. Robertson), as an artifact, a work of art *sui generis,* yet in a genre tradition (Morton Bloomfield, D. S. Brewer, D. Pearsall, H. Schelp), or as an archetypal romance *pattern* (Michael Curschmann, Kathryn Hume). The critique by the current "structuralists," almost a-historical, is an attempt to arrive at a structural formula by applying to medieval poetry the values, methods, terms, and even the fearful symmetries of the "new linguistics" (P. Zumthor, R. Scholes). Despite these discrete, often distinguished analyses, we lack a full-scale, scholarly survey of the whole spectrum of medieval romance, or even of Middle English romances. The volume under review does not fill the vacuum.

Dr. Stevens does not aim for "full coverage" and explains that his book is not "primarily about specific romances" (pp. 9–10). His goal is rather "an introductory book" which will "provide an approach" to the "traditions of romance and the concerns of romancers." The basic proposition is that "the central experiences of romance [being] idealistic" (p. 28), the Middle Ages saw "the creation, and continuous renewal, of stories which would express these idealisms" (p. 227), particularly the "beautiful idealisms of moral excellence" (pp. 21, 26).

Stevens also posits a second theme for his volume, that, since the central experiences of romance – "love, terror, adoration" (p. 16) – are "fundamental human concerns" (p. 21), romance is permanent, reappearing over extensive

time-range (passim, ch.1, pp. 9, 15) and pervasive (ch. 2). The brief Epilogue concludes that romance experiences appear in many genres, "crept into all sorts of corners" . . . (p. 227), "fragmented" into lyric, "diluted into history" (p. 229), are seen in the Cluny unicorn tapestries, even became "for the chosen few – part of the way of life" (p. 236).

The "concerns" and traditions are expressed through idealizations manifested as experience and necessarily characterized by "disengagement from ordinary life" (pp. 20, 28, 162ff., ch. 8, 9). "Conventions, motifs, archetypes, created to express the 'experiences' of romance in their essential nature," test the claims of the Ideal (p. 142); and Chapters 2–6 provide a consistent exposition of the different kinds of idealisms. For convenience of summary, I bring together these various elements with the relevant chapter headings: Idealized Love (ch. 2: the first and principal idealism of romance, an intensely private experience, p. 48); Idealized Social Virtue in an Idealized Society (ch. 3: the Romance of the "Gentil" man); Idealized Self and Self-fulfillment in valor and integrity (ch. 4: Man alone, Man and Superman, and ch. 5: Man and Supernature, the Marvellous in Romance, man facing mystery or death, the mysterious challenge, a moral polarization of good and an evil-not-always-understood by the protagonist, the lonely quest, a journey through a hostile land, a combat with a mysterious, often monstrous, enemy); Idealized religious aspiration (ch. 6: Man and God, Religious and Romance).

We must infer, since the book never provides a straightforward definition or rigorous limitations, that for Stevens, "medieval romance," a formal and stylized genre, means an idealized and idealizing knightly life of prowess and virtue revealed in successful chivalric adventures, performed in a society bound by the manners and formalized concepts of *courtoisie*, a closed society to which the victorious hero returns after his excursions into the unknown territory of mystery and marvels. These experiences are contrasted with those of the epic hero (pp. 76, 80).

The conclusions in this section of the book, well-explicated as they are, hardly mark an advance over suggestions tentatively set forth, with modifications, by Dorothy Everett over forty years ago. By deriving his generalizations for the most part from Chrétien de Troyes, Marie de France, and the *Romance of the Rose*, Stevens automatically excludes the larger body of English romances (he discusses or mentions only some 15 out of a corpus of 115). These latter can hardly be made to conform to his criteria, even by Procrustean stretching. For most English romancers, marriage and piety are far more important than *courtoisie*, and their women not infrequently display considerable awareness of their *id* and their own individuality (pp. 42, 105). Though he understands the need for "correctives" (pp. 48n.1 and 187n.9 – not in the Index; p. 49n.11) to the C. S. Lewis position (that the *roman courtois* is the romance tradition), Stevens, nevertheless, seems to project the same mistake. Surprisingly enough, Lewis and Huizinga alone of the modern critics are listed in the Index; others not indexed are, however, quoted and cited throughout the volume.

Though not so tightly bound together as the first six chapters, the later ones are more significant. These deal with the "mechanisms," the way romances "work," "modes as distinct from the themes" (p. 142): Realism in Characters (ch. 8) and Discourse, i.e., dialogue (ch. 9), and the persona of the narrator (ch. 10). "Images of Romance" (ch. 7) serves as the bridge between the "concerns" and the "modes." Stevens does not define "image" (p. 143) and, apparently, does not mean simile or metaphor in the conventional sense, but rather an event or scene which is weighted with symbolic meaning. Images, by

their capacity "to act as centres for different aspects" of romantic and courtly experience (p. 166), are characterized as the normatives for understanding the genre. The absence of space-time connections makes other connections, such as the image, more important (p. 149); the image becomes the method of "ordering the human experience," demanding consideration from the protagonist and reader, enigmatic yet "felt to crystallize the meaning of the scene" (p. 147). Among the half dozen examples are Percival's sight of the white lance from which a drop of red blood ran down – "an emphatically realized visual object which points beyond itself' (pp. 145, 147) – and that of The Lover of the *Roman de la Rose* viewing the Narcissan Well of Love, seeing the two crystals (i.e., the lady's eyes), and then the rose-bud. 'So much for the bare bones of the allegory; but there is a lot more to it than that. There are the suggestions of the Well image itself – deep and dark, a tunnel into which he might fall, but focussing light and eternal vitality at its bottom. . . ; there is one subtlety that could be overlooked, the Lover's choice of a bud that is not yet fully open. There are, finally, two or three aspects of the 'mirrour perilous' which suggest a psychological depth which the author might not have been able fully to formulate in abstract terms: love is, indeed, perilous; . . . it is a 'mirrour,' a glass, in which you see not reality but its reflection; and most profound of all, the reflection you see in your lady's eyes is *your own* [italics by Stevens]. The . . . Narcissus myth . . . shows how in this profound experience of love we may be looking not for another but for the image of ourselves" (pp. 157–160). These critiques are illustrative of the way Stevens enriches our understanding by applying, with sensitivity and skill, an analysis of imagery more usually associated with the lyric than with medieval narrative.

As the foregoing summary suggests, the real contribution of Stevens's volume lies not in the conclusions of the first six chapters, whose broad generalizations are neither new nor even valid for a large segment of romances passed over unnoticed, unmentioned, unheralded, unsung. The impact comes from his method, and it is to this we must now address ourselves.

Stevens avoids comparative, historical, and linear treatment; instead, throughout both parts of the book, his method is to isolate each illustrative passage from its narrative frame (he does provide extensive plot summaries). From the beginning, he titillates the reader by the juxtaposition of a wide-ranging array of references and extended quotations from non-medieval authors (ch. 1: Permanence of Romance). On the opening page, Sidney, Spenser, Shakespeare, Coleridge, Keats, Scott, and Jane Austen's *Northanger Abbey* are brought into the romance ambience. The exposition continues with analyses of quoted passages from James's *The American*, Conrad's *The Shadow-Line*, Wallace Stevens's *The Man with the Blue Guitar*, Alain-Fournier's *Le Grand Meaulnes*. Later comes glancing mention of Hemingway's *The Old Man and the Sea* (p. 22), Hardy (p. 166 n.8), G. M. Hopkins (p. 124), Kafka (p. 169), Kierkegaard (p. 119), Nabokov (p. 39), Cardinal Newman (p. 32), Stendhal's *Le Rouge et Le Noir* (p. 37), Laurence Sterne's *Sentimental Journey*, by way of Virginia Woolf (p. 149), Yeats (p. 61), even Ian Fleming (p. 83), not to name all.

When he turns to medieval literature itself, Stevens scrutinizes with more relevancy passages which effectively illustrate the specific idealisms under discussion. These great scenes, frequently appearing in anthologies, are drawn from *The Song of Roland*, *lais* of Marie de France, Chrétien's romances, the Tristan–Isolt love affair, *Gawain and the Green Knight*, "The Knight's Tale," *Troilus and Criseyde*, the alliterative *Morte Arthure*, and Malory – e.g., Roland

dying; Lancelot's meeting with dwarf and cart, finding the golden hair, crossing the sword bridge; Gawain's trip through the Wirral and his bedroom encounter with Bercilak's wife. Although the in-gathering is familiar, Stevens's comments are always fresh, lively, and to the point, communciating his own delight, and happily free of that jargonese condemned as modern academic style. He stays close to the scene *qua* scene, occasionally explicates or notes the poet's technical skills, provides glosses for the Middle English and translations for the Latin, Provençal, and Old French.

Stevens's critical intelligence is generally well-applied. Illustrative is his summing up of the cathedral-like mountain-side grotto (The Cave of Lovers) in Gottfried's *Tristan*, where he remarks, "how difficult it is . . . to distinguish between romances in which the author is making a daring and provocative use of religious imagery, in order to hint at the supremacy of idealized erotic love over all other forms of love, and romances in which the author is merely enhancing love by talking about it *as if it were* a religion – with a temple, gods, goddesses, a liturgy and devotions, priests, sins, penances, sacraments, . . . normal romance machinery. . . ." (p. 135; italics by Stevens). In view of Stevens's usual critical acumen, it is disconcerting to find him, at p. 61, citing "no country for old men" (*Sailing to Byzantium*) in the context of the fabliau comic *senex amans* of *the Romance of the Rose* and "The Merchant's Tale."

The pageantry of Stevens's anthology and the general richness of his critiques (particularly the discussions of images) amplify the sensibilities of a knowledgeable and sophisticated reader. But what can be grasped by the "general reader" and "ideal novice" (p. 10) for whom Stevens wrote this book? Can the novice see the affinities or better understand medieval romance because he is told that "art transforms reality" (*The Man with the Blue Guitar*, p. 25)? Can he understand medieval romance from *The Shadow-Line?* (Terror, yes, but neither love nor adoration – Stevens's central experiences of romance, p. 16). And, similarly, with *The American*, whose hero, despite Stevens, is not disengaged from time nor unencumbered by society (p. 17). For the novice, would not the dozen pages (though only 5 percent of the total) which explicate non-medieval works have been better deployed comparing some medieval romances which do not fit so cozily or obviously into Stevens' *schemata?* How do the modern illustrations help the novice differentiate medieval romance from epic, saint's life, miracles of the Virgin, fairy-tale, folk-tale, pseudo-history, or ballad, or even lyric and chronicle, which do share, as Stevens shows, though in different degrees, the same idealizations, motifs, conventions, structures? This is not to argue from any naively literal stance that medieval literature should be or can be approached only in terms of genre. Stevens shies away from definition. He is more concerned, he says, that we should be "responsive to the text . . . than that we should be able to put them in . . . categories." Rather than "attempt an immediate definition" (e.g., of image), he prefers to "give an example of the technique" (p. 143). The passages are well-chosen and well-explicated, but Stevens does not explain (p. 18), as we think he should, what recurrent traits defined and delimited the form to its medieval audience or what criteria will assist in critical comparison and evaluation. Not many medievalists, for example, will agree that the "idealized innocence of the little 'clergeon' singing the praises of the Blessed Virgin" (p. 28; "Prioress's Tale"), is an example of medieval romance.

The problem created by Stevens's procedure in not treating poems as units is striking in the discussions of *Gamelyn* and *Sir Orfeo*. The description of *Gamelyn's* "rude vigour" (p. 13), ". . . simple, rumbustious energy, . . . simply an adventure story" with archetypal motifs (p. 83) is valid to a degree

(but only that far); and his probable concession to the young in describing the poem, "for all the world like a good TV western," sounds like a parody and gives no hint of the poem's thematic complexities and other virtues: clever utilization of fourteenth-century legalisms, strategy of satirical condemnation of clerics, wry humor with its pre-Watergate villains hung up, "To swing on the ropes and to dry in the wind" (l. 880). With *Sir Orfeo*, its elusive, seductive, "ferli" quality is praised; following his method, Stevens quotes two memorable passages which depict the other-world. At the very beginning, he had announced: "We cannot consider here the full import of this tale." Your reviewer asks, "Why not?" Orfeo exiles himself from all humanity in a terrible despair nearing madness – *not* in quest of his wife, as Stevens indicates. Only after Orfeo sees Dame Heurodis among the "rout" of the King of Fairy does the quest begin. Nor does Stevens make reference to the elaborate multiple interpretations of Orpheus and Eurydice (which enrich the texture for an informed audience) – at one time understood as abstractions of ideal reason and passion, and only later as ideal lovers, and still later (in the English version), somewhat humorously shifting from the idealized king of *gentilesse* into something like a highly proper parliamentary ruler. The *Sir Orfeo* poet celebrates these and other "idealisms" deliberately; yet Stevens makes no reference to them.

There are other occasional trouble spots: the word *Luf-Daungere* (*dangier*), defined differently at least seven times (pp. 39, 158, 196, 200 note, 221, 234, 237n.17), is neither indexed nor cross-referenced. In a genre where the idealisms signify virtue, the reader is bemused by the statement "wickedness is idealized as well as goodness" (p. 169). At another point, Stevens makes the observation that in most romances the adventures are like a processional through a geographic, space-time vacuum, where meaning bears no relation to place, but only to experience (p. 149). While it is true that romances often have only a psychic landscape, a critic should not disregard (as Stevens does) those social settings where the specifics of armor, education, dress, named locale, and land rivalry supply by their solid, everyday normality a structural and dramatic counterweight to the *frisson* generated by the idealized manners and the unexpected marvels. Can we not almost smell the fish in the Grimsby market?

Stevens's vigor, his evident intelligence, and his learning make us wish that he had discussed more frequently and fully the dramatic and psychological positioning of his selected passages in the total poem, the interplay of various strands of action, as well as of the dynamism between character and action, which releases the character from mere typological representation and involves some treatment of causation. Only in his analysis of *Troilus and Criseyde* (which he praises for "a density of psychological interest . . . uniquely presented") does he show how Chaucer constantly manipulates the progress of the action to modify and intensify the spectator's response. The "happy ending" of this "litel bok," which Chaucer himself called "myn tragedye," presents a paradox. Here, as also in his discussion of "The Knight's Tale," Stevens seems insensitive to the ironies of the "happy ending," where the "ideal," pious happiness-in-eternity of Troilus and the shallow orderliness of the Palamon-Emily marriage merely emphasize more sharply that the hero's life has been tragic, because all life is (but see p. 49n. 12, p. 70). These Chaucer poems do not really conform to the view of life as successful achievement, a view essential to the romance genre. For idealizations and an achieved happy ending, joined and functioning in synergetic relationship are the heart and life-blood of romance.

We do not deny Stevens his right to determine the scope of his text, and it is true that he announces that he does not plan a full coverage. But, as we have indicated in other contexts, omissions leave the unsophisticated reader with a lop-sided view of extant romances. While Stevens's handling of the "thematic" approach has a certain interest and his treatment of images is illuminating, any method which neglects the romances as narrative structures must become a distortion. The volume gives no hint, moreover, of their number, range, and themes, or even of such superficial dissimilarities as length and verbal form, or of their constructs, moods, and rhetorical conduct (e.g., the English "school" of 26 tail-rhyme romances), or the difference even for Chaucer between a romance told in four-stress or five-stress couplets and one in stanzas. Nor will the reader know that there are homespun romances like *Athelston* or *Sir Degrevant*, or religious historico-romances like *Titus and Vesparian*, or burlesque parodies like *Sir Thopas*, which is more typically romance than Stevens's ill-advised example, "The Knight's Tale"; for we can say of it, as Stevens says of *Troilus*, "that it both consummates and transcends the romance tradition" (p. 139).

And we can be rightfully troubled with the proportions of a 250-page volume which does deal in detail with Perceval's quest of the Holy Grail, yet contains but these ten words on the most influential version: "Wolfram von Eschenbach's *Parzival* (1200–12); one of the masterpieces of German literature." It is no solace to recall that Stevens said he would refer "only occasionally to German . . . literature."

# Franciscan Spirituality: Two Approaches

### CAROLINE W. BYNUM

E. Randolph Daniel. *The Franciscan Concept of Mission in the High Middle Ages*. Lexington: University Press of Kentucky, 1975, Pp. xvi, 168. $10.95.
David L. Jeffrey. *The Early English Lyric and Franciscan Spirituality*. Lincoln: University of Nebraska Press, 1975, Pp. xiv, 306. $11.25.

In contrast to the early decades of this century, when American students of medieval Christianity concentrated chiefly on institutions, scholars of medieval history and literature are now deeply interested in spirituality – the attitudes and assumptions that underlie the ways in which people believe in, approach, and worship God. The two books under review here – one a work of literary history that explores the setting within which the early English lyric emerged, the other a work of intellectual history that locates a particular Franciscan idea within broader Franciscan attitudes – are both in their basic arguments studies in spirituality. Although the thesis of neither work is startlingly new, these are good books, reflecting some of the awareness of the interrelatedness of spiritual concerns that characterizes the best recent history of medieval religion. They both de-emphasize conflict within the Franciscan order, and they agree in seeing the Friars Minor as concerned most fundamentally with *imitatio Christi* and penitence, rather than with poverty. Neither book, however, carries its awareness of the pervasiveness of religious themes far enough to question (as historians like Chenu and Grundmann have done) whether the boundaries between spiritual attitudes and those between religious orders always coincide. Each is thus limited by an ambiguity that may be explained as follows. The phrase "Franciscan spirituality" can mean either (a) religious attitudes that are Franciscan or (b) religious attitudes that are uniquely Franciscan. While a survey of the ideas and practices of Franciscans will indubitably establish the first, it will never establish the second. For the latter, it is necessary to compare the Franciscans with preceding and contemporary religious movements, above all the Augustinian canons and the Dominicans. Each of these authors has written the sort of book that describes "Franciscan" spirituality in the first sense; each, however, sometimes appears to think that he has determined what is "Franciscan" in the second sense. In Daniel's work this leads to no intrinsic difficulties, although one needs to know whether the spirituality of martyrdom, *imitatio Christi,* and teaching *verbo et exemplo,* against which he locates the idea of mission, is found in other religious groups of the period, in order to evaluate the significance of his study. In Jeffrey's work, however, this confusion occasionally lends a disturbing circularity to his argument.

E. R. Daniel's *The Franciscan Concept of Mission* asserts that Franciscans from the thirteenth to the fifteenth century had a consistent ideology of mis-

sion, based on *imitatio crucis:* evangelism and desire for martyrdom fused in the belief that imitation of Christ's death could serve as a call to repentance for Christian and non-Christian alike. Daniel argues that this ideology appeared in the life and writings of Francis himself and found its full expression in the work of Bonaventure. He also argues that two alternative ideologies developed by individual Franciscans – the intellectual approach of Bacon and Llull, predicated on preaching and language study, and the Joachite expectation of apocalyptic conversion of non-Christians – never became popular with Franciscan missionaries. In Daniel's treatment, therefore (although he does not express it quite this way), the Franciscan concept of mission becomes synonymous with the Franciscan concept of vocation. Daniel protests the novelty of his insight a little too loudly, but his stress on a consistent Franciscan self-conception contrasts persuasively with the influential, late-nineteenth-century view of Paul Sabatier that Francis's ideal of poverty was betrayed within his order by clericalization, study, and evangelism.

It seems to this reviewer that Daniel slightly under-emphasizes love and evangelism and over-emphasizes martyrdom and repentance in his presentation of Franciscan themes, particularly in his earlier chapters. Moreover, if Daniel's subject is really the Franciscan ideal, and not merely the Franciscan approach to mission, one wonders why he has chosen to underline this ideal only by comparison to certain Joachite or scholastic ideas about conversion and intellectual activity. The Franciscan insistence that brothers are to teach more by example than by preaching is certainly far closer to the idea of teaching *verbo et exemplo* that we find among regular canons in the twelfth century and Dominicans in the thirteenth than it is to Roger Bacon's ideas about language study. And an emphasis on martyrdom and *imitatio crucis* were not, in the thirteenth and fourteenth centuries, limited to Franciscans. All this is only to say that, since the strength of Daniel's treatment lies in his realization that Franciscan ideas about mission *are*, in some sense, Franciscan spirituality, one wishes that he had tried to explore the extent to which the basic spiritual themes he isolates were uniquely "Franciscan" in the high Middle Ages.

David L. Jeffrey's *The Early English Lyric and Franciscan Spirituality* is an elaboration of the suggestion of Carleton Brown, R. H. Robbins, and Walter Ong that the emergence of the Middle English lyric can be understood only against the background of Franciscan preaching. Jeffrey argues that English Friars Minor, like Italian, used the vernacular lyric as a missionary and devotional tool, freely inserting it into sermons; and he traces in the earliest Middle English lyrics Franciscan themes of penitence, affectivity, and *imitatio Christi*. Although he occasionally seems to overemphasize the role of Joachite ideas and the Spiritual-Conventual split in the thirteenth century (for example, pp. 26 and 70), his general picture of Franciscan spirituality agrees with Daniel's and is more subtle and finely textured, stressing a meeting of evangelism, love, joy, contrition, and apocalyptic hope in the concentration on conformity to the Crucified Christ. He argues persuasively against the tendency to divide "secular" poems sharply from "sacred" and is able to show how common in early English lyric is the theme "now is the time for repentance," which is certainly "religious," if not "theological."

Jeffrey closes his introduction by remarking: "I do not presume in this book to propose a comprehensive *Ursprung* theory for the early English lyric. . . ." He closes his book with the statement: "The Middle English lyric is, essentially, a Franciscan song." If these remarks are not quite contradictory, their juxtaposition nonetheless underlies a certain confusion: Jeffrey is not sure quite how much he has proved, and this uncertainty seems, in essence, due to

the imprecision in the use of "Franciscan" noted at the opening of this review. While he appears to have considered comparative material sufficiently to establish that the Franciscans were unique among thirteenth- and fourteenth-century religious groups in the extent to which they used verse as a tool for evangelizing, Jeffrey is aware (see, for example, p. 259) that not all the themes he sees as Franciscan are uniquely Franciscan. Emphasis on contrition and suffering, on affective identification with the human life and death of Christ, on preaching by example, are found among Cistercians, mystics of many orders, and Dominicans. Thus, in chapter five, when he attempts to demonstrate a Franciscan provenance for certain friar miscellanies, because they contain poems "redolent of Franciscan theology and spirituality," the argument seems a bit circular. But Jeffrey has clearly established his basic thesis that Franciscan friars played the major role in the development of the earliest vernacular lyric in England, and in the course of his argument he provides many convincing and lovely analyses of medieval poems.

Taken together, the two books reviewed here present a Franciscan spirituality in which the central theme is *imitatio crucis*, leading to personal penitence, missionary fervor, and evangelism by song. The picture is convincing and quite different from the view now prevailing in textbooks of an order in perpetual decline or rebellion from its founder's vision of literal imitation of the poverty of Christ. To suggest that the authors should have placed their studies more squarely in the general context of thirteenth- and fourteenth-century spirituality is not to fault two good books. It is simply to point out that we will know even more – about the Friars Minor and about the high Middle Ages – when we know what is "uniquely Franciscan," as well as what is "Franciscan."

# Review Notices

E. J. Kenney. *The Classical Text: Aspects of Editing in the Age of the Printed Book.* Los Angeles and London: University of California Press, 1974. Pp. xi, 174. $8.95.

E. J. Kenney's brief history of textual criticism from about 1465 to modern times will correct many popular impressions. Some people think glowingly about the boon of early printing without realizing that *editiones principes* were usually derived from faulty current manuscripts, that printing froze many errors and tended to remove incentive to search for new readings (some texts were reprinted virtually unchanged for centuries). Likewise, some people have an exaggerated notion about the editorial skills of the Humanists. But these early scholars had little knowledge of paleography; they did not distinguish between collating and correcting; they had no concern for a manuscript, once it had been used; and they often ignored important manuscripts like the Medicean of Vergil (believed in the Renaissance to be the poet's autograph), even when such manuscripts were available. Humanists sometimes worked at a furious pace – for commercial reasons: Aldus's editor Johannes Andreas De Buxis prepared his edition of Silius in about fifteen days and his edition of Ovid's *Metamorphoses* in one summer. Also, sixteenth-century scholars are sometimes regarded as untarnishable knights of learning. But Erasmus, for example, delegated collating and final revisions to others and could say that a twelfth-century Greek manuscript appeared coeval with the apostles; Joseph Scaliger transposed ruthlessly whole groups of elegiac couplets in Propertius; Justus Lipsius proclaimed that he did not even have a desire to see the Medicean manuscript, which is fundamental for Tacitus's *Annals* I–VI, while he was working on the *Annals*. Many readers may have the idea that the scientific editorial method was born with Karl Lachmann, but, as S. Timpanaro (one of Kenney's chief sources) has already shown, virtually every aspect of Lachmann's technique had been anticipated by others.

Indeed, Kenney's work briefly examines a host of theoreticians and practitioners of textual criticism like Nicoalus Heinsius, Moritz Haupt, C. G. Cobet, and A. E. Housman, and the book shows how slowly progress was made in the development of effective editing. For example, only since the mid-nineteenth century did single-letter sigla regularly replace clumsy abbreviated names like *Oxon.* in a critical apparatus. There are reasons for such slow advances in effective editing, as Kenney is quick to see: the nomadic wanderings of manuscripts, the expense and difficulty of travel to see them before the use of photography; the want of (good) catalogues of manuscripts, the absence of journals, lack of handy reference (in the early days of printing there was rarely pagination, and line-numbering of verses in the present-day fashion

only commences late in the seventeenth century), the aesthetic considerations of publishers who did not like to clutter their pages with critical notes; the perspective of many scholars who saw only the polarity between the original brilliance of a text and the "filthy encrustation" of their day, without regard for the gradual developments that had intervened.

Though small in girth, the book conveys a wealth of concrete information, usually delivered with epigrammatic brevity and the precision of a scalpel. The book is enlivened with relevant anecdotes and with a language that sometimes rivals in pungency Housman himself (e.g., "the defunct scholarship that moulders in the charnel-house of Gruter's *Lampas*," p. 36; "that doyen of third-rate scholars, Tanaquil Faber," p. 43; "Havercamp would not have been Havercamp if he had performed even one part of his work well," p. 156). It is only regrettable that Kenney sometimes drew his quotations from second-hand sources (see, e.g., pp. 44 n1, 50 n3, 82 n7, 98 n2) and that he did not include discussion of contemporary classical editions like those of Sir Roger Mynors or the Harvard Servius.

Although the book is primarily concerned with the editing of classical works, many of the remarks about the development of paleographical terminology, about the transmission of texts, and about editorial method should interest medievalists.

<div style="text-align: right">

M. L. Colker
University of Virginia

</div>

Ernst Strehlke, ed. *Tabulae Ordinis Theutonici ex Tabularii Regii Berolinensis Codice Potissimum.* Berlin: Weidman, 1869; rpt. Toronto: University of Toronto Press, 1975. Pp. 491. $60.00.

Ernst Strehlke's *Tabulae Ordinis Theutonici,* nearly completed when the Prussian archivist died, was posthumously published, largely through the efforts of Philipp Jaffé. The book presented an edition of the great cartulary of the Teutonic Knights which is now found in Merseburg MS Rep. 94 V.E. bl. in the Deutsches Zentralarchiv, along with a few supplementary texts, notably from what is today MS OF 69 in the Staatliches Archivlager in Göttingen. The Merseburg codex consists of seven parts, written by different hands from the mid-thirteenth to the fifteenth century. This codex contains papal privileges for the order and charters granting to it properties in the Holy Land, Italy, France, Germany, Austria, and elsewhere.

These documents provide important insights into the history of the Teutonic Knights. For example, no. 579 indicates that certain members had been of an unsavory past, having engaged in arson, theft, or usury; nos. 322, 358, 379 show that Teutonic Knights were not univerally popular in Christendom but were sometimes knocked down from their horses and manhandled by parishioners (nos. 358, 379); nos. 304, 340, 353, 360, 412, 439 try to discourage desertions from the order, especially to the Templars (no. 488). As rivals of the Teutonic Knights, the Templars bristled over the fact that the Teutonic Knights were wearing a white mantellum similar to their own, and Pope Honorius III had to declare this petty irritation "revera ridiculum" (no. 368). The same pope granted the Teutonic Knights numerous privileges, like permission to baptize boys abandoned at their gates (no. 350) and to build towns, castles, and cemeteries in lands captured from the Saracens (no. 415).

Strehlke's original book, and as now reprinted, contains: Philipp Jaffé's pref-

ace; the texts, each headed with brief summary and accompanied with concise textual and historical notes; an *Index Rerum,* which is really an *Index Nominum.* The reprint offers valuable introductory matter by Hans E. Mayer: a biography of Strehlke, a description of the Merseburg manuscript, concordances showing where Strehlke's pieces are situated in this codex, a list of pieces in Strehlke that cannot be identified with pieces in the codex, and remarks about the central archives of the Teutonic Knights (Mayer believes that these archives were originally kept at Acre but that much of the material later moved about with the Grandmaster).

Since Strehlke's original book, printed over one hundred years ago, has become a rarity while remaining a basic source of an important phase of medieval history, the reprint is to be welcomed. But undiluted enthusiasm for the new book cannot be aroused as one considers the deficiencies that Mayer himself must acknowledge: Strehlke neither printed in full nor gave all the variants of re-issued documents, and such variants are often very important; he regarded undated texts as original issues, whereas they could be re-issues; he did not include many relevant texts from Venice, Vienna, the Vatican, and other cities. Furthermore, Strehlke's geographic, rather than chronological, arrangement and his failure to give folio references have created problems, and Mayer lists (pp. 62–63) about three hundred texts that are "demonstrably or possibly" (p. 62) missing from the Merseburg codex.

Nevertheless, after noticing the defects of Strehlke's book, Mayer is able to conclude: "It must, however, be stressed that the weaknesses pointed out above are not such that they would, on the whole, merit a new edition of Strehlke rather than a reprint of the book. . . . The fact that his edition does not meet all modern standards does not mean that his texts are unreliable" (p. 24). But surely some readers will reach, not unreasonably, the opposite conclusion, that a new edition, meeting all modern standards, is a desideratum. While Mayer, comparing some places of the original edition with the Merseburg codex, found "very few misreadings" (p. 19), nonetheless he did not verify Strehlke's texts word-by-word throughout (nor does Mayer reveal what are the misreadings that he discovered). Also, advances in historical research over the past hundred years ought to enable a better commentary on the texts to be written. However, until a really new (and fuller) edition of the Merseburg cartulary with other documents concerning the Teutonic Knights is published, the reprint of Strehlke can serve as a helpful stop-gap, particularly if, unlike the reviewer's copy, other copies have, as they should, texts at pp. 226–227, 230–231, 234–235, 238–239 instead of blank paper.

M. L. Colker
University of Virginia

Richard Vaughan. *Valois Burgundy.* Hamden, Connecticut: Archon Books, 1975. Pp. x, 254; ten maps, five genealogical tables. $12.50.

Richard Vaughan has long been acknowledged the *doyen* of English-speaking historians of late medieval Burgundy, although his massive four-volume study of the Valois dukes (*Philip the Bold,* 1962; *John the Fearless,* 1966; *Philip the Good,* 1970; *Charles the Bold,* 1973) has, unaccountably, received only limited and irregular attention in major journals such as *Speculum.* The present book is not a "major" work, but an effort to distill, without references, the gist and arguments of those four volumes for the convenience of the student and the non-specialist.

A work so conceived is useful and, within its limits, amply fulfills its promise. Vaughan argues vigorously that the Burgundian inheritance was not a mere agglomeration of lordships, randomly acquired and indifferently governed, but a genuine and cumulative polity. If the dukes' view was dynastic and highly personal, this represented more a difference of degree than of kind when compared with contemporary monarchs. The first duke and the last are accorded the most favorable treatment. Philip the Bold is credited with being the most "statesmanlike and successful" (p. 77) of the Valois, exploiting his relations with the French kings and the Emperors to create a bipartite state focused on ducal and comital Burgundy on one hand, and Flanders-Artois-Brabant on the other. Philip the Good enlarged Valois territory by acquiring or conquering Namur, Hainault, Holland-Zeeland, and Luxembourg, but left the essential structure (and problems) of government unchanged. From the 1440s, the weaknesses and inadequacies of a polycentric, multilingual, and geographically-scattered inheritance tended to outweigh its unity. It was thus the task of Charles the Bold to enlarge and to integrate his territories and to modernize its military and administrative organization (and to invigorate traditional Burgundian court culture by exposing it to Italianate influences). Charles's wars with the south German and Swiss cities were thus not minor squabbles of petty aggrandizement but were played for large and purposeful stakes. His defeat and death symbolized more than a needless personal tragedy; it marked the end of the constructive, if flawed, record of achievement of Valois governance.

The long development and sudden dismemberment of Valois Burgundy provide an excellent example of the motives, techniques, and fragility of dynastic politics in late medieval and early modern Europe. Scholars will be grateful that Vaughan has presented the fruits of his research and reflection in this convenient, balanced, and informative volume.

<div style="text-align:right">

Michael Altschul
Case Western Reserve University

</div>

*The Correspondence of Erasmus: Letters 142 to 297, 1501 to 1514*, trans. R. A. B. Mynors and D. F. S. Thomson, annot. Wallace K. Ferguson. Toronto: University of Toronto Press, 1975. Pp. xiv, 374. $25.00.

This second volume of the great edition takes us "from the beginning of 1501 to the summer of 1514" (xi), that is, through the first period of Erasmus's full maturity, productivity, and international fame. Unhappily, as Professor Ferguson says, the actual coverage is meager for the period 1502–11, especially for the years of study and writing at St. Omer or Louvain, Paris, and London, and for much of Erasmus's Italian sojourn. "Even after his return to England in the summer of 1509 there is a complete blank for nearly two years and Erasmus disappears from view until April 1511" (xii). However, the excellent notes enable us to make out a consecutive biographical record, and there are many letters and passages of substantial importance for our understanding of Erasmus as he clearly recognizes and fulfills his true vocation and mission. For various reasons, from occasional epidemics to the prosecution of his studies, he is driven to frequent migrations, and his spirits are subject to frequent changes, but his mind and soul move along a straight road.

Although near the end of 1504, Erasmus could tell John Colet that secular literature "has now ceased to give me pleasure" (Letter 181, p. 88; cf. pp. 100, 300), he had not lost interest in promoting the moral and cultural enlighten-

ment needed to overcome the darkness of Scotists, monks and other ecclesiastics, political leaders, and large portions of the general public, high and low. Thus, in or about 1501, he edited "those three truly golden books of Cicero's *De officiis*" (a work so highly esteemed by St. Ambrose and countless others); he corrected scribal errors "partly by collating editions, . . . partly by informed guesswork based on Cicero's style . . ." (pp. 29–31) – an early indication of the new scholarly methods Erasmus brought to editing. A new edition of the *Adagia* (published by Aldus in 1508) was immensely enlarged, especially in the Greek area; he described his plan in Letter 211, addressed to one of his patrons, Lord Mountjoy, to whom the work was dedicated. Like Milton and some other great humanists, Erasmus did not disdain to give time and labor to educational manuals, such as *De copia* and *De ratione studii* (published in 1512). Translations from Lucian, Euripides, and Plutarch, along with their intrinsic value for students, contributed to the mastery of Greek that Erasmus required for his great object, the right reading and interpretation of the New Testament and the "philosophy" of Christ (Letter 149, etc.). The letters of these years contain repeated declarations of that supreme goal. The learning of Greek was, he said in 1506 (p. 125), the main motive behind his long-cherished craving to visit Italy – though he found an unexcelled group of Grecians in England and profited much from their friendship, especially that of Colet and More. For study of the New Testament, Erasmus had a bold model in Lorenzo Valla, whose notes he had found and edited in 1505; Letter 182 is an exposition and defense of Valla's critical method, a method which – in opposition to uncritical acceptance of traditional errors – requires informed and precise understanding of language and grammar. Another significant letter (288) was a practical assertion of Christian principles; it contained the core of "Dulce bellum inexpertis," a fervent plea for peace in an age of incessant war which was included in the 1515 edition of the *Adagia* and had fifteen separate printings before 1540. (The pacifist efforts of Erasmus and other Christian humanists are fully described in Robert P. Adams's *The Better Part of Valor,* 1962.)

Erasmus's first direct attempt to inculcate the true spirit of Christianity, the imitation of Christ, was the *Enchiridion* (published in 1503). If the earnest purpose of that work was manifest, the same purpose was largely disguised in the *Moriae encomium*, written in More's house on Erasmus's return from Italy in 1509 and published at Paris in 1511; Letter 222 was printed in all the many editions as a dedication to More, "a man for all seasons" (p. 163). In this satirical and artistic masterpiece, as everyone knows, Erasmus distilled his abhorrence of the ways of the European world he knew so well, notably the ecclesiastical world. In Italy, for instance, he had seen Pope Julius II, the servant of the servants of God, riding in triumph at the head of the troops. But the satirical irony of the praise of folly turned, with a final paradoxical twist apparently missed by many readers then and later, into praise of the supreme "folly" of the Christlike life.

Along with such letters of special note there is, of course, much else of real, if lesser, interest to all readers concerned with Erasmus as a man and as an increasingly famous citizen of the world of religion and letters. If we have to regret his flattering appeals to patrons (flattery he denies) and his complaints about the niggardly, we must recognize that only with enlightened patronage could he maintain the most precious kind of independence, that of the mind and spirit; the alternative would have been a return to monastic bondage and mental and physical death (Letter 296). In that same letter of

1514, to a former monastic comrade who had become a prior, Erasmus could well justify his life in the world by citing the *Enchiridion, Adagia,* and *De copia,* his critical revision of St. Jerome's epistles and the New Testament, and a commentary begun on the epistles of St. Paul; it was, doubtless, discreet to omit the *Praise of Folly,* which did not altogether please the narrow-minded. Perhaps the only thing in these letters that we may really regret is Erasmus's echoing of a friend's jocose remark that the growing number of heretics in England (this is in 1511) had raised the prices of firewood (pp. 189, 192); he did not speak thus of the treatment of heretics in the *Praise of Folly.*

This volume displays the same fine, thorough scholarship as the first, from headnotes and footnotes to the full appendix on the value of coins and wages and the indexes. The translation, as before, combines fidelity with vitality and, so far as the material allows, achieves the desirable end of not reading like a translation. The only phrase that I have stumbled over is "however much in art uncouth his poetry was" (Letter 220, p. 159; Allen, Ep. 220, I, 457, "Ennium arte utcunque rudem"). I have observed more misprints than I did in the first volume, but nearly all of these nine or ten are the merest trifles and quite obvious. I may mention several that occur in references to poems: in n. 95, p. 74, "3.312–15" should be 3.212–15; in n. 152, p. 94, "4.51" should be 451; in n. 26–7, p. 198, "11–12" should be 11.12. For this last item, concerning "Britain's farthest shore," the note cites Catullus; since he was much less readily available than Horace, perhaps the reference should be to, or include, the latter, *Odes* I.35.29–30. But such things are only fly-specks on a monument.

Douglas Bush
Harvard University

Patrick Cullen. *Infernal Triad: The Flesh, the World, and the Devil in Spenser and Milton.* Princeton: Princeton University Press, 1974. Pp. xxxvi, 268. $13.50.

Michael McCanles. *Dialectal Criticism and Renaissance Literature.* Los Angeles and London: University of California Press, 1975. Pp. xviii, 278. $15.00.

It would be difficult to describe either of these volumes as necessary contributions to Renaissance studies. Neither work makes any essentially original advance in scholarship; each goes over ground that has been well tilled by others, though it must be said at once that there is much more to be gleaned by the patient reader from Cullen's *Infernal Triad* than from McCanles's *Dialectal Criticism.* The latter work is a curious production, more interested, by far, in its dialectical theory (derived in the main from modern aestheticians like Burke and Frye) than in the reading of Renaissance literature for its own sake. McCanles, it is true, devotes two-thirds of his book to analyses of works by Bacon (his best section, it seems to me), the metaphysical poets (Donnne, Herbert, and Marvell), Milton (*Paradise Lost*), and Shakespeare (eight plays). Each of these readings (they are linked by transitional essays) is designed to demonstrate the way in which dialectical analysis can help to bridge the gap between "formalist" and "historicist" approaches to literature. The introduction and a long (pp. 214–74) concluding section argue for the validity of McCanles's approach.

One can laud the ecumenical spirit behind McCanles's effort without expressing admiration for this system itself. I find his dialectical theory a rather

unsophisticated affair that is subject to confusions at a variety of levels. Mc-
Canles seems only vaguely cognizant of the role played by dialectic in the
Renaissance itself – and this despite the studies of Perry Miller, Tuve, and
Ong – and he admits (p. 214) that his terminology may appear "barbarous and
uncouth" to some. But the confusion ranges beyond the barbarity of terms like
"action-made" and "action-done" (pp. 219 ff.): we even find, on facing pages
(118–19), that "dialectical logic" and "logical dialectic" are apparently indif-
ferent locutions. After all the tortuous theorizing of the final section, one
wonders if we really have attained to anything more than a reworking of
various tensional theories of literature. Great literature (and it is only the
great that McCanles deals with) can accommodate a variety of tensions – or
"dialectics"; each great work, whether Renaissance or modern, ought to prove
amenable to the manipulations our thematic analyses impose upon it. The point
is pedagogically sound, but one hardly needed a three-hundred-page study to
demonstrate it.

Cullen, too, has his broad patterns to present, but his study is much more
traditional in its major outlines. Moreover, I came away from his book feeling
that he is primarily interested in the literature he is studying – and this despite
the fact that his central thesis is, at times, rather obviously over-argued. Once
Cullen has indicated the main lines in the development of his infernal trio,
from classical and biblical antiquity up to the Renaissance, he proceeds to
find triadic structures everywhere: in Books I and II of *The Faerie Queene*,
in *Paradise Lost*, in *Paradise Regained*, and in *Samson Agonistes*. The short
(25 pp.) chapter on *Paradise Lost* is the least satisfactory of Cullen's efforts; he
finds the world, the flesh, and the devil in both hell and Eden, but this dis-
covery is hardly earthshaking and it adds little to our overall appreciation of
Milton's grandest poem. With Spenser, however, and with *Paradise Regained*
and *Samson Agonistes*, Cullen is much more illuminating. He follows Berger
and Cheney (wholesome guides) in his reading of *Faerie Queene I*, and thus
stays alert to the constant interplay between allegorical signification and narra-
tive action that is Spenser's special excellence. Individual identifications of
triadic figures may be more open to doubt. I, for one, cannot see the char-
acterization of Orgoglio as the devil as in any way (certainly not in Cullen's
way) definitive. The giant can be called diabolic, but he is also a primitive,
pre-verbal monster, a horrific rendering of the "fleshliest' elements in the Red
Cross Knight himself. So, too, in what is for Cullen the final triad of Book I:
Despair (the flesh), the House of Holiness (the world), and the Dragon (the
devil). One agrees, in general, but so much seems to be left out. I would prefer
to see the Dragon (and I suppose we must "undragonize" him a little) as
Death in all its ramifications – spiritual death as well as physical death. After
all, no Christian knight (not even Christ) has ever claimed to *slay* the devil;
but the true Christian, like Spenser's St. George, can hope to triumph (yes, the
dragon *is* really dead in Canto XII) over death.

In his treatment of *Paradise Regained* and *Samson*, Cullen again tends to be
too schematical. Several times (e.g., pp. 188–9, 201) he finds Milton "schematiz-
ing," with the triads proliferating accordingly. Yet Satan's temptations in
*Paradise Regained* are fruitfully viewed as both mirroring and parodying the
excellences found truly in Christ alone, a mode of analysis that keeps Cullen,
for the most part, close to his text and pulls him up short when he attempts to
allow too much to his "trinal triplicities." His readings are bolstered through-
out the book by frequent summaries of the work of other scholars. Such a pro-
cedure is eminently fair, but I doubt if so much detailed paraphrase and
summary is essential. At times (e.g., pp. 113–14, 125–33, 150–2, 183–5, etc.),

the footnotes run on for page after page, putting a heavy burden on both Cullen's argument and the reader's power of endurance. A pruned-down bibliography (none is provided) would surely have better answered. Despite these qualifications, teachers of Spenser and Milton will find Cullen's book useful; one might even suggest that in its own small way it marks a beginning toward that much-desired and still largely-unwritten study of the relationship between these two great Renaissance poets.

R. S. Sylvester
Yale University

# Books Received

This list was compiled from books received between 1 April 1975 and 15 February 1976. The publishers and the editorial board would appreciate your mentioning *Medievalia et Humanistica* when ordering.

Alinei, Mario. *A Computerized Linguistic Inventory of Early Italian (960–1321)*. Bologna: Il Mulino, 1974. Pp. 58.

Barber, Richard. *The Knight and Chivalry*. Totowa, N.J.: Rowman and Littlefield, 1975. Pp. 339. $12.50.

Barraclough, Geoffrey. *The Crucible of Europe: The Ninth and Tenth Centuries in European History*. Berkeley: Univ. of California Press, 1976. Pp. viii, 180. $14.95.

Barzun, Jacques. *Classic, Romantic and Modern*. Chicago: Univ. of Chicago Press, 1975. Pp. 255. $3.45 paper.

Bertalot, Ludwig. *Studien zum Italienischen und Deutschen Humanismus*. Edited by Paul O. Kristeller. Roma: Edizioni di Storia e Letteratura, 129 and 130, 1975. Vol. 1: pp. xii–436; Vol. 2: pp. x–482. £35.000.

Bodin, Jean. *Colloquium of the Seven about Secrets of the Sublime*, trans. and annot. Marion Kuntz. Princeton: Princeton Univ. Press, 1975. Pp. lxxxi, 509. $25.00.

Booth, Wayne C. *A Rhetoric of Irony*. Chicago: Univ. of Chicago Press, 1975. Pp. xiv, 292. $4.50 paper.

Bornstein, Diane. *Mirrors of Courtesy*. Hamden, Conn.: Archon Books, 1975. Pp. 158. $10.00.

Brewer, Derek, ed. *Writers and their Background: Geoffrey Chaucer*. Athens: Ohio Univ. Press, 1975. Pp. xiv, 401. $12.50.

Brooke, Christopher, and Gillian Keir. *London 800–1216: The Shaping of a City*. Berkeley: Univ. of Calif. Press, 1975. Pp. xxi, 424. $21.00.

*Byzantinoslavica: Revue Internationale des Études Byzantines*, Tome XXXV, Fasc. 1. Prague: Academia Editions de l'Academie Tchecoslovaque des Sciences et Lettres, 1974. Pp. 164.

Clemoes, Peter, ed. *Anglo-Saxon England 4*. New York: Cambridge Univ. Press, 1975. Pp. ix, 262. Illus. $24.00.

Cormier, Raymond J. *One Heart One Mind: The Rebirth of Virgil's Hero in Medieval French Romance*. University, Mississippi: Romance Monographs, Inc., No. 3, 1973. Pp. 286. $10.00 cloth, $7.50 paper.

Daniel, E. Randolph. *The Franciscan Concept of Mission in the High Middle Ages*. Lexington: Univ. Press of Kentucky, 1975. Pp. xvi, 168. $11.25.

de Tolnay, Charles. *Michelangelo: Sculptor, Painter, Architect*. Princeton: Princeton Univ. Press, 1975. Pp. 283, 385 pl. $19.50.

Dorson, Richard M. *Folktales Told Around the World*. Chicago: Univ. of Chicago Press, 1975. Pp. xxv, 622. $17.50.

Dronke, Peter. *Fabula: Explorations into the Uses of Myth in Medieval Platonism*. Leiden and Koln: E. J. Brill, 1974. Pp. viii, 200. 58 gilders.

Erasmus, Desiderius. *Collected Works of Erasmus*, Vol 2, *The Correspondence of Erasmus: Letters 142 to 297, 1501 to 1514,* trans. R. A. B. Mynors and D. F. S. Thomson, annot. Wallace K. Ferguson. Toronto: Univ. of Toronto Press, 1975. Pp. xiv, 374. $25.00

——. *Inquisitio de Fide: A Colloquy,* ed. Craig R. Thompson. Hamden, Conn.: Archon Books, 1975. Pp. xii, 137. $8.50.

Evergates, Theodore. *Feudal Society in the Bailliage of Troyes under the Counts of Champagne, 1152–1284.* Baltimore: Johns Hopkins Univ. Press, 1975. Pp. xxi, 273. $14.00.

Gardner, John, trans. *The Complete Works of the Gawain-Poet.* Chicago: Univ. of Chicago Press, 1975. Pp. xiii, 347. Illus. $3.95 paper.

Gardner, John. *The Construction of Christian Poetry in Old English.* Carbondale: Southern Illinois Univ. Press, 1975. Pp. xii, 147. $8.95.

Gardiner, Stephen. *A Machiavellian Treatise,* ed. and trans. Peter S. Donaldson. New York: Cambridge Univ. Press, 1975. Pp. ix, 173. $22.50.

Gouron, Andre, and Odile Terrin. *Bibliographie des Coutumes de France,* Éditions Antérieures a la Révolution. Genève: Librarie Droz, 1975. Pp. 297.

Greene, Thomas M. *The Descent from Heaven: A Study in Epic Continuity.* New Haven: Yale Univ. Press, 1975. Pp. vii, 434. $19.50 cloth, $4.95 paper.

Hallberg, Peter. *Old Icelandic Poetry: Eddic Lay and Skaldic Verse.* Lincoln: Univ. of Nebraska Press, 1975. Pp. xii, 219. $12.95.

Hannaway, Owen. *The Chemists and the Word: The Didactic Origins of Chemistry.* Baltimore: Johns Hopkins Univ. Press, 1975. Pp. xiii, 165. $10.00

Hibbard, G. R., ed. *The Elizabethan Theatre V.* Hamden, Conn.: The Shoe String Press, Inc., 1975. Pp. xvii, 158. $10.00.

Howard, Donald R. *The Idea of the Canterbury Tales.* Berkeley: Univ. of California Press, 1976. Pp. xvi, 403. $15.00.

Jeffrey, David L. *The Early English Lyric and Franciscan Spirituality.* Lincoln: Univ. of Nebraska Press, 1975. Pp. xiv, 306. $10.95.

Jember, Gregory K., ed. *English–Old English, Old English–English Dictionary.* Colorado: Westview Press, Inc., 1975. Pp. xxxiii, 178. $15.00.

Kelly, Henry A. *Love and Marriage in the Age of Chaucer.* Ithaca: Cornell Univ. Press, 1975. Pp. 359. $15.00.

Krochalis, Jeanne, and Edward Peters, eds. *The World of Piers Plowman.* Philadelphia: Univ. of Pennsylvania Press, 1975. Pp. xxi, 265. $15.00 cloth, $7.95 paper.

Lanham, Carol Dana. *Salutatio "Formulas" in Latin Letters to 1200: Syntax, Style, and Theory.* München: Bei der Arbeo-Gesellschaft, 1975. Pp. xi, 140.

Leff, Gordon. *William of Ockham: The Metamorphosis of Scholastic Discourse.* Totowa, N. J.: Rowman and Littlefield, 1975. Pp. xxiv, 666. $47.50.

Lutz, Cora E. *Essays on Manuscripts and Rare Books.* Hamden, Conn.: Archon Books, 1975, Pp. 177. $10.00.

*Magia, Astrologia e Religione nel Rinascimento: Convegno polacco-italiano (Varsavia: 25–27 settembre 1972).* Rome: Accademia Polacca delle Scienze Biblioteca e Centro di Studi a Roma, 1974. Pp. 231.

Manitius, Karl, ed. *Eupolemius Das Bibelgedicht* (Monvmenta Germaniae Historica, IX). Weimar: Hermann Böhlaus Nachfolger, 1973. Pp. 127.

McCanles, Michael. *Dialectical Criticism and Rennaissance Literature.* Berkeley: Univ. of California Press, 1975. Pp. xvii, 278. $15.00.

McNeil, David O. *Guillaume Budé and Humanism in the Reign of Francis I.* Genève: Librairie Droz, 1975. Pp. v, 156.

Moody, Ernest A. *Studies in Medieval Philosophy, Science, and Logic: Collected Papers, 1933–1969.* Berkeley: Univ. of California Press, 1975. Pp. xix, 453. $20.00.

Moorman, Charles. *Editing the Middle English Manuscript.* Jackson: Univ. Press of Mississippi, 1975. Pp. 107. $6.95.

Morgan, Gwyneth. *Life in a Medieval Village, Cambridge Introduction to the History of Mankind, Topic Book.* New York: Cambridge Univ. Press, 1975. Pp. 48. 13 illus. $2.75 paper.

Morse, Ruth, ed. *St. Erkenwald.* New Jersey: Rowman and Littlefield, 1975. Pp. 54, 111. $10.00.

Nicholson, Lewis E., and Dolores Warwick Frese, eds. *Anglo-Saxon Poetry: Essays in Appreciation.* Notre Dame: Univ. of Notre Dame Press, 1975. Pp. xvi, 387. $15.95.

Nieva, Constantino S. *This Transcending God: The Teaching of the Author of "The Cloud of Unknowing."* London: The Mitre Press, 1971. Pp. xxiv, 274. $2.25.

Parsons, David, ed. *Tenth-Century Studies: Essays in Commemoration of the Millennium of the Council of Winchester and Regularis Concordia.* London and Chichester: Phillimore & Co., Ltd., 1975. Pp. 270, 24 pl. $25.00.

Pelikan, Jaroslav. *The Emergence of the Catholic Tradition (100–600).* Chicago: Univ. of Chicago Press, 1975. Pp. xxiii, 394. $4.95.

Petrarca, Francesco. *Rerum Familiarium Libri, I–VIII,* trans. Aldo S. Bernardo. Albany: State Univ. of New York Press, 1975. Pp. xxxii, 439. $20.00.

Polak, Emil J. *A Textual Study of Jacques de Dinant's "Summa Dictaminis."* Genève: Librarie Droz, 1975. Pp. 150 paper.

Power, Eileen. *Medieval Women,* ed. M. M. Postan. New York: Cambridge Univ. Press, 1975. Pp. viii, 112. $12.95 cloth, $4.45 paper.

Price, Glanville, ed. *William, Count of Orange: Four Old French Epics.* London: Rowman and Littlefield, 1975. Pp. xviii, 221. $6.00 paper.

Prieditis, Arthur. *The Fate of the Nations.* St. Paul, Minn.: Llewellyn Publications, 1974. Pp. xiii, 428.

Richmond, Velma B. *The Popularity of Middle English Romance.* Bowling Green, Ohio: Bowling Green Univ. Popular Press, 1975. 12 illus. Pp. 237. $12.95.

Roberts, John R., ed. *Essential Articles for the Study of John Donne's Poetry.* Hamden, Conn.: The Shoe String Press, Inc., 1975. Pp. xiii, 558. $17.50.

Russell, Frederick H. *The Just War in the Middle Ages.* (Cambridge Studies in Medieval Life and Thought, Third Series, Vol. 8) New York: Cambridge Univ. Press, 1975. Pp. xi, 332. $32.50.

Savage, Sister Elizabeth, S.S.J., ed. *John Donne's Devotions upon Emergent Occasions.* Salzburg: Institut für Englische Sprache und Literatur, 1975. Pp. Vol. 1, 123, Vol. 2, 269.

Seibt, Ferdinand. *Utopica.* Düsseldorf: Verlag L. Schwann, 1972. Pp. 327.

Sheridan, Ronald, and Anne Ross. *Gargoyles and Grotesques, Paganism in the Medieval Church.* Boston: New York Graphic Society, 1975. Pp. 127. 144 illus. $14.95.

Silverstein, Theodore, trans. *Sir Gawain and the Green Knight: A Comedy for Christmas.* Chicago: Univ. of Chicago Press, 1974. Pp. iii, 121. Illus. $10.00.

Société Internationale pour l'Étude de la Philosophie Médiévale, ed. *Bulletin de Philosophie Médiévale*, No. 15. Louvain: Secrétariat de la S.I.E.P.M., 1973. Pp. 240.

Sponsler, Lucy A. *Women in the Medieval Spanish Epic and Lyric Traditions.* Lexington: Univ. Press of Kentucky, 1975. Pp. iii, 134. $11.25.

Strehlke, Ernst, ed. *Tabulae Ordinis Theutonici ex Tabularii Regii Berolinensis Codice Potissimum.* Berlin: Weidman, 1869; rpt. Toronto: Univ. of Toronto Press, 1975. Pp. 491. $60.00.

Sumption, Jonathan. *Pilgrimage: An Image of Medieval Religion.* New Jersey: Rowman and Littlefield, 1975. Pp. x, 391. $15.00.

Tavoni, M. *Il Discorso Linguistico di Bartolomeo Benvoglienti.* Pisa: Arti Grafiche Pacini Mariotti, 1975. Pp. x, 107.

Vaughan, Richard. *Valois Burgundy.* Hamden, Conn.: Archon Books, 1975. Pp. ix, 254. $12.50.

Wainwright, Frederick T. *Scandinavian England.* Sussex: Phillimore & Co., Ltd., 1975. Pp. ix, 387. $21.50.

White, Lynn, Jr., ed. *Viator: Medieval and Renaissance Studies, Volume V.* Berkeley: Univ. of California Press, 1975. Pp. vi, 486. $15.00.

Whitman, Robert F. *Beyond Melancholy: John Webster and the Tragedy of Darkness.* Salzburg: Institute für Englische Sprache und Literatur, 1973. Pp. iii, 226.

Wixom, William D. *Renaissance Bronzes from Ohio Collections.* Kent, Ohio: Kent State Univ. Press, 1975. Pp. x, 184. 236 illus. $14.95 paper.

Zimmermann, Harald. *Der Canossagang von 1077 Wirkungen und Wirklichkeit.* Mainz: Akademie Der Wissenschaften und Der Literatur, 1975. Pp. 220, 21 pl.